The Seventies

The Age of Glitter in Popular Culture

Edited by

Shelton Waldrep

ROUTLEDGE
New York and London

Published in 2000 by
Routledge
29 West 35th Street
New York, NY 10001

Published in Great Britain by
Routledge
11 New Fetter Lane
London EC4P 4EE

Printed in the United States of America on acid-free paper.
Design: Jack Donner

Library of Congress Cataloging-in-Publication Data

The seventies : the age of glitter in popular culture / edited by Shelton Waldrep.
p. cm.
Includes bibliographical references and index.
ISBN 0–415–92534–7 (hb). — ISBN 0–415–92535–5 (pb)
1. United States—Social life and customs—1971– 2. Nineteen seventies.
3. Popular culture—United States—History—20th century. 4. Mass media—
United States—History—20th century. I. Waldrep, Shelton.
E169.02.S4535 2000
306'0973—dc21 99–31847
CIP

PART III: FASHIONING THE BODY

PART IV: QUEERING THE SEVENTIES

PART V: TALKING MUSIC

Acknowledgments

To work on the seventies is necessarily a group effort, and I would like to thank the contributors and everyone else who provided contacts and ideas that helped to shape this volume.

I owe a debt of gratitude to William Murphy, now at Random House, for his initial interest in our work on the seventies, and especially to our editor, Nick Syrett, whose expertise and unfailing good humor were essential to the book's publication. I would also like to thank Steven R. Tunnell for compiling the index and relieving me of much other work. As always, Jane Kuenz provided me with support of every kind.

Introducing the Seventies

SHELTON WALDREP

This volume seeks to illuminate the remarkable range of cultural production from the American 1970s. That anyone would want or feel the need to do this might seem curious since, from the standpoint of the 1990s, the seventies won't go away. One need only look at the revival of the seventies as it has permeated the work of Martin Scorsese (*Casino*, 1995) and Quentin Tarantino (*Pulp Fiction* and *Jackie Brown*, 1994 and 1997, respectively) or provided for the resurrection of Robert Altman (*The Player*, 1992) to see the influence in film. One need only note the covers of seventies songs and their use in sampling to see a pervasive influence in popular music. One need only marvel at Nick at Night's reverence for the seventies sitcom (*The Bob Newhart Show*) or dramatic series (*The White Shadow*) as gems of a bygone era to understand the importance of this earlier decade to ours today. It is in the seventies that the cultural zeitgeist of the nineties seems to locate itself, and it is not only nostalgia or generational demographics that powers this reexamination. What, for instance, does the revival of the disaster movie say about nineties anxieties? Though they may seem to be unrelated, *Boogie Nights* and *The Ice Storm*, both released in 1997, suggest complementary answers to this question. In the former, members of the porn industry on the West Coast attempt to act as an extended family while reproducing the outlines of suburbia; in the latter, actual suburban families on the East Coast feel the pressure to act out in their everyday lives what they imagine to be the appropriate sexuality of a porn film. *The Ice Storm* was described by its director as "a disaster movie. Except the disaster hits home."[1] Both movies suggest ways in which the seeds of nineties problems and paradigms may well be located in cultural changes that took place twenty—rather than, say, thirty—years ago. That is, the sixties no longer seem to be the inevitable moment of crisis in the century—

hence, the starting point of any discussion of the decades that have come after it. Rather, the seventies have now become a key part of the equation of our millennial anxiety—the place to look to for the answer to the question: Who have we become at the century's end? Whether in "high" art or in mass culture, the seventies were a time when the use of technology and self-referential popular culture began to evidence the full postmodern effect of the rise of late capitalism. The clue to our own present seems mysteriously locked somewhere in that slippery decade.

So many aspects of seventies culture are being revived that they are starting to come in packages, such as the string of films in 1998 that dealt with seventies "decadence"—*The Last Days of Disco*, *54*, and Todd Haynes's *Velvet Goldmine*, the last based on Iggy Pop and David Bowie. Next on the horizon are remakes of *Shaft* and *The Mack* as well as *Get Christie Love!* From Crayola crayons with retro seventies colors to TV movies on the rise and fall of Sonny and Cher, the focus on everything seventies remains pervasive. During the more innocent time of the early nineties, on an October 8, 1993, broadcast of *Late Night*, host Conan O'Brien described coming out of a convenience store one day during the early seventies to see his first AMC Pacer. Noting its trademark profile, he muttered to himself, "This is the future." If the seventies were the shape of things to come, then I think now we can finally say that the future has arrived. As Susan Buck-Morss has noted in a very different context, the cultural critic Walter Benjamin had hoped that his research on the Paris Arcades—a complex project on childhood nostalgia and the objects of the past—would be a work of "collective history as Proust had presented his own—not 'life as it was,' nor even life remembered, but life as it has been 'forgotten.'"[2] To study the seventies now is to work on what we are trying to remember as much as what we are trying to forget.

This book does not attempt to periodize the seventies so much as to begin to develop a methodology for investigating the decade in order to bring it to attention as an underexamined period in contemporary cultural criticism. The pieces in this collection share an approach to performance and performativity that places an emphasis on the ways in which the seventies constitute a laboratory for experimenting with self-creation. The very simplicity of creating oneself as a character in an ongoing story is a kind of pop performance that suggests that the seventies provided the tools and the instructions for their own reassembly at a later, more advantageous date. To reconstitute the self as something to be performed—in all the vicissitudes of gender, sexuality, race, region, and ethnicity this would involve—is a paradigmatic aspect of understanding how the seventies functioned and perhaps why they have come to seem so relevant once again.

This volume implicitly questions the assumptions behind the methodologies of the major preexisting paradigm for a book of this type, *The 60s With-*

out Apology.[3] Unlike that book, our goal is not to provide coverage of the most prominent historical events of the period—whether the oil crisis or the bicentennial celebration—but to redefine what is considered most important in a materialist tracing of the cultural past. This characterization would not, however, have been apparent without either the distance that passing through another decade has provided us or the maturation of the first generation of seventies youngsters to an age in which they are able to look back at their youth with some degree of summation. In other words, the seventies are as much the product of a generation's view of themselves as they are the symptoms of a series of historical moments. Younger critics see in the subject of the seventies an opportunity to experiment with writing that allows them to use their own history and memory as material.[4] The current wave of seventies revival, however, owes much of its popularity to the even younger members of the twentysomething group, most of whom probably missed the seventies entirely—such as the cast of *That '70s Show.* One possible explanation for this generation's fascination with the seventies might be that the seventies posited a future—however dated it might have been— while the eighties expressed only a return to the past, to the "classics" in fashion and behavior.[5] The seventies, by contrast, continued the sixties' attempts to embrace formal as well as social change.

Specifically, the seventies valued internal contradiction in the artistic forms that it produced.[6] This complexity not only created a richer popular culture than some might imagine, but it also provided an opportunity for a working out of social and aesthetic problems that were left over from various decades of the century. For example, in his film *Dazed and Confused* (1993), director Richard Linklater's choice of 1976—the bicentennial year—as emblematic of the decade seems not only a parodic homage to the glorious tackiness of the birthday party that the nation gave itself but also suggests that the seventies are defined by their middle period—perhaps bookended by the Watergate hearings in 1973 and the premiere of *Saturday Night Fever* in 1977. One of the high points in his film is when the protagonist predicts that since the seventies have been so dull and boring, the eighties will be a kind of renaissance of decadence. The fact that just the opposite was the case is one of the movie's grandest critiques, for the sexual and aesthetic liberation of the seventies seems, as Linklater puts it, "a lot like the post-WWI '20s: after witnessing the horrors of war and realizing that humanity was capable of such large-scale corruption."[7]

Indeed, as the only period of our nation's history when sex had few, if any, consequences of a physical kind, the seventies were a sort of apotheosis of the twenties era. This temporal aphasia was already present in the seventies in what some might have seen as that decade's search for a "self" or a stable definition by referencing periods of time from the past—whether the 1930s (*Chinatown,* 1974), or, most famously, the 1950s (*American Graffiti,* 1973).

Usually in reaction to a period representation in film or on TV, these obsessions with the historical past might not have been so much a symptom of insecurity as an acknowledgment that the past now exists in a different form.[8]

It is significant, therefore, that in a film like *The Brady Bunch Movie* (1995) the seventies would be portrayed as unchanging and innocent in comparison to the nineties. The film's conceit is that the Brady family still lives in the early seventies while within the confines of their home and yard, but venture outside into the nineties to work, attend school, and shop. This idea might be a reflection on the fact that for the original members of Generation X—people in their thirties now—the seventies represent a kind of stasis, in that they were at the right age then to be caught in the commodity fetish aspect of the seventies: our parents' homes are now museums to seventies trends and products. For the generation now in their twenties, the polyester-wearing Bradys can only appear innocent in their interaction with their earthier nineties counterparts. Indeed, the seventies might now seem like the last time a majority of people made a comfortable living: the last gasp of suburbia, of a collective style. As debased as it might seem, the sense of a suburban utopia is a form of optimism and might explain why the nostalgia for the seventies seems to be of such a distinctly middle-class type. If the seventies raise questions for a generation about how to think back to an originary moment in which their sense of themselves was formed as much against the specificities of the culture they were in as with them, then much seventies cultural production gives us an outline of how memory might work for finding our sense of a place or time without succumbing to the need for nostalgia.

In a recent essay on the sixties, George Lipsitz describes the transition from that decade to the seventies as one in which glitter became a substitute for rhetoric,

> sequins for beads, decadence for politics, and open plagiarism for originality. Whereas the counterculture of the 1960s tried to defuse sexual tension by having men and women take off their clothes, the "glam" ... rock of the 1970s encouraged men and women to wear each other's clothes.[9]

One may agree with Lipsitz's critique while also noting that it fails to take into consideration that it is both gender and sexuality that the seventies understood in ways that the sixties did not. The unstable nature of the seventies era—its very ambiguity—provides the period with its generative and disruptive influences. The body was a good thing then, not something to be gotten over, as it must be in eighties science fiction (*Aliens* [1986] and *The Terminator* [1984] for example).[10] In the eighties the body becomes a problem to be solved, which is a reversal of the seventies, when people would collage their clothes and themselves—from writing on a military jacket to imitating dif-

ferent genders—and when one's relation to the body was performative and transformative. Indeed, the body itself was different, as Ralph Sarkonak notes in a description of the gay French photographer Guibert Hervé's photo of his lover, "T.":

> T.'s body is a very 1970s body: they just don't seem to make men like that any more, for nowadays men come complete with muscles but hardly any hair! Looking at T., I am transported back to the Toronto of the seventies and all the long-haired, thin boys who used to amble along Yonge Street on their colorful, high-heeled shoes, wearing little leather jackets. In the photo of T. . . . the sensuality is not lodged in the muscle tissue beneath the skin, in the rock hard flesh that seeks to force its way out, like pent-up sperm about to come. Rather, the sensuality is located in the touch and feel of the body's outer envelope.[11]

For the seventies, depth was surface because details were there for all to read. The eighties carried this superficiality a step further—from glam to hype, perhaps—to create a different style of artificiality: one in which the details have been eroded, leaving only a surfaceless illusion of depth, an ambiguous border at best. The seventies were the last decade of the truly visual, the last time that surface could be seen as the textured representation of complexity and detail rather than the gleaming reflection of cybernetic indifference. What the eighties coded as the future-as-now, the seventies transcoded as the inability to absorb the present, to render visible the plurality of choices—fabrics, song stylings, sexual partners—that pop culture had tossed up after the explosion of the sixties and the synergistic power of the media and youth culture came together.

As Anne-Lise François argues, the attempt to find the limits of compulsive artifice—or the bounds that one may be able to place on the transformation of the male silhouette—evidences both a desire to eliminate embarrassment as a controlling social force and to install a set of codes to stabilize difference. Likewise, for Charles Kronengold the black action film establishes new boundaries for the action-thriller genre as the character John Shaft crosses and recrosses on foot and by subway the grid of the early-seventies urban city. To translate the sixties spy hero for the seventies, *Shaft* (1971) represents a major realignment of generic codes, both musical and cinematic. Both François and Kronengold establish the street as a stage upon which seventies pop aesthetics were played out.[12]

The erotics of looking and seeing, performing and being looked at, are also played out in Amber Vogel's essay on *Vogue* in the seventies. Not only is the shiny surface of a magazine article a boundary by which to be tantalized, but the skin as literal boundary in its repose of flesh teases the viewer metaphysically. Vogel's piece reminds us most of all that the seventies exist for us now as a found object, a layer of culture to be exhumed as we would the

yellowed pages of a Victorian newspaper. The detritus of a period becomes a way (back) into a mood or period delirium for many, perhaps most especially because the associations are devoid of collective memories but rich in personal, associative ones. For Vogel, the mere act of looking—and what we do or don't see when we try—is paramount to a rethinking of a period that placed an emphasis on the surface over "depth."

The question of surface versus depth is also on display in Greil Marcus's prescient collage review for Dylan's much-anticipated album of 1970, *Self Portrait*. Knowing full well the album's ability to be seen, now, as a harbinger of not only the end of the sixties but also the advent of the more stifling parts of the next decade, Marcus presents an X ray of the flip side of seventies productive self-definition. Locating within the album a series of paradoxes related to the idea of the artist as auteur, Marcus shows the inability of Dylan to adapt his persona to the stringencies of a seventies style. It was perhaps for no less a hyperauteur than David Bowie to suggest an alternate—and ultimately radical—path out of the quandary. But if Dylan's album suggests that the auteur theory can't work for him, then is the problem in the theory or in the inability of Dylan to change? Or is the problem manifest in a culture that no longer wants its heroes to be unironic and political in an activist sense? As early as 1970, before the advent of the seventies proper, these questions were posed, with a decade of often partial answers to follow. The return of Dylan, like the return of the sixties, was not to happen in the pure form imagined by the voices that dissect the album here.

What was to happen, as shown by the two oral histories of the music scene, was the creation of a different kind of music-based community: one urban, often gay, and ultimately decadent in just the way that Marcus interrogates this concept in his review. That is, the seventies become a space for the transformation of music culture from a warm campfire to the cool precision of disco lights. The hedonism of the period was an exfoliation of the artistic decadence of the glam period via the commonality of technology and dance-as-performance. Warhol and Dylan both got the people's touch, though not in a way anyone might have suspected. As Vince Aletti's interviews with the stars of the disco period suggest, the glamour of being caught up in a phenomenon—even one begun by commercial means—was more than merely intoxicating; it was transformative of a period and culture from one point to another, very different one. The sixties don't finally end until disco. The meaning of all that has come since in music—from sampling to the return of *queer*—was laid down in the funk and in the groove.

This argument does not mean that all was wonderful on disco's high side, as evidenced by Randolph Heard's interview with KC of the Sunshine Band. Existing here more as a survivor rather than as the triumphant prophet à la Barry White he was yet to become, KC reminds us of the pure danger of burnout. The very precision with which KC defines the period only under-

lines what he has forgotten or is unable to recall. Disco's utopian impulse doesn't exist so much as a lost "lifestyle" or ideology as it does a memory of the morning after that some seem to have forgotten.

Indeed, were the eighties one long hangover? A gigantic, mournful act of contrition for some that simply allowed for the less-restrained actions of others who hadn't had any fun to begin with? Certainly, as Sohnya Sayres makes clear, the seeds of lost rebellion were already sown in Jonestown. An instant monument and memorial to a decade that was not quite over, Jonestown was one example, as another critic notes, of "the 'self' returned with a vengeance, but with a reprogrammed machinic ego."[13] If the Manson family helped conclude the sixties, the seventies ended with its own massacre, one that illustrated the limitlessness of ego when it is given all the aid of the military, the rationalization of religion, and the efficient model of corporate organization. A miniature model of hell, complete with suburban family units and Kool-Aid, was not only one ending of the decade—in 1978—but also the breaking up of one type of cultural paradigm: henceforth, the goal of cults must be to deprogram. After Jonestown, we have New Age spiritualism: "the pluralism of the '60s, but with a postmodern twist."[14]

Perhaps a part of the dialectical rhythm of the century, the narrative that the seventies presents is of collective and individual change happening in a totally asynchronous manner. Attempting to understand where this effect might come from could also mean homogenizing the culture in ways that not only efface class and culture but differences of gender, race, and sexuality as well. Though the seventies may seem inclusive when viewed from the fragmentation of the nineties, they were hardly a zone of liberation in the real sense—only in the phantasmagoric. Yet, the cultural strata of the period's dense nexus of reference yields a few clues that many were watching what was happening with their own agendas in mind. David Allen Case's memoir about *Bewitched* is a literal example of the Nickelodeon cable channel's attempts to analyze "our TV heritage." Case makes clear that a queer child's reading of the seemingly innocuous sitcom is not only a barometer of the changes in culture from the sixties to the seventies, but also of the limitations of just the sort of fantastic camp that sixties television could represent so well once social awareness emerged in the seventies in the form of TV programming. The search for a sexual self on television could be seen as another metaphor for the search for one's own representation within culture. This same question is raised by Christopher Castiglia, who shows that though the seventies might seem to constitute a decade that no one ever would want to call their own, the seventies have come back in the nineties to haunt us—in some ways, literally. As Castiglia notes, in the short film *The Dead Boys' Club,*[15] the young gay protagonist is possessed by a ghost from the seventies past when he dons the disco clothes he has purchased from a street merchant. The insertion of the seventies into the present is here seen

as a talismanic function, the bodying forth of another era previously set off from the present by the borderline of AIDS. For the nineties, then, the seventies is a birthright to be reclaimed in a way the eighties can never really be, though it took the eighties to show us just how different the seventies have turned out.

Cindy Patton reminds us that the search for self is ultimately one mediated, at least in part, by the advent of technological change. Looking at a key seventies porn film, *The Opening of Misty Beethoven* (1975), Patton asks questions about performative utterances—those elocutionary phrases that are designed to *do* something, not simply to describe or question. Engaging with the debate in queer theory about the uses of J. L. Austin's *How to Do Things with Words*, Patton not only points out aspects of Austin's lectures that are perhaps missed in the usual take but also provides a critique of the standard communication model as seen by relativist philosophers like Richard Rorty. Her application of Austin to this particular film allows her to show the way in which the slippage between voice and character—as mediated or brought about by technology in porn films in general and this film in particular—metaphorizes and extends the implications of performative indexicals.[16]

As recent seventies nostalgia has shown, the period's re-creation is almost wholly in terms of its pop culture features—television theme songs, various film genres, fashion, and FM radio. Patton's essay brings home the implications of technology to understanding this era, while also emphasizing the queer erotics at work in the pedagogical dictates of a certain very Austinian moment in *Misty Beethoven*. The theme of self-reference, of reference contained within a system or genre, is not only a part of the dictates of convention that Charles Kronengold describes here in reference to the black action film, but is perhaps characteristic of the decade's logic.

Indeed, Van M. Cagle provides a case analysis of the limits of genre by analyzing what happens when one type of reaction to the authenticity and sincerity of the sixties—the influential glam or glitter movement in Britain—is translated to the U.S. context. A form of self-presentation that is almost wholly made up of self-referential stylistics and theatricalized personae that represent the fragmentation of any sort of stable self, the glitter influence had a brief and ultimately limited existence in this country. The peculiar logic of the U.S. fan system allowed for the initial acceptance of the New York Dolls as a bargain-basement version of glitter drag, as an "authentic" version of an inauthentic movement. But once the Dolls became more self-consciously referential with their formula, they faced resistance from those very same fans. Their experimentation with a U.S. version of seventies glam points up the fact, however, that the United States was not immune to the energy that was available after the ideological collapse of the sixties: whether powering the Velvet Underground or the New York Dolls, the seventies avant-garde did have another tale to tell, and the movement of the

arts scene from the underground to the middle class opened up possibilities for both fans and performers that resulted in changes that brought about a synthesis of "high" and "low" cultural production which has not, until the nineties, been equaled.

One story of how this synthesis resulted from the very unlikely mixture of the Black Panthers, New Journalism, and New York society culture is told in Michael E. Staub's essay on the part that the mythologizing of the sixties played in the formation of a seventies identity—one that would result in the emergence of the queer insider as a source of cultural capital. The unfinished project by Truman Capote, *Answered Prayers*, had it been completed, would have posited the adventures of such a figure and provided an example of the milieu that Staub begins to sketch here.

That the sixties play a key role in the seventies is not new, but that the seventies are ultimately to exist for the nineties as more than merely a passing trend now seems certain. Stephen Rachman provides us with a reading of the *Wayne's World* phenomenon which allows us to begin to decode just how the seventies could conquer the nineties pop culture imagination so completely, so early on in the decade. Many of the elements necessary for the invasion, it seems, were there in Wayne and Garth's mythical den. Rachman makes clear how the films cross generational boundaries to pull together different audiences by creating their own type of cultural critique. Though popular culture has asked us to look at the nineties through the seventies lens, it is equally as important to reexamine the seventies using the critical tools of the nineties. In looking at the sequel to the film *Cleopatra Jones*, Jennifer DeVere Brody chooses a particularly complexly coded text to analyze—one in which she sees, encoded within the dictates of the black action genre, a queer subtext that operates as much at the level of costume and mise-en-scène as dialogue. The spectacle of the genre is discussed here in relation to viewership to demonstrate the ways in which identity formation, both on the screen and off, functions in ways that unsettle genre to allow for subversive readings of works that seem to have been rendered "safe" by the passage of time. Indeed, the seventies' ability to provide for an experimentation with self and with the borders between genres and forms, eras and periods, has remained one of the strengths of its cultural production. To illustrate this claim, one need take only a brief look at someone like Bowie—a figure whose career functions as a case study of what it meant to be a seventies artist.

For a brief period of time, from 1975 to 1976, Bowie became the most famous pop performer in the United States. His album *Young Americans* earned him not only a Grammy award for the hit single "Fame," which he recorded in a proto-disco style, but also spots on both *Soul Train* and Cher's variety show. In 1975, Bowie's single was number one in *Creem* magazine's "Reader's Poll" in the categories of top single and top R&B single. He was also voted top male

singer (just above Mick Jagger and Elton John), and his album came in over-all at number four. Bowie even was ranked fourteenth in the category of "Top Twenty Groups."[17] By 1975, he had become something of a category unto himself.

Bowie's very seventies approach to his art can be seen in the change he made in the performance of his first major hit song, "Space Oddity." First recorded in 1969,[18] the song was written while he was working on vignettes to illustrate his songs for a film entitled *Love You till Tuesday*. Amid the saccharine tunes that Bowie was writing at the time, "Space Oddity" stood out, and, perhaps anxious to break into the big league with a bona fide hit, it is the song for which he saves his most lavish production. As the segment in *Love You till Tuesday* begins, we see Bowie dressed in a helmet and blue visor as the character Major Tom, who is awaiting the countdown to the launch of his spaceship. Once he achieves orbit, Major Tom steps outside his capsule to note that "the stars look very different today." In fact, the stars have become women—sirens, it turns out, who lure him into bed. The resignation in his character's voice at the end, "Planet Earth is blue / And there's nothing I can do," seems mostly a joke, as he has floated out into space only to find something better. This escapist interpretation is belied by another video of the song that Bowie was to make four years later. Here he sings the lyrics on the dark and empty backstage of a theater. Completely alone, his only company an array of meters and switches that stand in for "ground control," Bowie changes the meaning of the voyage from one of discovery in outer space to one of interiority and angst. The lyrics take on a sinister tone, yet the most striking difference—as it often is with Bowie—is the way that he looks. Gone is the young artiste of the earlier movie; here instead is the copper-shock Bowie with the vampiric teeth and androgynous gestural language. The seventies, Bowie seems to proclaim, are different. Major Tom is not who he once was.

Bowie was to drive home the significance of this change in a series of video clips that he made in the early seventies—none more dramatic than the one he made for the song "Life on Mars" from his 1971 album *Hunky Dory*. An album that owes much to an interest in blues and folk music as filtered through Dylan, the cover of the album shows a folksy Bowie dressed in natural fibers and sporting a very long Veronica Lake hairstyle—a look that was also used for the cover of the preceding album, *The Man Who Sold the World* (1970) (fig. 1). The image of Bowie in the video is very different (fig. 2). Here Bowie's white makeup refers to the mime tradition that interested him in the sixties and that has provided a template for many of his stylistic transformations and performances on film. The makeup's masklike effect causes his face to look like one seamless surface and emphasizes the delicacy of his features. The lack of shadow makes him appear somewhat alien—or perhaps like a Warhol pop painting.[19] The overall effect—from the faintly neo-Edwardian suit he wears to the famous Ziggy hair—becomes the basis for the

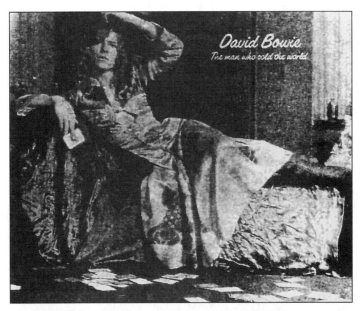

figure 1

combination of factors that Bowie is to go on to combine here and through-out his career: gay fashion stereotypes, science fiction, Orientalism, and, gen-erally, a play with surface that reduces all style to a series of codes that are reprocessed with each new transformation of character. It is not surprising, for example, that Bowie's face is, at the end of the video clip, reduced to a series of signs in the form of camera closeups of his eyebrows, mouth, hair. His style is all style, signifying an artifice almost beyond itself, a simulacrum, if you will, of a new type of self-creation.

Throughout his career Bowie seems always to be commenting on his previous incarnations even as he is creating a new one, another version of the present in the form of the future.[20] In an essay entitled "Concerning the Progress of Rock & Roll," Michael Jarrett notes that "the dandy … 'appears above all in periods of transition,' which makes me suspect that the nearly simultaneous rise of rock & roll and poststructuralism is sympto-matic of a paradigm shift, a fundamental change in the way we approach the materials of the past."[21] Like his predecessors in the last fin de siècle, Bowie knew that it is only through an awareness of this process that we can ever hope to bring about changes in how we live in the present. For Bowie, like Warhol in a different register, the approach to take was one of *becoming* rather than *being*.[22]

The resulting synaesthesia of pop culture periods created by artists like Bowie can be seen in a later figure like Prince, whose work is brilliantly

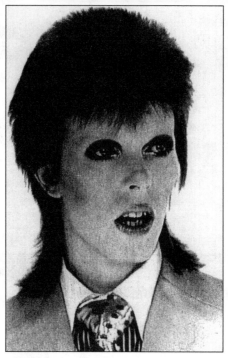

figure 2

parodied by Sandra Bernhard in her performance of "Little Red Corvette" as a sixties hippie song–cum-striptease in her film *Without You I'm Nothing* (1990). Bernhard's mixing of references to the sixties, seventies, and eighties is credited neither to postmodernism nor simple eclectic eccentricity but to the seventies as the time that established a performative self-definition free of naturalistic sources or intentions.[23] The seventies, and the past in general, seem for her to be that which one inevitably replays as a pop cultural source in order to reveal not only one's favorite interests or influences, but somehow to order what one was forced to experience as a child, make it one's own, and simultaneously recode it as, say, an attack on homophobia, a parody of the pretension of certain essential cultural experiences, or the representation of a new consciousness. Bernhard makes this methodology explicit in one segment, where she says:

> Out of all the decades that we've exploited—and we've exploited all of them—the seventies remain the least understood and yet to me the most intriguing and pivotal to my aesthetic and philosophy. When I try to think of the one person who encapsulizes it to me, it was Patti Smith. She was a prophetess. She saw so far into the future she could afford to take ten years off and not say another word. The one thing that she said that rings true

to me today and has become my anthem and goal in life is "I may not have fucked much with the past, but I have fucked plenty with the future." I'd like to believe in that quote and all the other wonderful sayings of the past. It's hard to be that optimistic these days. Perhaps Cher said it best when she said: "Miniskirts were once the rage / Uh huh / And history has turned a page / Uh huh / And the beat goes on."

Bernhard's tongue-in-cheek spotlighting of the seventies in this performance piece does its own kind of encapsulating of the seventies as property worthy of a history, a meaning, and as a source for understanding the present. Bernhard's more serious point is that an understanding of the postmodern present is first available in the seventies. The present, like the past, is really more a blend of the twin possibilities of the past and the future—both ultimately unknowable. The seventies, then, are our own future now—embedded, like us, in time.

NOTES

1. Richard Corliss, "Left Out in the Cold," *Time*, 29 September 1997.

2. Susan Buck-Morss, *The Dialectics of Seeing* (Cambridge, Mass.: MIT Press, 1990), 39.

3. A somewhat similar critique of this volume is made by Michael Warner in the second footnote to his "Introduction," in *Fear of a Queer Planet: Queer Politics and Social Theory*, ed. Michael Warner (Minneapolis: University of Minnesota Press, 1993), xxviii.

4. Perhaps this change was also brought about by the dominance of the baby boom generation, whose members, now that they are in their 40s and early 50s, may think of time in generational rather than historical terms. Similarly, the mere size of this generation is such that all who come after it find that they must define time in relation to this massive group. At any rate, the demographics of the post-sixties period are complex. Sociologists tell us that the boom generation is in fact two generations that have been lumped together. Likewise, as someone in his 30s, I am technically a part of Generation X, originally theorized by Douglas Coupland. The term now is used to refer to anyone who is, roughly speaking, post–college age but not yet 30. Of course, since people do continue to age, Generation X is no longer the generation of those who grew up in the seventies and went to high school then—director Richard Linklater's handy definition—but, rather, a sort of moving demographic mass that comes ever closer to the present without actually arriving. In talking to my own students about demographic definitions—and just from watching MTV's *The Real World*—it is easy to see that the current generation of people in their teens and twenties is not the same as the one that Linklater and I populate. Another shift, in other words, has already occurred, and it won't be long before these younger people define themselves as something other than Gen X,

although the original definition of this faction may hold better for them than for us. The seventies as a period, therefore, exists in several parallel dimensions. It is a zone of generational memory, a boundary between times of political excess, a period of still underexamined cultural production that marks the beginning of a new plurality and diversity in popular and artistic diversity of which we are still a part. Indeed, a related issue is the growing friction between those of the boom generation who claim the sixties and dismiss the seventies—or who feel that the sixties can only be theorized by them. See Rick Perlstein, "Who Owns the Sixties?" *Lingua Franca* (May–June 1996): 30–37, or the large number of letters published in *Vanity Fair* (March 1996) in reaction to Christopher Hitchens's "The Baby-Boomer Wasteland."

5. The eighties were a sort of respite from style in that they embraced, for the most part, a preppy nonstyle—a WASPish escape from both the temptations and the dictates of change.

6. I take this idea in part from an unpublished talk given by Charles Kronengold entitled "Excess and the Contract of Genre: Functions of the Hook in Popular Music."

7. Richard Linklater, *Dazed and Confused* (New York: St. Martin's Press, 1993), n.p.

8. Pagan Kennedy provides the best description of how the 1950s form an "alternate universe" for seventies television. Beginning realistically as a reference to *American Graffiti*, the television show *Happy Days* "[s]lowly . . . ceased to make reference to the fifties at all and began to exist in its own hermetic universe" (*Platforms* [New York: St. Martin's Press, 1994], 6). Eventually the show, like the decade, implodes in its own self-consciousness, creating not only *Laverne and Shirley* but the surreal variety show *Sha Na Na* in 1977. That same year, as Kennedy describes, "Donny and Marie guest-starred on the loathsome 'Brady Bunch Hour.' In a fifties segment too weird to be believed, the Bradys head for a roller rink and affect Italian accents as they perform jazzed-up rollerboogie versions of oldies hits. Just when you think it can't get any worse, Donny Osmond shows up, calling himself 'The Don,' riding a motorcycle, and otherwise pretending to be the Fonz. This is TV at its most self-referential" (8).

9. George Lipsitz, *The Sixties: From Memory to History*, ed. David Farber (Chapel Hill: University of North Carolina Press, 1994), 230.

10. Thanks to Richard Swartz for pointing out this subtle distinction.

11. Ralph Sarkonak, "Traces and Shadows: Fragments of Hervé Guibert," *Yale French Studies* 90 (1996): 187.

12. Public space—perhaps still a recognizable form before the ubiquitous dominance of the suburban shopping mall and urban atrium space of the eighties—might have had its last signifying moment at the point at which the seventies began.

13. Erik Davis, "Stairways to Heaven," *Zirkus: The Journal of Seventies Studies* (ed. Charles Kronengold and Suzanne Yang) 13, 3 (Summer 1988): 26.

14. Ibid.

15. Director Mark Christopher, 1992.

16. Vincent Crapanzano provides a suggestive definition of indexicals:

> Despite popular grammatical understanding that a pronoun is simply a noun substitute, there is ... a fundamental difference between first and second person personal pronouns ("I" and "you" and their plurals) and third person pronouns ("he," "she," "it," "they"). The first and second are properly indexical: they "relate" to the context of utterance. The third person pronouns refer back anaphorically to an antecedent, a noun, often enough a proper noun, in the text. They are liberated, so to speak, from the context of utterance, but they are embedded in the textual context. They are intratextual and derive their meaning from their textually described antecedents.

(Vincent Crapanzano, "Hermes' Dilemma: The Masking of Subversion in Ethnographic Description," in *Writing Culture: The Poetics and Politics of Ethnography*, ed. James Clifford and George E. Marcus [Berkeley: University of California Press, 1986], 71.)

17. The poll is reproduced in Linklater, *Dazed and Confused*, n.p.

18. Released in time to be used by British TV during their coverage of the American moon landing, the song was suggested to Bowie by Stanley Kubrick's *2001*.

19. The look he has here, in fact, provides the basis for three album covers: *Aladdin Sane*, *Diamond Dogs*, and the aptly titled *Pin-Ups*. Brian Eno, among others, also seems to have borrowed the look for his *Taking Tiger Mountain (By Strategy)* (1974).

20. In 1993, Bowie began to provide his fans with convenient ways to reevaluate his career. Rykodisc released his entire oeuvre on remastered compact discs and most of his videos on two videocassettes. The records he has produced in the nineties contain numerous homages to his seventies work. Of course, Bowie had already looked back at his earlier self in 1980 when he recorded "Ashes to Ashes," which takes up the story of Major Tom from where he is left in 1969.

21. Michael Jarrett, "Concerning the Progress of Rock & Roll," *South Atlantic Quarterly: Rock & Roll Culture* (ed. Anthony DeCurtis) 90, 4 (Fall 1991): 814.

22. In contrast, Lipsitz writes that William Chafe "describes the countercultural sensibility that emerged [in the 1960s] as one that held that 'being' was more important than 'becoming.'" (Lipsitz, *The Sixties*, 214).

23. Although Greil Marcus, Carter Radcliff, and others have discussed modernism's influence on the musical production of the seventies, Carrie Jaurès Noland's "Rimbaud and Patti Smith: Style as Social Deviance" (*Critical Inquiry* 21 [Spring 1995]: 581–610) not only provides an account for the influence of decadence and modernism on popular music generally (the Doors, for example) and Smith in particular, but also attempts to begin to theorize a way to discuss the interaction of "high" and "low" art in popular music, a project fundamental to an understanding of seventies music.

Re/Defining the Seventies

Setting up the Seventies

Black Panthers, New Journalism, and the Rewriting of the Sixties

MICHAEL E. STAUB

In the August 13, 1995, edition of the Sunday *New York Times*, the "Week in Review" section ran as its lead story an article that mobilized memories of the sixties for the purpose of ridiculing and neutralizing political activism in the nineties. In itself, this rhetorical maneuver might be considered noteworthy only because of its typicality. For as Meta Mendel-Reyes has recently summarized it, "What is at stake in the American struggle over who owns the sixties is ownership of the nineties."[1]

But there was more to this particular news story showily decorated with neopsychedelic pop art (fig. 1.1). Written by respected veteran *Times* journalist Francis X. Clines, the article, "The Case That Brought Back Radical Chic," began like this:

> The hard fact that criminal justice is grossly relative is never clearer than when a felon gifted with articulateness approaches the gallows, rallying celebrities to his side. Tongue-tied peers—3,009 and growing at last count of America's burgeoning death rows—can only wonder in silence, perchance grunting of their own innocence, but well ignored. So it goes with the condemned among us lately as a throng from the arts, academic and entertainment worlds singles out the cause of Mumia Abu-Jamal, a finely expressive, dramatically dreadlocked, suddenly celebrated ... convicted cop-killer.

Taking advantage of an opening provided by the last-minute stay of execution granted former Black Panther Abu-Jamal a few days earlier, Clines aired his views on black militants who write books, and on "the championing of an underclass cause by an overclass gathering." Clines reminded readers of Tom Wolfe's "hilariously" rendered send-up of "radical chic" adoration for

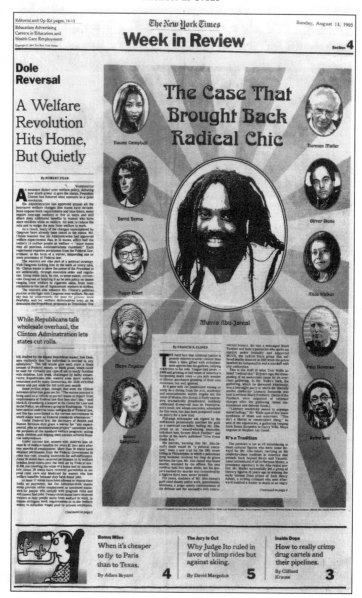

figure 1.1

the Black Panthers in 1970 and cited Wolfe as his star witness. Indeed, it was a Wolfe quote about Abu-Jamal—that "literary sensitivity seems to expunge moral failings"—that supplied the Clines piece with its organizing thesis.[2] What does it mean that, in commenting on progressive nineties advocates of a militant African American, Francis X. Clines and the *New York Times* could

hark back with such comedic "commonsense" knowingness (and author-
ity) to a moment a quarter of a century earlier? And how is it that, in pre-
tending to express sympathy for the "grunting" individuals sentenced to die
(even as he insulted them), Clines could shift away from the racial politics
and flawed legal processes that put such a disproportionate number of blacks
on death row (the real way that justice is "grossly relative") and toward a
satiric invocation of radical chic culture? What Clines's revival of radical chic
managed was an adroit double displacement. In this view, elites in the United
States do not hold political power (which can be used *against* blacks) but
merely set trendy cultural standards so that they might derive self-
gratification from them; and matters of life and death are, in this view, only
matters of style.

The conjunction of Tom Wolfe, the Black Panthers, and radical chic intro-
duces the subject of this essay: the mainstream media response to the Black
Panthers in 1969–70, and, more particularly, the role played by the New Jour-
nalism. As Fredric Jameson has commented, the sixties did not end in an
instant but extended until "around 1972–74."[3] And, crucially—contempo-
rary neoconservative punditry notwithstanding—the sixties were hardly
simply a utopian era when the Left flowered and flourished. This was also a
moment when sophisticated anti-Left strategies were already being tested
and refined, and these trends intensified at the turn to the seventies. The
memory of the sixties (both as historical event and as metaphorical refer-
ence point) was, in short, being fought over almost immediately; history was
getting rewritten practically as it was happening. This in itself is no great sur-
prise to students of this era. It may be more surprising to discover how the
1970 media spasm surrounding the Black Panther Party, and particularly the
crucial role of the New Journalism within it, contributed to the elaboration
of an anti-Left agenda. The seventies began with the defining and denigrat-
ing of the sixties.

THE NEW JOURNALISM

The New Journalism—that genre-blurred mélange of ethnography, inves-
tigative reportage, and fiction—is widely and rightly considered to be *the*
characteristic genre of the sixties. For a time, and certainly by mid-decade,
it looked as if the surest means for a novelist to build a reputation—or
rebuild it, as the case may be—was to write a nonfiction report on a historical
event, but write it as if it were a novel. Whether the subject was a cold-
blooded serial killing (Truman Capote), the hippie counterculture (Joan
Didion), or a march on the Pentagon (Norman Mailer), writers who had first
written successful fictions found themselves turning to "the rising author-
ity of nonfiction" to help make sense of the "fast-paced . . . apocalyptic" times
they were living in.[4] Likewise, a new generation of younger writers—for

instance, Wolfe, Michael Herr, Gail Sheehy, and Hunter S. Thompson—
developed through the New Journalism a freedom of approach and range of
style (along with an enormously receptive reading public) that even just sev-
eral years earlier would probably not have been possible. Self-identified fic-
tion, as none other than *The Harper American Literature* matter-of-factly informs
students, temporarily lost its charms, as precisely the destabilizing hecticity
of the era made life seem more interesting than art.[5] Or, as activist-scholar
Todd Gitlin put it more evocatively, utilizing the highly metaphoric tense-
switching language of the New Journalism itself, the "years 1967, 1968, 1969,
and 1970 were a cyclone in a wind tunnel . . . when history comes off the leash,
when reality appears illusory and illusions take on lives of their own, [and]
when the novelist loses the platform on which imagination builds its plau-
sible appearances."[6]

The New Journalism styled itself as providing an alternative to more stan-
dard media renderings of social reality, promising to deliver a "more real"
reality, the truer story of the many social crises splitting American society
in the 1960s. For it was not only a loss of interest in fiction that engendered
the search for a new style. It was, probably even more significantly, precisely
the atmosphere of social crisis that had begun to make the traditional media
seem so suspect, and that had called attention to the way the media's claim
to be "objective" was frequently a smokescreen for bias. Media coverage of
Vietnam provided some of the most appalling examples, and some of the
decade's best New Journalism brought readers a different version of the Viet-
nam War (Herr) and of antiwar protest (Mailer). But the more general inten-
sification of domestic turmoil also contributed to the impression that many
standard journalistic conventions ought to be scrapped—or at least radically
modified—since, as journalist and scholar Nicolaus Mills has noted, a "who,
what, where, when, why style of reporting could not begin to capture the
anger of a black power movement or the euphoria of a Woodstock. . . . For
an audience either deeply concerned or directly involved in the changes
going on in America, it was necessary to report events from the inside out,
and this is what the new journalism attempted to do." Furthermore, as one
practitioner, Nat Hentoff, argued already in 1968, the New Journalism
offered its audience an opportunity to read news reportage by journalists who
could express that they really cared about their subjects. Only through a dra-
matic "novelistic" method, he proposed, could reporters openly communi-
cate (rather than mask) their own direct engagement with and active
participation in the experiences they reported and thereby "help break the
glass between the reader and the world he lives in." Similarly, as Michael
Schudson observed in his excellent survey of the development of the jour-
nalistic profession, in an era as conflicted as the sixties when "'objectivity'
became a term of abuse," a media-savvy audience eagerly sought out "voices
of an adversary culture," and the openly subjective approach of the New Jour-

nalism was extraordinarily welcome. In short, it was only by allowing imagination into journalism that journalism could speak to the imagination of the times. Indeed, according to Gay Talese, another pioneer of the genre, it was only by using fictional techniques that the media could produce news "as reliable as the most reliable reporting." This was precisely because the New Journalist "seeks a larger truth than is possible through the mere compilation of verifiable facts."[7]

Yet, although this is not so well remembered now, the New Journalism and the incorporation of subjectivity into reportage were not always associated with the counterculture. The publishing history of the New Journalism cannot be separated from the history of two magazines during the mid- to late sixties and early seventies: *Esquire*, whose literary editor was Clay Felker, and *New York* (initially the Sunday supplement to the now-defunct *New York Herald Tribune*), which Felker edited when he left *Esquire*. Under Felker's guidance, *Esquire* and *New York* published a good many writers who were closely associated with the genre: Capote, Herr, Sheehy, Talese—as well as James Breslin, Robert Christgau, Terry Southern—and (most of all) Wolfe. These writers represented a spectrum of opinions on a range of issues. It is my point, however, that *New York*'s historic role as journalistic gadfly placed it in the unusual cultural position of appearing adversarial in content (or politics) even while it was truly adversarial only in style—and I emphasize that I mean unusual *at that time*, since several other magazines (*Rolling Stone* and *Esquire* come immediately to mind) ultimately came also to fit into this category, although only *New York* self-consciously inhabited this split identity and thrived on being understood as simultaneously hip *and* sold out by contemporaneous media watchers. Felker's *New York*, at least for a while, knew its media niche as the place to go to read "the story behind the story"; or to hear about the latest trend or celebrity gossip; or to find out what the mainstream press was too cautious to report, or too invested in keeping from view. All this was related through the New Journalistic fact-based storytelling technique the standard press loved to hate—or perhaps just hated to love.

This essay focuses on two New Journalistic efforts, both written for *New York* in 1970, and both (although in very different ways) purporting to provide a truer narrative than available elsewhere about the phenomenon of the Black Panther Party and its white supporters. One is Gail Sheehy's two-part "Panthermania," ostensibly mainly a report on the impact of the Panthers on the black community.[8] The other is the Tom Wolfe piece Francis X. Clines found so funny—"Radical Chic: That Party at Lenny's"—an article whose main purpose was to skewer the white supporters.[9] Both pieces appeared in book form as well in late 1970 and early 1971. Although Sheehy's writing on the Panthers has long been largely forgotten (even while Sheehy herself has once again been in the news as she serves up another installment of *Passages*), her essay bears reexamination today, for its representations of

racial identities and relations, its main tropes and obsessions, will appear quite (and I hope distressingly) familiar to nineties readers. Wolfe's tale, meanwhile, is of course infinitely more infamous, although, as I will show, it too is worth another rereading. Its title entered the language, while its content arguably shaped the historical memory of the Panthers and their white supporters—and indeed the memory of the sixties more generally—more than any other single journalistic piece from the era.

BLACK PANTHERS IN THE NEWS

In order to make sense of the timing, and much of the content, of Sheehy's and Wolfe's narratives, it is important to take an excursion into the coverage of the Panthers in the more standard news media. Something like what British cultural studies scholars have called a "moral panic" occurred in the media in response to the Panthers, putting the Panthers into the role of what British sociologist Stan Cohen has memorably termed "folk devils."[10] The Panthers were definitely cast in the folk devil role in the mainstream media, portrayed as a motley crew of unstable, paranoid black juvenile delinquents. Crucially, however, the panic did not set in either at the moment or in the manner one might expect.

While it is widely known how Federal Bureau of Investigation Director J. Edgar Hoover—who singled out the Black Panther Party (BPP) already in the summer of 1969 as "the greatest threat to the internal security of the country"—turned his considerable covert counterintelligence resources against the BPP, it is rather less noted that such standard media venues as the *New York Times*, *Newsweek*, *Time*, and *U.S. News and World Report* hesitated several more months before they too aggressively began to register the group in folk devil language.[11] Indeed, for more than three years, or from the inception of the party in 1966 until the winter of 1969, mainstream media representations of the Panthers had been neither particularly hostile nor especially sympathetic. Even when, in May 1967, several dozen armed Panthers marched into California's state assembly to protest against gun control legislation, the incident earned only one sentence in *Newsweek* and no mention in *Time*.[12] In short, reportage about Panther activity was inconsistent, and what there was acknowledged—especially in the wake of Martin Luther King's assassination in spring 1968—that black Americans might legitimately turn even to so-called extremist means in response to the crisis in American race relations. Likewise, when white support for the Panthers was mentioned during this time (in one instance, for example, Marlon Brando's support was reported), the media handled it in an evenhanded manner.[13] It was only as the decade wound to a close, from December 1969 onward, that the panic over the Black Panthers set in, and quite dramatically, escalating steadily through the first half of 1970. And yet this particular panic followed an unusual course that

would ultimately shift away from demonizing rhetoric to trivializations and would finally present the Black Panther member more as oversexed media sweetheart than violence-prone social menace. And it is that trivialization that has left the most lasting legacy.

My research suggests that the combination of two key events catalyzed the onset of the moral panic. One was the December 4, 1969, FBI-instigated police killing of twenty-one-year-old Illinois Black Panther Party Chairman Fred Hampton, in his home, along with the ensuing rhetorical battle over whether the U.S. government was indeed targeting a group of its own citizens for assassination. The deaths of Hampton and fellow Panther Mark Clark clearly catalyzed a crisis of objectivity for the mainstream media.[14] It was a crisis sparked largely by Charles Garry, chief counsel for the Panthers, who dramatically charged on the day following Hampton's and Clark's deaths that these were "the twenty-seventh and twenty-eighth Panthers murdered by the police" since January 1968.[15] Strikingly, although Edward J. Epstein would a year later authoritatively refute Garry's charge point by point in the respected pages of the *New Yorker*, the number of twenty-eight murdered Panthers is today presented in history books essentially as fact.[16] Most of the media handled the matter differently from the *New Yorker*, however. In the immediate wake of the Chicago killings, most of the mainstream media, in a peculiar double maneuver, simultaneously allowed Garry's statement to stand as a provocative possibility (as well as reporting doubts about the police version of events based on their own investigations) and—as I will describe in what follows—launched a full-scale rhetorical campaign *against* the Panthers.[17]

The second key event contributing to the escalation of a moral panic involved the spectacle/specter of wealthy white liberal support for black militancy, a phenomenon that first splashed into the news as a "problem" on January 15, 1970. That day, Charlotte Curtis, fashion editor of the *New York Times*, reported with tongue-in-cheek humor on the January 14 fundraiser at Leonard and Felicia Bernstein's Park Avenue apartment (the gathering Wolfe would later immortalize) for the defense of twenty-one Black Panther Party members on trial in New York for plotting to kill policemen and blow up department stores. Describing the way the mostly white (along with a few black) socialites and the Panthers "from the ghetto" had begun the evening by chatting amiably and at times incoherently during "what may or may not have been the social hour" in the midst of the Bernsteins' sumptuous furnishings, Curtis also recorded snatches of conversation from the ensuing "meeting" where the plight of the imprisoned Panthers was discussed and (considerable) donations were accepted. Curtis recounted, for example, how "tall, handsome" Panther Don Cox earnestly attempted "to assure a white woman that she would not be killed even if she is a rich member of the middle class with a self-avowed capitalist for a husband."[18] Rather

than passing over the event with no futher notice, the *Times* the next day editorialized in harsh tones about how disturbing it was that the Panthers had emerged "as the romanticized darlings of the politico-cultural jet set" because "the Beautiful People" were addicted to "elegant slumming." A week after that, the *Times* published a letter to the editor that worried, "We shall soon witness the birth of local Rent-a-Panther organizations" for those wishing to engage in "an evening of anti-Establishment vituperations" in order "to bring out the *mea culpa* in all."[19]

Although the Bernsteins' gesture was hardly as misguided as the ensuing brouhaha suggested, since the Panthers were indeed subsequently acquitted on all charges, the history of the event did not end there. If it had, the Bernstein bash might not have become the most notorious political fundraiser in American history (not to mention an occasion of almost Baudrillardian hyperreality, in which the proliferating welter of mutually referential representations became the real event). As if in a round of "Can You Top This?" *Time* magazine on January 26 offered the first self-reflexive media item on the initial reporting, opening up a more open-ended second (and third) round of reflections. Under the title "Upper East Side Story," *Time* quoted and analyzed the Curtis piece, which had captured "some ludicrous exchanges—which Bernstein denies—between the field marshall of the pig-baiters and the aesthetic doge of the Upper East Side." Two weeks after that, William F. Buckley, Jr., again quoting the initial Curtis piece, weighed in with a column called "Have a Panther to Lunch," which reminisced about angering Eldridge Cleaver when Buckley told the Panther leader "that the Black Panther Party exists primarily for the satisfaction of white people, rather than black people. The white people like to strut their toleration, and strip themselves of their turtleneck sweaters to reveal their shame."[20]

It was in the wake of Hampton's and Clark's deaths, Garry's charge, and the abrupt explosion of interest in interracial, cross-class bonding that the Panthers were suddenly turned into folk devils. From this point on, media representations amplified and distorted the Panthers' dealings far more than they had before. But while most scholarship on the moral panic scenario has assumed that folk devils are caricatured and demonized in a fairly straightforward, uniform fashion, an examination of the media coverage of the Panthers reveals a discordant jumble of representations, a set of metaphoric images and associations that were both vigorously fear-mongering *and* sniggeringly derisive.

It was, for instance, widely reported that outraged Panther sympathizers—Garry first among them—were speaking of "a national scheme" to "commit genocide upon" the Black Panther Party and that Reverend Dr. Ralph Abernathy had (at Hampton's funeral) described government intentions vis-à-vis the Panthers as "a calculated design of genocide" as "brutal as Nazi Germany."[21] At the same time and in the same media sources, it was

only after this historical moment (for it had not occurred previously) that the Panthers themselves would be indicted as—to quote the *New York Times* from its anti-Bernstein editorial on January 16—a "so-called party" that promoted a "confusion of Mao-Marxist ideology and Fascist para-militarism." Thereafter, once the *Times* broke the taboo on the Nazi analogy—itself seemingly adapted from the words of Garry and Abernathy in a sensational rhetorical reversal presumably designed to neutralize the power of their charges—other respectable forums followed suit. In May 1970, for example, the *Atlantic* linked the Panthers with "Hitler's Brown Shirts." Mixing the time-honored technique of infantilizing blacks (which goes back to slavery days) with an elaboration of its Nazi reference, *The Atlantic* described the Panthers as "boy scouts" with guns, "little kids" both "awed and securely warmed" by the party's "quasimilitary discipline." In August 1970 (while also taking jabs at the white liberal "patsies" who supported the BPP), *Harper's* compared Panther Bobby Seale to none other than Adolf Hitler:

> Both are anti-rational. Hitler's injunction to "think with your blood" is echoed by Bobby's appeal to the impulses of Black Soul. Both proclaim a new morality, rising above the restraints of Christianity. . . . Both try to dehumanize their enemies by classifying them as "pigs"—the Nazi term was "*Saujuden*" (Jewish swine)—because it is easier to kill if you believe your victim is really a beast. . . . To Seale, even more than to Hitler, the gun is a mystic symbol of defiance and virility.[22]

The tone in much of the coverage was, in short, alarmist. To *Newsweek*, for example, reaching for an Afrocentric metaphor—although the "party's Illinois chieftain" (that is, Hampton) had been found "sprawled on his blood-drenched mattress, his copies of Malcolm X and Frantz Fanon and a three-volume life of Lenin scattered around him"—there was the fresh anxiety that Hampton's death "may in fact have saved the Panthers' Chicago chapter" by revitalizing a group "grown suspicious to the point of paranoia." And *Time* magazine, perhaps trumping them all, issued the warning that the Panthers' "inflammatory rhetoric" could well result in generalized race warfare: "To most whites, violence is not justifiable; to an increasing number of blacks, it is."[23]

But other countervailing images jostled with these. For example, already in December 1969, in the immediate wake of Hampton's death, *Time* announced that among the Panthers there was "more tough talk than provable action," and *U.S. News and World Report* reported that the Panthers, "in spite of their tough talk," were "in fact . . . losing ground" and "steadily losing members." Later, for the *Atlantic*, the Panthers were such a self-destructive lot, rushing "as joyously as cavorting lemmings toward judicial suicide," that one need only step aside while they did themselves in. *Newsweek* was even more stinging, declaring that the Panthers were hardly the "Bad Niggers of

white America's nightmares" they pretended to be. According to *Newsweek*, the Panthers yearned to "be men," and "white student radicals" were "entranced by Panther *machismo*." But really, they were not the threat Hoover had imagined. Instead, "They are guerrilla theater masterfully done," just a few "irresistibly photogenic" youths, "Media Age revolutionaries," "Crazy Cats" whose "gift for getting shot considerably exceeds their gift for shooting."[24] And finally, *Esquire* recapitulated the humor in the whole media spasm when (in the autumn of 1970) it offered up, in a classic faux-documentary photo essay, a complete consumer guide for those fearful that they might not be able immediately to "tell the difference between real Panthers, black Party sympathizers, and police infiltrators." *Esquire* thus posed the single most burning question on every concerned American citizen's lips—"Is It Too Late for You to Be Pals with a Black Panther?"—just as the moral panic over these particular folk devils appeared to have run its course.[25]

The year 1970, then, marked the moment when, all at once, the activities of the Black Panther Party appeared to pose the gravest danger to civic stability, were announced to be passé, and came to decorate journalistic parodies of white anxiety, liberal guilt, or both. Simultaneously, the Panthers were portrayed as a profound threat, much as Hoover had intended them to be, *and* a "crisis" that was already over at the very moment it was being first reported. What emerges, in sum, is a constantly contradictory, ambivalent, and at times even highly ironic and self-conscious take on the hyperventilated significance of the Black Panthers.

Already in June 1970, New Journalist Hunter Thompson highlighted and spoofed the mass media hype surrounding the BPP when he opened his brilliant and loopy "The Kentucky Derby is Decadent and Depraved" with a brief exchange he claims to have had with an average Derby fan from Houston calling himself "Jimbo." When Thompson told "Jimbo" that he was in Louisville as a photographer for *Playboy*, the Texan laughed: "Well goddam! What are you gonna take pictures of—nekkid horses?" Since it was May 1970, Thompson could solemnly deadpan that this was no joke; his assignment, he said, was "to take pictures of the riot . . . At the track. On Derby Day. The Black Panthers. . . . Don't you read the newspapers?" The Texan, gesticulating crazily "as if to ward off the words he was hearing," could not contain his outrage: "Why? Why *here?* Don't they respect *anything?*"[26] Although Thompson was most definitely playing a con game—no riot was planned, no Panthers were in sight, and he didn't even really work for *Playboy*—what he managed to elicit from his interlocutor was of course exactly the sense of irrational alarm that the mere mention of the Panthers could produce at that historical moment.

The other two, much more substantial, New Journalistic contributions to the debate about the Black Panthers, Sheehy's and Wolfe's, had far more serious designs. (Because of the more lasting influence of Wolfe's piece, I will

discuss Sheehy's essay first, even though it did not appear in *New York* until November; then I will conclude with Wolfe's June 1970 contribution.) What enabled Sheehy and Wolfe to do the damage they did was precisely their New Journalistic appropriations of fictional techniques: the development of dramatic story lines; the elaborate descriptions of settings particularly through the accumulation of what Wolfe called the "details of status life" of the characters;[27] the invitation for readers to identify with the characters and/or the narrator; the reconstruction of "realistic" dialogue and the imaginative construction of characters' interior monologues; the playing with multiple points of view; and, finally, the liberty to speculate on the most intimate (and ultimately sexual) aspects of the characters' lives.

PANTHERMANIA

The first weekend in May 1970, while Hunter Thompson was conning the unsuspecting Derby fan in Louisville, Gail Sheehy was in New Haven, Connecticut, on assignment for *New York* to cover a support rally for the Panthers at Yale University. At the beginning of *Panthermania*, the book version of the *New York* essay, it is intimated that it was indeed the double crisis induced by, first, Fred Hampton's death (and Garry's ensuing charge of systematic genocide) and, second, the phenomenon of white support for the Panthers, which motivated Sheehy as she wrote. She opens *Panthermania* with the dismissive statement that "without verification, Garry's body count passed like gospel throughout the white media" while "the beautiful people created a new social cachet known as the Panther defense fund party." Meanwhile, Sheehy also announced that she found her assignment to be an especially tough one, because in the midst of the enormous social pressures on liberal whites to think "with one propagandized mind," she was one of the "lonely" few courageous enough to "ask questions" and "pursue the facts."[28]

On the most overt level, Sheehy's original two-part story for *New York* was a study of the anguished response of New Haven's middle-class black community to the New Haven trial of twelve Panthers for murdering one of their own.[29] Her major message was that the Panthers were bad news for blacks themselves.[30] She centered her essay on the stories of three black men from "good families" who were drawn into Panther life: two come to sad ends (John Huggins was murdered by rival black militants, and Warren Kimbro was sent to prison for participation in the New Haven murder); the third, a teenager with the fictional name Junius Jones, seemed, she implied, despite the best efforts of his father, William, also to be headed toward tragedy.

Yet, like the more standard news venues, Sheehy incorporated contradictory perspectives into her narrative. Black Panthers were, according to her, an ominous and growing threat that desperately required immediate intervention (and that therefore of course also justified her own journalistic

intervention)—a "pathology," a "deadly virus" felling the best and bright-est of the black community,[31] an ugly cult with "a certain psycho-politi-cal hold . . . on black children burning like a billion wooden matches."[32] *And* they were already "passé"—"A pretty small group of leftovers now. Mostly misfits—angry, unhappy, low-IQ kids."[33] Panthers were both fascist-like—Ericka Huggins, for example, is described as "a black Ilse Koch . . . you know, the Nazi"—*and* "naive," "political infants" engaged in "Amateur Night."[34] They were also—in a double move pioneered, incidentally, by Joan Did-ion—both like a force of nature ("an unquenchable brushfire" fueled by the "hot . . . Santa Ana . . . wind") *and* like preprogrammed automatons, "a party [that] has no room for individual convictions," whose supporters' "propagandist wisdom" had to be "committed to memory like a page from *Dick and Jane*."[35]

Indeed, not only Sheehy's "naturalization" of the Panthers, along with her strategic contrasting of "authentic" versus "performative" selves, but also her particular infantilization of them, are best understood as simply poach-ings from the work of Joan Didion. It was Didion, for example, who had first concluded that the 1965 Watts Rebellion was just another natural hazard of southern California life, much like "the violence and the unpredictability of the Santa Ana . . . wind"; both caused fires, and both reflected Los Angeles's "weather of catastrophe, of apocalypse."[36] Furthermore, already in the title piece of her widely acclaimed *Slouching Towards Bethlehem*, Didion had deemed the existence of a sexually profligate and dysfunctional white hippie coun-terculture "proof that things fall apart." In an idealized invocation of a more wholesome past, she suggested that precisely because the hippies lacked "the web of cousins and great-aunts and family doctors and lifelong neighbors who had traditionally suggested and enforced the society's values," they were inca-pable of independent thinking and would thus "feed back exactly what is given them." In a similar vein, in the *Saturday Evening Post*—long before the panic about the Panthers hit the rest of the media—Didion had both called Black Panther Huey Newton "a bright child with a good memory" *and* lamented his automaton qualities, describing him as "one of those educa-tional fun-fair machines where pressing a button elicits great thoughts on selected subjects."[37] Sheehy clearly had read Didion closely.

Finally, for Sheehy, the Panthers really were all about style, not sub-stance. Bobby Seale, for example, was "Mr. Publicity." What the Panthers offered was "pure theater," "political theater." And it was the "*delivery* of his testimony" that got one "actor"/defendant in the murder trial in New Haven (that "Broadway-tryout town") the lowest possible sentence from his "audience"/jury.[38] As Cornel West has pointed out, there is a long-stand-ing association between blackness and performance: "Owing to both a par-ticular African heritage and specific forms of Euro-American oppression, black American cultural production has focused primarily on performance

and pageantry, style and spectacle."[39] While West's purpose was to explore the creativity and oppositional potential in this linkage, Sheehy's aim was trivialization.

Meanwhile, white supporters of Black Panthers could be best understood as people "frantically and selfishly seeking [their] personal psychological release"—their "release from Whitemiddleclass paralysis." But they were also utterly fickle, "summer radical[s]" flocking to New Haven for a political "Woodstock."[40] The cooperation between black militants and white supporters was treated seriously (if that is the right word) through recurrent disdainful asides about the Panthers' rejection of black separatism and willingness to work with whites. And the combination was mocked. For, as Sheehy said in her opening volley, for "the urban guerrilla"—who was, in any event, addicted to the "desperate habitual rhythm of hustling"—the appeal of Pantherdom would indeed be hard to resist:

> Consider also the lure of mobility. Revolutionaries travel—planes, cabs, Chicago, Detroit, California, Cuba, Hanoi, Algiers, moving with the spontaneity of the jet set and the mystery of the Mafia, all financed by adoring white liberals and dignified by a noble cause.[41]

But the most overwhelming feature of Sheehy's essay is the way it constituted a compendium of every ugly cliché about blacks one could imagine. According to Sheehy, not only were urban blacks addicted to hustling, they also were prone to failing to finish high school and to "chipping a little heroin under the skin of [the] knee" (where it doesn't show), were overly sexual, had low IQs, and were too concerned with cool headgear and fancy cars. Sheehy even mobilized the motif of the emasculated black man "desperate to claim his manhood," fixated entirely on "ego and sex." Indeed, she had one of her sources announce: "If it weren't for the toughness of black women, black men would all be like buffaloes. Extinct."[42]

Meanwhile, she implied that the Panther Party was really run by women: "There are no Panthers in Connecticut except Ericka" was a repeated refrain. And Panther women were the most dangerous Panthers of all. Sheehy underscored this point by contrasting Panther women Elaine Brown and Ericka Huggins with respectable liberal middle-class black Betty Kimbro Osborne. And again the contradictions proliferated. Panther women were both "*uncontrollably* aggressive . . . man-haters" *and* into "Pussy Power," defined as "the concept that a woman's function is to use her body to entice men into the Panther Party." Ericka, left a single mother by the murder of her husband, Panther John Huggins, refused to "forget the Panthers and raise John's baby safe." Instead, she spent her time seducing other women's husbands. Betty, by contrast, "patrolled the house tucking in children and making lists from Julia Child's cookbook."[43]

Sheehy's biggest strategy, in short, was to put down black people. But

72133

she got away with this largely by writing from "within" a (as it turns out, constantly shifting) black perspective. It was by befriending members of the New Haven black middle class, for example, that Sheehy could hide behind *their* disdain for "the Negro downtrodden . . . laying about with their hands out," and the "pregnant girls and mental midgets" of the Panther rank and file. Indeed, the major trajectory of Sheehy's narrative invited identification with New Haven's respectable black middle class even as that narrative reflected undisguised nostalgia for the days when black men had to work "four jobs at once" to get out of the ghetto into the modest black suburbs, and when deliberately acting stupid around powerful whites—in one of those servile jobs—was the best way to keep informed about city politics. But never one to have a unitary message, Sheehy also implicitly mocked the black middle-class respectability she idealized, capturing for her readers—this time from "within" a poor or militant black's perspective—the "docile," "housefolk," and "Tom" mentality of the "button-down, party-dip" black suburbanites who had "taken their manners" and their cues "from the least mobile white population—that careful, myopic, mildly-spoken core of liner-uppers and Sunday-besters." At one point, indeed, she referred to "the New Haven Negro" as "not black." And it was in this context that Sheehy could even make allusions to the uptight "old-biddy" sexlessness of the black middle class that was rumored to be the price of respectability in a white-ruled world.[44]

What enabled Sheehy to incorporate all these shifting and unquestionably suspect perspectives was the New Journalistic methodology itself, for it permitted her to cross the imagined boundaries of race and move her narrative into a "black" consciousness—indeed, inside numerous "black" points of view—and then illustrate how each spoke ill of all the others. Not incidentally, it was also from "within" a black perspective that Sheehy was able to remind her readers of the popular association of Jews with capitalism (of the "shrewd" "speculators" variety) when she referred, without quotation marks, to black factory workers' views on "Hymie the owner." Crucially, Sheehy legitimated her entire venture by announcing early on that in her perambulations around New Haven she was constantly accompanied by "black photographer David Parks," even though in the course of her tale she barely granted him a speaking role.[45] Sheehy's various narrative techniques, in sum, enabled her to outdo the more standard news media's folk devil portrait of the Panthers. These techniques came in especially handy in the hatchet job she did on Ericka Huggins. In Sheehy's portrait, Huggins's activity in oppositional politics, her coercive sexuality, and her irresponsible (and potentially abusive) parenting style were all linked by an intrinsic logic, a disturbingly familiar chain of associations to anyone attentive to how poor black teenage mothers are maligned in our contemporary race-coded political arena.[46]

RADICAL CHIC

In contrast to Sheehy's literarily more forgettable (yet nonetheless politically prescient) efforts, Tom Wolfe's punishing job on Leonard Bernstein, in his stylistic tour de force "Radical Chic: That Party at Lenny's," has long been notorious. Wolfe, like Sheehy, utilized the narrative freedom of the New Journalism in order to move subtly and cleverly from perspective to perspective—none of them completely his own nor identifiably anyone else's—as well as to circle repetitively (and disorientingly) through his story line in imitation of the circularity of individual consciousness. Instead of inviting (though then also blocking) identification with the narrative's characters, as Sheehy did, Wolfe invited identification with, if anyone, his supercilious omniscient narrator. Wolfe toured the Bernsteins' apartment and introduced the celebrity guests with suave malice. He mocked the need of rich liberal whites (particularly in view of the evening's occasion) to find nonblack servants. He digressed into an extended analysis of the history of what he called *nostalgie de la boue*—nostalgia for the mud—the slumming he astutely observed was often part of the way the very upwardly mobile certified their arrival within the social aristocracy. He took a long detour through a prior "radical chic" party on behalf of California's striking grape workers. He also repeatedly stressed the "funky"-ness and militancy of the Panthers ("These are no civil-rights *Negroes* wearing gray suits three sizes too big"), and he exploited for humorous effect the historic phenomenon of close affinities *and* profound tensions between blacks and Jews while also working to fuel those hostilities.[47] And finally, Wolfe ended his narrative with a long disquisition resummarizing the ways in which the Bernstein event had been circulated and recirculated through the media. In the midst of all this, he documented and commented upon some of the main exchanges between the Panthers, the other guests, and the hosts about Panther politics. And through it all, by playing with tense and tone, he managed to make the sixties themselves seem like they were part of some previous century.

Cultural critic (and Random House editor) Jason Epstein, and scholars Alan Trachtenberg and Morris Dickstein, among others, have all in various venues weighed in on Wolfe's tale; Epstein, for instance, accused Wolfe of being "cruel and shallow" and of being moved, above all, by his own "resentment and envy of the rich and talented," desperate to be noted and fêted himself. Trachtenberg too saw in Wolfe a pandering to "both a hatred and an envy of intellectuals." In Wolfe's work, he announced, "the mechanisms of a middlebrow mass culture are transparent"; furthermore, "Far from revolutionary it is a conformist writing." And Dickstein has opined (the harshest cut) that "Radical Chic" is simply "monotonous." In addition, he has noted that Wolfe is guilty of a complete "misreading of the sixties," and that

"Wolfe himself is nothing if not a creature of fashion. . . . [The] snobbishness and triviality [of his characters] mirror his own interests."[48] But all these criticisms, I want to propose, miss what is in many ways the essay's most pernicious subtext.

On the surface, Wolfe's message was simple: "Radical Chic, after all, is only radical in style; in its heart it is part of Society and its traditions." There was Leonard Bernstein, the host, against whom Wolfe mobilized an always popular resentment against class privilege, noting how convenient it must be to live a "right-wing life style" while one clings to a "left-wing outlook." And then there were the guests. At one point, for example, Wolfe mobilized yet another ever-popular perspective, a common "explanation" for black-white political cooperation: Wolfe fantasized "a beautiful ash-blond girl with the most perfect Miss Porter's face" telling one Panther that she would like "to do something, but what can we do? Is there some kind of committee, or some kind of . . . I don't know . . . ," the black man's (unspoken) response implying the "taboo" of miscegenation: "Well baby, if you really—."[49]

It was not, however, the composer's or his guests' politics that most preoccupied Wolfe, except as this ostensible subject allowed the New Journalist to investigate Bernstein's mannerisms, his flamboyant personal style, and the iconography of his Upper East Side apartment. Throughout, Wolfe found Bernstein too fastidious and too Jewish (always reminding people that his name was "-*stein* not -*steen*"), too fussy and too pretentious (especially when it came to his "million-dollar *chatchka* flotilla of family photographs")—or, in short, simply too ambiguous in general.[50]

Wolfe's narrative is structured around mysteries and secrets, beginning with the opening page, when he recounts a dream Bernstein had in which he stood on a stage and told the audience, "I love," while "a Negro rises up from out of the curve of the grand piano and starts saying things like 'The audience is curiously embarassed.'" Wolfe never solves this mystery for his readers—he never explains the meaning of the dream—but he refers to it constantly throughout his narrative, repeatedly foreshadowing the way the "Negro at the piano" would be the signal of Bernstein's ultimate humiliation. Furthermore, Wolfe appears throughout inordinately preoccupied with what people "know" about Leonard Bernstein, remarking not only about "what a flood of taboo thoughts runs through one's head at these . . . events . . . it's delicious," but also speculating at one point, for example, that "Leon Quat [a Panther attorney] must be the only man in the room who does not know about Lenny" and referring at another point to what "more than one person in this room knows" about Bernstein.[51]

What is it that people "know" about Bernstein? Although Wolfe situates his remarks on knowledge in the context of commentary on Bernstein's well-known insomnia and love of conversation, the way these remarks are positioned in the narrative suggests another reading as well. As numerous

queer theorists have pointed out, there is above all one "love that is famous for daring not speak its name," and that is gay love, "the 'open secret,' widely known but never spoken"—the one thing that must not, but also need not, be named explicitly.[52] And indeed, in the midst of completely unconnected remarks, Wolfe embeds references to "Bayard Rustin" (the black civil rights leader who, although again Wolfe does not say this, was also known to be gay); "the mint fairy" (that allowed those "puffed," "fragile," "melt-crazed" after-dinner mints suddenly to materialize in elegant silver bowls), and a particular "flaming revelation" of Bernstein's. At another point in the piece Wolfe suggests that while the Panthers are *"real men,"* Bernstein himself apparently does not have enough virility, for "the very idea of them, these real revolutionaries . . . runs through Lenny's duplex like a rogue hormone." Similarly, in yet another instance, when asked about Panther predilection for violence, Panther spokesman Don Cox had insisted that Panther violence would be in self-defense only. In an obvious effort to help his wealthy white listeners identify with his point, he declared, "I don't think there's anybody in here who wouldn't defend themselves if somebody came in and attacked them or their families." Then Wolfe's narrative voice abruptly interjected, "—and every woman in the room thinks of her husband . . . with his cocoa-butter jowls and Dior Men's Boutique pajamas . . . ducking into the bathroom and locking the door and turning the shower on, so he can say later that he didn't hear a thing—."[53]

As Eve Kosofsky Sedgwick has observed in her study of the special connections between "knowledge" and (homo)sexuality, "to crack a code and enjoy the reassuring exhilarations of knowingness is to buy into the specific formula 'We Know What That Means.'"[54] The interesting thing about Wolfe's piece is that there are countless coded references to Jews as well: the strategic deployment of obviously Jewish names, references to gas chambers, to famously exploitative ghetto merchants, to Occupation Zone commandants, and so on. But these veiled references are juxtaposed with extensive analytic passages explicitly elaborating on the complexities of anti-Semitism and the ways it might induce wealthy Jews to partake of radical chic.[55] In short, the introduction of overt discussions of Jewishness in the midst of coded allusions to it leave the gay aspect of Bernstein's character the one truly unnamed, unspoken element. However well known Bernstein's gayness was at the time (and Wolfe's maneuvers would not have been so effective unless it *was* well known), this was also a moment when Bernstein was trying to be in the closet.[56] And it is exactly at this moment that Tom Wolfe was busy deriding Bernstein's left-leaning sympathies through a very particular associative chain. This chain not only illustrated, in gay critic Wayne Koestenbaum's words, "how frequently the flaming are made scapegoats."[57] Nor did it simply advance the notion that radical-leaning white men are not real men. Most importantly, like Sheehy with her racist mythologies about

black women and black men, Wolfe was using derogatory representations of sexual matters to cast aspersions on the political seriousness of progressive projects.

Many of the stories told about the sixties now are uncannily close to the stories told by Sheehy and Wolfe. They have entered the cultural "common sense," have come to seem, in Stuart Hall's words, "absolutely basic ... bedrock wisdom" whose "very taken-for-grantedness" renders their own premises and presuppositions invisible.[58] One need only think of the current bipartisan consensus (always implicitly race-coded) about welfare and teen pregnancy, drugs and violence, to recognize the staying power of Sheehy's notions. And one need only consider the enormous popularity of *Forrest Gump* (1994), with its scathing portrait of the unmanliness and misogyny of white leftist men attending a party thrown by the Black Panthers, its success in portraying left activism as out of touch with the good common sense of ordinary folks, and its more general leering at what the sixties are said to have stood for,[59] to recognize the powerful hold of Wolfe's views on the national imagination. To note that these summaries, and dismissals, of much of what was important in the sixties were produced already in 1970 should give us pause. How is it that the ideas of these two erstwhile self-styled revisionists have come to seem so persuasive to so many? That, as Fredric Jameson once put it in a different but not unrelated context, "is a question we must leave open."[60]

NOTES

1. Meta Mendel-Reyes, *Reclaiming Democracy: The Sixties in Politics and Memory* (New York: Routledge, 1995), 25.

2. Francis X. Clines, "The Case That Brought Back Radical Chic," *New York Times*, 13 August 1995, sec. 4, 1. For an impassioned critique of Clines's effort to bash nineties activism with sixties tradition, see Katha Pollitt, "Subject to Debate," *Nation*, 11 September 1995, 228.

3. Fredric Jameson, "Periodizing the 60s," in *The Ideologies of Theory: Essays, 1971–1986* (Minneapolis: University of Minnesota Press, 1988), 184.

4. Truman Capote, *In Cold Blood: A True Account of a Multiple Murder and Its Consequences* (New York: Random House, 1965); Joan Didion, *Slouching towards Bethelem* (London: Flamingo, 1968); Norman Mailer, *The Armies of the Night: History as a Novel, the Novel as History* (New York: New American Library, 1968); David Minter, "The Literature of Postwar America: Prose 1940–1975," in *The Harper American Literature, Volume 2*, ed. Donald McQuade et al. (New York: HarperCollins, 1993), 1517.

5. Minter, "Literature," 1517.

6. Todd Gitlin, *The Sixties: Years of Hope, Days of Rage* (New York: Bantam, 1987), 242–43.

7. Michael Herr, *Dispatches* (New York: Knopf, 1977); Mailer, *Armies*; Nicolaus

Mills, introduction to *The New Journalism: A Historical Anthology* (New York: McGraw Hill, 1974), xvii; Nat Hentoff, "Behold the New Journalism—It's Coming After You!" *Evergreen Review* 12 (July 1968): 50; Michael Schudson, *Discovering the News: A Social History of American Newspapers* (New York: Basic Books, 1978), 160, 187; Gay Talese, *Fame and Obscurity* (New York: World, 1970), vii.

8. Gail Sheehy, "Black Against Black: The Agony of Panthermania," *New York*, 16 November 1970; and Gail Sheehy, "The Consequences of Panthermania," *New York*, 23 November 1970.

9. Tom Wolfe, "Radical Chic: That Party at Lenny's," *New York*, 8 June 1970.

10. Stanley Cohen, *Folk Devils and Moral Panics: The Creation of the Mods and Rockers* (London: MacGibbon and Kee, 1972). For an instructive overview of moral panic scholarship, see Angela McRobbie, "The Moral Panic in the Age of the Postmodern Mass Media," in *Postmodernism and Popular Culture* (New York: Routledge, 1994), 198–219.

11. J. Edgar Hoover quoted in "Too Late for the Panthers?" *Newsweek*, 22 December 1969, 26.

12. See "Which Way For the Negro?" *Newsweek*, 14 May 1967, 27. The event also received notice in the back pages of the *New York Times*, and in *U.S. News and World Report*, but in neither case was the coverage sensationalist. See "Armed Negroes Enter California Assembly in Gun Bill Protest," *New York Times*, 3 May 1967, 24; "An 'Invasion' by Armed 'Black Panthers,'" *U.S. News and World Report*, 15 May 1967, 12.

13. See the report on Marlon Brando in "Shoot-Out on 28th Street," *Time*, 19 April 1968, 17–8. Cf. the nonhostile coverage of white support for the BPP in "Guns and Butter," *Newsweek*, 5 May 1969, 40–41; and Nora Sayre, "The Black Panthers are Coming: America on the Eve of Race Revolution," *New Statesman*, 2 May 1969, 613–16.

14. The first full police version of the raid was reported in Edward Lee and Robert Wiedrich, "Exclusive: Hanrahan, Police Tell Panther Story," *Chicago Tribune*, 11 December 1969, sec. 1, 1–3. But it was later shown that police had hammered nails through the door in order to create the impression that bullets had been fired from within the apartment; ballistics experts also proved that police had fired every bullet but one, and had also fired first (and second). For an excellent summary of the raid, see Roy Wilkins and Ramsey Clark, *Search and Destroy: A Report by the Commission of Inquiry into the Black Panthers and the Police* (New York: Metropolitan Applied Research Center, 1973). Also see Ward Churchill and Jim Vander Wall, *Agents of Repression: The FBI's Secret Wars Against the Black Panther Party and the American Indian Movement* (Boston: South End Press, 1990), 64–77.

15. Charles Garry quoted in Edward J. Epstein, "The Panthers and the Police: A Pattern of Genocide?" *New Yorker*, 13 February 1971, 45. Garry's statements were first reported in John Kifner, "Police in Chicago Slay 2 Panthers," *New York Times*, 5 December 1969, 1.

16. Epstein repeated his view on "the misreporting" of Garry's claim in his intro-

duction to *Between Fact and Fiction: The Problem of Journalism* (New York: Vintage, 1975), 7. For recent standard histories that accept Garry's figure basically as fact, see William H. Chafe, *The Unfinished Journey: America Since World War II* (New York: Oxford University Press, 1995), 413; and Terry H. Anderson, *The Movement and the Sixties: Protest in America from Greensboro to Wounded Knee* (New York: Oxford University Press, 1995), 327.

17. It is instructive to compare the media coverage of Fred Hampton's murder in December 1969 with the coverage of Panther Bobby Hutton's death at the hands of police in April 1968. Even though the circumstances surrounding Hampton's death were far more damaging to police than those surrounding Hutton's (indisputably, some Panthers accompanying Hutton had fired back at the police, and it was at least plausible that Hutton himself had been armed), the media reported Hutton's death in terms substantially more sympathetic to the Panthers. Possibly this was due to a national spasm of remorse coming in the wake of Martin Luther King's assassination one week earlier; in any event, it highlights the transformation in media tone that accompanied Hampton's death. Cf. "Shoot-Out on 28th Street."

18. Charlotte Curtis, "Black Panther Philosophy Is Debated at the Bernsteins," *New York Times*, 15 January 1970, 50. Also see Felicia Bernstein's angry letter to the editor in response to the Curtis article the following week: *New York Times*, 21 January 1970, 46.

19. "False Note on Black Panthers," *New York Times*, 16 January 1970, 46; Harry W. Porter, 3d, letter to the editor, *New York Times*, 20 January 1970, 42.

20. "Upper East Side Story," *Time*, 26 January 1970, 14; William F. Buckley, Jr., "Have a Panther to Lunch," *National Review*, 10 February 1970, 168.

21. Garry and Rev. Dr. Ralph Abernathy quoted in Epstein, "The Panthers and the Police," 45; and Philip Caputo, "5,000 Mourners Walk Past Coffin of Hampton in Suburb," *Chicago Tribune*, 10 December 1969, sec. 1, 3.

22. "False Note on Black Panthers," 46; Don Schanche, "Panthers Against the Wall," *Atlantic*, May 1970, 55; John Fischer, "Black Panthers and Their White Hero-Worshipers," *Harper's*, August 1970, 18.

23. "The Panthers and the Law," *Newsweek*, 23 February 1970, 27, 30; "Police and Panthers: Growing Paranoia," *Time*, 19 December 1969, 14.

24. "Police and Panthers at War," *Time*, 12 December 1969, 20; "A Close Look at 'Black Panther' Shootouts," *U.S. News and World Report*, 22 December 1969, 25, 26; Schanche, "Panthers Against the Wall," 59; "The Panthers and the Law," 26, 30.

25. "Is It Too Late for You to Be Pals with a Black Panther?" *Esquire* (November 1970): 140, 142–43.

26. Hunter S. Thompson, "The Kentucky Derby is Decadent and Depraved," *Scanlan's Monthly* (June 1970): 3.

27. Tom Wolfe and E. W. Johnson, eds., *The New Journalism* (New York: Harper and Row, 1973), 377.

28. Gail Sheehy, *Panthermania: The Clash of Black against Black in One American City* (New York: Harper and Row, 1971), x, 3, xiii, xi, xii.

29. For accounts of the complicated circumstances surrounding (though not excusing) the murder, see Frank J. Donner, *The Age of Surveillance: Aims and Methods of America's Political Intelligence System* (New York: Vintage, 1980), 226–30; and Kenneth O'Reilly, *"Racial Matters": The FBI's Secret File on Black America, 1960–1972* (New York: Free Press, 1989), 310.

30. For more differentiated and thoughtful accounts of the strengths and weaknesses of the BPP—which include attention to the Panthers' violence and masculinism alike—see Elaine Brown, *A Taste of Power: A Black Woman's Story* (New York: Pantheon, 1992); and Angela Davis's review of it, "The Making of a Revolutionary," *Women's Review of Books* (June 1993): 1, 3–4.

31. Sheehy, "Consequences," 45, 56.

32. Sheehy, "Black Against," 38.

33. Ibid., 58, 48.

34. Sheehy, "Consequences," 47; Sheehy, "Black Against," 50; Sheehy, "Consequences," 61.

35. Sheehy, "Black Against," 38, 47, 42; Sheehy, "Consequences," 58.

36. Didion, *Slouching*, 221. Contrast the infinitely more insightful New Journalistic analysis of Watts in Thomas Pynchon, "A Journey into the Mind of Watts," *New York Times Magazine*, 12 June 1966.

37. Didion, *Slouching*, 122–23; Joan Didion, "Black Panther," *Saturday Evening Post*, 4 May 1968, 20.

38. Sheehy, "Consequences," 57, 70, 58, 70.

39. Cornel West, "Black Culture and Postmodernism," in *Remaking History*, ed. Barbara Kruger and Phil Mariani (Seattle: Bay Press, 1989), 92.

40. Sheehy, "Consequences," 58, 59, 66, 61.

41. Sheehy, "Black Against," 38.

42. Sheehy, "Consequences," 46; Sheehy, "Black Against," 56; Sheehy, "Consequences," 48, 47.

43. Sheehy, "Consequences," 49, 62, 47; Sheehy, "Black Against," 48; Sheehy, "Consequences," 47, 48.

44. Sheehy, "Black Against," 47; Sheehy, "Consequences," 55; Sheehy, "Black Against," 45, 42; Sheehy, "Consequences," 47; Sheehy, "Black Against," 45, 42, 38, 47.

45. Sheehy, "Black Against," 42, 40.

46. That Ericka Huggins was hardly the irresponsible woman Sheehy suggests, and that no awful fate awaited John and Ericka's child, is made clear in Ron Chepesuik, "Ericka Huggins: From Black Panther to AIDS Activist" in his *Sixties Radicals, Then and Now: Candid Conversations with Those Who Shaped the Era* (Jefferson, N.C.: McFarland, 1975), 198–210.

47. Wolfe, "Radical Chic," 28.

48. Jason Epstein, "Journal du Voyeur," *New York Review of Books*, 17 December 1970, 4, 3; Alan Trachtenberg, "What's New?" *Partisan Review* 41, 2 (1974): 300–01; Morris Dickstein, "The Working Press, the Literary Culture, and the

New Journalism," in *Gates of Eden: American Culture in the Sixties* (New York: Basic Books, 1977), 141–42.

49. Wolfe, "Radical Chic," 56, 39, 36, 46.

50. Ibid., 33.

51. Ibid., 27, 30, 33, 46.

52. Eve Kosofsky Sedgwick, *Epistemology of the Closet* (Berkeley: University of Californian Press, 1990), 67; George Chauncey, *Gay New York: Gender, Urban Culture, and the Making of the Gay Male World, 1890–1940* (New York: Basic Books, 1994), 267.

53. Wolfe, "Radical Chic," 48, 50, 28, 34. On the ways luxury milieux function as signifiers of gayness, see Richard Dyer, "Homosexuality and Film Noir," in *The Matter of Images: Essays on Representation* (New York: Routledge, 1993), 61, cf. 63. Note also the way Wolfe ended his tragic and farcical tale of Bernstein's fall from grace with an elaborate "documentation" of Bernstein's fickleness and unreliability, his immediate denials of his commitment to the Panthers in the face of the avalanche of criticism his cocktail party received. This too is evocative of a phenomenon John D'Emilio has analyzed, the portrayal of the homosexual as politically unreliable, the ultimate blackmailable traitor. See John D'Emilio, "The Homosexual Menace: The Politics of Sexuality in Cold War America," in *Passion and Power: Sexuality in History*, ed. Kathy Peiss and Christina Simmons (Philadelphia: Temple University Press, 1989), 226–40.

54. Sedgwick, *Epistemology*, 204.

55. Consider also the parallels between anti-Semitism and homophobia discussed in ibid., 67–90, esp. 75, as well as (even more strikingly) the mutual constitutiveness of Jewishness and queerness (in the anti-Semitic homophobic imagination) discussed in Daniel Boyarin, "Freud's Baby, Fliess's Maybe: Homophobia, Anti-Semitism, and the Invention of Oedipus," *GLQ* 2, 1–2 (1995): 115–47.

56. See Humphrey Burton, *Leonard Bernstein* (London: Faber and Faber, 1994).

57. Wayne Koestenbaum, "The Maestro and a World of Ambiguity," *Manchester Guardian Weekly*, 29 May 1994, 18.

58. Stuart Hall, "Culture, the Media and the 'Ideological Effect,'" in *Mass Communication and Society*, ed. James Curran, Michael Gurevitch, and Janet Woollacott (London: Edward Arnold, 1977), 325.

59. For an elaboration of these points, see the analysis of *Forrest Gump* in Jonathan Rosenbaum, "Stupidity as Redemption," in *Movies as Politics* (Berkeley: University of California Press, 1997), 166–70.

60. Fredric Jameson, "Postmodernism and Consumer Society," in *The Anti-Aesthetic: Essays on Postmodern Culture*, ed. Hal Foster (Seattle: Bay Press, 1983), 125.

The Wayne's Worlding of America

Performing the Seventies in the Nineties

STEPHEN RACHMAN

Wayne's World was the 1992 hit comedy film based on an NBC *Saturday Night Live* TV skit about two heavy-metal dudes, Wayne Campbell and Garth Algar, who broadcast their own public-access cable talk show from the basement of their parents' suburban Chicago home, and the wacky consequences that ensue when that show is picked up by sleazy commercial producers who want to use them as a vehicle to promote a video-game parlor. Lorne Michaels, *Saturday Night Live*'s guiding spirit, produced the film for Paramount Studios. Penelope Spheeris, "rockumentarian" and MTV commentator, directed Mike Myers (Wayne's creator) and Dana Carvey, two mainstays of the *Saturday Night Live* cast. Myers wrote the script with his partners, Bonnie and Terry Turner. Even if you've never seen the film or TV sketch, you know that *Wayne's World* was responsible for the currency of that post-expressionist locution— "...NOT!"—during the 1992 presidential campaign. The film did extremely well at the box office, taking in more than $200 million. It spawned an MTV video renaissance of the English rock band Queen, a hit soundtrack, a best-seller, T-shirts, baseball caps, and, courtesy of Mattell Inc., a line of games, including a 3-D card game and a VCR board game with an interactive videocassette that features footage of Wayne and Garth "talking" to game players and instructing them on how to play. At various intervals, the characters reappear to challenge players to get to "Party Central."[1] This last detail seems to me particularly savory: a performance about home cable TV that originated on live TV completed its first circle of mediation as a home interactive video game. The inevitable sequel, *Wayne's World II*, appeared with diminishing returns in 1993.

 Wayne's World is also a film so unabashedly cartoonish and suffocating in its own pop cultural references that it hardly seems worthy of scrutiny. Its

protagonists are aggressively inane and pathetic (but likable). The plot is an extended series of gags that work better in excerpt than as a whole. But it is precisely because the film is about playing dumb that it resonates as a sociological artifact of the 1990s. Whether one finds *Wayne's World* profoundly funny or profoundly sophomoric, it is undeniably a prodigy of media saturation and marketing, and because it is also a performance about that saturation it is worth scrutiny. By taking the cultural low road, *Wayne's World* sheds its own peculiar light on the nature of what mainstream culture performs when it performs "culture" these days. If one were to summarize the culture that *Wayne's World* describes, it would be a caricature of what Mike Myers has called "the suburban heavy-metal North American Experience." Wayne Campbell lives in suburban Chicago, working more than his share of "Joe jobs" (fast-food restaurant labor) with the name tags and hair nets to prove it. But these elements are peripheral; if Wayne's world depicts anything remotely corresponding to suburban experience, it lies in the way that experience is obsessively expressed in the rock and TV culture of the 1970s. Though ostensibly set in Aurora, Illinois, *Wayne's World* really takes place in seventies TV-land. To point out the most obvious examples, Milwaukee is geographically recognizable to the extent that "Laverne and Shirley" work in a bottling plant there, giving Wayne and Garth an opportunity to mimic the intro-sequence to that long-running series. This concept of TV-land is also reinforced by Wayne's collision with another seventies icon, Alice Cooper, who informs him that Milwaukee is the only major city in America to have elected three socialist mayors. The car they get around in, the so-called "mirthmobile," is none other than the seventies answer to George Jetson's mode of transportation, an AMC Pacer. This pool of references comprises such an integral part of the movie that if one were to ask what culture is being performed in *Wayne's World* the obvious answer would be that Wayne and Garth, like many a *Simpsons* episode, are performing the seventies for the nineties.

The celebrated sequence of Wayne and Garth air-jamming along to Queen's "Bohemian Rhapsody" offers a good indication of this kind of performance's impact (fig. 2.1). On the strength of this tribute, *Wayne's World* propelled Queen's "Bohemian Rhapsody" once again to the top of the Billboard charts, even higher than when it originally made its debut.[2] While hit movies frequently revitalize or reintroduce an old hit song (think of the Righteous Brothers' "Unchained Melody" from *Ghost* [1990], or Scott Joplin's "The Entertainer" from *The Sting* [1973]), *Wayne's World* places its soundtrack at the center of the action. Wayne and Garth give a short course in heavy-metal music appreciation and male bonding. They actively show the audience how to listen. "Let's go with a little 'Bohemian Rhapsody,' gentlemen?" Wayne asks, brandishing a cassette. "Good call," Garth responds. Synchronized head banging in time to the music clinches the shared nirvana of the moment's

figure 2.1

ritual affect. That this is hilarious, even self-deprecatory, doesn't detract from its sincere endorsement of the music and the culture that attends it. As with *This Is Spinal Tap* (1984), it is both a joke and a celebration; the distinction between parody and reality becomes generational (older rockers tend to view it as parody; newer ones, reality). Nevertheless, whether parodic or mimetic, through the performance of ecstatic listening, what was formerly Queen becomes "classic" Queen; *Wayne's World* not only spawned the contemporary commercial revival of "Bohemian Rhapsody" it initiated through an example of ritual listening the song's canonization. *Wayne's World* demonstrates so wonderfully the power of cultural performance to canonize, to produce classics, to reclaim from the kingdom of trivia, and even, as it happens in this case, through the uproarious example of collective head banging, to show new listeners and remind or reinvent for old ones the affective power of rock music.

By performing the seventies for the nineties, *Wayne's World* participates in a broader pop cultural enterprise that has distinguished the last ten years—not only an acceleration of nostalgia for all things sixties and seventies but the assertion of that nostalgia in the production, or transformation, of mainstream hits and mainstream products into "classics"—from Madonna's appropriation of voguing (a "dance" that originated in the seventies black and Latin gay ball scene in Harlem, and, as Madonna performs it, focuses on the mainstream recognition of classic looks) and the resurgence of Abba, to the rock festival booths and head shops that regularly peddle T-shirts and buttons with retro-culture iconography.[3] But rather than appealing strictly to older listeners, *Wayne's World* has reformatted suburban seventies culture as part of the cable ghetto of the nineties. In this heavy-metal *Masterpiece Theater*, a new classicism emerges. In the face of Samuel Johnson's definition of a classic as a mark that a work had withstood the test of time, that a work was valuable on ahistorical transcendental grounds,[4] *Wayne's World* demon-

strates how much classics rely upon historical sleight of hand to produce their timeless qualities. By impersonating a new generation or hybrid generation, Wayne and Garth make a claim on that generation's musical taste. Whereas "Classic Rock" once referred to the sounds of the mid-1950s—of Little Richard, Chuck Berry, Elvis Presley, Eddie Cochran, and the like—the term reemerged in the eighties as a radio marketing strategy, a response to synth pop, New Wave, disco, rap and, in general, to the age segregation implicit in rock's youth-oriented culture. *Wayne's World* signals how "classic" has become the mark of niche marketability.[5] Now a commonplace marketing buzzword, as in "Classic Coke," the term is not the sign of timeless culture but of cultural, generational, and market competition. A classic amounts to something that you can sell again today, and the proliferation of classics corresponds to a media trend toward "narrow-casting" or increased market segmentation, especially by age. With the arrival of the new classicism, we recognize an affective/effective response to the "age segregation" that, in the 1960s, Tom Wolfe found so disturbing in the surf culture of the Pump House Gang and the kids of southern California who "establish whole little societies for themselves."[6] The language of radio marketing conveys the way Wolfe's observation has perpetuated itself in media listening patterns: new music captures the sixteen- to twenty-five-year-old listeners, and classic rock attracts the twenty-five- to thirty-four-year-old listeners. As performance, *Wayne's World* offers the terms on which age segregation will be breached in the nineties pop culture market. Of course, technological forces play a big part in this—cable is, after all, a technology, as is the cassette that Wayne pops in the tape deck, and it is worth pointing out that just as Mick Jagger has been able to sell "Satisfaction" in five different media (45s, LPs, eight-tracks, cassettes, and CDs), *Wayne's World* has found a way to package the past for contemporary consumption. But it hardly seems to matter that "Bohemian Rhapsody" bears little resemblance to a standard-issue heavy-metal tune. It has been recontextualized in a metal setting, and its new classic status affords it generic latitude. (In an extreme case of genre blurring, a young listener called a Los Angeles classic rock station requesting "Bohemian Rap City.")[7]

This explains why we experience a necessary ambiguity in Wayne's and Garth's ages. They are twenty-somethings, teenagers, and prepubescents all rolled into one. Many reviews of the film describe the pair as teenagers despite Wayne's opening explanation that he lives in his parents' house—in name only; his parents never materialize—and is evidently in his twenties (at least).[8] Thus, while it is obvious that the actors Carvey and Myers are portraying teenagers, there is also a less obvious way in which Wayne and Garth—within the film's context—are also impersonating adolescents. By way of this impersonation, *Wayne's World* replicates the logic of contemporary rock as Lawrence Grossberg has recently assessed it. He writes,

[R]ock defines the politics of fun (where fun is not the same thing as plea-
sure, nor is it a simple ahistorical experience). In privileging youth, rock
transforms a temporary and transitional identity into a culture of transi-
tions. Youth itself is transformed from a matter of age into an ambiguous
matter of attitude, defined by its rejection of boredom and its celebration
of movement, change, energy; that is, fun.[9]

Wayne and Garth are not so much cases of arrested development as mani-
festations of the way youth has, indeed, become "an ambiguous matter of
attitude." Adolescent impersonation indicates how the politics of fun are nei-
ther particularly constrained by aging nor restricted to rock music but
include an array of television shows and cartoons, toys, and candies. *Scooby-
Doo*, *Laverne & Shirley*, *Emergency*, "Stairway to Heaven," "Ballroom Blitz,"
Queen and Alice Cooper, kung fu fighting, Stan Mikita (not as 1960s NHL
assist man to Bobby Hull but as mythical donut entrepreneur), street hock-
ey, string licorice, and other markers of seventies pop culture are translat-
ed into the world of Wayne as part of the iconology of the politics of fun.
Inasmuch as these markers can be said to be part of a mainstream culture,
a "North American Suburban Experience," then *Wayne's World* demonstrates
how that culture exists in a mediated landscape, or, more precisely, in a con-
scious experience of that landscape, and how that landscape is experienced
today in a cable TV subdivision. If mainstream culture is commercial cul-
ture, then the adolescent impersonation in *Wayne's World* reflects an aware-
ness of a balkanization that has become part of "mainstream" culture.
Cultural performance becomes the means by which, in effect, ghettoized
culture attempts to gain access to, or even create, mainstream culture. The
rock and TV culture of the seventies performs the necessary work of mark-
ing that creation as fun.

In light of all this impersonation, it is worth mentioning that Wayne and
Garth are not threatened by commercial corruption of their public-access
virtue. In a very amusing product endorsement spoof (fig. 2.2), Wayne and
Garth revel in making billboards of themselves for Doritos, Pepsi, Nuprin,
and Reebok while protesting how they'd never sell out. In another gag, Garth
finds the shifty TV executive's (Rob Lowe's) memo book, and reads, "Daily
Reminder: Thursday. Purchase feeble public-access cable show and exploit
it." He wonders who that could be. The gratuitous plot of *Wayne's World* and
the continual allusions to its gratuitousness tell us that pleasure is in the per-
formance and the language of that performance, especially how that lan-
guage participates in commercial culture. Wayne and Garth are ratings
machines, human arbitrons, and their wit is based on a system of rigorous
evaluation. The content of their talk show amounts to a ratings game—
bringing heavy-metal punditry to commercial culture. "Excellent," sings
Wayne giving the camera a shoulder-hunching, slit-eyed, thumbs-up grin.

figure 2.2

"Wow! What a totally excellent invention—NOT!" Much of the humor turns on Myers's and Carvey's ability to perform a kind of live animation. Garth is sent flying like an electronic luv-o-meter. Wayne pays tribute to a model's sex appeal with a Pavlovian paean: "She's a babe! SHWING!" In a sense, playing dumb amounts to using cartoon effects to display the Pavlovian impact of commercial culture on human desire. If Bergson long ago posited that the comic was produced by *mécanisation de la vie*, or finding the mechanical in human behavior, then *Wayne's World* is virtually a treatise in Bergsonian humor. Thus the way they talk reflects the way their taste is both powerfully asserted and powerfully manipulated. Their ambition is not to be rock stars *per se* but to be professional fans (robo-fans) or talk stars. Consequently, the real threat that commercialism poses to Wayne and Garth is a linguistic one. Wayne and Garth are not worried about selling out; what bothers them is how market forces denature their language. They are most disturbed by the new production values of the commercial version of their show, which neutralizes the inflections of dude-speak.

The infectious influence of *Wayne's World* on everyday speech habits testifies to the power of this performance. Its most permanent contribution to the language—the locution "... NOT!"—a phrase that William Safire has described as a "pseudo-Gallic negative," was, as one reporter complained, the most overused nonce-phrase since Saddam Hussein's "the mother of all battles."[10] Within months of the film's release, other pundits of every stripe were incorporating Wayne-speak into their rhetoric. George Will used "... Not!"; Safire devoted an "On Language" column to it. The Republican National Committee to Re-Elect the President produced a T-shirt that read "Didn't inhale ... NOT!" Many major newspapers ran columns about the phenomenon, complete with instructions on how to say it. "Utter any declarative sentence, preferably one conveying a compliment or conviction—then pause and undercut its meaning with a quick 'not.'" This sort of stuff conjures in

my mind the image of inept people taking dance lessons in the Catskills, teaching the squares how to walk the latest walk and talk the latest hep jive lingo. "... NOT!"—which should be properly conceived of as the verbal equivalent of coaxing Carrie to the prom and making her prom queen for the express purpose of dumping pig's blood on her head—reveals that the button-down dudes inside the Beltway share with Wayne and Garth a common need for touts and put-downs and a zest for verbal violence, a desire to quash all that is "bogus" if only to confirm a sense of their own self-righteousness in the firm outlines of their likes and dislikes. Recently, I watched in amazement while two six- and seven-year-old boys at play expressed their pleasure by thrusting their pelvises in unison and shouting, "SHWING!" With the coming and going of this language fad, whether we lament or embrace it, we ought to acknowledge the absurd power of its taste making sensibility, and we should also acknowledge that Mike Myers, of course, did not wholly invent this language. Not only have "babe," "dude," "excellent," and "party" (I can recall saying things like "Party-hearty, dude" in high school), been around, but the "... NOT!" business finds its etymology in a late-seventies *Saturday Night Live* skit in which Bill Murray and Gilda Radner impersonate nerdy teenagers Todd Di LaMuca and Lisa Loopner. Once again a shard of seventies impersonation leads to nineties impersonation. I suppose one could probably trace its lineage back to the twenties, and one certainly hears a distant relation in Holden Caufield's use of the word "phony."

Wayne's World also demonstrates how cultural performance enables generational transmission. The envoi sequence (fig. 2.3) reflects the filmmaker's awareness of this strategy. As Wayne wraps up the film, he says, "Okay. That's the film. We hope you found it entertaining, whimsical yet relevant with an underlying revisionist conceit that belied the film's emotional attachment

figure 2.3

to the subject matter." Then Garth adds, "I just hope you didn't think it sucked." Ultimately, the film tries to participate powerfully in both idioms. Wayne leaps out of dude-speak to articulate his relation to his performance, and Garth reclaims it back in the powerful ratings language of dudes. In this way, the film tries to please both audiences that it has imagined for itself, twenty-five and older, and fifteen to twenty-five. One has to admire its precision because it tries (and succeeds) in just those terms. It tries to be whimsical yet relevant, and it also tries not to suck—all the while marketing its own preoccupation with seventies culture for a nineties audience.

Of course, we cannot fully appreciate this idiom without glancing at the social type it speaks for. Wayne and Garth are caricatures of "Valley Guys" and metal dudes, which are themselves caricatures. They have evolved from Cheech and Chong in the seventies to Sean Penn's intensely likable stoner/surfer dude, Jeff Spicoli, in *Fast Times at Ridgemont High* (1982) and Crispin Glover's high-strung diabolical performance in *River's Edge* (1986) to Bill and Ted from *Bill and Ted's Excellent Adventure* (1988) to MTV's Beevis and Butthead. Part of the humor and power of these characters derives from the need to express the myopia of youth culture. These characters all share a relentlessly personal vision; thus, it is no accident of form that history and philosophy (and other school subjects) are prime targets for the metal dude's satire. Bill and Ted's time machine affords an endless series of gags about famous philosophical and historical figures. Jeff Spicoli's explanation of the Declaration of Independence in *Fast Times at Ridgemont High* conveys the essence of the genre: "What Jefferson was saying was, hey, you know we left that England place 'cause it was bogus. So if we don't get some cool rules ourselves— and pronto—we'll just be bogus, too. Nyay?" "The best slang," as H. L. Mencken observed, "is not only ingenious and amusing; it also embodies a kind of social criticism."[11] Not only does Spicoli's speech mark him as part of a youth culture but it signals the need to place American history in hilariously personal terms. The Declaration of Independence becomes a problem of bogusness, a Holden Caufield—style questioning of the phoniness of society, and an occasion to express a naive, clubhouse belief that a set of rules will prevent pervasive hypocrisy. That is to say that Spicoli has brought Jefferson's Declaration in line with his own concerns. While it is unlikely that anyone would take this for historical criticism, as a kind of *social* criticism it does advance the central concerns of youth culture.

The difference between these precursors and the more recent examples is that most of the newer ones have been delivered over to an almost exclusively linguistic realm. It is rare to find a stand-up comedian without his or her impression of a stoner, and yet as we acknowledge the ubiquitousness of this stereotype, we should also recognize that Wayne and Garth (and Bill and Ted) distinguish themselves from their sociological counterparts through a distinct absence of menace. Their hang-dog, sheepish, sloppy-toothed grins,

however phony, suggest the fangless fun-loving aspects of the suburban punk. As a friend of mine put it, the question that Bill's and Ted's and Wayne's and Garth's performances pose and never answer is, Why do you talk that way if you don't do drugs?

For all the talk of partying—think of the theme song "Wayne's World. Wayne's World. Party Time. Excellent . . ."—very little partying, that is, drug taking and drinking, goes on. Partying in *Wayne's World* has been detached from drugs, has become an ambiguous matter of attitude more than one of intake. Cassandra (Tia Carrere), the sexy, career-oriented "robo-babe" bass player that Wayne falls in love with is seen sipping bottled water the whole time. The word "party" expresses the distance between the seventies drug culture it came out of and the world Wayne has incorporated it into. A genial goofiness has displaced the vacant stare of the pothead. While we are in the land of "sphincter boys" and body cavity searches, the land of high school sexual put-downs, *Wayne's World* is basically a benign world, of self-effacing hero worship in the face of dubious idols, sexual competition, and slavishly self-stylized imitation. No doubt if one were to reattach Wayne's world to the drug culture that so obviously surrounds the heavy-metal scene, it wouldn't be funny—or at least as funny. It would resemble Penelope Spheeris's other films, *The Decline of Western Civilization* (1981), and (especially) its sequel, *Part II: The Metal Years* (1988), and lose the power to produce classics.

Evidently, the makers of *Wayne's World* know that referentiality does not require accuracy to strike a chord. The film trades so adroitly upon the superficiality of its references that the closer one comes to the uneasy sources of *Wayne's World*'s aggressive joke making, the less discernible the raison d'être for these references. Clearly, *Wayne's World* not only illustrates but also acts out the process of cultural incorporation—the mechanism, as Dick Hebdige describes it, by which the dominant culture redefines, labels, or converts the signs and styles of a subculture into mass-produced objects.[12] If Wayne's basement culture amounts to a subculture, then the film is really about the impossibility of *not* being commodified or "recuperated" by commercial culture. The old version of this process ran, as Henri Lefebvre argues, "That which yesterday was reviled today becomes cultural consumer-goods," and this makes sense for Hebdige's account of how British punk styles became marketed and coopted.[13] But as successive generations have witnessed the inevitable recuperation of one or another subculture, the argument runs: that which yesterday was recuperated as consumer goods today becomes consumer goods again. Rock culture draws, in Lawrence Grossberg's fine phrase, "'lines of flight' which transform the boredom of the repetition of everyday life into the energizing possibilities of fun."[14] But those lines are continually being circumscribed by recuperative forces of culture. *Wayne's World* engages the affective relations between these two forces of culture: the inner cartoonish life of rock'n'roll fantasy colliding with buying and selling. In the

postmodern rock/pop idiom of *Wayne's World*, commodification attempts to acquire integrity by fostering the appearance of recuperation. Thus, Wayne can rejoice in the integrity of his purchase of the ultimate rock commodity, a "classic" 1964 Fender Stratocaster, by informing us that the guitar was manufactured "pre-CBS corporate Fender buyout."

As an artifact of the early 1990s, *Wayne's World* takes place in a belated moment in which the laws of recuperation are already widely known or at least widely felt by anyone who lives within or through rock culture and its fantasies. The film's knowingness, its outbursts of critical vocabulary, make this abundantly clear. In a sense, because critics like Hebdige and, more recently, Tricia Rose, have theorized the mechanisms by which "dominant groups—the police, the media, the judiciary" label and redefine the deviant behavior of youth subcultures, Wayne Campbell can ask (in Cantonese with English subtitles, no less) "Was it Kierkegaard or Dick Van Patten who said, 'If you label me, you negate me'?"[15] The joke speaks not only to the dual language of generational transmission that I referred to above (parodied because it is uttered in translation), but to the awareness that labeling and negation have become routine parts of the affective life of youth culture. The college-educated and the TV-literate may smile at the fusion of a major nineteenth-century philosopher with a minor 1970s television star, but perhaps the deeper joke lies in the possibility that the insight or pseudo-insight about labeling could have arisen from serious figures of philosophy or those of television trivia. In the machinery of pop culture it doesn't matter. In a culture of relentless commodification, all categories of knowledge are equal or equally trivial. Wayne's world is a place where Kierkegaard and Dick Van Patten have equally gratuitous equal-footing.

Seventies TV culture functions not only as trivia in *Wayne's World* but as a principle of trivialization and indeterminacy. Obviously, Mike Myers (who was born in 1962) expresses his own television interests or those of his childhood and adolescence. But inasmuch as these preoccupations with 1970s television reflect a generation coming of age and giving voice to its own collection of cultural associations, they equally appear to have a widespread, transgenerational appeal. This principle of trivialization, I suggest, gives a strong clue as to why the seventies have become the watershed for nineties pop culture and why *Wayne's World* might be an exemplary if trivial film. By mimicking the beginning of *Laverne & Shirley* or the end of *Scooby-Doo*, the makers of *Wayne's World* privilege form—and the recognition of form—over content; they "make fun" by emphasizing the potential insignificance of culture. Just as Wayne and Garth bow and scrape to Alice Cooper ("We're not worthy! We're not worthy!") the film offers the pleasure of recognition as a substitute reply to the problem of the indeterminate value of pop/TV culture. We recognize the association and take pleasure in the recognition but we cannot be certain of its significance or of its utter insignificance. I suppose that

the film clinches this point by offering three arbitrary endings: a disaster ending, a *Scooby-Doo* ending, and a megahappy ending. In the last instance, Wayne stands before us grinning into the camera, fatuously explaining how he has become a better person. This utter sarcasm about becoming truly better amounts to a kind of negative sincerity, as if ". . . NOT!" were the only heartfelt thing that could be said. Indirectly, the ending reiterates the quasi-punk statement that Freddie Mercury croons in the denouement of "Bohemian Rhapsody":

> Nothing really matters
> Anyone can see
> Nothing really matters
> Nothing really matters
> To me
> (Any way the wind blows)

I wouldn't pretend that this sums up what the seventies performance means or has come to mean, but it is certainly part of what it suggests—an era of residual forms, a style of humor that functions like Lawrence Grossberg's lines of flight, where a commonplace nihilism might be transformed into wispy fibers of fun.

Anyone who grew up in the seventies, as I did, can't help but feel a certain queasy nostalgia in this kind of cultural performance, especially in the face of requests for "Bohemian Rap City." *Wayne's World II*, with its spoof of Woodstock ("Waynestock"), The Village People, and a rock'n'roll heaven fantasy where Jim Morrison and Sammy Davis, Jr., find themselves soulmates, delved further into the seventies and late sixties for its gags. It announced the near-exhaustion of the genre even as it anticipated the first Woodstock

figure 2.4

revival of August 1994, while maintaining its deep awareness of generational slippage (a place where the Candy Man and the Lizard King have business together). Despite the sequel, *Wayne's World* feels recessional, like a fad of the early nineties. At the time, Dana Carvey's George Herbert Walker Bush impression was excellent enough to get him invited to a sleepover party at 1600 Pennsylvania Avenue, but just a few months after the election it seemed to be a mere eddy in the swirl of Murphy Brownian motion that enveloped the final days of the Bush administration. If anything, it reminds us of how much we take our temporal cues from political transitions like changes in administration as much as we do from decade markers. We are performing time for one another, yet the meaning of the performance seems to be caught between the inner life of TV-viewing and repackaging the past. We grow older but we don't exactly grow up and out of it. But with each performance, our nostalgia becomes more aggressive. In *Wayne's World* we see the future of rock, and, like the environment, it is in recycling, and it seems quite fitting that rock would fashion a kind of nostalgia *as* its future. In 1994, I saw an advertisement on cable for a collection of *nineties* music, the decade not yet half over and already waxing nostalgic for the instantaneous past. There is a ruthless logic in this commercial gesture: as we speculate on futures and future markets, so shall we speculate on the past. Perhaps the lesson we can take away from *Wayne's World* and its performance of the seventies is this: as the lines of flight that youth culture promises and continues to promise are more rigorously circumscribed, the segments get shorter and shorter, until there is little left but a gag, or the time it takes to laugh. The pleasures of recognition are great but short-lived. We are on the edge—the cutting edge of retro, as I heard one radio station position itself. So, like Gatsby, we beat on, boats against the current, borne ceaselessly back into the past, into an Aurora, Illinois, of the mind. Party on.

NOTES

1. "Mattell Inc.," *Wall Street Journal*, 21 August, 1992, sec. B, 4.
2. Greg Kot, "Queen's World," *Chicago Tribune*, 19 April 1992, sec. 13, 6–7. In 1976, "Bohemian Rhapsody" reached number nine on the billboard charts; it broke into the top five in 1992.
3. On voguing's origins, see Willi Ninja, "Not a Mutant Turtle," in *Microphone Fiends: Youth Music & Youth Culture*, ed. Andrew Ross and Tricia Rose (New York: Routledge, 1994), 160–62.
4. Samuel Johnson, "Preface to Shakespeare," in *The Great Critics*, ed. James Harry Smith and Edd Winfield Parks, 3rd ed. (New York: Norton, 1951), 444–45. For a discussion of the historical contestation of classic texts, see Jane Tompkins, *Sensational Designs: The Cultural Work of American Fiction 1790–1860* (New York: Oxford University Press, 1985), 3–5, 36–37.
5. For reference to the period of 1956–59 as the era of classic rock, see Nik Cohn,

Rock: From the Beginning (New York: Stein and Day, 1969), 29–50. On more recent trends, see Michael Goldberg, "Radio's Rock of Ages," *Rolling Stone*, 1 June 1989, 19–20. Eric Boehlert, "Classic Rock on a roll . . .," *Billboard* 22 August 1992. Telephone interview with Fred Jacobs, Jacobs Media, October 10, 1993.

6. Tom Wolfe, *The Pump House Gang* (New York: Farrar, Straus & Giroux, 1968), 22.

7. Steve Hochman, "Queen Classic Recrowned, Thanks to Wayne's World," *Los Angeles Times*, 4 April 1992, sec. F, 1.

8. In the *Saturday Night Live* skits, Phil Hartman appears as Garth's dad (Beev).

9. Lawrence Grossberg, "Is Anybody Listening? Does Anybody Care? On the 'State of Rock'" in *Microphone Fiends*, 51.

10. Larry McShane, "If Wayne-Speak Has You Tongue-Tied, Here's Help to Slip the Not," *Chicago Tribune* (evening), 17 April 1992, 2.

11. H. L. Mencken, *The American Language; An Inquiry into the Development of English in the United States* (New York: Knopf, 1936), 557.

12. Dick Hebdige, *Subculture: The Meaning of Style* (London: Methuen, 1979), 94.

13. Henri Lefebvre, *Everyday Life in the Modern World*, trans. Sacha Rabinovitch (London: Penguin, 1971), quoted in Hebdige, *Subculture*, 92.

14. Grossberg, "Is Anybody Listening?" 51.

15. Hebdige, *Subculture*, 94; Tricia Rose, "A Style Nobody Can Deal With: Politics, Style and the Postindustrial City in Hip Hop" in *Microphone Fiends*, 71–88.

Jonestown

Reflections on a Seventies Monument

SOHNYA SAYRES

1969

Why not start this story dead in the cusp of the transformation from the declining idealism of the "hope-filled, rage-filled days" of the sixties into the more sharply ideological New Left. Why not. 1969. Jim Jones and his Peoples Temple already had a decade under their belts, and already had traversed the poor people's and racial equality campaigns, in something of their own updated Father Divine fashion.[1] The Peoples Temple had already made its first trek from Indianapolis to Ukiah, California, armed with the learned information that Ukiah was one of the nuclear holocaust safe zones. By 1969, Jones was expanding rapidly on the original hundred-or-so Indiana followers and was finding his way, as he had done in Indianapolis, into local politics, and he was moving fast into San Francisco's.

I am about to launch myself into the thesis, caution to the wind, that the times found and made Jones, inwardly exonerating myself because in 1969 time was very hurried-up, compacted, and forceful. Restless people were jumping the boundaries (and Jones was very jumpy) right off the rhetorical maps of safe politics and recognized religion, past the pleasure principle in sexual exploration, past the youth culture's hold on the definition of needs, past the civil rights' and antiwar's, into a "draw-new-lines-of-self-creation-which-cannot-be-crossed" mood. Or, draw new lines of confrontation with the American ethos. One expected to have to draw lines because the opposition was bearing down; or one did not expect to, but found out the hard way.[2]

In these aspects, Jones was ahead of the curve: he was already up from small-town (Lynn, Indiana) poverty of the Depression, his father's invalidism, his mother's eccentric manners and union organizing, his boyhood

stint at preaching and holy rolling, with a hypersharpened edge for intel-
lectual go-it-alone-ism. He dropped out of his first year at college, having
sometimes flung the Bible in his roommates' faces, somewhat later flinging
it out the door. He was only eighteen when he married the lovely, rather con-
ventional Marceline, a nurse years older than he who saw him as a handsome
hospital orderly, more than a little lost and impulsive, but articulate and
committed, in high-toned youthful speeches, to the world's sufferings. She
discovered sadly, in those first years of marriage, that he was in many ways
still "a terror"—his term for himself as a child in the autobiography he was
dictating at the end. Others remembered him at this time as seducing and
bullying, in turn, one scared soul after another, including Marceline.

It must be said here that too many of these memories suffer under the
dictates of foregone conclusions. Whomever this almost inconceivable tale
touched enough to take up the pen or come forward with an experience to
share has strained to reselect signs of pathology while dimming the nodes
of their own complicity or concurrence. For the outside commentators,
Jonestown is one of the late century's vacuum pumps, siphoning up con-
science along with one's favorite social theory, pulling the whole period, "the
seventies," if you wish, into its reprehensible grotesquerie.

Eight days after the murders of California Congressman Leo Ryan and
four of his party in Guyana (the event that capitulated the mass sui-
cides/murders), San Francisco Mayor George Moscone and Supervisor Har-
vey Milk were assassinated. Whether one was inclined to believe that Jones
had managed to drug or brainwash the assassin, Dan White, to finish his
revenge (rumored still), or whether one was not so inclined, for Californi-
ans the feeling was that they were being bludgeoned by radical, freakish
extremes of themselves. This time, the summary of events was truly horri-
fying. The state had already called an emergency, dreading what those Tem-
ple members still in California might do or what might happen to them.
Many came to believe that "the climate of violence" "had triggered," as one
writer put it, conservative Dan White (denied reinstatement to the city coun-
cil after he had resigned) to finish off the nest of liberal and gay vipers that
had risen from the same swamp as, and partially at the behest of, Jim Jones.
Jonestown soon became the very image of the backwater detritus of the peri-
od's early idealism, its fetid sideshow, and Jones was its carrion eater. Surely,
this was the end of an era.[3]

In the rush of sensationalizing profiles of the Peoples Temple that fol-
lowed, Jones's wife Marceline was allowed to go more gently into that night,
out of sympathy, perhaps, toward her three surviving sons. In all her trials,
we saw Marceline holding on, caretaking and loving, calming, stabilizing,
neutralizing Jones's excesses—Temple members counted on her in this—
until the end. At the end, her one natural son Stephan believes that, from
reports he heard, she had to be held down when they began injecting the

babies. The very last words from Jonestown were in the voice of Jones, now famously crying out "mother, mother, mother." Marceline was the sainted "Mother" as he was the dubious "Dad" to the residents.[4]

It was Marceline, in Jones's own telling, who helped shape his wayward, spewing atheism into a more godly direction. In 1952, Marceline, trying to win him over to her family's religion, took him to a Methodist church, where he spotted the "Methodist Social Creed" pinned to a wall—a five-page document calling for jobs for all, free speech, justice against racism. Inflamed, Jones became a Methodist student assistant pastor. He studied for his position erratically, in night and correspondence courses.[5] His instincts told him to seize ground in the newly integrating middle-class neighborhoods and instill those staid churches with his own version of the preacherly dramatics of Pentecostalism. His own version included strong antifundamentalist twists: he would rant away against "Sky God-isms" and the error-filled Bible. They were the opiates—the "hope-isms," he would say—that did nothing to lessen people's real misery. Those who heard this boundlessly energetic, petulant, impatient, rhetorically clever, and very young man found ways to square their religion with his. Apparently he touched a deeper spiritual place that ached for community and ethical action. For him—and Marceline readily would grant this fact—the religion was a pretext for the social and socialist beliefs that he dared to speak about, then, in the midst of the McCarthyite fifties.

It's important to dignify this moment, for there were anomalies and schisms in his path that he carried with him to the end. It was not long before this campaigning rationalist found himself tempted to the faith-healing bonanza of church building. He recalled that he was dumbfounded by this "gift." Perhaps he was. The night of his first "discernments" he broke out in hives. For the rest of his days his healings would be a staple of his services, winning him the most numerous converts, the most disgusted enemies, and the least attractive or least steadfast of his followers. When the first of a series of printed attacks reached him in the wake of his big growth spurt into San Francisco urban churches and politics in 1972 (by the "religious curmudgeon," Episcopal minister Lester Kinsolving) Jones had been raising the dead. With ill-concealed glee, Shiva Naipaul captures this portrait of Jones:

> The Temple was stunned by this attack. Its foot soldiers began to picket the [San Francisco] Examiner with Bibles and placards, Jones was given the right to reply. It took the form of an interview. Jones explained that his resurrections were spontaneous events, involving no magic words, no special prayers. All he did was radiate his love. It was an extremely democratic process. "I would say, 'This is Jim.' That's my title. No 'Reverend' or anything." Corpses responded well to this mixture of love and egalitarianism. If he had no previous acquaintance with the corpse, he might say, "This is Pastor."[6]

The Peoples Temple weathered this first media storm, continues Naipaul, "with its characteristic mixture of innuendo, slander and threat, . . . and with the help of a Vice President, a Governor, a Lieutenant Governor, a Mayor, two Prime Ministers, assorted Assemblymen, communists, socialists, Black Panthers, ministers, feminists, ecologists, friendly journalists, social workers, Chilean martyrs—[it entered] the most glorious moment of its career."[7] Jones, "the rational, humane, reviver of the dead," had managed to send the religious editor of the *San Francisco Examiner* packing.

To return to my point about the cusp of the change, in 1969 Jones was a small preacher to an oddball, communalist, integration congregation in Mendocino County and, by 1972, a man with important friends to outmatch his conservative enemies in big-time politics. Yet he sensed the pact would not hold. Though he had never given up the theme of American brutalism, in 1972 he renewed it with conviction: his temple would have to search elsewhere for the Promised Land.

1969. A few cautions are slipping in here that I do need to fend off. Many Americans prefer their history to read: "the culture" died in 1969, that is, gave up its easy ways, its explorative styles, its demonstration politics for the more provocative kinds with their inevitable evils of sectarianism and siege mentality. From this perspective, now virtually consensual, from the year 1969 forward, perhaps up to 1974, the revolution in the culture devoured its children by imposing fundamentally unworkable neomarxist, neocolonialist models on the United States and pressing into service black alienation to stand for universal radical consciousness. Under such weight, supposedly, what was focused and concerted in the movement cracked, and out flew members into the folly of adventurism while the core dissipated into the "politics-is-personal" conundrum. These latter are conceived as lesser programs, of gender, or sexual orientation, ethnicity, or New Age spiritualism and communalism. Whatever this collective counterculture had been (and for many other reasons, to be fair, not listed here), "it" had lost the main cause.

Soon, I suspect, the seventies will be saved from this thesis. Those lesser programs became lasting social movements. While the victory was costly, the United States government had been forced to restrain secret operations and presidential corruption. In ending the Vietnam War, the thirty-year hold of cold warism was finally broken. It was in the midst of these substantial successes that Jones had to keep wresting defeat from victory. The tapes found in Jonestown recorded how Jones claimed that Los Angeles had fallen under an earthquake, armed racialist conflagration, firestorms. He missed by more than a decade, just as his rhetorical apparatus missed the resilience of a mass society.

On the other hand, the story of the Peoples Temple and Jim Jones runs only too well along the path of the consensual model. If you prefer the buoyant view of the sixties, then the seventies were anxious, dispiriting years,

which, having run amok before midpoint, show their sad, pointless con-
clusion in the scene such as the November 18, 1978, "White Night." That
night, some 914 laid down in concentric circles around the chair of their
leader, to die, poisoned by cyanide mixed with Kool-Aid. They were far away
from home, building a new town named after that leader—Jonestown—
in the interior, hot Guyana jungle. It was a brutal prison camp to its critics,
maybe even a Central Intelligence Agency MK-ULTRA experiment in mind
control and genocide.[8] To its residents, it was supposed to be a haven from
the torments of home—U.S. culture. Home came after them, a racist, muck-
raking, scandal-loving, cult-smashing but oddly naive home, still tending
to its wounds from the years before, occasionally willing, in stagy ways, to
hold out olive branches to its former beliefs.

The religious writer Stephen C. Rose sees Jones as a "crisis" thinker:

> Jim Jones saw real and imagined crises. He responded. He retreated. Final-
> ly, he manufactured paranoid crises in his mind. The final result was the
> same as if he had been an Eastern guru: a terminal numbness. Numb tran-
> scending individuals gravitate to gurus; while numb transforming indi-
> viduals—social activists—get angry, repress their anger, and look for
> messiahs like Jim Jones.[9]

There happen to be many more routes to take than these two, gurus and
messiahs. However, "numb transforming individuals" is quite a category. Dis-
cussions of Jones have brought forth some fascinating social oddities. If these
discussions happen to be written from inside church history, one can expect
to hear personal failings of the writer mixed with utopianism, then matched
with psychosocial studies of communities, including a substantial list of
precedents in collective suicides. There are now more than thirty such
respectable books on the subject. The truth is that Jonestown stunned the
nation. The Gallup poll for December 1978 found that 98 percent of Amer-
icans had read or heard about Jonestown, a figure that compared then to
only two other events in the Gallup poll's forty-three-year history: Pearl Har-
bor and Hiroshima.

There were no real-time media feeding frenzies then, just outpourings
of news briefs, articles, instant books and, somewhat later, several movies.
James Reston, Jr., recalls seeing his college students, subdued, walking about
with these books and articles under their arms—Jonestown was their "Kent
State," he concludes. The comparison is startling in its pointlessness, except
in one instance Reston might not have considered: some people did mur-
mur to themselves that if Jonestown had been a plot to discredit radical black
grassroots organizing, no more perfect plot could have been invented. The
sight of all those black people dying in front of a white leader was more bit-
ter than gall itself.

The story of Jonestown, or rather the story of its interpreters, now spread

across the ensuing years, leaps back into the heart and up against repugnance in its own details, as much as in the commentators' need for it. The commentators' need for it does, not surprisingly, prevail. Since that rule extends to me, I acknowledge that Jonestown struck when the painful-to-me washout of the New Left brought down befuddled apologists and gloating disparagers to survey Jonestown's fields. Hundreds of reporters, later veritable pilgrims, went to point fingers at it in warning. Since I have never been a joiner, I had no more feeling for its intimate history than most; what I did sense was that what these people had wanted to express would not be allowed through that barrage of penny professional normalizers, nor would the shape of the event settle into the country's self-recognition. In deference to those goals:

THE BACKGROUND TO 1969

In the 1950s, the young and tremulous Jones builds his tiny church in a down-trodden Indianapolis neighborhood by inventing on the Methodist Social Creed with "free restaurants" and a nursing home, run out of his parsonage with the help of Marceline and her parents. When invitations came to exchange pulpits, he would go happily parishioner stealing, a practice that won him no small amount of resentment. At home, he took in stray kids and worn adults, and shortly began creating his "rainbow" family—first with Korean War children, then he and Marceline became the first couple in Indianapolis to adopt a black baby, "Jimmy." As the household grew along with the numbers of church members, so too came animals. He went door to door selling little monkeys he said he had rescued from laboratories. He seemed tireless—a talkaholic, in fact. No doubt he was resourceful. In that sometimes mean-spirited town, headquarters of the Ku Klux Klan, he managed some terrific integration stunts. His nature was gutsy, manic, and flamboyant. He stretched points as a matter of habit, structured hyperbole and inflation right into his folksy, raucous metaphors. He began speaking of himself as part Native American; his dramatically black hair and high cheekbones made this plausible, though for all he knew it was not true. His family was Anglo-Welsh. The new cachet allowed the thunder from his pulpit to broaden across the history of America, further and further from theological dogma.

On matters of program, he was impressionable, syncretic, a quick study. He paid a fawning visit to the still-living Father Divine, adopting Divine's position on sexual abstinence to quell population growth, among other things. Later in the early seventies, when Divine was officially dead and lying in a sarcophagus in his mansion, under bronze angels and surrounded by gold tile walls, Jones demanded his mantle. The ploy didn't work, even with Temple members madly cajoling and strong-arming Peace Mission members; Mother Divine wouldn't have it. The rejection did not seem to set him back much. His attraction to black-centered integration movements had been strong and

indelible since the Indianapolis days; indeed he felt then he could learn from the black Muslims, and he did. When he quoted the phrase "Sunday mornings are the most segregated hours in America," he was doing something about it, a fact that excused his parishioner-stealing. In all, he pulled together the loci of his enticements to restless, disaffected members of more conservative, often black churches with his in-motion, let's-do-it-together, let's-do-it-now style.

Behind the scenes, he would acknowledge other feelings. The faith healings particularly exhausted him, as they do shamans; for Jones, the healings must have had the extra burden of his dissonance. He did not really believe in them. Others noticed that he waffled here and there on their psychic placebo effectiveness; they noticed too that he suffered from fears of a general, free-floating kind, akin more to those of shell-shocked soldiers than those specifically paranoid. There was plenty of hostility bred by his integration fights, most grant him that. However, he seemed not above exaggerating or inventing threats in order to grandstand or in order to be the hand that molded his own demons. Whatever was the case, his attention-getting skills, his piebald congregation, his conscience won him friends across the racialist divide. In 1961, at the age of twenty-nine, he was appointed civil rights commissioner of Indianapolis.

In a little more than a year he bolted from that job to South America, staying briefly in Georgetown, Guyana, then going on to Belo Horizonte, Brazil, then on again to Rio. *Esquire* had published an article in 1962 naming the nine safest places from nuclear catastrophe. Belo Horizonte (and northern California) figured among them; ostensibly he was doing some advanced scouting in a missionary guise.

The conspiratorialists have him in their grips at this moment, for his stay in these countries corresponds to CIA-backed, right-wing coups against the socialist governments. They see him being whisked away for a briefing just at the moment when he was discovering a taste for power and when the contradictions in his own position would only worsen in the public glare. He would have made prime CIA fodder—a poor man with a poor man's resentments; an egotist who suffered shuddering attacks on his self-confidence; a vain man given to paunch whose whirlwind mix of fakery and do-goodism could easily be turned against him. He would be only too prone to the entrapments of secret agent stuff with its megalomaniacal idea of agency, the fear-riddened strain in his character only too readily warped into the paranoid worldview of the cold war.

He would have been an asset to the CIA, according to this perspective, by his proven, uncanny way of being an insider in the black community with talk so loose on the subject of socialism it was unclear whether he was anti-communist and secretly communist, or vice versa. Shortly after Castro had come to power, Jones flew to Havana to recruit, he told his church, forty

black Cuban families for his new community of mutual self-help. Castro's scarcity communism would not fit them, he said. He managed to bring one man home, a man he buttonholed in the lobby of the hotel, telling him he was a nightclub performer and missionary on the side. After an all-night talk fest on Jones's vision, the man agreed to be Jones's houseguest for awhile before moving in with relatives in New York. The abrupt "mission" and the timing had Jones's mark in Latin America, so too the lame show. The pattern grew so sticky—Guyana, Brazil, Cuba, Grenada—the surveillance sleuths had become quite glued in it.

Eventually Jones wrestled the octopus arms of his political ideals into the term "paranormal socialism." The Russians were very interested in studying his paranormal socialism, he told the Jonestown camp on the last night. His staff had been negotiating for months with the Russian embassy in Georgetown to be granted asylum. "Would the Russians come to rescue us tonight?" someone asked. "No," replied Jones. "Unfortunately, tonight there won't be time."

When Jones returned from Rio in 1963, he got out, he told everyone, "just in time, ahead of the 1964 military coup." He said he had been slipping money and offering sanctuary to the Left underground. Besides, the Kennedy assassination convinced him that he was needed at home to fight fascism. Not quite, thinks Michael Meiers in his compendium *Was Jonestown a CIA Medical Experiment: A Review of the Evidence.* [10] Jones was denounced in Belo Horizonte as a CIA agent by a local newspaper, Meiers claims. Jones then split for Rio, where his teaching appointment was arranged for him; his wanderings into the poorest *favelas* with Temple monies were a perfect cover to establish left-wing connections.

To Tom Reiterman, Jones's biographer, all these Latin American activities can be explained on the surface of things.[11] What is important is that Jones returned exhausted and defeated: his trip had been a failure, he was very unsure of himself, he felt exposed—a dangerous moment for a charismatic personality. Jones had encouraged a missionary he had met in Belo Horizonte to return to Indianapolis and take over his church, whose membership had been failing badly. He had confessed to this man, a tough character himself, many of his inner fears, including those for his mental health; upon his return he had to bear the older man's eyes on his increasing oracular posturings (fancified with his study of Afro-Brazilian religions). One night Jones invited this man to the roof of the church with him alone. It was later recalled as an unmistakable death threat, and the substitute preacher left within the month. For Reiterman, Jones never again would bear criticism from those around him; a sinister strain had rooted itself.[12]

Within a year and a half, Jones pulled up stakes and headed for California, ahead of possible heresy charges. On his radio program he was Bible trashing again, his preaching dangerously godless and self-aggrandizing. But this

threat would hardly have sufficed to make Jones turn tail. His motives have never been very well explained, and this act was costly. Without homes or jobs secured for them, only about a hundred followers ventured to go with him. He had been naming dates for nuclear armageddon, such as 1967. Perhaps he meant it.

There in Redwood Valley for several years the families huddled in the garage of Jones's modest house until they were able to expand his home over the swimming pool in the backyard. They were then mastering the soul of their success, channeling poverty program monies into their own nursing and foster-care units, briskly playing the field in local government. Jones was a "complete political whore," remembers one Ukiah official—supporting both candidates at once, while sitting on community boards, building publicity, running old buses to demonstrations. Jones organized Ukiah's first antiwar march. The Temple began to draw in a core of new idealists, often middle class, from the swelling ranks of such idealists from all classes and groups—lawyers, business people, daughters of ministers. Here was a bright iconoclastic place—a church built over a swimming pool!—with women troops, alternating light and dark skins, lining the drive to greet you; communal dinners; all sorts of fun, activist things to do. For most in that company, these were not bad years, 1965–1969, even with Jones occasionally dipping over the edge on the issue of nuclear holocaust or demanding that the church arm and fence itself against its John Birchian neighbors. By 1969, the Peoples Temple had about three hundred members.

1969

We are now at the cusp. The infamous Year of the Panther. The year before, within eight weeks of each other, Martin Luther King and Robert Kennedy were assassinated, then followed the disastrous Chicago convention; the country had seen a hundred cities burning, Vietnam burning—not to repeat the litany but to recall the seared panorama that brought Nixon to power and which convinced him to greatly expand domestic surveillance and bring the counterinsurgency war home. Shortly after the 1969 Students for a Democratic Society convention every student member would have a file; a thousand new FBI agents were assigned to coordinate ratting professors with local and federal subversive squads. The government was preparing an enormous, ludicrous list of organizations and publications, affiliation with which made one ineligible for government work and the organizations themselves subject to professionalized harassments which invented on themselves—tappers, informers, infiltrators, agents provocateurs; break-ins, frame-ups; moonlighting cop "goon" patrols, scandalous disinformation tactics, and parades of nuisance investigations from taxing and regulatory agencies; custodial imprisonments. Sympathizers were threatened, lawyers disbarred,

conspiracies charged, leaders targeted, deadly shoot-outs took place. It was, to use Lillian Hellman's phrase, "scoundrel time" exploded by the prince of the original. For black nationalists, highlighted by the vicious FBI's COIN-TELPRO ("neutralize-disrupt" actions) and the CIA operation CHAOS (domestic monitoring), the year was a rout. For the Black Panthers, recipient of two-thirds of the covert action, twenty-eight would die in eighteen months; the leadership was dead, imprisoned, or exiled.[13] The country (unlike the storybook Marceline) did not go gently into the next decade.

INTO THE SEVENTIES

How did Jones fare under these darkening clouds? People who remembered him then did not consider him "mad"—jumpy and globalizing, but not mad. He talked constantly of being a target, but then, he was in the corner battling with one of the country's sorest losers, racism, with one of its honored traditions, grassroots, nondenominational, social-activist, apostolic communalist Christianity. Given the times, he had to believe that he was listed; he used the rhetoric of black nationalism with his increasing black membership; this fact alone would have nominated him. Ministerial positions had not protected others.

But then again, in another of the ironies of the onslaught, perhaps he missed the honor. Reporters who survived the Jonestown massacre remembered being besieged not only by instant book requests but also by the FBI, which claimed not to know a thing. Charles Garry, lawyer to the Temple, made inquiries under the Freedom of Information Act concerning members of the Temple. To his surprise, contradicting his considerable experience with radical groups, no files were found. Of course, if the CIA was secretly. . .? What is a matter of record is that when Jones openly supported the kidnapping of Patty Hearst and her subsequent transformation into "Tania" in 1974 (while sending letters of condolence and money to her father), he was clamped onto a Los Angeles terrorist list. Shortly, so many other investigations would be launched against him, this one might have been gratifying.

Perhaps Jones knew, in the way one does and does not know, that the plugs in his own character would not hold, knew by listening to some background hum in himself, in history, in the pact he made with the American scene. The times vise-pressured those standing on either side of the battle lines; the mass arrests in Washington, more disclosures abroad—Allende's overthrow, for example—confirmed that America's "friendly face" was cracking. Few were sure of what was coming down, Nixon included, and they had difficulty fending off ominousness. It looked as if the effort to keep the whole antiwar effort nonviolent might just be borne away by tiny renegade guerrilla groups, most of whom had FBI plants. The ominousness etched into Jones until he announced to his committee an escape plan. Now he had the

money, now he had the rationale, now most in his "total care" communi-
ty could be made to share the feeling. And should that escape not prove pos-
sible, then they could turn and face the enemy, he determined, united in
"revolutionary suicide." The term was Huey Newton's, forged from the in-
and-out-of-jail glory of defiance; Newton had meant fight until the last. Most
of Jones's company were children, retired people, and the ill. In the "armed
camp" of Jonestown only a few rifles and pistols were found.

As the seventies quieted down some, Jones had more names he could
drop, more photos of himself with VIPs; he had a near-professional public
relations team, growing coffers, and glowing commendations. Yet, it is still
difficult to believe that he believed, by reasons of his qualms, by reason of
the distortions and extortions he practiced, that he would ever get cleaned
up enough for mainstream "national movement leader" stature. But that
stature was his ambition, some of his critics held, and he had to be stopped.

He was, actually, dedicatedly foul-mouthed and marvelously blasphe-
mous, decent, if that was what was wanted, in the tradition of Lenny Bruce.
The reason Satan left heaven, he told his screaming audiences, is that Satan
couldn't stand hallelujahing all day that mean ol' buzzard Sky God. Nobody
should ever have to give, he insisted unconvincingly, shouting and dancing,
genuflection to nobody. The uppers and downers he took brought him
humiliating moments, often robbing the interstices of his judgment their
last weak spring, yet the drugs probably were not in excess of those taken
by the candidates Hunter S. Thompson describes on the fear-and-loathing
campaigns of the period. He did suffer from a plethora of vague complaints;
his health was an incessant topic, he regularly visited his doctor in the com-
pany of bodyguards. The diagnosis was usually gross fatigue: he kept a with-
ering schedule with three churches, broadcasts, projects, rallies, and
demonstrations, appearances; his sexual "obligations" exhausted him, Amer-
ican fascism wore him out. By the way, if you were cured in one of his heal-
ing services, you were nevertheless sent to the doctor. The Temple had
organized an excellent medical referral system.

He agreed at one point (around 1975) to a psychological examination. The
results: "paranoid with delusions of grandeur." "Paranoid?" his personal
physician and supporter, notable black community activist A. Gordon
Goodlett, queried after all was over. "Who would not have been?" Jones told
his group that he had his head examined, and it was in great shape.

He was equally undaunted when someone pointed out that he elevated
and made special with his sexual attention only light-skinned women. That
is because, he retorted, ever adroit, black women have been so humiliated
by white men he would not think of imposing. So licentious was he with
men and women on his inner staff, they seemed to have suffered the con-
fusion of the king's mistresses and lovers. Even while running scared for legit-
imacy in the scandalized air of those last years in California, Jones was so

caught up in his mystique of a sexual giant that he could not help himself from bragging about it in a mass rally.[14]

It's difficult to imagine the reception of Jones's little slip-up in that sloganeering, cheering atmosphere, though someone remembers Angela Davis saying she was uneasy about the control Jones had over his followers. Perhaps he had received only a hearty laugh at his daring self-promotion, a relishing of the gilt frame the times put around raw dynamism, a smirk at his cultivated down-home posing, or slight alarm at the crack in the block of respectability dignitaries had steadily supplied. This was at a time (1976) when San Francisco Mayor Moscone had appointed Jones chairman of the Housing Authority, a position directed at the heart of Moscone's conservative, big landlord opposition. Jones had turned down Moscone's offer of civil rights commissioner, perhaps as too low level and backward looking. He demanded this job instead. He would ring old tenements with whipped-up crowds in a showdown with developers, all the while knowing that sitting in the district attorney's office as an assistant was his own closest adviser, Tim Stoen. Soon would follow "The Martin Luther King Humanitarian of the Year Award," in 1977.

Be that as it may, he stayed reckless and more than a trifle strange: he wore sunglasses, he told his audience, to protect them from his radiant eyes; he sold charms of himself; he was still showing around chicken livers as coughed-up tumors during his healing services. In those years, government was still primed to take the heat of a good many blazing rhetoricians, and it regularly sought out mollifying incorporation. Jones stood out, and he worked long to get there. He was not discovered; he asked for his due. He was a great one for sending in Temple money in significant but not disturbing amounts to hedge his political bets or fend off criticism.

Who his constituency was, exactly, was probably no more worried over than with other spokespersons of the disempowered. Tim Stoen has estimated that over the years, Jones might have preached to fifty to one hundred thousand.[15] The Temple's *Peoples Forum* tabloid claimed a circulation of six hundred thousand.[16] More to his political account was his reputation for being able to organize a crowd for a political rally in under six hours. If you threatened him, as investigators did, as the defectors did, he could muster pickets, letter writing, and phone harassment campaigns seemingly without reprieve.[17]

He was that odd combination of the times, an alarmist with a glad hand, a shoulder rubber and headline grabber, a hard worker with an escape/exodus planned to the jungle of a black socialist land. As Jones counted on a paradise slowly rising out of the jungle, he and the Peoples Temple steadily urbanized their community activities with drug, mental health, and physical rehabilitation programs, foster care, housing, meals, thrift shops. The numbers quadrupled because he exercised his old Indianapolis habit of lifting them out

of other preachers' pews. Those preachers complained, but Goodlett asked the preachers to ask themselves what they thought Jones might be doing right. A harder accusation to refute was that Jones was allowing the Temple to pyramid with the loyal bunch from Redwood (largely white) sitting on the key positions, badly color-dividing the top from the base. He took grief for this, even more so in the retrospectives, as another instance of the falseness of the man. Had he not been tightening the controls, had there been less to do, the inequity might have wrecked him.

As it was, the Peoples Temple created venues of personal expansion: there were community boards to be elected to; public service jobs the Temple urged one to; group, nursing, foster-care homes to run; Temple services to plan, publicity, a newspaper. The Temple choir cut forty-eight albums. There was, in fact, an "endless stream" of activities to be taken up when the regular programs "flagged," writes scholar John R. Hall, so that "everyone, no matter what his or her station in life, had a chance to be 'somebody'": besides the choir, one could play in the band, join the defense drill teams, play basketball, or present skits with the "loosely vaudevillian Skitsophrenics" on "venereal disease, slavery, mental illness, the Ku Klux Klan, and concentration camps . . . [or make] humorous caricatures of Temple members."[18] People's skills were put right to work, just as their money was put into the communal pot, and more was required of them than many thought they had in them.

Sometimes, too, they were just on-the-road happy. Jones had his buses ramble up to parks where the choir would sing and members proselytize. They once marched on the Golden Gate Bridge to protest the lack of a suicide barrier (yes). With the plans for the Guyana settlement more and more realized, there was adventure in the air and bootstrap operations to ready oneself to learn agriculture, construction, diplomacy—a new town to forge in an almost new world.

Much has been made in all those books on Jonestown of the seduction of the middle class, especially its young single women, to the Temple's inner core. When the fathers plotted rescue with mercenaries or sent sons to plead for their sisters in Jonestown, the dramatic value was very high—painful exemplars of the bondage Jones could wield. Just as likely, those who stayed loyal did so because Jones kept rewarding them with jobs that were challenging. But should any of these well-placed persons have quit in time, they carried with them not only the secrets of the Temple, but also the Temple's dread of pursuit. They had ghastly stories to sell, and they were fiercely reclaimed. To the world, they had crashed through the checkpoint gates of the iron curtain of Jones's control. They said that they feared phone calls, that "hit squads" would follow them. Jones had had a body double die for him, they said; they would never be free. Panic and vindication rolled over them (about fifty people) as they were sought out by reporters and pub-

lishers. As the world went on, they had to face one of the most fearsome of the aftermath's murders from the null comfort of the government's position of "no evidence." The Millses—mother, father, and daughter—were machine-gunned down in their home a year and a half after the mass suicides in Jonestown.[19] They had been the Temple's most vociferous, concentrated enemies since 1975, having created an ex-cult "Human Freedom Center," while pumping back to the press tales of drugs, beatings, fraudulent deals, depleting mind games, forced confessions, forced sex, and suspected homicides. In Jeannie Mills's *Six Years with God: Life Inside Reverend Jim Jones' Peoples Temple,* Jones stands condemned in such vivid, explicit detail that her conclusion becomes conceivable: that the "monster-minister" who created the "ultimate spectator sport" is still alive.[20]

In turn, Jones might never have trusted his decision makers and planners. The first "White Night" was practiced on them. In 1976, after a particularly grueling planning commission meeting, he passed around cups of wine. People were taken aback—drinking was prohibited—but as they relaxed, Jones informed them that he had poisoned it. It was only a test, with one panicked woman shot with a blank by a guard at the door; those who were grateful remembered it as a powerfully cathartic moment of honor.

Discerning the good from the dregs, Jones's gross manipulativeness, the double sexual standards (Jones railed against the evils of promiscuity while "humbly" acquiescing to his sexual "duties"), the rigid boundaries and burned bridges of total commitment, the fear structure, the suicide rituals— no one story can hold the parts together. No one book has yet been able to. So many died anonymously, without a whisper of a chance to add their version. The journalistic tendency to highlight only a few participants as the dramatis personae privileges the modestly privileged in a way the community itself was tired of, setting their sacrifices up as higher than others'. It makes their reasons for staying, against the Temple's cruelties and deceptions, more mystifying. Mike Prokes, a survivor, writing his account of the Temple before he shot himself in front of reporters four months later, said that he never liked Jones much; in fact, he had been hired in 1972 to infiltrate the group. But he could not separate himself from the others, nor could he countenance the quitters, mostly middle class and white like himself, who were demoralized by the hardships and who covered their weakness with counterattack.

Prokes was the consummate PR man, retorted the defectors. He did his duty to the Temple to his last breath.

No one will understand, wrote one Temple member from the grave, the discipline it took to keep order among so many castoffs of American society—the violent war veterans, the ex-criminals, the addicts, the cripples, the mentally ill, the seniles, the tough street kids—who came to the Temple for safe harbor. No one will understand.

THE COUNTDOWN

Few then grasped that with its outward successes, inwardly the Temple felt a countdown had begun. Kinsolving had his home burglarized after his series of articles on the Temple appeared in 1972. In 1973, Jones was arrested for waving his penis at an undercover cop in the men's bathroom. The cop insisted on prosecuting Jones on homosexual solicitation charges. The lenient judge, however, ordered the records sealed and destroyed.[21] For some reason, they were not, possibly at the connivance of hostile investigators and the tax and firearm authorities. In 1974, police intelligence started a file on Jones for his sermon supporting the kidnapping of Patty Hearst; it did not look good for him when Hearst named Jones and a group Jones was entangled with (WAPAC) as one of the food distribution sites. In fact, several of the members of the Symbionese Liberation Army (SLA), including the nominal leader, Donald DeFreeze, had been seen in Temple meetings.

Around this time Jones befriended Dennis Banks, who had fled to California for sanctuary from extradition for his role in the Wounded Knee uprising. In 1976, Banks would receive almost $20,000 from the Temple to bail out his wife and daughter from jail; he would also receive a visit from Conn, a Treasury Department agent, who privately had been probing Jones's operations for years. Conn tried to intimidate Banks into making a public statement against the Temple. Banks refused and warned Jones of the secret investigations. The Customs Service, at the urging of the Federal Bureau of Alcohol, Tobacco and Firearms, was closely monitoring the Temple's shipments to Guyana.

So by 1976, with Hearst, DeFreeze, and Banks in his aura, confirmation of investigations, and all of the above, one can only imagine how Jones must have grated on the truly conservative nerves of the city council of San Francisco. Once the rumors had it that Jones wanted the mayorship, or something on that order, the charge went out to the conservative newspapers to do something. In steps Reiterman. The Concerned Relatives began collaborating with Reiterman and other reporters on damning articles, collaboration which the Temple learned of through its own extensive, overwired snitch channels and which it began to fight with every tactic it had. But it was losing. The articles were scheduled for summer of 1977. Once Tim Stoen, the Temple's chief crisis controller, turned away, in fatigue and doubt, and then decided to go after Jones to get his son back—the little boy John-John whom Jones believed he had fathered—the time had come.

In that summer of 1977, in secret, the Peoples Temple turned its back on the United States. Small caravans of buses crossed the country to the eastern seaboard. Marceline stayed behind presumably to disguise the flight with ever louder regular services. Members dropped out of their jobs overnight, telling relatives nothing or that they were going on vacation. They began

arriving in Guyana by commercial airline, forty or fifty at a time. By the end of July, there were eight hundred and fifty of them; by the end of August, nearly a thousand. The camp was not ready. [22]

That summer the notorious Kilduff and Tracy article for *New West* appeared, which led off by reminding its readers that Jones was "one of the state's most politically potent leaders" who, little unbeknownst to anyone, behind the locked, armed doors of his church conducted communist and cult atrocities, financial fraud, nursing home and foster-care abuses, child torture, and terrible reprisals against the disaffected. The source of these charges were the "Ten Who Quit."

An avalanche of magazine, newspaper, and TV news exposés followed, with reporters in full bay, laying on innuendo and ignoring problems of credibility. Reiterman was key among them. Reiterman writes of his piece:

> Probably more than a million people saw the headline story on August 7, 1977: "Rev. Jones: Power Broker, Political Maneuvering of a Preacher Man." An opus by newspaper standards, the story filled dozens of columns . . . including a history going back to Jones's monkey selling days. . . . The next story appeared on August 14, 1977. "The Temple, A Nightmare World," went beyond the *New West* article in describing a dehumanizing lifestyle— of children being assigned to beg in the streets, of two-dollar allowances for adults who turned over everything, "catharsis" sessions, faked healings and resurrections, boxings and beatings. [23]

Most of Jones's liberal supporters, Reiterman says, adopted a "wait-and-see" posture. "The church's most important supporters—namely Willie Brown, George Moscone, and A. Gordon Goodlett—stood behind the Temple publicly." [24] But by running away, they had to admit, Jones looked guilty.

JONESTOWN, GUYANA, 1977–78: NO SANCTUARY

Jones was not in Guyana a month before Tim Stoen pressed a custody suit against him. The Georgetown court sent an official to serve a writ on Jones in Jonestown. When Jones hears of it, he is aghast. "Alert! Alert!" he screams over the camp microphone, tape recorder playing. Soon the community armed itself with machetes and painted faces—that is, except those who could get to the few rifles. They had to be prepared to face down "the mercenaries that Tim Stoen had hired to attack them," Jones kept crying out.

The one government official who came to deliver the court papers proved a bit anticlimactic. They sneered him away. But several days later the Guyanese court ordered Jones arrested for contempt. With this, he knew the army would come. "I am ready to go," he said to the panicking Marceline over the radio patch to her back in California, "but the people won't let me." Unless they were given asylum, they were ready to die for their

principles; they were ready to commit revolutionary suicide. It was their decision.

Marceline knew they were so ready; she can be heard sobbing to her sons on the tapes. Terrified, she flew about for the next six days trying to locate Jones's Guyanese friends, who, when found, called off the court. The exhausted community went back to their duties. The White Night was averted; their beginning in their new home with their leader was a catharsis of frightful proportions. On what basis could they possibly have recovered?[25]

The campaigning reporters and Concerned Relatives then threw themselves on the U.S. government's mercy, but not before hiring some private eyes. The Temple added conspiratorial specialist Mark Lane to their arsenal, not that this made their chief lawyer Charles Garry's job any easier. Garry needed to concentrate on the Temple and its immediate war with reporters, defectors, and relatives.

Jones ran from the public life he had built, back into the fold of the dream, the fold of his people. But apparently he had despaired, from its inception some five years before, that the haven in the jungle of a black-run, socialist land would ever be anything like the paradise he had promised. He had been scouting out alternatives in Romania, Uganda, Russia, and Cuba. It must be said for him, though, as the year progressed in Jonestown, that he would not let the others' enthusiasm outstrip his. He would bolster and cheer, guide, resolve conflicts, lecture, sermonize, and beseech until he was carried helpless back to his cabin. He had his group up on their toes maneuvering in Guyanese politics; he had his team managing the complex finances; he allowed a (small) stream of visitors. They were up to the fight against the press and the Concerned Relatives. Something of the place was infectious to the spirit, when despair had not quite gotten hold of him. Jonestown functioned despite all its burdens. There were even small achievements here and there in processing food and lumber. No agricultural project in that country had yet paid for itself, but perhaps this one would, eventually. In his brighter days, those thousand people's collective goodwill and skills bolstered him.

But the counterpart in him—that they would have to die, as a testament—had also settled fixedly into his plans and his address. The cascading number of hostile exposures and intimidations were, as he proclaimed to his group, prophesied.

A word should be said about Jones's publicness, for it deserted him in that place. He had fled from it, and it abandoned him, with dizzying speed. When Congressman Ryan came, he came fairly well assured that Jones was no longer a player in his world, though Ryan's beginning had been supported by Jones. Reiterman and others, there to capitalize on the atrocity stories they had already published, had Jones mostly locked out of the temple's California friends and influences by the cult accusations. He had locked him-

self out and had become the pariah he said they would make of him, by lead-
ing the dark-of-night exodus.

A STORY THAT AMERICA CANNOT TOLERATE

Mike Prokes, the survivor who shot himself in front of reporters in March
1979, said that his message was that "this is a story that America cannot tol-
erate." Each of the many writers on Jonestown knows what anchor they have
thrown out to keep themselves from the vortex of Prokes's meaning. [26]

Prokes hoped his death would, if his life had meant anything, at least
prompt another book. The problem is . . . as he guessed. Within the circula-
tion of money and its friends—administrative posts, information and com-
mentary, institutions of research and reproduction—who could have
anything to say about the little man preachers with their strange gifts that
won't turn to coin? Who would convince little people to throw their stake
at a place like Guyana, to be punished like Guyana itself, for renegade visions
and collective dreams?

For the more comfortable middle of the country, groping toward a wel-
comed peace after the mid-seventies, the sense was that secret government
also must be sobered and groping for middle ground, at least internally. Cen-
tral America was another matter. An invented naiveté fell over a new gen-
eration of reporters concerning government harassment, and not too many
people bothered to point it out. It was almost a pleasure.

I do recall that at the time I felt that the first string of books on Jones-
town failed to see how compelling was the story of this group's hope for a
place of love, integration, and respite first being pushed out of the heartland
of America, then out of golden California, then out of the country itself, only
to be pursued. That Jones cracked early and grew monstrous did not lessen
the image for me, though the idolizing of him was and is beyond my grasp
of things. I heard an American jeremiad being preached, until, in the bleak-
est hours of the early seventies, it was no longer accompanied by trust in
America to redeem itself.[27] The acid condemnations inherent in the jeremi-
ad, the rafter-raising prophecies, this time were not couched in the promise
of America. Other persecuted, disillusioned communalists were taking
flight to Canada, Chiapas, Belize—a leakage of the hippie spirit. When it final-
ly came, the Peoples Temple's exodus and end was a planned monument.

NOTES

1. See Robert Weisbrot's corrective—overly so—book on Father Divine, the
 Depression-era preacher and integrationist. *Father Divine and the Struggle for Racial
 Equality* (Urbana: University of Illinois Press, 1983).
2. Terry H. Anderson recalls the bikers' raids, drug busts, harassments, and

bombings of the communes in his *The Movement and the Sixties: Protest in America from Greensboro to Wounded Knee* (New York: Oxford University Press, 1995), 283–85.

3. It took a concerted effort of rabbis and clergymen—the first such concerted effort among them, they proudly announced—to find a resting place in California for the hundreds of unidentified and unclaimed bodies. Officials in other states said the remains would defile the ground they would lie in, and that the graves would stimulate cultic reenactments. California officials finally resolved on a mass grave with a simple marker. By then there was enough reportorial dirt to see the unclaimed soundly buried.

4. The reel-to-reel tapes ran out before Jones died, and quite possibly, before many of the others were dead. He had been walking among the dying, urging the last standing to come forward and take their drink of poison. Some of the mothers were crouched over their children, weeping uncontrollably. The "mother, mother, mother" might have been his admonition to them to preserve their dignity.

5. Jones graduated in 1961 from the institution he started out in: Butler University. About this time, through friendly discussion and as a tireless, imaginative integrationist, he was granted affiliation with the Disciples of Christ Church, a large, respectable, almost creedless denomination; he was ordained by them in 1964. Jones had only to observe baptism and the eucharist. The baptisms in the Ukiah church were held in the swimming pool he had added to his house and then built his church around. The communal dinners were his celebrations of the eucharist. As Jones expanded in San Francisco and Los Angeles, the Disciples came to regard his as one of their most successful ministries—contributing more than a million dollars to the central fund, and proudly binding "people of all walks of life" to a "truly extraordinary commitment to human service ... staggering in scope and effectiveness" (Rev. Karl Irvin, Jr., regional minister of the Disciples, in 1975, cited in David Chidester, *Salvation and Suicide: An Interpretation of Jim Jones, the Peoples Temple, and Jonestown* [Bloomington: Indiana University Press, 1988], 39). Apparently, the Disciples had no procedures for removing a congregation. When the news came back from Guyana, they scrambled to disavow association.

6. Shiva Naipaul, *Journey to Nowhere: A New World Tragedy* (London: Abacus Sphere, 1981), 256.

7. Ibid., 257.

8. The MK-ULTRA project (changed to MKSEARCH in 1965) was the CIA's code name for its mind-control experiments, begun after the Korean War and continuing for twenty years. CIA Director James Schlesinger reputably ordered the project stopped in 1973. Nevertheless, say the conspiracy theorists, Latin America was special; a throwaway community like Jonestown would be an almost perfect experimental setup. The large supply of Thorazine, Seconal, and Nembutal-type drugs found at Jonestown were strikingly like the drugs used in the "sleep cocktails" of the projects; the

coffin-like affair used to quiet Jonestown discontents mimicked the project's use of sensory-deprivation chambers. Moreover, the MK-ULTRA project was suspected of trying to perfect a method of drugging someone into becoming an assassin. The behavior of Ryan's assassin and Moscone's and Milk's assassin suggested that both men were heavily drugged at the time of arrest. But this is not all: missionaries and grassroot religious leaders in Latin America had been recruited into CIA pacification and counterinsurgency projects, including the collection of Amazon mind-altering flora. The hair-raising details of this story can be found in Gerald Colby's and Charlotte Dennett's book *Thy Will Be Done: The Conquest of the Amazon: Nelson Rockefeller and Evangelism in the Age of Oil* (New York: HarperCollins, 1995). Even if one puts aside this scenario as too awful, U.S. congressional hearings were forcing disclosures about mind-control and ethnic weapons research in 1977, the last panic-filled year of the Peoples Temple. The communards heard these disclosures as confirmation of what Jones all along had been telling them.

9. Stephen C. Rose, "Jim Jones and Crisis Thought," in *New Religious Movements, Mass Suicide and Peoples Temple: Scholarly Perspectives on a Tragedy*, ed. Rebecca Moore and Fielding McGehee III (Lewiston, N.Y.: E. Mellon Press, 1989), 156.

10. Michael Meiers, *Was Jonestown a CIA Experiment: A Review of the Evidence* (Lewiston, N.Y.: E. Mellon Press, 1989).

11. Much of the information for this history is indebted to Tim Reiterman's and John Jacobs's extensive biography of Jones called *Raven: The Untold Story of the Rev. Jim Jones and His People* (New York: Dutton, 1982).

12. The missionary's daughter would write her own book about Jim Jones. However, since it is now well documented that Protestant missionaries in Brazil were led into supporting CIA efforts, an alternate reading of this confrontation might have Jones challenging this man on *his* politics. Reiterman's book is not prepared to offer any insights into such alternative possibilities.

13. See Frank J. Donner's excellent *The Age of Surveillance: Aims and Methods of America's Political Intelligence System* (New York: Vintage, 1980).

14. Reiterman catches this moment of Jones's swagger style: the Black Muslims (whom Jones found racist and sexist) had their temple near the Los Angeles temple of Jones; tensions and flare-up were common. As relations improved,

> in 1976, the two organizations planned a historic event for the Los Angeles Convention Center. For their joint "Spiritual Jubilee" of May 23, 1976, the Muslims and the Temple invited political figures to their gigantic "demonstration of brotherhood." Among those converging on the convention center were some of the Temple's most treasured friends and political contacts—Dr. Carlton Goodlett, Angela Davis, San Francisco District Attorney Joe Freitas, Lieutenant Governor Mervyn Dymally, not to mention Los Angeles City Mayor Tom Bradley, whom the Temple wooed with little success.
>
> In his strong staccato voice, Jones blazed an impressionistic trail of rhetoric, leaping abruptly from "unity" to Christianity to the need for a

free press to Watergate to—totally out of context—a reference to himself as a sexual object of desire. Finally, Jones pledged support to the Muslims, declaring that he wished Wallace Muhammad were running for President of the United States. (Reiterman and Jacobs, *Raven*, 282).

15. Stoen is quoted in John R. Hall, *Gone from the Promised Land: Jonestown in American Cultural History* (New Brunswick, N.J.: Transaction Books, 1987), 69.

16. The *Peoples Forum* is described by Hall as an "eye-catcher." It headlined natural disasters and social outrages, had news items on the Temple, editorialized on progressive political struggles, and managed to attract "feverish" letters and "catalyzed extreme responses" from all sorts: gay activists, hardhats, communists, proponents of space colonization, a man advocating "Democratic Free Enterprise Socialist Party," and proto-Nazis (Hall, *Gone From the Promised Land*, 161).

17. Those who might have shared his perceived constituency were often too splintered, too suspicious, too uncompromising, and too broke to invest in mainstream friends. Thirty different Black militant groups were said to pick at their differences in Oakland in the later sixties. Some of the leadership of these groups got caught up directing poverty programs even as monies for these programs were drying up, while some of their membership probably were interwoven with extortion rackets for drugs, cash, and arms, as critics now emphasize.

18. Hall, *Gone From the Promised Land*, 109.

19. Police believe the Millses' murders were drug related. The Millses' daughter was known to have drug problems.

20. Jeannie Mills, *Six Years with God: Life Inside Reverend Jim Jones' Peoples Temple* (New York: A and W, 1979).

21. The fingerprints from Jones's arraignment were the ones used to identify his body. The defectors suspected a substitute appeared for Jones at that arraignment, a look-alike. It was this man who was shot in Jonestown, they believe.

22. A small group had been working away with great energy and mostly excellent spirits since 1974, but they were far from ready to welcome a thousand people that summer of 1977. They had grown heady on the project—there were only about fifty of them, 90 percent of whom were under thirty years old—and they were not all that thrilled with Jones, especially not his teenage sons. He arrived with threats behind him and a rebellious front crew.

23. Reiterman and Jacobs, *Raven*, 331.

24. Ibid., 332.

25. By Temple logic four-year-old John-John Stoen was Jones's natural son, sired by Jones at the request of Tim Stoen, abandoned by his mother, and given over to Jones in a sworn affidavit by his money-loving and turncoat, nominal dad. Stoen, they had reason to believe, was in "deep cover" for the CIA. The little boy had always been part of their community. That September

John-John was finding his place among the other children, the brightest stars of their new home, in the makeshift playgrounds and nursery of Jonestown. They could not give him over without giving over a part of themselves, just at the moment when they had pushed off the shore together. They had only to look over their shoulder to see how many on that shore were plotting to break them up.

26. Reiterman discounts Prokes's story of being an agent won over to Jones. Meiers writes that his suicide was "alleged." Rebecca Moore, author of a series of books on Jonestown seeking to understand her two sisters' deaths from the position of commitment that their father, Rev. Moore, had taught, finds Prokes's death redolent of the despair the families and survivors were struggling with. She is willing to include the other grizzly murder/suicides that followed, such as former Temple member Tyrone Mitchell's opening fire on a California playground, killing one child and wounding others before shooting himself, as more testimony to the anguish.

27. Sacvan Bercovitch's study of the American jeremiad describes how the faith in the errand to build the New Jerusalem in America rose against the castigations, the great declension into sin. One cannot read the American classics, he says, without hearing this expression of that particular vision. Bercovitch, *The American Jeremiad* (Madison: University of Wisconsin Press, 1978).

Identifying
Genres

Identity, Value, and the Work of Genre
Black Action Films

CHARLES KRONENGOLD

The black action films of the 1970s stand in an ideal position for reevalua-
tion. Like many cultural productions of the seventies, they have left strong
traces in popular culture itself—in film, television, music, fashion—but can
hardly be located in the critical literature. They remain as a moment that
cannot quite be dismissed but might best be forgotten. The vast majority of
the recent work on these films appears in studies of African-American cin-
ema and focuses on thematic configurations, depictions of black Americans,
and responses of audiences. In order to shift the discussion away from the
question of audience responses, this paper will focus more upon the black
action film's connections with other genres. Through comparisons among
genres and close analysis of a particular film, Gordon Parks's *Shaft*, I will
attempt to move beyond thematic configurations and broad descriptions of
style.[1]

I might say initially that the black action film enriches and complicates
the action/adventure hero as derived from the sixties—exemplified by
James Bond—by drawing upon and revising the genre of film noir. What
this somewhat pat formulation neglects, however, is the role of specifically
African-American cultural practices in providing strategies of revision and
techniques for generic mixture.[2] Musical practices, in particular, inform the
flexible use of genre in these films.[3] Throughout this essay, I will emphasize
generic mixture and movement among genres over static descriptions of
individual genres. Such descriptions will remain useful, but only as a model
that no actual film completely embodies. It is worth remembering that the
authority of genre is both concrete and limited. A genre provides a film with
a clear identity that, however, cannot describe the film completely. Further,
its constitutive features form a collection too large and diverse to be

exhibited by any one film. A genre therefore establishes rules for identity without demanding that they all be followed. The resulting give and take, as decisions are made about what a film should include, provides an impetus and a means for evaluating films against one another, and helps to establish a conversation among the films in a genre. This conversation is grounded in an understanding that a single film represents only imperfectly the whole of any genre.

Issues of identity have formed a substantial part of the criticism of these films. Considerations of genre can deepen this critical discussion because of a fundamental homology of (1) the behavior of a person within a social context; (2) the function of a character in a film; and (3) the place of a film in its genre. This homology will be brought out in several ways. First, questions of identity within the confines of a genre can provide a model for such questions in late modern society. Consider the questions one might ask about identity in respect to the black action film: What does a character need to do in order to be a black action hero, as opposed, say, to a white action hero? What role in the constitution and transformation of the genre is played by the aspects of its characters that exceed those needs? How can a character's identity *contest* the action genre's conventions if this identity is *produced* by the genre? What is the fundamental unit of the genre—a single feature or group of features? an individual film? a group of films unified by actor, director, production company, or theme? a subgenre? or the entire collection of films? These questions all have analogues in recent discussions of identity: How are identities constituted and bestowed? What is the social function of that which exceeds, challenges, or subverts conventional identities? What does it mean that a politicized identity is both a contestation and a production of the liberal state? How can we define the relations among a person's multiple and overlapping identities?[4] The construction of identities both informs and is informed by the play of genre: we can learn about people through considering their behavior generically, and we can learn about genre through considering the multicontextuality of people. Second, by both defining the identity of an individual and establishing a place for that which exceeds the definition, a genre raises issues of style and provokes questions about the *place* of style: How will a character's deviations from convention affect the structure of the film? How will a film's assertions of individuality help to transform the genre's identity? Finally, generic motion is frequently initiated and underscored by the physical movement of its characters: considerations of genre help us to see what happens when people move from one social context to another.

I will focus here on the ways that *Shaft* constructs its hero's personality discursively, through the use of "genre as a field of potential identities."[5] To do so, I will look not only at John Shaft's most obvious traits, but also at the contingent features of his identity as conveyed through Richard Roundtree's

performance. These contingent features—the details of his speech, move-
ment, and appearance; his response to minor difficulties as well as to major
ones; his multiple modes of competence and his multicontextuality—form
a necessary part of both the film's cinematic economy and its character
development. They become more than a simple backdrop for the action;
because the emphasis on secondary elements takes screen time away from
the dramatic core of the films, it forces the violent set pieces to work hard-
er. *Shaft*, generally remembered as a straightforward, violent action picture,
delivers a series of three long montages separated only by short connnect-
ing scenes: the search for Shaft's old friend Ben Buford, shot mostly with-
out sound; a sex scene; and a slow, nighttime drive from Times Square to
Buford's place in Harlem. The discursive style of these three montages
allows the music, locations, and mise-en-scène to dominate the film for a
considerable length of time. This series, which appears early in the film,
should be enough to make the viewer wonder what, exactly, all this other
stuff has to do with a tough action thriller. Further, it gives the viewer the
right to say "*Show me* that this is really an action movie." Blistering action
sequences thereby become a structural requirement. This is so not only
because they occupy less time than they do in many action/adventure films,
but also because the film must actually demonstrate their preeminence.

Just as internal contrast and variety help to determine the makeup of
the films, the conflicting aspects of the protagonists play a similar role in
shaping character. These films follow the gangster tradition in presenting
characters who often speak beautifully, dress elegantly, and display profi-
ciency in surprising areas despite being hard-boiled and morally suspect. As
I will show later in connection with *Shaft*, the films commit themselves to
creating protagonists who are multifaceted even while single-minded, and
refined despite their frequent recourse to violence.[6] The characters' violent
behavior must engage—dialectically, as it were—their cultural refine-
ments. It is the intensity of the contrast that defines the characterization. A
character's internal contrasts also become the basis for conflict *between* char-
acters in a film. Thus, a film's dramatic conflicts are partly developed out-
side of its plot, through differences in speech, dress, and movement.

INTRODUCTIONS:
THE CREDIT SEQUENCE AND THE "THEME FROM SHAFT"

Because action films often have simple thematic configurations and pre-
dictable narrative curves, they will seem repetitive when viewed through
that lens.[7] Instead of focusing solely upon the points at which these basic
requirements are fulfilled, therefore, one ought to look also at the move-
ment between and around these points. The films help to create an appre-
ciation for this movement by emphasizing their characters' efforts at getting

around. We sense these efforts right at the beginning of the film, which introduces the main character. A moving shot sweeps down toward Times Square, preparing us for Shaft's grand entrance; unexpectedly, he emerges from the subway as the theme music kicks in. The rest of the credit sequence mostly depicts Shaft walking. At several points in this sequence, Shaft displays well-developed jaywalking skills; his first utterance, in fact, is a curse directed at a driver who has refused to stop for him. That Shaft is shown taking the subway and getting around on foot already marks him as different. In a credit sequence, one might expect a less goal-driven activity than is normal for the rest of the film, but Shaft is in fact depicted as walking the streets for much of the movie. Not only does this distance him from figures like James Bond, who seldom needs to hit pavement, it makes good on a promise of the film noir that is very seldom fulfilled. Specifically, the characters of film noir, while they are understood to walk a lot—because of their personalities as much as the plots—are seldom actually seen doing so. *Shaft* seems to explore the question of what it means for a character to walk, and for a movie to include walking in its economy.[8] Shaft's character is revealed in part through the ways that he walks in the city and encounters people. By means of such performances of ordinary activities, the characters of black action films acquire a complex dimensionality that their roles in the plots can only hint at.[9]

While walking remains the master trope of performative identity, black action films have many ways of creating a shift away from the mechanism of the plot. One might point to the Cleopatra Jones movies, which star fashion model Tamara Dobson, and which are, in effect, cut to the fashion. In these movies, the progress of the plot must often be put on hold while the camera slowly takes in one of Cleo's new outfits.[10] These cinematic modes create important effects within the films: they provide a pause in the narrative which allows the music to take on a greater role; they encourage an attention to visual detail; and they present the practices of ordinary life as modes of knowledge, often nonverbal—jaywalking, feeling the material of a leather coat, using a phone booth.[11]

The nature of the music in these films reveals a connection between a greater role for the soundtrack and an attention to details. The emphasis on detail and specificity is crucial to African-American popular music of this period, emblematized by the black action film soundtrack. What the soundtrack provides for musicians, beginning with Isaac Hayes, *Shaft*'s composer, is an opportunity to investigate new production techniques, arranging tricks, grooves, melodic and harmonic materials, and so on, without the pressure to create catchy hooks or to stick to conventional song forms. What happens, in part because of these soundtracks, is that the conventional song and the idea of the hook are greatly transformed in the seventies. The early seventies represent an extraordinarily creative period in soul and funk. The

movie producers and directors who went after black musicians at this time might have thought that they were simply buying the rights to surefire hits in an accepted contemporary style. They guessed right, but this should not allow us to forget that black popular music was very much under construction in the early seventies. African-American music in this period underwent significant changes in its institutional frames, in the constitution of artists, in its aesthetic economy. It did not present itself as a stable resource fit to be taken into another medium. Nor did contemporary soul provide the only resource for the composers of the black action film soundtracks; many cues make use of earlier musical codes and present the kind of music a scene might have called forth in an earlier film, filtered, however, through a soul sensibility. One can hear many styles in the jazz and Western classical traditions, often reorchestrated to emphasize the feel of the rhythm section. Such a mixture of genres and styles, while part of recorded black music throughout its history, becomes a defining feature in the seventies.[12] These movies clear a great deal of space for the soundtrack, and what they receive in return is a sense of depth—consciousness, even a conscience—that the image and dialogue cannot themselves provide.[13] The music, for its part, must tie itself to the film's concrete visual cues, but this explicit function frees it to explore the implications of its new aesthetic materials outside of the traditional pop song's economy.[14] Moreover, the African-American characters of these films provide the music with visible support in its attempt to create new styles and sensibilities.

It is worth considering the "Theme from Shaft" in order to hear the possibilities that it provides for an understanding of the film. I cannot discuss this theme song without remarking its strangeness. The presence of a vocal theme describing a central character requires some explanation. Traditionally, a film contains an instrumental cue that stands as that character's theme music. The score may supplement this instrumental theme with a title song that bears a more oblique relation to the character, as in the Bond series. In *Shaft*, the opening credits are accompanied by a song that actually describes the lead character. Why does *Shaft* take so literally the notion that a theme song should define the protagonist? One reason has already been mentioned: the musical codes are not yet fully established, but are in the process of being defined. This creates an aesthetically favorable situation, but it compromises the theme's ability to serve its customary function. Second, there is the suggestion that, because of its novelty, Shaft's character requires all the definition it can get. Of course Hayes and Parks recognize the borrowed elements in John Shaft, and it is with self-conscious wit that they give the theme song a free hand to assert his novelty. This strategy creates an amusing effect: the theme song should define the character, so Hayes just up and tells you what you need to know; Parks requests that the song convey Shaft's complexity, and Hayes sings "He's a complicated man. . . ."

Does a theme song's telling you that a character is complex make him complex? Not necessarily, but it shows at least that the film will perform its work of definition by any means necessary; and if the music can demonstrate this complexity, the lyrics cannot be taken as making an unsubstantiated claim. Instead, they should be understood as doing in an obvious way what the music does in more subtle ways.[15]

Rather than analyze the song as a whole, I will focus on one of its most recognizable features: the use of the wah-wah pedal. The wah-wah pedal in this song has become so famous that it often gets taken as a joke, but that should not stop us from thinking about what it does, how it changes the meaning of this device in order to create a particular effect. This treatment of the wah-wah pedal has a complex genealogy. In the sixties, the wah-wah pedal provided a way to add nuance to melodic lines on the guitar, specifically to give them a more vocal, more expressive quality. With Jimi Hendrix and other guitarists, the wah becomes more than a way to enhance an otherwise traditional melodic phrase, and begins itself to provide access to a new range of otherwordly sounds. These sounds do not obliterate the guitar, but they often stretch it into unrecognizable shapes. Such a use of the wah-wah pedal remains rooted in the intensely vocal cry of the blues, however, even at its most distant from guitar technique as these musicians inherited it. The "Theme from Shaft" draws on an alternate strand of guitar technique, one derived from the funk of James Brown. Brown's guitarist, Jimmy Nolen, following earlier R&B and jazz traditions, took the percussive component of guitar picking, a component of the sound ideally to be eliminated, and made it into a positive feature, something to be brought out. In Nolen's hands, the electric guitar became a complex rhythmic voice that added harmonic support without ever renouncing its right to make a melodic intervention. When other guitarists add the wah-wah pedal, as in the "Theme from Shaft," this percussive component of the sound becomes more important than the pitch itself. The guitar functions simply as *that which enables the wah-wah pedal*: the manipulation of the pedal is almost solely responsible for whatever profile the guitar part has, since it stands on one pitch and locks into a single rhythmic value.

Hayes makes the arrangement respond to this shift in roles. In the absence of any melodic hook or full-blown groove, the rather restrained guitar part moves into the foreground. We are encouraged to focus upon the subtle nuances of the guitar because, for a while, there is not much else. Later, when other instruments enter, the guitar holds things together, providing the glue for a bunch of melodic fragments that float in and out without attempting to constitute a traditional backing arrangement. Because the "Theme from Shaft" takes quite some time to become anything like a pop song—the voice does not appear until more than halfway in—we must invest in the details for themselves, and not simply as cushions for the voice.

The theme song teaches us to pay careful attention to that which has been passed over as without value. In Emersonian terms, "that which was negligently trodden under foot"—the wah-wah pedal, of course—becomes "sublimed and poetized."[16] This revaluation or reinvestment becomes important in a movie that makes so much of money, value, and evaluation.

The work performed by the theme song parallels the work of the visual track that accompanies it. First, the theme provides an introduction to the film in general and to the main character in specific. Its own internal structure, particularly its long introduction, can teach us about the nature and role of introductions as such. Second, it creates a musical economy as it unfolds by investing in some unlikely elements while reevaluating some older holdings. This economy is different from that of the traditional pop song, but respectful of it. Third, the theme establishes the generic frame for the music. It begins with the hi-hat cymbal and processed guitar rather than orchestral instruments, and goes on to give the unmistakable feel of a soul rhythm section. It also presents both diachronic and synchronic means of generic transformation. The wah-wah pedal is introduced as a new sound and argued for through its enhanced role in the arrangement. The song's simple chord structure creates a novel harmonic feel with familiar means.[17] This feel exerts a subtle pressure upon other musical parameters: form, melody, arrangement. The possibilities of synchronic transformation, too, are grounded in the tradition of rhythm and blues. The song provides just enough of a groove to keep the listener involved, and thereby leaves space for extrageneric materials to ease into the mix. While the theme song does not include any material really foreign to late-sixties soul, it reveals Hayes's and coarranger Johnny Allen's modus operandi: movement from genre to genre is lateral, exploiting the common ground between genres and relying upon the continuity provided by the rhythm section and the classic Stax Records production style. The soundtrack as a whole encompasses a wide variety of genres, but not as foreign material plucked out of the air; rather, it pictures the broad generic mixture as inherent in soul music, part of its tendencies, its affinities, its history. Fourth, the theme defines a style built on contrasting elements and an appreciation for details. The visual track works similarly to achieve comparable ends for the film. It introduces the character, developing new *modes* of introduction in the process; establishes the film's economy; defines the generic frame and the means of generic transformation; and shows the role that details and contrasts play in the film's visual style.

The credit sequence depicts Shaft's walk from the subway to a shoe repair place, where he gets a shoeshine before going up to his office. The vast majority of this footage was shot without sound and sensitively edited to the music. The credit sequence therefore becomes both emblematic, because of its formal elegance and introductory function, and naturalized, through its

narrative role. This combination of emblematic and realistic functions is announced early by the traffic sounds with which the film opens: although seemingly a realistic element, they quickly disappear from the soundtrack as soon as the music starts. This traffic noise helps the film depict morning rush hour in Times Square, but its sudden withdrawal shows that it serves also to emblematize the film's urban setting. Many visual details can be shown to perform practical, rhetorical, formal, and thematic functions. To take one such detail: Shaft walks against the early-morning sun and is momentarily lost to view as bright light floods the frame. The editor actually cuts in about twenty-five frames of white to create this effect. Although created by pure white light, the effect appears as a *distortion* of the image, since the sunlight seems to overload the camera's capacity. The practical function of this edit might well have been to cover up a continuity problem or a flaw in the footage—although the shots immediately preceeding and following the frames of white *look* continuous, they might in fact have been patched together using the white as a seam. This solution leaves a visible trace, however, and thereby calls attention to the very technical means it is supposed to hide. Although a crude device, this explosion of sunlight works rhetorically as a moment of lyrical or impressionistic emphasis on the viewer's perception of light and the camera's ability to represent that perception. The flash of white makes a formal connection with the soundtrack, since it coincides with a prominent trumpet hit in the theme song. This moment of intense, local engagement between image and music constitutes an especially clear instance of the energetic rhythmic counterpoint between media (which is maintained through much of the film, and for which editor Hugh Robertson deserves most of the credit). The frames of white serve a thematic function as well. Like other visual touches in the credit sequence, it hovers between crudeness and subtlety, rawness and artifice, and, as such, helps the film to create a noir sensibility. More specifically, it points to film noir's high-contrast cinematography and use of harsh whites.

The walking itself helps to establish the film's economy. Think of Shaft's walking as functionally equivalent to the constant wah-wah guitar part in the theme song: his walk makes connections among a diverse group of images, and asserts the value of motion, transition, and local detail as a complement to conventional set pieces and fixed narrative sites.[18] Shaft is depicted as continuously in motion; clues about genres and generic transformation are provided by *where* he walks. Shaft walks out of the subway, against traffic, through steam from a manhole, among striking employees of the *New York Times*. Shaft's use of the subway works with and against his fashionable clothes to define the film as a specifically *urban* thriller—a viewer can expect that *Shaft* will more closely resemble *Bullitt* (1968), say, than a James Bond movie. As an example of complex, real-time negotiation with his environment, Shaft's jaywalking confirms his status as an active subject

rather than a racialized object: unlike many "ethnic" characters, he is *in* the city and not merely *of* it. The image of a solitary figure walking through steam is part of the generic repertoire of film noir. Along with other elements of this repertoire—visual framing devices like mirrors and bars, extreme closeups of small objects (especially Shaft's deputy badge), posters, advertisements and other ephemera, the harsh white light—the steam gives an indication that *Shaft* will draw freely upon noir topoi, despite (or as part of) its attempt to look contemporary. When Shaft walks past the picket line, the viewer may be reminded of documentary and news footage of the civil rights movement, particularly because this scene is shot in a documentary *style*, with an active shoulder-mounted or handheld camera. His movement among these sites helps to take the viewer from genre to genre, here and in the rest of the film. All four of the genres touched on in the credit sequence—urban thriller, action/adventure film, film noir, and documentary—play significant roles in the film.

Interwoven with the footage of Shaft walking are three scenes with sound, the first of which has already been mentioned as containing Shaft's first line. In this brief scene, Shaft curses at a driver who cuts him off as he is attempting to jaywalk; once the car has stopped, Shaft gives the driver the finger (fig. 4.1). Probably because this scene was shot initially without sound, Shaft's dialogue is out-of-sync. There is also a continuity problem with his position relative to the car's, which serves to jerk the viewer into

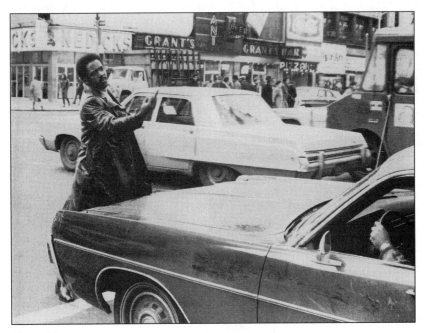

figure 4.1

the scene. Although clearly the result of these two technical flaws, the raw-
ness of this moment carries a palpable charge, adding to the violence of the
confrontation. Yes, Parks and Robertson would surely have noticed these
problems, and could have fixed them (possibly without reshooting) or sim-
ply removed the scene. Left as it is, however, the scene serves some useful
functions. It forces the viewer to notice Shaft's jaywalking and encourages
speculation on its role in determining his character.[19] As Shaft's first line in
the film, the curse becomes emblematic, initiating the hard-boiled dialogue
and establishing a distinctly urban tone. Shaft's physical contact with the car
demonstrates the city's impingement on the space of the character, again
suggesting the film's urban seriousness. In a funny way, this exchange con-
stitutes an *action sequence*, or perhaps a distillation of one—it is, after all, a
physical confrontation shot and edited in a dynamic style, "mistakes"
notwithstanding. As such, it gives an early indication of the film's generic
frame. Moreover, the mistakes themselves perform valuable aesthetic work.
To the extent that this scene seems unfinished, amateurish, or low-tech, it
enhances the documentary character of the credit sequence. The mistakes
also connect the work of making the film with the efforts of the central
character. Both the credit sequence and the theme song, anticipating the
film as a whole, must respond to competing, almost exclusive demands: the
song must be incidental and assertive, raw and sophisticated. The credit
sequence must establish the film's connection with earlier genres like film
noir, but not at the expense of its contemporaneity. It should look both real-
istic and "artistic." Shaft, too, must be both urbane and *urban*—elegant, but
willing to get his uniform dirty (fig. 4.2). These competing demands become
manifest in the film's contrastive visual style. With the visual contrasts that
are derived from noir, with the mixture of action and documentary genres,
and with the alternation between carefully composed shots using a station-
ary camera and dynamic shots using a moving camera, the credit sequence
establishes the interdependence of realistic and artificial modes of depiction
and argues for the particularity of each.[20]

GENERIC MIXTURE AND GENERIC MOTION

The changing cinematic economy, with its greater investment in movement
and specificity, provides a means for understanding genre in films of the sev-
enties. Movies like *Shaft* can be particularly useful for a revised notion of
genre and generic mixture, because they often picture genres as occupying
discrete places in a film's landscape. This scheme allows the movement
among genres to be physically traversed—in *Shaft*'s case, on foot.[21]

In the credit sequence, for example, Shaft moves through and responds
to the strike, and thereby engages the documentary mode on his own terms.
Handheld (or shoulder-mounted) camera footage reflects and helps to

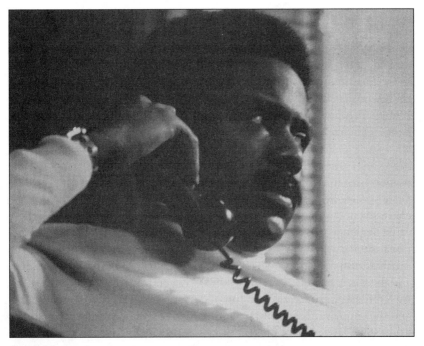

figure 4.2

bring about this excursion into another genre. The handheld camera does not belong exclusively to documentary and other kinds of *cinema verité*: its ability to convey a sense of motion gives it a place in action/adventure films, for example. The combination of the strike and the handheld footage, however, makes clear the allusion to documentary here. The documentary genre can play a particular role in a post-sixties political context. In many cultural productions of the 1970s, the political mode is depicted as rare, and more effort is invested in showing the approach to and possibility of political action than in actually staging this action. This depiction marks a distance from a notion of political action as necessary, common in cultural productions of the late sixties, and from a notion of such action as impossible, common both in film noir and in mainstream cinema of the late seventies and the eighties. *Shaft*'s use of documentary conventions makes a point about moving through political space (physically, as it were); although some have seen *Shaft* and films like it as constituting a wasted opportunity for political action, there is nevertheless a kind of energy that derives from a situation in which political action is neither expected nor foreclosed, in which the political does not embrace every aspect of life, but still exists *somewhere*.

Although the film does not embrace the documentary genre as fully as it does film noir, it keeps documentary in play enough for its function to

become clear. This generic allusion can add a special dimension to a film with a largely African-American cast, emphasizing the novelty of a black character over his or her conventional role in the plot. The codes of *cinema verité* suggest several things about the material depicted: that it is new or new to the medium of film; that it has inherent importance, independent of aesthetic considerations; and that it can only be captured once, and cannot be restaged. The documentary, by showing a slice of life, encourages the viewer to ask what leads up to the film's opening and what happens after it ends—to wonder in what way and to what extent the film represents the life it depicts. Of course, the techniques of *cinema verité* can be used as stylistic mannerisms in their own right, not only through questioning their identification with *cinema verité*'s claims to truth, but also through the flexibility and expressiveness of the style's low-tech approach. Because black action films so often depict people and settings more familiar to documentary than to fictional modes, they can use the codes of *cinema verité* without drawing too much attention to them. These codes help to suggest that these characters and their lives have *not* been shown in Hollywood cinema. At the same time, the combination of high- and low-tech approaches in the musical scores, and the music's mixture of raw and refined sensibilities, encourage one to understand these cinematic techniques as providing another way to create visual detail.

A few sequences later, the film clearly depicts Shaft entering the space of the film noir. His office building itself, the lobby, the service entrance, the elevator, and, especially, his office door's frosted glass window bearing his name and title in simple black type: these elements do not merely suggest film noir, they are indistinguishable from their originals. They function as both a memory and a holdover. This entrance into another genre is reflected in other aspects of the film. The introduction of hard-boiled dialogue places the film in the broader category of the urban crime film, but the visual style creates an unmistakable sense of forties noir. The lighting becomes more high-key, the framing more off-angle, the focus much shallower. Moving away from the idioms of rhythm and blues for the moment, the music works accordingly, presenting a unison chromatic line that could have been drawn from a film noir score.[22] In Shaft's office, the movie's first fight scene ensues. The cultivation of a noir sensibility continues, however, thanks to the music and the visuals, including touches like the Hitchcockian point-of-view shots in which the camera gets throttled and punched in the mouth.[23]

The movie goes to considerable pains to establish connections with film noir, but it does not fulfill many of that genre's most crucial requirements. I will not hold up the genre of film noir as an abstract model and take *Shaft*'s departures from it as constituting some kind of failure or mistake. This is not so much an acknowledgment that *Shaft*'s borrowings from noir constitute

surplus elements as it is a recognition of the movie's ability to account for these departures. It will be helpful to spell out *Shaft*'s relation to the conventions of film noir. The conventions that the film does not observe can be as useful as those that it does in revealing how it becomes more a revision of noir than simply an homage. Let me first list the elements that Shaft borrows from noir.[24]

Shaft is a private investigator who works out of a sparsely furnished office in a seedy midtown office building. His thoughts and actions constitute the narrative voice of the film. His status as a figure of knowledge is revealed through his verbal wit, his diligence, and his prowess in a wide variety of activities. Shaft is what might now be called multicontextual: he can speak in a range of modes, he can navigate the whole of the city, and he seems to have cultivated a relationship with everyone he encounters on the street. He occupies a kind of middle position—he is neither cop nor criminal, but he is fully at home in the world of crime. The depiction of the city's topography reflects this position: he works in one neighborhood, lives in another, and must handle a case in a third.[25] The different ethnic, economic, and physical makeups of these neighborhoods take on a moral force in connection with the plot. The film makes extensive use of its New York locations, presenting not only neighborhoods, but specific blocks, buildings, stores, and restaurants that can be easily recognized.[26] These recognizable public settings can be the sites of the film's most important conversations. The variety among the settings, too, becomes an indispensable element. The streets are often very crowded or almost deserted. We see the most opulent neighborhoods as well as some of the most neglected. This high degree of contrast holds for the interiors. (A seedy outer room resembling a janitor's basement office leads, most unexpectedly, into the oasis that is Bumpy's office.) Each interior in the film is depicted in only one guise, and cannot be understood independent of the specific ways that it is lit and framed by the camera. As such, each location conveys a single mood, sometimes a particular moral character.

There is frequent violence, both during the action sequences and not, as well as violence that is either barely suppressed or narrowly averted. The bluntness of violence as *Shaft*'s principal mode of power works well alongside the clarity of money as the film's principal mode of valuation. The characters tend to discuss financial matters, often with reference to specific dollar amounts. The cash itself asserts a strong physical presence. As money is made into an "expressive object," so too does crime become an expressive medium.[27] The film allows for a charmed space outside of the law, a space that facilitates this aestheticization of crime. The aestheticization of crime, in turn, makes a place for the aesthetic as such.[28] Beginning with the credit sequence, *Shaft* asserts the importance of contingent elements, unecessary exchanges, and small details. The specificity of objects, locations, and names,

and the tendency of the camera to linger on ephemera like billboards, strike posters, and magazines, might at first be seen as realistic techniques, but these techniques quickly seem mannered, part of a conscious effort to create a visual style. Combined with the nuances of cinematic technique, and with traditional noir visual motifs—mirrors, steam, artworks, photographs, extreme closeups of objects—the small details help to load even the most conventional plot elements and stereotyped characters with extra significance. These devices encourage the viewer to appreciate the variety within the film's "secondary" elements: cinematography, editing, costumes, music, decor. Recent musical approaches, especially, come to the fore, sometimes with the capacity to comment upon the action. Realistic modes of depiction certainly govern individual sequences and locations, but not the film as a whole. Realism, therefore, is but one of the film's depictive modes. Interlaced with other modes, it can serve particular functions without forcing the viewer to take things too literally.

The extent of this list should not obscure the essential elements of film noir that *Shaft* does not preserve. Nor will it help to point to other films in the black action cycle that observe the conventions of noir more strictly than does *Shaft*. While it is true that many elements the film observes are less important than those it does not, the film shows a capacity to answer for these absences. By establishing a dialogue with the conventions of noir, the black action film can create itself as a specifically African-American counter-genre to film noir. First, Shaft is constituted differently than many noir protagonists. He has no "dark past": he has put in his share of "street time," but he is not running away from anything he has done or been. He never becomes personally involved in the case, except to the extent that his old friend Ben Buford is brought on board. He seems neither alienated nor flat and distant, however, as his engaging laugh makes clear. Unlike the classic noir hero, Shaft shows concern for his appearance. In many noirs, the tension between work and romantic involvement, when it does not produce a pathological sexuality or push sexuality aside entirely, places a strain on romantic relationships. Although he shows misogynist and promiscuous tendencies, Shaft seems capable of maintaining a romantic commitment. This relationship undergoes no great stress as a result of his work on Bumpy Jonas's case. The lack of a femme fatale in *Shaft* may strike the viewer as a departure from classic noir (even though many noirs themselves do not contain such a figure). The absence of betrayals might constitute a more significant difference, however—how can you have a film noir in which people are what they appear to be? Similarly, the plot is not particularly complex or surprising, since it follows the outlines of the action/adventure genre rather than those of noir. Nor does *Shaft* place its action against a bleak landscape of sinister locations permeated with power. While its visual scheme seems to respect noir's reliance upon a strong contrast between

black and white, the film also features soft earth tones and liberal doses of the famous, early-seventies "golden amber kind of feeling."[29]

The film seems to justify these departures in several ways. The justifications converge upon two points: the film's overriding attempts to look *new* (despite its borrowings from an earlier genre), and, especially, its racial configurations. I should say initially, however, that the absence of a femme fatale only counts as a departure according to an overly literal characterization of noir, and that the same holds for the lack of sinister locations, betrayals, and a complex plot.[30] The figure of the femme fatale generates many fascinating characters and performances, but can be better understood as representing a larger theme: the interpenetrations of public and private spaces, of professionalism and intimacy, of civil society and the domestic sphere. The femme fatale's characteristic ability to blur the boundaries between work and sex places this larger theme in the foreground, but this theme is explored just as frequently through familial and homosocial bonds. The lack of a strong (or strongly individualized) female character nevertheless deserves attention. The screenwriters of *Shaft* probably imagined that they were actually doing a bit better on sexuality than the action/adventure genre demanded, and with some justification. While most violent action films of the late sixties either present only random sex or radically exclude sexuality from the hero's life, *Shaft*, at least, appears to create a steady relationship that exists within the bounds of middle-class morality. Shaft and Ellie talk on the phone, he has keys to her apartment, he seems to rely on her when things go wrong, they each have photographs of the other prominently displayed. (Her photograph of him is much bigger than his of her, but what can you do.) Nor does it seem right to take Shaft's tryst with a white woman as compromising the relationship. However distasteful it may seem, this one-night love affair remains well within the confines of a "progressive," *Playboy*-derived sexuality that accepts mild promiscuity within a largely monogamous frame. This sequence surely does objectify Linda, the white woman; nevertheless, she does at least get to fight back in a playful way, criticizing Shaft's treatment of her, calling him "shitty" several times, and refusing to close the door behind her after she has been shuffled out. In depicting Ellie, however, the film should have given us more than just the sex scene. It is enduringly sleazy that *Shaft* should assert the seriousness of the relationship but just show us the bump and grind. In this instance, Isaac Hayes's claim about Shaft in the theme song, "no one understands him but his woman," is not demonstrated in the film. All it would have taken was a single scene, probably, in which Ellie, or the relationship as such, exhibited some kind of particularity. With Hayes's music for "Ellie's Theme," along with the film's usually generous depiction of minor characters, the mechanism for making her into a real character was already in place. Some black action films do provide something more, but too many

simply reveal the T and A. *Shaft* was in the position, as the first mainstream black action film, to raise the stakes of depicting African-American women in typically "male" genres. Sadly, it did not.[31]

When the film does bring extra energy to its use of a conventional or borrowed element, it can pit strength against strength—the power of the new, of the particular, or of black culture against the authority of genre. *Shaft's* qualified adoption of a noirish visual scheme better illustrates the film's complex relation to the genre of film noir. As mentioned, films noir often feature strong contrasts both *within* shots (through high-key lighting and mixture of textures), and *among* them (through a great range of locations and varied mise-en-scène). *Shaft*, too, exhibits this contrastive visual scheme, but also goes a bit further. Because of its generic mixture, the film can create a scheme that pits noir-derived visuals against the softer look of the late sixties and early seventies.[32] This strategy, in fact, constitutes a second-order noir visual scheme: the high degree of contrast between shots that recall film noir and those that do not itself recalls noir's characteristic mixture of contrasting visual styles (even as it presents images that do not belong in film noir). Often, this contrast helps the viewer to recognize the elements of *Shaft* that are derived from film noir, like Shaft's office building and the police station. These elements can be strongly differentiated from those that mark the film as contemporary. Shaft's and Ellie's fashionable, colorful apartments, for example, seem almost anti-noir—again a suggestion that black Americans are *in* the world of the film and not simpy *of* it. More subtly, the film creates this contrast within particular interiors. In several instances, part of a room will be lit to emphasize blacks, whites, and grays, while another part will contain warm earth tones. This division works to separate the old from the new, and, in doing so, underscores the differences among characters. One can observe this contrast in an important bar sequence and in Bumpy's office. In the former, two mobsters, sitting near the bar's front window, are bathed in white light, lending their gray suits and pasty complexions an almost deathly quality. The rest of the bar is dominated by wood and earth tones, not to mention the bohemian dress and ethnic variety of its patrons. The scene in Bumpy's office shows the gray-suited Bumpy on a charcoal couch in front of a gray op-art painting, and places Shaft and Buford under a distinctly yellow fluorescent light that underscores the warm colors of their clothes. In both cases, the contrasting color schemes bring out a central point about the mobsters and Bumpy: the fact that they are throwbacks, out of place in the new New York of the early seventies—they would seem more at home in black and white.[33] This separation is created by other means as well—clothing, physical mannerisms, and, especially, diction—and makes clear that Shaft can move in and out of film noir without becoming part of that world.

Shaft is drawn in part through his incursions into and resistances to film

noir. The construction of Shaft's character with and against the conventions of film noir, action/adventure films in the Bond mode, and violent films of the late sixties and early seventies will be further discussed. The absence of sinister urban locations in *Shaft* provides another subject for dialogue with noir. The film makes a point of showing, generally, great variety among the living conditions of black Americans, and, more specifically, well-kept apartments in badly maintained buildings. The film's depictions of Harlem life serve to clarify the distinction between the conditions that produce economic hardship and the people who must live under such conditions, a distinction often blurred in urban films. Unlike most urban thrillers, black action films tend not to criminalize poverty, even when they glorify wealth. A film like *Shaft* can thereby argue against the stereotyped depictions of African Americans in films while remaining within the frame of the action/adventure genre. Many of the film's departures from noir run in this direction. Produced not only with an appreciation of classic noir's (white) protagonists, but also with an understanding of how these films depict *black* culture, *Shaft* works to demystify "the ghetto" (as I have suggested), and to denaturalize those aspects of black culture that have been taken as natural.[34]

Some elements of noir are present in *Shaft* and other black action films, but divested of their negative moral connotations: poverty, the city, black culture, racial mixing, ornate decor, fancy dress, and visual framing devices. Other elements, more or less morally neutral in classic noir—like promptness, multicontextuality, friendliness, verbal wit, and purchasing power—are invested with positive ethical meanings. *Shaft*'s treatment of its hero's multicontextuality allows for an interesting comparison with film noir. In noir, a protagonist's friendship with minor characters merely provides another way of depicting his isolation. If these characters are minorities, homosexuals, elderly women, children, or disabled people, there is often the ugly suggestion that the hero cannot maintain relations with "normal" people—as in *Kiss Me Deadly* (1955)—or that he possesses noble qualities that only the mysterious moral perceptiveness of these "others" can detect—as with the deaf-mute teenager in *Out of the Past* (1947). This treatment of multicontextuality carries over into mainstream cinema of the fifties and beyond. (In most white action or horror films, if you are a person of color and the lead character befriends you, you had better start making out your will.) In *Shaft*, however, these friendships come with no strings attached. Partly because the film places its hero in competition with figures in *other films*, it defines and develops him by continually increasing his possibilities for action rather than narrowing them as the plot unfolds. Shaft therefore possesses a greater degree of openness and exuberance than do his white counterparts: he need not shut himself off from any segment of society or aspect of life.[35]

The codes of film noir give Shaft a way to compete with white heroes and provide the film with the means for distancing itself from glossier

action/adventure films. At the same time, *Shaft*'s departures from noir reveal that it will challenge these codes as well. Many black action films work in precisely this way, adopting a mode of critique that requires an acknowledgment of the generic frame in order to become intelligible. Such a mode reminds us that films must converse with other films at the same time as they speak to social issues. This kind of revision shows itself less clearly than does outright subversion. Film criticism tends to operate according to a distinction between genre films that are primary, or commercial, and those that are secondary, or critical.[36] As a result, the conventions of a genre represent unfreedom, and subversion of these conventions equals freedom. A whole range of responses and approaches can work to transform a genre, however, and subversion is but one such mode. Moreover, overtly subversive films can actually become parasitic upon a genre by (1) picturing its conventions as more hardened than they are; (2) making the work of revision seem to belong exclusively to the process of subversion; and (3) refusing to acknowledge the metaconventions of subversion and *their* degree of fixity: sad endings, failures, dead ends, oblique narrative moves, vague characterizations and responses of characters to events, evaded climaxes, caricature, explanatory titles at a film's end, sequences of which the reality remains deliberately unclear, destabilizing repetitions, defamiliarization of sound and lighting. The valorization of subversion as such begs questions that the work of revision ought to confront: Whence does the film's energy derive—from the conventions subverted, or from those observed? Do we truly need to be told that a genre's conventions are unreal?[37]

African-American culture often refuses to make this division so cut-and-dried: thinking of the detective genre, for example, would a novel like Chester Himes's *Blind Man With a Pistol* be primary or secondary? Like Himes's novels, the black action films effect transformation not by subversion but by a revisionary process that brings black culture to bear on a genre's conventions.[38] This process begins simply, with the very fact of African-American characters.[39] Himes, in a interview given in 1969, even exaggerates the extent of his borrowing from white detective story writers in order to make a stronger point about both the detective genre and black generic transformations:

> I was just imitating all the other American detective story writers, other than the fact that I introduced various new angles which were my own. But on the whole, I mean the detective story in the plain narrative form—straightforward violence—is an American product. So I haven't created anything whatsoever; I just made the faces black, that's all.

Here, Himes downplays the values of innovation and subversion in order to emphasize his decision to write in an existing genre (one that tells a truth about American culture), rather than create a new genre or attempt to tran-

scend genre. Later in the interview, he argues that genres can function as tools in political struggle—that competition between examples of a genre, and between genres, performs valuable political work:

> I remember Sartre made a statement which was recorded in the French press (I never had any use for Sartre since) that in writing his play *The Respectful Prostitute* he recognized the fact that a black man could not assault a white person in America. That's the reason I began writing the detective stories. I wanted to introduce the idea of violence. After all, America lives by violence, and violence achieves—regardless of what anyone says, regardless of the distaste of the white community—its own ends.[40]

In Himes's rather arch admission of his debts, he confesses to doing nothing more than slotting black characters into traditionally white roles. (What's so great about the detective novel, he seems to ask, that I should want to have created it? He would rather be understood as raising its thematic stakes and increasing its literary value.) His reference to Sartre reveals that the detective genre provides a way for him to arm his black characters in a fight against racism—both Sartre's sophisticated paternalism and other, more overt forms. Two struggles are thereby connected, one aesthetic (derived from his taking Sartre's line partly as a literary challenge), and one political (his attempt to expose the violence contained in and by American civilization).

Himes realizes as well that the process of "ma[king] the faces black" entails more than the simple presence of black characters. It opens up the novel or the film to the revisionary power of black culture as a whole. While this process does not leave African-American culture as it is—without the need for a critique from within—it can still force a genre's conventions to compete with other determinants of themes, settings, and characters.

IDENTITY, EFFORT, AND EVALUATION

A film's identity comes from its placement within a particular genre, and a character's identity derives from the conventions of that genre. We have already seen that a film's generic identity cannot fully describe it, and that a character's identity serves in part as a stable backdrop against which deviations, transformations, and superfluities can be measured. That which exceeds an identity requires effort and demands evaluation. The effort shows in the African-American director's battles against institutional pressures of various sorts—not only in getting an opportunity to direct and in creating opportunities for other African Americans behind the camera, but in the use of skills and techniques drawn from other areas, and in the quest for depth, balance, and realism in a genre not noted for these qualities.[41]

More importantly, the films thematize work, effort, efficiency, value, and evaluation.

Shaft contains much dialogue about money and other modes of valuation, as well as many kinds of work and many forms of efficiency. The films use realistic exchanges and pieces of business for antirealistic ends.[42] A human activity like bribery was probably brought into cinema as a realistic element, necessary to showing a life that was new to the screen. In *Shaft* and some films noir, however, it becomes a means for creating a genre-bound world with its own rules and institutions. In this world, bribery is something you do several times a day, like brushing your teeth. There is enough bribery in *Shaft* to give a viewer the sense that human relationships can be adequately expressed through a variety of bribes, just as a filmmaker, novelist, or philosopher might express this complexity through other forms of exchange, like arguments, promises, performances, sales, sexual encounters, and so on. Shaft delivers five bribes in the film, all different in style. First, while Shaft is getting a shine, the proprietor tells him that some uptown hoods have been looking for him. As the proprietor describes these hoods, Shaft folds two crisp tens into his newspaper. He performs this operation absentmindedly, almost as if he is so concerned with who is looking for him that he does not realize what his hands are doing. As he steps down from the chair, Shaft hands the proprietor his newspaper with the bills folded into it. Neither mentions the bribe directly, but they do joke about money and the good life as Shaft is leaving. Second, searching for his old friend Ben Buford, Shaft encounters Bunky, a small-time hood played by brilliant character actor Antonio Fargas. Shaft asks him whether he has seen Ben:

Bunky: *Ben*? Ben who?
Shaft: Ben *Buford*! You know who I mean, man.
Bunky: Hey, man, I don't know no "Ben Buford."
Shaft: [*holds out a grubby twenty*] Twenty.
Bunky: Oh-ho-ho . . . *that* Ben Buford.

Third, as he approaches Buford's apartment building, Shaft sees a young boy shivering on the stoop of a neighboring building. Shaft tells the boy that he looks cold, hands him a single, and asks him to go get something to eat. Is this actually a bribe? Shaft's concern for the boy may extend to the boy's safety should a gun battle break out, and this concern may be mixed with Shaft's wish to avoid being seen entering the building. This exchange, then, would seem to represent some mixture of explicit charity and unspoken concern, perhaps combined with motives of self-interest. Fourth, in order to escape from a detachment of mafia hitmen, Shaft and Ben break down the door of an apartment in Ben's building. Once the danger has passed, Shaft says to the middle-aged woman living there, "Everything's OK, ma'am. No need to worry. Sorry about your door. That'll cover it," as he holds out a ten. Fifth,

when Shaft arrives at his neighborhood bar, he recognizes two mobsters staking out his apartment from the bar's front window. He realizes that he can go undetected by posing as the help. After Shaft and the gay bartender commiserate about two women in the establishment, Shaft asks if he might tend bar for a few minutes. He apparently offers the bartender a twenty, since the bartender replies, with correct gay wit, "There's nothing I wouldn't do for twenty dollars." The bartender shows a kind of class or grace in drawing attention to the payoff, in letting Shaft know that he does not mind being bribed, and that neither of them ought to be embarrassed. As Shaft turns to put on the bartender's apron, the bartender pinches his butt, completing the exchange.

This series of bribes admirably displays Shaft's multicontextuality, and, in doing so, shows as well the richness of possibility in a conventional activity not known for its variety. Such an elevated role for bribery requires that the film depict it as a legitimate human institution and not as a circumvention of legitimate institutions. Since the presence of money thereby becomes second nature in human relationships, does this make all relationships purely instrumental? Not necessarily, as the performances in these scenes work to suggest. One must still ask, however, what kind of a world it is in which bribery and other cash-money interventions become second nature. A specific importance attaches to money as such in the film, another element derived from noir. In these bribes and elsewhere, money functions as an expressive object. After tearfully repeating his request that Shaft rescue his daughter, Bumpy reaches into his breast pocket and slowly draws out, first, an envelope of money, and next, a handkerchief. The envelope, produced at the moment when words have reached their limit, seems thereby to express the emotion that language cannot communicate. Later, when Shaft realizes that Bumpy has played him for a sucker, he bears no grudge but demands more money to complete the job. Bumpy reminds him that they have made a deal. "Not at these prices," Shaft replies, slamming the envelope of money on Bumpy's desk. In real life, all U.S. currency is commensurable—Shaft could have *kept* the first outlay of cash and asked for *additional* money; he would not have had to give back the first envelope and ask for *different* money.

In black action films, however, the physical cash is the crucial thing, and rightly so: most of these films, like their film noir precursors, do not show the private detective spending his money, only receiving and possessing it. A host of black action films—both noir-derived and not—devote whole scenes to the depiction of money. *The Mack* (1973) provides a good example, with its frequent images of money changing hands, particularly on the gambling tables, and its pivotal early scene in which Goldy, the lead character, fantasizes a shower of paper money. Scenes like this lend money a symbolic charge, but also suggest its inadequacy as a practical key to happiness;

when a film tells us how the big money will be used—to escape the life of the drug dealer (*Superfly* [1977]), to start a black bank (*Cool Breeze* [1972]), to provide for the poor (*Thomasine and Bushrod* [1974])—there is no problem; when a character treats money as the means for *achieving* "the life," however, its symbolic power is shown to be masking its insufficiency. This unmasking occurs not only in *The Mack* but also in other films that come out of the thirties gangster tradition, *Black Caesar* (1973) in particular.[43]

Shaft follows the classic noirs in making money a crucial part of the texture, partly because it serves as a mode of evaluation and helps to place emphasis on questions of value. The scene in which Shaft trades in his original money for new money can be instructive. As part of the restructured contract, Ben, whose militia has been retained for the job, asks Bumpy for $10,000 a man, since "that's what the honky government pays a man in the army for insurance." Shaft immediately says, "If he's worth ten, I'm worth twenty." When Bumpy pays them up front and demands results for his money, Shaft reminds him of his statement that money didn't matter in comparison with his daughter's safety. Bumpy replies, with his perfect diction, "Money always matters." Placing a dollar sign on a person seems crude, but it ought not to imply that people have a merely instrumental value. Rather than subsume people under money, these films use money as an obvious way of calling attention to the evaluation of people. The clarity and generality of money as a mode of valuation also draw attention to the *competitive mode's very tenacity*, its extension into every area of life. Thus the competition among characters in a film connects with the competition across films in its genre and in related genres. Shaft's status as a "black" action hero and the movie's status as a "black" action film will have many viewers immediately making comparisons along racial lines, comparisons that do not leap to the fore in connection with most "white" films and their heroes. Such comparisons will not only cover the obvious things—the strength of the fight scenes, the inventiveness of the other action sequences—but also the charm of locations and minor characters, the distinctiveness of the visuals, the stylishness of the clothes, the hipness of the music. Although Shaft's toughness will be registered against that of other action/adventure heroes, he will also be evaluated for his class, his cool, his degree of style, against both his European-American contemporaries and his African-American ones, Sidney Poitier in particular.[44]

Viewers will likely sense as well the definite political weight that attaches to the depiction of African Americans receiving equal pay for equal work. The strong presence of money serves thereby to establish the possibility of an antiracist critique, all the more because *Shaft*'s convention are clear and well known. One might say, yes, the movie is escapist fare, and yes, Shaft is mostly a collection of stereotypes, but both the film as a whole and the character in particular can frame these conventions and stereotypes as part of a

job. Like the classic noirs, *Shaft* challenges its detective with the humdrum as well as the life-threatening. Shaft's handling of ordinary activities can constitute his beating the white cops at their own game. It is significant that he gets to work early, stays on schedule and knows how to manage his "workforce," and is often seen waking up the other characters—he's already on the job while everybody else is still in bed. Shaft's expertise in working the phones plays at least as great a role in the film as his pounding the pavement. As in Chester Himes's "Harlem domestic" novels, the fact of a black detective cannot be seen to require compromises: it would be giving in too easily to suggest that Shaft's particular strengths come at the expense of his ability to live in "mainstream" society.[45] Within the context of the urban film, a viewer should *expect* that an African-American character will play by his own set of rules, and that the film will hardly give this personal code a positive spin. It becomes more progressive to make Shaft a professional than it does to make him a radical, precisely because his professionalism subverts this expectation.[46] The orbit of professionalism—doing what you say you can do, doing what you have been paid to do—brings us closer to James Bond films than to the more violent action movies of the sixties. Black action films like *Shaft* swerve away from Bond, however, not only by depicting the details of payment, but also by emphasizing the effort involved in handling minor difficulties. Shaft's trouble getting a cab, to take an obvious example, displays a well-known part of the African-American urban condition that would have no place in the world of Bond.[47] Against the backdrop of institutional racism, professionalism becomes unexpected, and therefore more self-conscious.[48] Even Shaft's appearance is shown to demand effort. While he is getting a shoeshine, he is told that one of his shoes has a scuff. He looks down at the shoe and curses under his breath. Not only does this little sequence show the work of looking good, it calls attention to a detail that the viewer cannot see, thereby foregrounding the effort required in areas where work goes unnoticed.[49]

Why so much concern for appearance? Black action films suggest that the performance of everyday acts with style has political consequences. The flip side, however, is that explicitly political words and acts cannot be privileged, nor can they be understood independent of the nuances of performance. The bottom line can be expressed as follows: if a political act succeeds in the black action film, it is because the characters look good doing it. If the characters act all tired, with no style, they will fail. Political speculation requires that some kind of aesthetic integrity be put up as collateral. "Looking good," however, is neither a static nor a one-sided notion: there are many forms of currency acceptable for looking good, and the films constantly try to tender new forms. Ben Buford's militants are introduced as chumps, for example, sitting around in a shabby one-room, overpowered first by a poster of Malcolm X and then by the mafia's hit squad.[50] It is only

once they start tailing Shaft and the mobster, and we see them walking in formation (to the accompaniment of one of Hayes's best cues), that the film encourages us to think that their way of life and mode of organization can get things done.

These shifts in depiction refute the claim that protagonists like Shaft do not undergo any significant change over the course of a film—that they do not seem to grow as people. This is a familiar strain in criticism of "genre films," but it contains an insight specific to movies like *Shaft*, *Superfly*, and others. First, it should be remembered that the vast majority of black action films, like most film genres, do not operate according to models of the *Bildungsroman* or of tragic drama. The progress toward adulthood or toward a recognition of human finitude cannot function in movies characterized by a more discursive style that finds meaning wherever it can instead of moving towards transcendence. They abandon the linear model of transcendence only with difficulty, however, and the appropriateness of the charge made against the supposed stasis or flatness of characters like Shaft, *Superfly*'s Priest, and Goldy in *The Mack* comes from the way that these characters *hint at the possibility* of development. The characters of black action films—private dicks, pimps, pushers, as well as nurses—think and talk about their lives a great deal. The self-consciousness of the characters, taken with the inexorable progress of the plot (whatever the narrative style), can make one think that they want desperately to change themselves or the people around them. It is not, therefore, a choice of one model of character development over another, made once and for all; it is a conversation among several modes. Character development becomes, ultimately, more like what we call "development" in music: material is introduced and then placed in a variety of contexts, made to serve varied purposes. This notion of character, as changing—in our eyes—through the performances of everyday activities as much as through transformative events, effects a corresponding shift that balances the importance of the plot and of the action as such.

The idea of a character's changing his tone as he moves from one context to another may not sound surprising, but it helps to differentiate Shaft from both "ethnic" bit parts and white lead characters. The mere fact that Shaft buys things and has relaxed exchanges with blacks and whites goes against the usual cinematic depictions of African Americans.[51] Steve McQueen's purchase of a newspaper in *Bullitt* carries no weight in determining his character. When Shaft purchases one, however, and the transaction runs smoothly, a point has been made about his character and about the film's depictive mode: his character works against previous depictions of African Americans in mainstream films, and the ordinary activities through which he performs this work function structurally as a contrast to his more spectacular activities. Sidney Poitier, whose roles have often required him to adopt a particular form of dignity wherein a single mode of speech and car-

riage holds for an entire film, displays innner complexity but not this degree of outward variety. Unlike late-sixties heroes, who often remain more or less static, Shaft speaks and moves differently in different contexts, an approach one might associate more with comic actors.[52] The various characterizations of James Bond rely heavily on Cary Grant's performances for Hitchcock, but they downplay Grant's comic breadth in favor of his suavity.[53] By taking the best of the exaggerated gestural repertoire expected of "ethnic" types and combining it with the restraint that the private detective demands, Roundtree can have it both ways. This combination and similar ones occur frequently in these films, with results that are not always harmonious, but often interesting: a stentorian voice is put in service of the most vulgar material, or a set of physical and vocal mannerisms, commonly used to represent a stereotype, is suddenly called upon to convey the complexity of a lead character.

Conscious attention within the film to the construction of identity can provide an aid to critical discussions of this issue. The variety and contestability of the means of evaluation leave a space for *individuality* without buying into the regulatory mechanisms of *individualism*.[54] The contradictions and superfluities in the characters have helped to make black action films a problem for criticism. The critical literature on these films sometimes espouses a particular view of African-American identity and opposes it to one that a given film is said to embody. Often, however, the films in question themselves contain oppositions of this sort in the constructions of characters and in the conflicts among them. What is demonstrated by the influence of these films is that they attempt to *transform* black culture and black identity as they grapple with community and institutional pressures. Rather than endorse one stable identity, these films enact the conflicts among competing notions of identity—the same conflicts as are worked through in the critical literature. These movies demonstrate what Henry Louis Gates and others have argued: that there is no finished, stable black identity or black experience that can be tapped into for the purposes of cultural representations. In the black action film, identity—of both persons and groups—is radically under construction, and it demands a strong degree of internal difference in order to constitute itself as a whole. The characters in virtually every black action film put forth claims about identity—that it is either biologically determined or constructed, or that it inheres more in either an individual or a collective. These claims come in many forms, from formal lectures to nonverbal jokes. It is interesting to note the frequency with which characters' identity claims are challenged in these films: "You're not so black"; "Don't call me 'Brother.'" That these conflicts take place, and that the participants show great commitment to them, becomes more important than any final determination.[55] The conflicts among characters (and internal conflicts) are

expressed within the films's often volatile generic mixtures. Each of the genres a film makes use of may begin to pull the film in a different direction. Put another way: the film can seem to take on a varied, sometimes conflicting set of responsibilities.

THE AUTHORITY OF GENRE

If generic mixture becomes indispensable to the creation of characters and to the construction of films as a whole, what can the films then be said to *owe* the genres from which they borrow? To the extent that a film accepts responsibility for its borrowings, it shows respect for a form of authority which is not backed up by power. The ethical ground of *unenforceable authority* becomes a way that the black action film can distinguish itself from both the sixties action/adventure film and the film noir. In order to begin to understand this form of authority, it will be helpful to look again at the "Theme from Shaft," specifically at a well-remembered exchange between Hayes and his backup singers. This exchange runs as follows:

> *Hayes:* "They say that cat Shaft is a bad mother——"
> *Backup singers:* "Shut your mouth!"
> *Hayes:* "I'm talking about Shaft . . ."
> *Backup singers:* ". . . then we can dig it."

The song generates complexity, here, by making a scheme into a trope. The joke of this moment comes from taking a conventional arrangement scheme—solo male lead singer plus multiple female backing singers—and teasing out its implications, including those of gender and class. Why is this moment funny? We do not really expect the relation of the lead singer to the background singers to be dialogic. Yes, the convention of call and response involves a kind of interaction between the lead singers and the backup singers. (It is this more conventionalized call and response that we hear when Hayes asks, earlier, "Who's the black private dick that's a sex machine to all the chicks?" and the backing singers "answer" with the main vocal hook—"Shaft.") Normally, however, there isn't any real problem—the song doesn't break down, the singers don't get into fights. When the backup singers say ". . . then we can dig it," the joke hinges on our hearing this exclamation as a real change of mind: the singers have already acknowledged a convention—that one does not curse in a public forum—and they make a rational decision to let Hayes defy that convention, even if this decision comes too late.

This negotiation over the use of a convention performs in an obvious way what other aspects of the song—and the movie as well—perform in more subtle ways. This funny scene presupposes and helps to realize an active conversation among the musicians, thereby providing the film with a

model for conversation as such. Here, a musical convention—that of call and response—is given an ethical dimension through association with a social convention. One could easily imagine something like this dialogue occuring between Hayes and the executive producer. The executive producer might argue as follows: "You can't say 'motherfucker' in the song— we won't get any airplay," to which Hayes would reply, "But I'm talking about Shaft—don't you understand that the old rules just won't apply anymore?" As a discussion that could have taken place at an earlier stage of production, this exchange between the singers presents the negotiation *within* the texture of the song, making contestation part of the song itself. In the song, however, Hayes does not get reprimanded by some studio or record company boss who holds power over him: it is his female background singers who call him out. They should not have the right to speak like this, according to the conventions of this arrangement scheme—after all, they are backup singers, wage slaves. A similar class conflict arises when James Brown asks his band members "Can I scream?" You might want to respond "Sure, I guess so, it's your band, why are you asking me? And why do you even want to ask permission to do something that's supposed to lie *outside* of a life of permissions and negotiations?" (Although this line of questioning might lead Brown to suggest that it's time you started your *own* band.)

Because the background singers adopt a motherly tone when they tell Hayes to shut his mouth, they take on a special kind of authority. They hint that there is something ethically higher than the lead singer, some mode of authority that momentarily transcends the background singers' status as hired hands.[56] What kind of authority is this? It is (1) unexpected, despite being (2) somehow *familiar*, partly because of the motherly tone but also because (3) it fits within the generic frame. Most important, it is (4) unenforceable—not backed by power. The conjunction of (3) and (4) here shows the authority of genre in its best form: it suggests the possibility of a just authority separable from power.[57] We can understand *Shaft*'s borrowings from film noir in the same light. No studio boss, desiring a moneymaker, and no audience member, expecting a good action movie, would have entered a screening of the film demanding that the worn-out conventions of a dead genre like noir be faithfully observed. *Shaft* does what it must, by fulfilling the requirements of the action film, but it takes on an additional set of responsibilities once it can be seen as drawing on the generic repertoire of noir. To the extent that the movie takes on and fulfills its responsibilities to film noir, it does so out of respect for the genre, and not because of obligations built into its institutional frame. The acceptance of extra responsibility and the respect for a dead genre's conventions helps the film to create a distinction between authority and power.

This distinction becomes apparent when one compares the depictions of authority in classic noir, the Bond series, and *Shaft*. In film noir, authority is

pervasive; it seeps into every aspect of the movie—characters, objects, institutions, and the cities in which they are set—and works to enforce the solitariness of the hero. The James Bond movies and other spy films, on the other hand, picture authority as grounding the hero's activity, "authorizing" him to do what he wants, even providing the famous "license to kill." In noir (and violent films of the sixties), authority is simply a subset of power, while Bond backs the traditional models of territorial, governmental, and military authority it depicts with unlimited resources of power. When these two genres come together in *Shaft*, however, you lose the power of both a hostile authority working against the hero's interests, and a stable authority that gives purpose to the hero and keeps him from harm. Shaft's freedom, unlike that of James Bond, is not freedom of movement, freedom from want, freedom to act: it is the more difficult freedom to accept or reject the claims that people make upon him. Unlike Bond, Shaft does not embody the highest law of the world he inhabits; and if he does act out of obligation, it is because he willingly submits to the claims of others—as people, and not as bearers of institutional power. This distinction—between the thick conception of the self engaged by loyalty or friendship and the thin identity required by obligation—becomes visible in Shaft's relation with police lieutenant Androzzi. Some critics have wondered at the friendship between these two, wishing for a more aggressive stance toward the police, while others have taken this friendship as purely cynical or instrumental. Attentive viewing shows, however, that the friendship is genuine, but that Shaft turns it off like a light as soon as Androzzi seeks to frame their relationship as that of cop to stoolie, to place Shaft in the role of the "pigeon of color." Not only would such a placement work against Shaft's status in the film, it would constitute an unwelcome return to a tired crime-film stereotype that provided one of the few points of entry for black characters in the bad old days.

The emphasis on loyalty and friendship over obligation is paralleled by the emphasis on authority over power. This latter emphasis is first suggested by Shaft's jaywalking during the credit sequence. As mentioned earlier, we see Shaft cursing at a driver, and then performing a modified "J" along the double yellow lines of a two-way street. Jaywalking provides a perfect example of a form of authority without power. To the extent that a jaywalker challenges a moving vehicle, he or she does so through pure attitude with no physical or legal power behind it. It is important to note that the conflict between cars and pedestrians in urban centers was very much an issue at the beginning of the seventies, and that the media's discussion of this issue centered on midtown Manhattan. This was the only period in which the banning of cars in urban centers was seriously discussed. New York's city council and Mayor John Lindsay established several programs in late 1969 and early 1970 which sought to restrict traffic in areas of high pedestrian density, and experimented with banning autos in midtown on selected days. The

business interests in the city vigorously opposed these programs, most of which lasted for only a little over a year. These programs and the responses to them encouraged the press to speculate on the rights and the pleasures of urban pedestrians, and generated a lot of soul-searching about jaywalking. In typical fashion, the *New York Times* questioned a sociologist on the root causes of jaywalking. The sociologist suggested—guess what—that people who live in New York lead busy, stressful lives and sometimes run late for appointments.[58] In this charged context, Shaft's jaywalking presents a curious conjunction of Black Power and pedestrian authority. Without an understanding of this context, it might be tempting to see his jaywalking as a noir-derived intimation that he is beset by hostile powers on all sides, and that every step he takes is outside of the law. In fact, Shaft's jaywalking reveals him as a more or less well-adjusted subject who possesses himself securely enough to operate in the vague area between authority and power.[59] It is more a sign of health than of sickness, a suggestion of possibility rather than an image of dessication. These small or mild forms of authority suffuse the film, loosening the grip of institutional power and helping to naturalize the impossible acts of heroism that the action/adventure genre requires. Along with jaywalking and other forms of nonverbal urban knowledge, *Shaft* presents many forms of authority that are separable from power. One might notice, for example, that *Shaft*'s minor characters give orders with a strange sense of confidence. They point their fingers and (like Hayes's backup singers) speak with the strength of mothers or respected elders, as if to claim in authority what they lack in physical or institutional power. By contrast, those characters with the power to back up their orders—cops, armed mobsters—deliver them without style and without effect.

The black action film depicts authority as grounded in loyalty, respect, pride, expertise, and effort. The disposition to act according to authority comes from within the character himself: unlike obligation, which is rule-governed and clear-cut, loyalty is "motivated by the entire personality of the agent."[60] Midway through the film, Shaft accompanies one of the mafiosi to the room where Bumpy's daughter is being held so he can assure Bumpy that she has not been harmed. When Shaft takes one mobster hostage and attempts to trade him for Bumpy's daughter, the mobster explains that his colleagues would sooner shoot one of their own than release their captive. Despite his characterization as one who has seen it all, Shaft is taken aback by the mobsters' willingness to kill each other. At the same time, he seems to recognize the operation of a strict code of honor. The hostage, for his part, appears to respect Shaft's indignation, and almost takes pride in explaining a conflicting system of loyalty to one whose "loyalty to loyalty" can be counted on.[61] "You trying to tell me they'd blow you away to get me?" Shaft asks his hostage. "That's right," he replies, while the

man with the gun nods grimly. This exchange provides a moment of shared humanity that the narrative structure demands before the hostage is killed: when Shaft decides to test the mobsters' pledge, his hostage is quickly shot dead, and Shaft is seriously wounded, beaten, and kept alive only because he must deliver word to Bumpy. The black action film creatively misreads the film noir to place authority, respect, honor, loyalty, and revenge over the mechanisms of power, obligation, blame, and legal responsibility. In the less tractable realms of authority and loyalty, simple conflicts can take on a complex dimensionality. So, too, does following a genre's rules become a more problematical affair than one might at first suppose.

BLACK ACTION FILMS AS GENRE

The idea of a borrowed genre as bearing an unenforceable authority that nevertheless seems to command respect, coupled with the understanding of a home genre as but a partial determinant of a film's contents, can suggest a conception of genre more nuanced than most of its rival conceptions. Instead of saying, for instance, that the pleasure of genre consists either in the familiarity of observed conventions or in the novelty of unobserved or subverted conventions—in the comfort of following rules or in the thrill of breaking them—one might acknowledge the importance of both observance and nonobservance, both tradition and revision, in the formation and continuity of a genre.[62] The observance of a *borrowed* genre's conventions, too, can influence a conception of genre that wishes to do justice to the interdependence of freedom and constraint.

The rules that can be compiled for a genre cannot fully describe it, nor can the placement of a film within a certain genre, for purposes of the market, tell you everything about that film. The action movie, in particular, raises the question of what a given film should contain. Unlike Westerns, war movies, science fiction films, costume dramas, and even films noir, action films cannot be established through their settings. Nor are their narrative structures determinate enough to provide them with an overall shape. All that the genre demands of the narrative, at bottom, is a place and role for the action sequences. Since an action film cannot consist entirely of fight scenes, escapes, and car chases, it leaves a certain amount of space for contingent elements. We cannot really know when, how, and to what extent the repetition of those elements—say, fancy clothes and good soundtracks, in black action films—changes them from wants into needs. It seems, at least, to be a dialectical process by which superfluous elements become necessary while still bearing an ineradicable trace of their origin as ornament. It does remain useful to preserve the notion of genre as a set of rules and constitutive features, particularly if diachronic transformation is allowed to play a prominent role; but the major film and musical genres of the seventies can often be better

defined with reference to their internal variety and proliferation of subgenres, their modes of revision and transformation, and their movement toward other genres. It is not only that cultural productions of the seventies tend to depart from these rules and conventions, it is more that they often picture them as, variously, all-but-arbitrary, irrelevant to the real issues, or simply quaint.

It becomes difficult to define what constitutes a film genre, since feature films all have the same outward form. It would be more precise, but perhaps less interesting, to speak of genre only when comparing feature films to television serials, shorts, documentaries, music videos, home movies, and so on, and to treat film genres as modes. As long as we realize that the concept of genre must remain flexible, we shouldn't have problems. We can still remember that film genres are defined in a heterogeneous variety of ways. In addition to more traditional modes of definition, a film genre can be defined by the amount and nature of the violence or sex it contains, by the size of its budget, by its place or conditions of origin, sometimes partly by its MPAA rating. This flexible kind of definition results in a large number of quasi-genres whose status must be determined on a case-by-case basis: the summer blockbuster, the art film, the independent.[63] According to this conception of genre, an individual genre may cross, overlap, or encompass other genres. Indeed, the best reference work on black action films correctly includes a vast number of films that might also be classed as Westerns, horror films, mysteries, suspense films, police procedurals, martial arts films, romances, historical epics, coming-of-age dramas, satires, comedies, and children's films.[64] Put crudely, a genre is always a metagenre: it is not only a set of constitutive features—big guns, wah-wah pedals, and funky hats—but it proposes a dynamic system of genres and a way of moving around within this system. A genre designs the generic space and determines its inhabitants. It must place itself within this space, not necessarily at the center, and establish possibilities of movement. (Just as a genre requires observance and nonobservance of conventions, so too does it need to establish an inside and an outside.) Crucially, a genre also determines the role and limits of an individual example in redrawing this map as it goes along. A genre pictures cultural space according to its own needs, but it must do so in contestation with forces from within and without.

Focus on the black action film can help to bring out a largely unarticulated hierarchy of film genres and an unexamined goal of transcending genre.[65] The critical histories of African-American cinema since the sixties have often opposed films like *Sounder* (1972) and *Cooley High* (1975) to black action films, partly on the grounds that they are less determined by cinematic conventions and therefore are more realistic, truer to (black) experience. *Sounder*, *Cooley High*, and most of the other films singled out in this way are family dramas or coming-of-age narratives, and usually period pieces.

These genres are as loaded with convention as any, and their apppearance of realism and universality is part of a rhetorical stance—it need not be taken literally. Lindsay Patterson, who edited the first collection of essays on African-American cinema, comes down hard on the action films but finds almost equal fault with *Sounder* and its reception. Speaking from his background in the lowlands of Louisiana, where the film takes place, Patterson takes exception to the film's naturalistic treatment of a sharecropper's and his wife's efforts to obtain food for their children, precisely because it is false to the region the film so lovingly depicts. His review brings out the larger point that those cinematic elements that are coded as realistic—in the acting, the script, the direction, and the mise-en-scène—entail departures from reality as it was lived in Depression-era Louisiana.[66] Whether or not one is bothered in principle by these departures, one at least ought to acknowledge them as *part of* cinematic realism—departures from *reality* do not constitute departures from the conventions of *realism*. Most critics have said that black action films did not go far enough in their depictions of black urban life, that they fell back too easily on the conventions of action movies. Part of the strength of these films, however, is that they exhibit a connection between the use of realistic elements and the adherence to fictive conventions. With this connection in mind, one can question the veracity of more realistic genres and refuse to place these genres above those that are more explicitly fictive. Ishmael Reed's novels show that unexamined hierarchies of genres should be questioned, and that all genres contain compromises and untruths. One can see, more positively, that the tension between arbitrariness and inherent rightness in a genre's grounding conventions can be a productive tension. The greatest danger, as Reed has shown, lies in those genres that seem (1) universal, (2) real, honest, or direct, or (3) stable or adequate. There can be larger returns in those genres, like the black action films, that seem to require addition, revision, and subversion.

The tragedy of the blaxploitation era and its demise is not so much that the people involved in making these films were forced to work under formidable constraints of time, money, and genre, but that they could not then further their artistic development under constraints that were, at least, different, if not less strict. Many of their contemporaries in "white exploitation" received opportunities to work in other genres—Martin Scorcese, Brian DePalma, Francis Ford Coppola, and David Cronenberg among them. The directors, actors, screenwriters, cinematographers, and composers who worked on the black action films understood the conflicting expectations of the studios that hired them and of the communities that were their intended audience. They knew, also, that this might be the only work they would get. Blaxploitation became the fixed star around which all black American cinema in the seventies was forced to revolve (unlike "white exploitation"

in mainstream cinema). As a result, their work loads the action film with such aesthetic, social, and political ambition as to make this genre an ideal test case for how genres work in the seventies—not despite but precisely because of the demands placed on it from within and without. The doubts of the makers, the challenge of African-American critics, and the protests of the black community actually strengthen these films. Despite the clearly fictive nature of the settings, plots, and characters of black action films, their producers and audiences refuse to accept the films' status as mere entertainment. They do not attempt to transcend the constraints of the action genre, but they take the genre's indeterminate aspects as providing an opportunity for additional strands to be woven into a film's texture. The films can help us to ask whether any genre, mode, medium—or social space—is *inherently* well suited to articulate the needs of a culture. They, better than realistic genres and genres whose conventions are unacknowledged, help us to remember that no one genre can embody everything positive about life.

As the idea of identity as a "contingent artifice" becomes increasingly useful, so-called genre films, and black action movies in particular, can provide excellent material to study. They *begin* with the notion of identity as artifice and create a space for resistances to the demands of identity, whether that identity be imposed from above or created from below. Identity, like the conventions of a genre, becomes a source of creative tension. The genre provides both the means of resistance and a more or less stable frame for the appreciation of difference. Black action films should have provided a positive spur to mainstream ("white") cinema, raising the ethical stakes of racialized identity and revealing the constructed character of *every* genre, character, setting, and cinematic economy. At the same time, they should have functioned as a thorn in the side of explicitly political cinema, helping it to question its self-certainties.[67] That they could not do so then does not mean that they cannot do so now. We might yet draw out those strands of the black action films that show the work of developing new identities and the need for questioning existing ones.

NOTES

1. Let me provide a brief synopsis of this film, released by MGM in 1971: John Shaft (Richard Roundtree), a private detective working out of Times Square, is hired by Harlem crime boss Bumpy Jonas (Moses Gunn) to locate Bumpy's daughter. Bumpy suggests that a militant group led by Shaft's old friend Ben Buford (Christopher St. John) may be behind the kidnapping. Shaft doubts their involvement but agrees to track them down. It emerges that the local mafia is responsible for the kidnapping, and that Bumpy—who knew this from the first—simply wanted Buford's group to work with Shaft on a rescue mission. Keeping police lieutenant Vic Androzzi (Charles

Cioffi) at arm's length, Shaft finds Bumpy's daughter, formulates a detailed plan, and rescues her in a climactic final sequence.

2. These practices also provide the means for distinguishing black action films from other violent crime films of the late sixties and early seventies, some of which also borrow from film noir. This varied group would include, among others, *Point Blank, Bullitt, Coogan's Bluff, The Kremlin Letters, Dirty Harry*, and *The French Connection*. For more on the noir revival, see the entries on the above films in Alain Silver and Elizabeth Ward, eds., *Film Noir: An Encyclopedic Reference to the American Style* (Woodstock, N.Y.: Overlook Press, 1979), or, better, Robert Kolker, *A Cinema of Loneliness: Penn, Kubrick, Scorcese, Spielberg, Altman*, 2nd. ed. (New York: Oxford University Press, 1988), 63–66. Neither work discusses the participation of the black films in this revival, probably because of the films' status as blaxploitation—strange, given the low budgets and "B" status of many forties and fifties noirs—which ought not to argue against the self-consciousness necessary to revive a genre. Besides *Shaft*, one could cite a host of early seventies black action films that can be profitably considered in relation to film noir: *Across 110th Street, Black Eye, Black Gunn, Coffy, Come Back Charleston Blue, Cool Breeze, Gordon's War, Hammer, Hickey and Boggs, Hit, Hit Man, Melinda, Shaft's Big Score, Superfly, Trouble Man*, and *Willie Dynamite*. Manthia Diawara discusses more recent black revisions of film noir in "*Noir* by *Noirs*: Towards a New Realism in Black Cinema," *African American Review* 27, 4 (Winter 1993): 525–37. Diawara shrewdly places black crime films of the late eighties and early nineties against the Harlem crime novels of Chester Himes. These novels themselves undertook a full-scale revision of the (white) detective novel and provided the story for two black action films of the seventies, *Cotton Comes to Harlem* (really a precursor, made in 1970) and *Come Back Charleston Blue*. Diawara does not mention any films from the seventies, however, nor the existence of the seventies noir revival—a disservice both to the films of the seventies and to those he focuses on, which borrow extensively from them. It is the realistic aims of these recent crime films that lead Diawara back, past the black action films of the seventies, to classic noir and to Himes, but neither of these ultimate sources is primarily realistic in style.

3. The musical scores for these movies play a crucial role both in the films themselves and in African-American popular music of the time. These soundtracks have often fared well, even in critical literature that treats the black action films dismissively, but the way that they reshape the action genre has not been thoroughly considered. Throughout this paper, I will draw upon the action film soundtracks and other African-American popular music of this period as a heuristic resource.

4. These questions about identity have been explored by William Connolly in *Identity/Difference: Democratic Negotiations of Political Paradox* (Ithaca, N.Y.: Cornell University Press, 1991) and *The Ethos of Pluralization* (Minneapolis: University of Minnesota Press, 1995). Both books have much to offer for theories of genre through Connolly's emphasis on the contingent, relational aspects of identity and through his respect for that which exceeds an identity. Wendy

Brown discusses the structure of politicized identity in "Wounded Attachments," in her *States of Injury: Power and Freedom in Late Modernity* (Princeton, N.J.: Princeton University Press, 1995).

5. The phrase comes from Julie Ellison, who uses it in connection with Margaret Fuller's construction of "her own hybrid form of heroism." She describes it as a process by which "stylistic heterogeneity takes on ethical qualities . . . while it becomes the means of vocalizing autonomous behavior in a complex social frame" (*Delicate Subjects: Romanticism, Gender, and the Ethics of Understanding* [Ithaca, N.Y.: Cornell University Press, 1990], 229).

6. Most of the films avoid subsuming the violence under these cultural refinements, however, lest the films lose their edge. By contrast, the James Bond series follows adventure films in the classic mode by treating the violence as pageantry. This strategy ensures a PG rating, but requires a devotion to glamour that forces many kinds of person and setting out of the picture and effectively precludes a whole range of plot developments. (Bond will never have to go underground, for instance, without money, resources, and the opportunity to shave every few hours. Neither will a film contain long sequences of Bond's recovery or rehabilitation from an ass-whipping.)

7. Ed Guerrero emphasizes similarities over differences in his discussion of the black action films. While Guerrero does not attempt to provide detailed stylistic analysis of these films, he does a good job recreating the critical controversy that surrounded them. See *Framing Blackness: The African American Image in Film* (Philadelphia: Temple University Press, 1994), chap. three, especially pp. 91–96.

8. A typical counterexample from classic noir can be found in *Double Indemnity* (1944). The film is structured as a sequence of flashbacks framed by protagonist Walter Neff's confession to conspiracy and murder, which he speaks into a dictaphone in the film's present. At a certain point in his spoken narrative, Neff (Fred MacMurray) explains that he was forced to make a long walk home in order to avoid being recognized on the bus. In the flashback, however, the actual walk is elided; we see him just as he arrives at his building. This is precisely what one would expect, as the plot requires all the screen time it can get. Indeed, the walking that we do see in film noir tends to be thematic—if not desperate—as in Ray Milland's exterior scenes in *The Lost Weekend* (1945). We seldom see walking simply as a mode of transportation in classic noir. The same is true of the walking in a sixties post-noir like *Point Blank* (1967), whose main character (Lee Marvin) has the "speaking name" Walker. *Shaft* and later crime or "problem" films, however, often feature the silent or solitary walk, particularly if the film is shot on location in New York City: *Superfly, Black Caesar, Serpico, Mean Streets, Death Wish, Saturday Night Fever, The Warriors, Ms. 45, The Brother from Another Planet,* and *Do the Right Thing.* Note that almost all of the above have prominent scores emphasizing black musical genres.

9. The theme song tells us that Shaft is "a complicated man," and the whole

film explicates this statement. But the walking motif, in the credit sequence and in the black action cycle as a whole, works to suggest a self already formed, with all of its complexities and inconsistencies. It takes a later use of this convention to clarify its meaning. *Black Caesar* (1973) presents the walking montage not at the film's opening, when Tommy Gibbs (Fred Williamson) is a child, nor in the first scene of his adulthood, which would be the expected choice. Not until Gibbs has established himself as a Harlem crime lord does he get to walk his turf to the accompaniment of his theme music. The convention of the walking montage with theme music serves as an expression of a finished identity. Structurally, however, it takes the place of character development, showing us in compressed form the protagonist's knowledge and inner complexity. *Black Caesar's* walking montage, in fact, cuts in scenes of Gibbs's education and growth as a criminal. Shaft's knowledge is sufficient, while Gibbs's is soon outstripped by his ambition; in both cases, though, the characters learn nothing new after the walking sequence has been completed.

10. The cinematic handling of Shaft's clothes provides a precedent: although less grandly than *Cleopatra Jones's*, *Shaft's* acting and cinematography seem to bend, at times, to the will of the costumes. Roundtree, too, had worked as a model and Parks as a fashion photographer, and they allow these parts of their training to come out.

11. It has been possible to move the self-conscious mannerisms of these films to one side, leaving the "real issues" to take center stage. The importance of style as a mode of knowledge and a realm of action makes this separation difficult to maintain, however. The films rely upon aesthetic innovations to work against the institutional and narrative constraints of the genre. (Whether or not these innovations are real or just putative is not so important—they are pitched as "new.")

12. In a recent documentary, legendary Philadelphia producers Kenneth Gamble and Leon Huff described the Philly sound as "a little bit of jazz, a little bit of gospel, a little classical," and stressed the importance of having musicians who worked in a variety of genres ("They would be playing with Leonard Bernstein one day, and with us the next day"), and were of varied ages and backgrounds.

13. Many viewers have noticed this aspect of Curtis Mayfield's soundtrack for *Superfly*—Nelson George in *Blackface: Reflections on African-Americans and the Movies* (New York: Harper Collins, 1994), 34; Guerrero in *Framing Blackness*, 96; and Nathan McCall in *Makes Me Wanna Holler* (New York: Vintage, 1994), 101, for example. It is misleading, however, to suggest that this contrast—between glorification of the drug dealer's life and critique of that life—exists only *between* the soundtrack and the film; it exists *within* both the soundtrack and the film.

14. The conventions of film scores are neither more nor less restrictive than those of pop songs; they are different enough to require a shift in priorities, to bring out different aspects of musicians' backgrounds and techniques.

15. And what of Hayes? What kind of figure is he? From what position does he speak? The question does not become easier to answer for a film like *Truck Turner* (1974), in which Hayes writes and performs a theme song about himself as lead character.

16. The line is drawn from a central passage in Emerson's address "The American Scholar."

17. Although the harmonic structure is simple and built out of ordinary materials, it is not commonplace. The *a* section of the song repeats a four-measure unit that alternates two measures of F major with two measures of E minor, while the *b* section stays on G major. Without harmonic relations built on fourths and fifths (such as one has in blues harmony and its derivatives), the song seems to hover between E minor as tonic and G major as tonic without really asserting the primacy of either.

18. This group of images cannot quite be naturalized as "things encountered on the way to work," if only because Shaft traverses certain blocks more than once. Another "mistake," this repetition might have been necessitated by the long duration of the theme song—the "Theme from Shaft" is almost a minute and a half longer than the average pop song of the time. If unanticipated, this longer length would have forced Robertson to scramble for sufficient footage.

19. I discuss Shaft's jaywalking below.

20. This contrast between reality and artifice formed a crucial part of Parks's aesthetic development as he describes it in his recent memoir, *Voices in the Mirror: An Autobiography* (New York: Doubleday, 1990): "I was also becoming aware of the vast difference between documentary work and fashion photography. In one lay the responsibility to capture a prevailing mood, while in the other was the obligation to create a mood" (95, see also 75).

21. The clearest example of such a scheme can be found in the movie *Westworld*. A futuristic disaster film, *Westworld* (1973) takes place at a theme park that consists of three attractions, all designed for role-playing and stocked with androids: Roman World, Medieval World, and Western World. These three realms are overseen from a central command station, which itself becomes the movie's fourth site. Those unacquainted with the film might do well to imagine it as a smarter *Jurassic Park* (1993): the technology that produces the park goes awry, and the androids begin to do away with the patrons. Toward the end of the film, the generic scheme becomes extremely clear. The last surviving guest that we have been tracking, played by Richard Benjamin, escapes from Western World on horseback and makes his way through Roman World to Medieval World. The final sequences in Western World take on the feel of a Western: besides the setting, the film creates this effect through the dialogue, the acting, the mise-en-scène, the pacing, the music, and the plot. Once Benjamin enters Medieval World, the movie becomes gothic horror, in the manner of a Hammer film. When he goes into the park's underground command center, the film's science fiction affinities come to the fore.

22. In actuality, it just reflects the kinds of source that a classical film composer might draw on: its four-note motive recalls the harmonic world of early Stravinsky, a principal source for a range of dark affects in the classical Hollywood film score. The question of specific sources is secondary to the fact that this four-note motive is coded as modernist Western classical music and developed in a manner appropriate to that tradition.

23. Readers may recall Farley Granger's right cross to the camera in *Strangers on a Train* (1951).

24. For descriptions of noir's generic repertoire, see above, note 2, and Paul Schrader, "Notes on Film Noir," *Film Comment* 8 (Spring 1972): 8–13; J. A. Place and L. S. Peterson, "Some Visual Motifs of Film Noir," in Bill Nichols, ed., *Movies and Methods: Volume I* (Berkeley: University of California Press, 1976), 325–38; and Richard Dyer, "Homosexuality and Film Noir," in his *The Matter of Images: Essays on Representations* (New York: Routledge, 1993), 53–59.

25. Shaft's position as "middleman" is mentioned by Guerrero, in *Framing Blackness*, but without reference to the conventions that engender it (92–93). In the absence of the generic frame for this characterization, Shaft appears simply as the stiff, steadfast individual of bourgeois culture. I think it is more helpful to emphasize his patchwork quality. Guerrero's description of John Shaft seems more appropriate to a character like Frank Serpico, who is truly alone—Al Pacino even looks like a nineteenth-century romantic hero by the middle of *Serpico*.

26. One interesting example from another black action film: Harlem audiences knew that Priest's car in *Superfly* belonged to local pimp KC (who appears in the film). See Lindsay Patterson, ed., *Black Films and Filmmakers: A Comprehensive Anthology from Stereotype to Superhero* (New York: Dodd, Mead, 1975), 241.

27. James Naremore discusses the function of expressive objects in his *Acting in the Cinema* (Berkeley: University of California Press, 1988), 83–88 and passim.

28. This charmed space plays such a role in Jean-Luc Godard's post-noirs, early and late, especially *Breathless* (1959), *Pierrot le Fou* (1965), *First Name: Carmen* (1983), and *Detective* (1985).

29. Cinematographer Gordon Willis's phrase, as recorded in Dennis Schraeder and Larry Salvato, *Masters of Light: Conversations with Contemporary Cinematographers* (Berkeley: University of California Press, 1984), 288.

30. The literature on film noir sometimes blunts the genre's *thematic elements* into *constitutive features*. Complicated plots, for example, constitute but one way that film noir can play against the classical Hollywood narrative: digressions, dead ends, and set pieces, too, destabilize the role of the plot in determining a film's texture and structure. Film noir's readiness to question the fixity of identities and the truth in appearances goes beyond betrayals and sinister locations. The flashback, to take a particular feature, has acquired an importance in noir criticism that goes far beyond the frequency of its occurence. Let it just stand as emblematizing the way that film noir puts into question the veracity or credibility of a film's narrative voice.

31. The only positive consequence lies in the work of the black action *heroines*, especially Pam Grier, who come on so hard as to make their film's revenge plots seem like the revenge is taken against patriarchy itself. A viewer can also become sensitized, in such a masculinist context, to the efforts of African-American actresses to show strength or depth or wit or sensitivity, even when nothing in the film around them seems to justify it and no one seems to notice.

32. This look probably emerged as a reaction to the high-contrast color cinematography of the early and mid-sixties.

33. The black action films often include "old time" black characters—usually comic—as foils to the hero. Some of the best comic examples are Drew Bundini Brown (*Shaft*), Sam Laws (*Hit Man*), and Richard Ward (*Across 110th St.*).

34. It is important that black action films use music as a source of ideas, and not as the manifestation of some kind of innate black musicality. The depictions of African-American music in noirs and post-noirs, from the "monkey music" that maddens William Bendix in *The Blue Dahlia* (1946) to the mincing performance of the incompetent, unnamed soul singer in *Point Blank*, must have given the musicians involved in the black action films an additional spur. Richard Dyer explores this distinction—between the "active use of music" and what he calls the "all-blacks-got-rhythm syndrome"—in "Is *Car Wash* a Musical?" in Manthia Diawara, ed., *Black American Cinema* (New York: Routledge, 1993), 98–101ff. Wayne Wang's marvelous *Chan Is Missing* (1982) carries out the project of demystification with respect to Chinese-American culture, working with and against the frame of the (urban) detective film.

35. This openness can be sensed at the perfect homosocial moment when a gay acquaintance (the bartender) pinches Shaft's butt. You won't recall anyone pinching Steve McQueen's butt in *Bullitt* or Lee Marvin's in *Point Blank*. (As I will show further, Shaft's exuberance opens him up to a range of interactions greater than that experienced by these more sullen white heroes.) It is a strength of the movie that Shaft's getting his butt pinched constitutes the only "punishment" for his greater involvement in the everyday—and he is clearly more amused than threatened by the pinch in question.

36. Take this endlessly repeated story as an example: German expressionist films (experimental) become a resource for thirties gangster movies and films noir (commercial). These films, in turn, influence the French *nouvelle vague* (critical/experimental), the techniques of which in turn trickle down to American cinema of the seventies (commercial).

37. In a film like *The French Connection* (1971), subversion is treated as a neutral process that strips away the fictions we have treated as real. *The French Connection* shows what is lost when subversion is privileged over other modes of revision. It might be called an existential thriller, which means that it gains its intellectual capital precisely to the extent that it frustrates viewers' expectations. The codes of the thriller (here, both the international and the urban subgenres) provide the narrative impetus. The film's many dis-

cursive and interruptive sequences, and the imperfections of its heroes, especially Popeye Doyle (Gene Hackman), are typical for the thriller, and are grounded in the promise of eventual success. Doyle has the reputation of coming up with false leads; a viewer literate in the conventions of police thrillers *knows*, however, that Doyle will be right this time. The final scenes, in which these promises are broken, can easily strike one as unsatisfying, tacked on. The film must lie, in effect: through the awkward device of explanatory titles over a final freeze-frame, the film tells us that, despite appearances, the big drug bust has not really been successful and the French drug kingpin Charnier (Fernando Rey) has somehow escaped from New York's Randall's Island (how? by swimming to Queens?). Despite the thematic rightness of such endings, they cannot be naturalized narratively— all one has is the director's will imposed on the film's structure. (This is a very difficult move to pull off. In *Paths of Glory* [1957], for example, the failure is expressed as a possibility very early on—beginning with the title— and throughout. A film like *Asphalt Jungle* [1950], though it creates sympathy for its criminals, contains this failure within the conventions of the genre: crime doesn't pay.) There may not be any special virtue in frustrating audience expectations, however; this may not itself constitute a critique. One might instead show that fictions are unreal by placing them against other fictions rather than by confronting them with "the way things really are."

38. I have followed some critics in using the term "black action films" for these movies, rather than the more common "blaxploitation film," a term that denies the genre's self-consciousness and distances one from the human activity of making these movies. But the more purely descriptive term "black action film" also implies a judgment that needs to be made explicit. It contains the assumption that there already exists some white, or really race-neutral, action film that can simply be put into blackface: that there is a fully constituted genre and the black action film is just a variation upon it. A study of the action movies that precede the black action films would tell a different story. I do not have space to tell that story here, but it shows that the black action films, far from constituting a quaint diversion, bring the action genre to maturity and determine the course of its life thereafter. Because issues of race and power form the principal themes of the black action film, a full investigation of these lines of influence would demand a rethinking of the politics of margin and center.

39. One should not underestimate the effect of mostly black casts upon the cinematography of black action films. As strange as it may sound, many of the cinematographers who worked on these films felt the need to develop a "special theory for lighting black people." In earlier films, black characters would be lit separately, sometimes almost as an afterthought, so that "the room probably looked great, probably all the light-skinned actors showed up pretty good, but probably the black person didn't show up very well. So they get by with it and kind of glance over it." With black-oriented films, however, cinematographers could not take this route, and were forced to experiment: "I soon discovered that you could light their faces well the same as anyone

else, it just took some care with the exposure and certainly with the way light fell upon their faces. I used a soft light from the front which wouldn't be the way you'd normally go about it. I approached it from the philosophy of how you would light a person if you were taking his portrait" (*Masters of Light*, 89, see also 27–28, 30). Parks's experience as a portrait photographer clearly contributes to the look of the characters and of the film as a whole; the film simply does not look like most action films of its time. Another effect of a film's emphasis on black actors is the racializing of its *white* characters, who will sometimes be noticeably overlit, too yellow or too pink. Some films make the white characters look grotesque, much as whiteness becomes pathological in Himes's novels—think of a figure like Pinky, the African-American albino giant in *The Heat's On* (New York: Vintage, 1966).

40. John A. Williams, "An Interview with Chester Himes," *Amistad* 1 (1970): 49, 75.

41. In *Voices in the Mirror*, Parks discusses each of these issues. He recalls his attempts to increase the number of African Americans in the crews for his films (275, 308) and argues for the importance of his training as a still photographer and musician in directing *The Learning Tree* (1969), his first film (274–76). In his discussion of *Shaft*, he describes his fights to shoot on location in New York and to keep Richard Roundtree's mustache despite an unspoken Hollywood rule that a black man with a mustache was "too macho" (305–08). (Nelson George, in *Blackface*, reflects sensitively upon the parallels between Parks's life and Shaft's character [195].) Charles Michener chronicles some of the strategies for enriching a film's "human elements," in *Black Films and Filmmakers*, 242–43, including calling on the NAACP to pressure the studios into making script changes.

42. One unusual piece of business involves Shaft's elaborate procedure for storing his gun in the freezer. It seems too realistic (and unglamorous) a detail for a typical shoot-'em-up, but it serves to display the film's careful equilibrium between violence and domesticity.

43. *Superfly*, in fact, begins precisely where *The Mack* and *Black Caesar* end, with the realization that the money one makes acquires a power of its own that must be counterbalanced by one's efforts of will.

44. The black action hero opens himself up to an enormous variety of comparisons: with white heroes of the sixties (Steve McQueen, Clint Eastwood, Sean Connery, Michael Caine), black sixties heroes (Sidney Poitier, Jim Brown, Raymond St. Jacques), black "ethnic" characters and second bananas (Woody Strode, Bill Cosby), black "race-neutral" characters (Greg Morris in *Mission: Impossible*, the doctor in *Bullitt*), noir and gangster film protagonists (Bogart, Cagney), noir "ethnic" characters (including many nonspeaking roles), fashionable athletes and musicians of the late sixties and early seventies (Walt "Clyde" Frazier, The Temptations), the African Americans depicted in news and documentary footage, the black subjectivity constructed by the civil rights and Black Power movements.

45. Ishmael Reed discusses Himes's portrayal of lower-middle-class values in

"Hyped or Hip," a review essay reprinted in his *Writin' Is Fightin'* (New York: Atheneum, 1988), 128–29.

46. In Marlon Riggs's documentary *Color Adjustment*, actress Esther Rolle reports that she demanded and received a husband for her character before accepting the starring role on *Good Times*. To present her as a single mother would have been to capitulate to a stereotype about the black family.

47. This difficulty still exists, more than twenty years later, and is depicted in the opening of two recent texts: Cornel West's book *Race Matters* (Boston: Beacon Press, 1993), and the video for GangStarr's "Code of the Streets." In the latter, this topos is expanded to affect, not only the person attempting to hail a cab, but an entire racialized Brooklyn.

48. The famous car chase in *Bullitt* provides a helpful counterexample. The absence of incidental music in this scene would already have been remarkable when the film appeared, even before the black action film's musical conventions took hold in film and on television. The silence accompanying the sounds of the chase indicates that the chase speaks for itself: it needs no enhancement of any kind, particularly for the many viewers who knew that McQueen, and not a stunt double, was behind the wheel. In relation to black action films, another aspect of this silence stands out—the silence of the characters involved. It is unthinkable that a car chase of such high quality would appear in a black action film without the characters' providing a running commentary upon the difficulty, danger, and excitement of the proceedings, without somebody's saying "Oh, shit! Oh, shit! Oh, shit" in an ascending arpeggio. Anticipating the question of a viewer's identification with the characters, the characters act as their own observers. In sequences *not* as spectacular as *Bullitt*'s car chase, such running commentary can teach the audience to notice the effort and ability of the characters, to appreciate what might be taken for granted.

49. An entertaining essay by Carlo Ginzburg, "Clues: Roots of an Evidential Paradigm," in his *Clues, Myths, and the Historical Method*, trans. John and Anne Tedeschi (Baltimore: Johns Hopkins University Press, 1989), makes clear that both the detective and the connoisseur rely upon the discernment of details.

50. The visual style of this depiction resembles Parks's 1967 photographs of urban poverty for *Life* magazine and perhaps even his much earlier shots of Harlem gangs. His many photographs of the Black Panthers seem not to have influenced his depiction of Buford's group.

51. Donald Bogle's *Toms, Coons, Mulattoes, Mammies & Bucks: An Interpretive History of Blacks in American Films* (New York: Continuum, 1973) and the many books and articles of Thomas Cripps have provided the grammar for discussing the depictions of black Americans in film. Writing in the late sixties about mainstream Hollywood cinema, Stanley Cavell notes that black performers were only then beginning to appear as "individualities that projected particular ways of inhabiting a social role." With some justice, Cavell adds that he "cannot at the moment remember a black person in a film making

an ordinary purchase—say of a newspaper, or a ticket to a movie or for a train, let alone writing a check." The point is that viewers of Hollywood cinema prior to the sixties seldom got to see a black actor doing things not inscribed within well-known stereotypes. It is equally important that African-American characters in black action films often adopt stereotypes as a way of fooling the whites. In *Shaft*, for example, Ben Buford plays the dumb bellhop and Shaft himself takes on the mannerisms of the black buck while he is tending bar.

52. The exceptions can be illuminating. Take three: in the title role of *Harper* (1966), Paul Newman adopts a variety of accents and mannerisms in order to disguise himself while digging for information; in *On Her Majesty's Secret Service* (1969), James Bond (George Lazenby) masquerades as a scholar of heraldry, but blows his own cover when it becomes too disagreeable; *They Call Me MISTER Tibbs!* (1970) splits Sidney Poitier's role into two parts— tough cop and loving family man. In the first two cases, the change of style constitutes a dissimulation that serves a clear purpose. It has a major function in the plot of the Bond film, while it is mostly a shtick in *Harper*. Both cases, however, show the character consciously playing a role. (These two look back toward Philip Marlowe's performance as an effete "professor" in *The Big Sleep* [1946]—an improvisation by Humphrey Bogart.) In *Mister Tibbs*, both modes of performance are equally a part of his character, but the obvious bifurcation serves merely to emphasize the internal consistency of each mode. The neatness of the division in all three cases reinforces the ideal of a consistent self.

53. Naremore mentions Grant's influence on the Bond character in the course of an excellent discussion of Grant's performance in Hitchcock's *North by Northwest* (1959) (*Acting in the Cinema*, 220).

54. Connolly draws this distinction clearly: "individual*ism* presupposes a model of the normal or rational individual against which the conduct and interior of each actual self are to be appraised," while individual*ity* "gives primacy to the individual while qualifying or problematizing the hegemony of the normal individual. Here nonidentity with a normal or official self constitutes a sign of individuality" (*Identity/Difference*, 73–75). I should probably add that Connolly himself does not endorse either position. The argument for individuality (as against what Connolly defines as individualism) has been recently advanced by George Kateb, in his book *The Inner Ocean: Individualism and Democratic Culture* (Ithaca, N.Y.: Cornell University Press, 1992), especially in the essay "Democratic Individuality and the Claims of Politics."

55. Many of the positions adopted by the characters in black films can be placed upon a matrix with essentialism/antiessentialism on one axis and individuality/collectivity on the other. Studying these movies can give us good reason to move from attempts to choose the best position on this matrix to considerations of when, why, and how these various positions are taken up, and how they shape the discourses of which they are a part.

56. This is the same tone as that of the teacher in Stevie Wonder's "I Wish": "You *nasty* boy!"

57. This separation is central to Hannah Arendt's essay "What is Authority": "authority precludes the use of external means of coercion; where force is used, authority itself has failed.... Authority implies an obedience in which men retain their freedom" (*Between Past and Future*, enlarged ed. [New York: Penguin, 1977], 93, 106). Following Arendt, Connolly elaborates the distinction between authority and power in *The Terms of Political Discourse*, 3rd ed. (Princeton, N.J.: Princeton University Press, 1993), 107–16. See also Hanna Fenichel Pitkin, *Wittgenstein and Justice* (Berkeley: University of California Press, 1993), 277–79.

58. *New York Times*, 25 June 1971, 37, 2. See the *New York Times Index*, 1970, vol. 2, 1903–05 and 1971, vol. 2, 1677–79. *Time* offered "Some Pedestrian Observations: Manhattan's Forty-Second Street," 11 May 1970, and "Power to Peds: Banning Autos in New York and Tokyo," 4 August 1970, while *Newsweek* countered with "Pedestrian Roulette," 19 October 1970.

59. Recall that Hobbes defines freedom *as* freedom of movement: "Liberty, or freedom, signifieth ... the absence of opposition (by opposition, I mean external impediments of motion)" (*Leviathan*, ed. C. B. McPherson [New York: Penguin, 1968], 183). Jaywalking can be understood in this light as emblematizing the *pursuit* of freedom against obstacles in civil society *without* legal recourse.

60. See Judith Shklar, "Obligation, Loyalty, Exile," *Political Theory* 21, 2 (May 1993): 181–97.

61. I refer to the central concept of Josiah Royce's *Philosophy of Loyalty* (1908). Royce believed that one's intense feelings of loyalty to a cause or group could lead to a respect for similar feelings in one's enemies. While he did not entertain the thought that such respect could *prevent* conflict, he hoped that it might encourage an acknowledgment of shared humanity in the heat of conflict.

62. Studies of literary genre have been better able to articulate the balance between tradition and revision, probably because they are more alert to diachronic change and generic mixture. The best recent study of genre remains Alistair Fowler's *Kinds of Literature: An Introduction to the Theory of Genres and Modes* (Cambridge, Mass.: Harvard University Press, 1982), a work whose emphasis upon canonical literature seems to have limited its adoption by students of popular culture.

63. What Americans call the "foreign film"—particularly as a category in video rental houses—would seem unlikely to constitute a genre, but it can frequently be defined by its mode of distribution, production values, themes, settings, acting styles, cinematography, and music. Even the science fiction film in the seventies presents a complex example. Beginning perhaps with *2001* (1968), sci-fi films become derivative more of written science fiction than of earlier sci-fi films. Following these written sources, the settings and generic signals of science fiction do not provide the films with thematic or

structural determinants. The films must therefore take their themes and structure from other genres: war, voyage, Western, crime, action, police procedural, horror, suspense.

64. James Parish and George Hill, *Black Action Films* (Jefferson, N.C.: McFarland, 1989).

65. Film historians David Bordwell and Janet Staiger base a discussion of so-called New Hollywood cinema on the claim that "even the most ambitious [American] directors cannot escape genres" despite their borrowings from "art cinema" (Bordwell, Staiger, and Kristin Thompson, *The Classical Hollywood Cinema* [New York: Columbia University Press, 1985], 375). Such a claim entails the following related claims: (1) that at least some New Hollywood directors try to "escape genres"; (2) that all "ambitious" directors *should* try to escape them; (3) that "art cinema" has attempted such an escape and succeeded in it; (4) that directorial ambition cannot be manifested *within* genres; and (5) that "art cinema" does not constitute a genre or group of genres. Bordwell and Staiger seem to endorse (3) (373–74) but simply assume (1), (2), (4), and (5). The authors implicitly contest (5) in their discussion of "alternative modes of film practice" (378–85).

66. *Black Films and Filmmakers*, 106–08. I cannot follow Patterson in condemning the movie on these grounds, but I applaud his attempt to question the realistic mode of the film, and regret that this attempt has had no effect upon its critical reception. Patterson, in fact, remains silent on the film's merits as a fiction, and it seems reasonable that one might withhold such an opinion until the film's fictional status has been agreed upon. His principal objection is to the reception of the film as "true to life," and part of this reception has to do with the metageneric context of commercial "black-oriented" film. In this context, a film like *Sounder* would be taken as rare rather than routine—as *departing* from the conventions of blaxploitation rather than as *conforming* to those of classic Hollywood film.

67. This position, though fundamentally *negative*, politically, is not thereby escapist or apolitical: as Connolly argues, "a democratic ethos, at its best, *introduces an active tension between cultural drives to identity and the persistent ethical need to contest the dogmatization of hegemonic, relational identities*" (*The Ethos of Pluralization*, 93, his italics).

Trudging through the Glitter Trenches
The Case of the New York Dolls

VAN M. CAGLE

In the early 1970s, the increasing popularity of so-called corporate rock prompted rock critics, musicians, and fans to engage in high-spirited debates concerning the aesthetic and affective dimensions of "authentic rock." In many cases, the most common line of argument centered on a postmortem 1960s premise: authentic rock was analogous to a folk art.[1] Accordingly, this assumption suggested that authentic rock was inextricably tied to its audience, the implication being that authenticity automatically dissolved the star/fan dichotomy. In this sense a kind of "community agreement" determined the range of rock-oriented experiences that were deemed allowable. Hence, when championing "real" rock genres (such as punk), rock critics and fans lauded bands that remained "true" to their roots, especially if this meant signing with local, independent labels. By way of comparison, bands were quickly labeled "inauthentic" if they willfully succumbed to the managerial/promotional practice of "creating" (and therefore "manipulating") an audience. Likewise, harsh criticisms often surfaced when authentic bands chose to develop musical styles and/or visual formats that attempted to move beyond "community appeal" and into the arena of "mass rock." In all of these cases, the arguments focused on a negatively inspired view of capital; fans of authentic rock believed that they *owned* the communal rights to "their" bands.

In 1972 glitter rock confounded the boundaries set forth by this debate. Most importantly, glitter's major practitioners (David Bowie, Lou Reed, Iggy Pop, Alice Cooper, and others) each derived from "authentic" subcultures (such as Warhol's Factory) where the premises of real rock were intertwined with an openness regarding nonstraight sexual identities and eclectic performance styles.[2] In utilizing glitter as their medium, Bowie, Lou Reed,

and others like them translated their insular, context-specific ideas for a broader audience, thereby recasting situational notions of sexual/performance subversion through commercial means.

However, unlike many commercial rock genres of the early 1970s, glitter did not freeze the ("authentic") subcultural aesthetics and ideas that were used to systematize mass appeal. For even as glitter performers lifted elements from a number of interconnected subcultures,[3] they also *precisely* rearticulated the *essence* of these elements. In this way, glitter did not represent a unilateral form of ideological or commercial incorporation, because the style(s) that it generated faithfully recontextualized the foundational principles that had served as an impetus.[4]

Furthermore, the recontextualization process provided glitter fans with *direct* access to a number of bohemian conventions that had not been readily available through the channels of mass media.[5] In particular, glitter's artful signification of subcultural style unlocked a wide range of cultural possibilities for fans, many of whom were limited by their geographical locations, their social backgrounds, or both. Thus, their predominant subcultural experience in the early 1970s occurred through the application of subcultural precepts that were transmitted by way of a mass-mediated and highly commercial format.

Along more specific lines, given that glitter rock represented the commercial translation of subcultural perspectives, the primary question becomes: What *exactly* did mass-mediated transfusion offer fans? Quite clearly, glitter rock encouraged new sensibilities toward conventional formations and representations of gender, and its themes encouraged active inquiries regarding adolescent sexuality. According to Gary Herman:

> David Bowie's emergence in the early seventies was perhaps the single most important influence in the development of an explicit and outrageous sexualization of rock. . . . The press coverage given to Bowie and his wife's professed bisexuality and "open marriage" gave credibility to the singer's musical claim to be a child of the future at a time when "free sexuality" was being passionately pursued as the most likely candidate to usher western society into a golden age.[6]

In referencing the cultural impact of glitter, Angela Bowie claims, "We decided to take a stand on the subject [of gay (and bi) sexuality] as a matter of policy. Gay people came to thank us personally for the exposure we gave to the subject."[7] And, as Dick Hebdige states, "Bowie was responsible for opening up questions of sexual identity which had previously been repressed, ignored, or merely hinted at in rock and roll and youth culture."[8]

Here the notion of sexual identity which had previously been "hinted at" provides us with an important insight into glitter's significance as a subculturally based genre of popular music. Glitter rock was the first absolutely

forthright form of rock and roll to move queerness from subtext to text and make it unashamed, playful, and decoded for mass consumption. In the process, glitter provided gay and bisexual (rock and roll–oriented) youth with what were perhaps their first-ever role models, while suggesting to others that they might "try on the roles" of sexual subordinates through experimenting with androgynous style. From a subcultural point of view, then, glitter can be interpreted as either the opaque but still seditious pronouncement of a style that had sexual undercurrents, or it can be understood as a genre that furnished fans with a method whereby they could explicitly announce their sexual preference(s) or orientation(s).[9] In the case of glitter rock, each assessment is valid in that the genre operated both at the surface level of style and at the more affective level where it allowed fans an outlet for expressing their sexual feelings.

Equally significant in regard to glitter's thematic tone is the fact that glitter singers/musicians *willfully* operated from the center of rock's commercial spectrum. In doing so, glitter performers simultaneously celebrated *and* critiqued the commercial rock process by demonstrating that in order to effectively transmit oppositional ideas, one had to articulate a stance that emanated from the nucleus of popular culture. Through implementing this premise at every turn, Bowie and his cohorts challenged the very system that they used as a lever for advancing their ideas.

If glitter rock altered and confused the debate concerning authenticity/commercialism—especially through its exposition of subversive sexual themes—then a band such as the New York Dolls presents an intriguing anomaly: they advertently *and* inadvertently constructed a visual and musical format that positioned them on the margins of glitter rock style. This positioning was somewhat schismatic, given the already radical precepts that glitter was demonstrating during its inceptive stage (late 1972 to early 1973). For in order to remain on the margins of a style that was consistently reaffirming a marginal ideology, the Dolls and their fans had to "cut up" glitter's significative fractions by juxtaposing and "playing with" many of the tensions that were endemic to the genre. This cut-up method was accomplished as the Dolls (and their followers) developed stylistic strategies that celebrated the implications of metaphors and double entendres: in a manner that was abstract yet detectable, glitter was thus conceptualized as "glitter," pop as "pop," camp as "camp." Subsequently, every *movement* as well as every intonation made sly references to the practice of layering quotes on top of quotes; a double-edged sense of irony permeated the Dolls' music and their stage comportment.

Interestingly enough, through examining the Dolls' infatuation with ironical premises, we will find that even though the band and their fans denied having an explicit association with glitter, in actuality both groups reveled in many of the genre's stylistic themes. And whereas this contra-

diction induced bafflement among some observers, many notable rock journalists found themselves captivated by the Dolls' uncanny "reaction" to glitter rock. Subsequently, journalistic captivation lead to critical acclamation; in turn, the Dolls acquired a number of coveted titles that provided a gateway for the band's entrance into the commercial landscape that it both parodied and resisted. But as the Dolls attempted to live up to a journalistic consensus that was intent on fostering the band's move into a broader commercial sphere, they found that "authentic fans" were indeed unwilling to relinquish control over the structures of meaning that had come to define the margins of glitter during the early 1970s.

GRATING MUSIC, ANDROGYNOUS CLOTHES, AND THE DEVELOPMENT OF A CULT FOLLOWING

During the winter and spring of 1972, as Bowie's "Ziggy Stardust" sought "world domination,"[10] the New York Dolls were defining *and* confusing the lines of demarcation in glitter rock. From January 1972 and throughout the months of rehearsals that spring, the Dolls also made clear that they were treading on highly shaky territory in this the era of guitar rock virtuosos and introspective folk songwriters. Perhaps because of these prevailing forces in pop music, the Dolls reacted in their acclimated manner and played and behaved as they were: amateurs from Staten Island who wanted to produce music that would reside on the far latitudes of rock minimalism.

By the summer of 1972, the Dolls had gained weekly billings at the Mercer Arts Center, a defunct Manhattan hotel that housed an art gallery, a clothing boutique, a theater, and a number of "performance rooms." Although the Mercer eventually suffered a literal collapse, in the Dolls' early days it was the center of a burgeoning scene that featured video artists (The Kitchen) and raucous rock and roll bands such as the Magic Tramps, Wayne County's Queen Elizabeth, Ruby and the Rednecks, and Teenage Lust. But none of these spoke to and of the Mercer scene as accurately, viciously, sympathetically, and comically as the New York Dolls.

For a period of three months, the Dolls were virtually unknown outside of this venue, and then unexpectedly in July 1972, the band found a prominent yet transitory place on the international music map. Britain's Roy Hollingsworth, already a committed Bowie/Lou Reed fan, believed that in the Dolls he had discovered a band that was gloriously unrefined and much more mean-spirited than any contemporary glitter act. He announced in the July 22, 1972, edition of *Melody Maker*: "The Dolls just might be the best rock and roll band in the world."[11] He went on to explain that the Dolls and their fans were decidedly bored with "endless singer-songwriters" and the "switches and swatches of progressive music."[12] Instead, the Dolls had "picked up on the remnants of things that are gone, things that have been

misused. They sound like a cross between the Deviants, Pretty Things, and very early Rolling Stones."[13]

Whereas the general tone of this praise was well taken, the Dolls both condoned and rejected the more specific comparisons. In reference to "things that are gone," the band did acknowledge that its most obvious derivations came from the 1960s "girl group" sound and mid-1960s British Invasion pop. In addition, the Dolls were quick to claim that much of their musical inspiration stemmed from sources as diverse as the Velvet Underground, Sonny Boy Williamson, the Shangri-Las, and Archie Bell. In the views of band members, however, these somewhat discordant sources coalesced to form the group's musical inner core. In this sense, Hollingsworth's article only hinted at the Dolls' *actual* musical roots, while simultaneously encouraging a comparison to the overtly *commercial* Rolling Stones. The resulting journalistic tendency was to compartmentalize the band as "Stones Clones," a label that particularly disturbed lead singer David Johansen, even though he couldn't disavow some of the musical and visual similarities.[14] In reference to this association, Johansen stated sarcastically:

> That label bothered my mother. I don't know. I have a pretty shitty attitude toward [rock] journalism in general. Most journalists cop out a lot. They like to take short cuts. Rock journalism is just like a free ride. It's not a very dedicated profession.[15]

In the heady days of 1972, however, this "free ride" had much to offer a beginning band with little equipment and virtually no professional musical skills. By the end of the summer, the New York Dolls had flown to London to open for the Faces, and as Pete Frame explains, "every record label in America got on their trail."[16] Undoubtedly, what most confounded the A&R scouts was what they actually discovered in the process—a band whose music was more uncompromising than that of Iggy's Stooges, and whose visual demeanor proved to be just as extreme.

With David Johansen on lead vocals, Johnny Thunders on lead guitar, Sylvain Sylvain on guitar and piano, Arthur Kane on bass, and Billy Murcia on drums, the Dolls began their career amid a wave of public notice and subsequent controversy. After the London gig, drummer Murcia died of a drug overdose, and as Frame states, "the band beetled home in disorder."[17] Nonetheless, as Sylvain explains in Jon Savage's *England's Dreaming*, "It got us a lot of publicity. We were living this movie: everybody wants to see it, and we were giving it to them."[18] In turn, Murcia's death helped to establish the band as one that was dedicated to the principle of intemperance—whatever the form. And the incident, in fact, seemed to add emphasis to the label Roy Hollingsworth had used when summing up the Dolls' overall image: "subterranean sleezoid flash."[19] Whereas this label eventually forced the band to have to grapple with a number of creative predicaments, during the

summer and fall of 1972 the term seemed only to suggest an inexhaustible adventure.

"We're trisexual," Johansen often claimed of the Dolls, "We'll try anything once."[20] Although the statement was perceived by the rock press as being a frivolous reference to Bowie's bisexuality, the implications of this claim were quite demonstrable. The band seemingly knew no aesthetic (or philosophical) limits. Thus, by the time that Jerry Nolan had been acquired as the new drummer, the New York Dolls had already begun to fracture then conventional rock standards in America by swirling together past visual images and musical styles in a manner that seemed brilliantly reckless in those early days.

Indeed, if Phil Spector's girl groups represented a glamorous sense of ocular vulgarity in 1962, by 1972 it was as if the Dolls had suddenly (re)discovered the male version of the lesson. In terms of fashion, they dressed (both onstage and off) in all manner of tawdry, gender-bending attire: gold lamé capri pants; tacky polka-dot dresses; fishnets; bouffant wigs; shorty nightgowns; leopard-print tights; football jerseys; feather boas; open-necked shirts; multicolored, "reveal-all" spandex; off-the-shoulder T-shirts with "New York" emblazoned across the front; black, narrow-legged, "poured-on" jeans; mod caps and bowlers; oversized plastic bracelets and chokers; bow ties; satin scarves; platform shoes; high heels; and thigh-riding stacked boots. The Dolls complemented such stylistic inventions with the cheapest brands of Woolworth's lipstick and eye shadow, which always gave the appearance of slightly haphazard application. In an attempt to add further potency to their visual imagery, band members created a number of preposterous hairstyles. Locks were chopped off in an uneven manner; the hair was then teased in both upward and outward directions. And in all public arenas the Dolls not only *swaggered* as they walked; they reinvented the term—sluttishly wobbling in their high heels as if they'd literally thrown themselves together after a long night of drinking, smoking, and street tricks. In the process, the Dolls managed to look menacing, as if they might wield the filed end of a switchblade at the first sign of harassment. On the whole, it was an unyielding and intimidating appearance that on the surface seemed to defy reason. Then again, the milieu that had become their own was the Mercer, and, by late 1972, Max's Kansas City, where all types of misfits were held in high esteem. As Jon Savage points out, "The Dolls were sharing space with the tail end of the sixties Warhol scene which had been the venue for drag queens, speed freaks, every possible outcast."[21]

In this particular milieu the New York Dolls represented a direct extension of the late 1960s Warholian underground, as opposed to a commercialized version of it (glitter rock). The band stressed this distinction by demonstrating a disdain for conceptual glitter rock performers (Bowie), especially those who had adopted stage personas (Bowie and Alice Cooper).[22]

The Dolls attempted instead to generate paradoxes that were analogous to those that had been inscribed by Iggy Pop and the Stooges (circa 1969) and Lou Reed and the Velvet Underground (1966–69)—only they weren't about to learn from past "mistakes," nor would they admit taking their cues from former bands. Hence the Dolls' music embodied their predecessors' approach to form, while the overall cacophony was even more untamed and chancy. In *Rock of Ages* Ken Tucker points out, "[Lou] Reed's example was followed by virtually every street smart band in the city and nowhere was his influence more vividly felt than in that great protopunk band, the New York Dolls."[23] But as Robert Christgau acknowledges, "They refused to pay their dues. So we had to pay instead.... And they wanted their music to sound like whatever it was."[24]

Drawing on Christgau's assessment, we are able to arrive at a number of related assertions. In the New York club circuit, the Dolls became the epitome of instant rock celebrities. Such fame was acquired in part because the band's music was considered so abrasive that it was immediately labeled "difficult," even among those who had developed the requisite acquired taste. As Christgau claims, "The joy in the Dolls' rock and roll was *literally* painful; it had to be *earned.*"[25]

In one sense this "pain" was directly illustrated by the fact that the Dolls were self-taught and proud of maintaining their nonprofessional status. Their lack of proficiency also often played into the justification for a sound that intentionally mimicked the fast pace of innermost Manhattan. And for those critics who increasingly despised contemporaneous rock, the Dolls' music provided a dazzling jolt that was comparable to the commotion of subways roaring past stops, the wailing of sirens—New York aural energy as if it had been laced with amphetamines.[26]

The band's inspired rush of musical energy, its technical amateurism, and its lackluster attitude toward contrived rock formats operated in a coherent manner to demarcate the band as one that was reconstructing rock primitivism for a new decade of listeners. Twenty-three years later this musical assault is still relentless, as revealed by a close listening to both *The Mercer Tapes* and *The New York Dolls*: Thunder's guitar doesn't strum; it pounds and confuses the chords. Simultaneously, Kane's bass misses any notion of a prompt—because none is provided. Clashing intentionally are Sylvain's skillful but piercing rhythmic blasts, which set the whole force into motion, thus leaving Nolan's drums not ordering the beat but instead struggling just to maintain the pulsating momentum. Amid the chaos, Johansen slurs his words and barks his vocals, adding even more mayhem to the already maniacal pace. However, as a musical barrage, this certainly wasn't rock and roll that had returned to its purist roots; this grating musical conglomeration seemingly had no systematically traceable references. Consequently, by raising decibel levels to extraordinary degrees and by playing so "sloppily" and

so fast that the music furnished its own antimelody, the Dolls managed to gain an atypical and extremely dedicated following. Even so, the band did not espouse the time-honored notion of "finding fans"; fans had to both discover and come to terms with the Dolls' unsettling brand of music. In turn, the maxim of "paying your dues" became one that was applied to devotees, not to the band itself.

If such dues had to be paid, there was obviously a reason. The Dolls were, quite simply, like no other band in the city—or the nation—at that time. Their hard-edged musical simplicity and extraordinary visual style meant that devoting one's energy to the band called for an evident engagement with the chaotic format it presented.

Accordingly, faithful followers employed the mismatched "sleezoid" look in their own personal fashion designs; clothes and objects that were "cheap," plastic, gaudy, ribald, and (especially) rejected (thrift stores, closeout sales) became the norm for female and male fans. In addition, cross-gendered fashion references to Frederick's of Hollywood and *International Male* coincided with insidious shades of makeup and nail polish. The effect was to make the streetwalkers on 42nd Street appear tame by comparison; the most gratuitous and revealing styles became the most esteemed. As rock critic Emily Oakes noted, "The look of the moment for the sex of your choice was straight ahead billion dollar baby hooker."[27] The result was the self-appointed label "smack and scandal," and an exhausting display of adoration from dedicated New York rock writers who found themselves habitually lured to the Dolls' sets not only to observe the onstage displays but also to take note of the audiences' "performances" as well. In turn, the fans' polymorphous approach to fashion functioned to establish them as an "insider's club"—the added bonus being that this particular club appeared too disheveled to appeal to even the most curious of uptown vogue adherents.

But the conspicuous fashions and the brutal, slanderous rock and roll came to a head precisely at the most opportune and inopportune of moments. During the late months of 1972 and the early months of 1973, the Dolls were often perceived outside their inner circle as "another glitter band" that seemed to be riding on the coattails of a Bowie-inspired "camp-charged" project.[28] In actuality, this was the one band that *didn't belong* in the shadow of Bowie's highly methodical approach to glitter, the one band that—at least in the beginning—was steadfast in defining its own terms. And during the initial stages of the band's development, the fans were following suit, complementing the unrefined spirit that drove the Dolls to their own particular stylistic extremes.

Yet, as the Dolls began touring outside New York and gaining more widespread national coverage, many untutored critics didn't understand the contextual features that were central to the band's image. With some critics and reviewers basing their assessments *purely* on visual style, both the Dolls

and their fans became "glitter rockers," a label that was both indirectly suitable and broadly inappropriate. At the same time, music critics (Lisa Robinson, Lester Bangs, Dave Marsh, Robert Christgau) who had "insider's knowledge" of the Dolls' insurgent premises repeatedly attempted to situate the band within a new musical range. Still, given the classification schemes common to the rock press (during the early 1970s), no label seemed befitting except the ever-convenient designation of glitter rock (or slight variations on it, such as "post-glitter").[29]

Thus, within the span of one year, the Dolls would face a growing dilemma. Many well-intentioned members of the rock press would mark them "America's answer to glitter," "America's answer to David Bowie/The Rolling Stones," and "the greatest rock and roll band in the U.S."[30] Not wanting to downplay the press coverage, the Dolls would find themselves in a precarious position. In a simultaneous attempt to "play with" the glitter tag and to dismiss its relevance altogether, the Dolls strived to embody what the press viewed as a joyous, frantic glamour-drama that had stretched glitter's aesthetic boundaries to new levels of kitsch.

As the details of this drama unfolded, the Dolls provoked both irritation and elation precisely because they consistently attempted to defy the boundaries of the glitter spectrum. Simultaneously, the band's tie to contextuality and its perpetuation of a camp sense of style resulted in frequent confusion. Such confusion is in fact documented in the infamous 1973 *Creem* readers' poll in which the band was voted *both* "best" and "worst" new group of that year.[31] Along the way, as this dichotomy was in the process of forming, the Dolls orchestrated a number of episodic celebrations, which eventually resulted in the casualty of what remains the most alternative of all 1970s alternative bands.

AUTHENTICITY, CAMP, AND THE BINDS OF COMMERCIALISM

As suggested earlier, the Dolls often charged that glitter rock represented a commercial ruse; yet this accusation didn't thwart the band's attempt to gain a nationwide following. Still, as their first album and tour would make clear, the Dolls were unwilling to compromise their vehement approach to rock and roll. If anything, the band exaggerated its campy contextual features, and in doing so it acquired an extremely dedicated group of followers. However, in 1974 a number of interrelated circumstances caused the Dolls to break from their camp-laden mold and enter into the more commercial vein of hard/pop rock. Whereas the Dolls could justify their shift in musical/visual focus, they could not foresee the predicaments that would arise due to former contextual affiliations. Most importantly, the Dolls' initial axioms hampered the band's accessibility by irrefutably positioning it as *so* alternative that it actually stood little chance of becoming the "answer" to Bowie,

the Stones, or any mega-rock ensemble. Concurrently, the Dolls' "new image" underwent extraordinary scrutiny by original fans, who, in this particular case, provided the definitive last word on the issue of authenticity.

In the early stages of glitter rock, the New York Dolls emerged from the Mercer scene with manager Marty Thau in search of a record deal. Believing that the Dolls' music could be successfully marketed to a cult following in the United States, Thau met with twenty executives from major labels during the late fall of 1972 and the winter and spring of 1973. His asking price for the Dolls was $250,000, a figure that astounded most executives who turned up at the Mercer shows only to find the band's music and clothing style reprehensible. CBS Records president (and reigning "liberal") Clive Davis maintained "that if you wanted to work in the music business you didn't go around admitting that you saw the New York Dolls. That was like admitting that you had friends who were homosexual."[32]

While the Dolls flaunted their arrogance toward middle-aged executives "with polished heads, [who were] snorting coke," one younger representative, Mercury A&R head Paul Nelson, did find some favor with the band.[33] After returning to the Dolls' performances a total of *eighty times*, he engaged in a one-man crusade to get the band signed to the label. By late spring 1973, the band signed a contract with Mercury; the head executives were still skeptical, yet willing to tolerate a risk. After all, Mercury was trailing in the market, and upon losing David Bowie to RCA, the label's executives felt that even though they despised the Dolls, the band might at least help to "update" the company's image.

By August 1973, *The New York Dolls* was completed, and by the end of the month it had been placed in record stores across the United States. By appearance, and thus by comparison, the cover presented the most direct assertion of gender bending since Bowie's *The Man Who Sold The World*. And like many of Andy Warhol's films, the jacket design sparked a tremendous amount of controversy, whether one ever heard the music inside the sleeve or not.

On the album's cover (see fig. 5.1) a stark black-and-white photograph was highlighted at the top by the band's name, which was presented as having been inscribed by a tube of hot-pink lipstick. Below the bullet-shaped tube sat the Dolls, who were crammed on a sofa in all their "sleezoid" grandeur. At the center was Johansen, who sported a high teased hairstyle, white makeup, lipstick, eye shadow, bracelets, an unbuttoned striped shirt, skintight satin pants, and clog-style glitter platforms. Most noticeably, he was holding an open powder compact, which allowed for a rather blatant display of narcissistic infatuation. To Johansen's left sat Sylvain Sylvain, who had applied glaring rouge marks to his cheeks. Looking sullen and removed from the ensemble, Sylvain reclined on the sofa, presenting the viewer with his mismatched wardrobe consisting of a cowboy shirt, a polka-dot scarf,

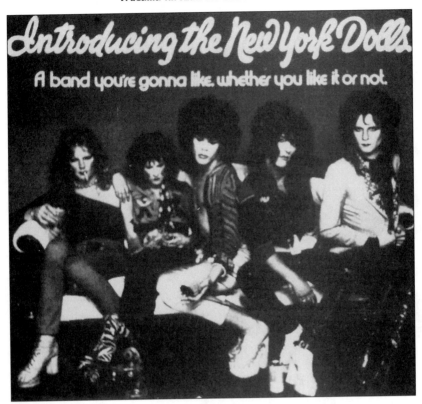

Introducing the New York Dolls
A band you're gonna like, whether you like it or not.

figure 5.1

tight black jeans, and roller skates. His right arm was nonchalantly resting on the bare shoulder of Arthur Kane, whose "high vamp" makeup was accented by a string of gaudy pearls. Of all the Dolls, Kane appeared to be the most obliterated, as he stared toward the floor, ignoring his smoking cigarette and his half-filled champagne glass. To Johansen's right was Johnny Thunders, complete with bouffant hairstyle, heavily applied makeup, tight black pants, and white platforms with leather anklets. In slight contrast to Johansen's self-obsessed gaze, Thunders's hard glance toward the camera implied the sexual allure of a drunken harlot, his legs spread wide to further the invitation. On the edge of the sofa sat Jerry Nolan, who stared neatly ahead at the camera, a long spit-curl falling down his forehead. Nolan presented the only dissimilar image, in that he was positioned in a prim manner, pulling his embroidered jacket together at the lapels, his heeled ankles tucked to one side.

Overall, this coherent/incoherent image was much more flamboyant than any of those presented on the covers of *Love it to Death* (Alice Cooper, 1971), *Raw Power* (Iggy and the Stooges, 1973), *Transformer* (Lou Reed, 1972), or

The Rise and Fall of Ziggy Stardust and the Spiders from Mars (David Bowie, 1972). Here the Dolls were not only flagrantly toying with transvestism, they were portraying for a national public an image that presumably could not be comprehended outside the inner ranks at the Mercer or Max's. "Subterranean sleezoid flash" was thus on the verge of announcing itself to a larger audience; among those who comprised that audience, it would seem that in the context of summer 1973, the only comparable references might have been media-induced images of hardened street prostitutes.[34] Or, as would often be the case, the Dolls were perceived as "trampy glitter rockers" (a label that they neither encouraged nor denied at this time). Curious about the Dolls' intentions, Danny Sugerman asked of Johansen, "But what about the midwest where the kid comes in looking for the new Allman Bros. album and he sees five guys in drag on this cover with their name drawn in lipstick?"[35] Johansen responded:

> That album cover, we wanted to do a high camp kinda thing on pop, you know what I mean? A camp on pop, that's one of our favorite hobbies. Take pop to its logical extension. That's pretty much what pop is about anyway. If you're gonna be a pop artist and really understand what pop is, then you *have* to camp on it, I mean that's cause that's part of what pop is. So what we do is camp on all the elements of rock and roll and things like that. We designed the cover as kind of a joke. I think when the kid comes in and sees the picture, he's gonna forget about the Allman Bros. and he's gonna have to buy it. You know he's gonna have to wonder what the hell's inside that![36]

Once the album was opened and actually *heard*, the kid of Johansen's description was presented with a record that was certainly indicative of early punk.[37] Indeed, the album was a major source of inspiration for John Lydon (a.k.a. "Johnny Rotten"), the future members of the Ramones, and a broad spectrum of young musicians who considered it to be of immediate significance in the early 1970s. In reference to this impact, Tony Parsons states, "Until the *New York Dolls* a hangover from the sixties had permeated the music scene. That album was where a new decade began, where a contemporary version of the essence of rock 'n' roll emerged to kick out the tired old men and clear the way for the New Order."[38]

In *The Noise: Notes on a Rock 'n' Roll Era*, Robert Duncan's retrospective account of the 1970s, the author suggests that the Dolls' nihilistic, "post-Bowie" approach to glitter rock actually involved a dismissal of much of what glitter (and rock and roll in general) had come to represent in 1973. In effect, the Dolls established a punk-oriented, paradoxical strategy; they played rock and roll, and in the process they discarded most preordained notions about *how* to play rock and roll. In addition, and more importantly,

whereas Bowie's self-absorbed "Ziggy Stardust" character both critiqued and celebrated the plasticity of rock stardom:

> [The Dolls] seemed prepared even to dispense with the rock stardom, playing instead "rock stars" from yet another [negatively inspired] distance, "*glitter rock stars*." But unlike the negative movie-within-a-movie of Gimmie Shelter, finally it worked. The quotes-in-quotes, all that self-consciousness laid on self-consciousness, somehow served to make the Dolls about as genuine a rock 'n' roll band as turned up in the last decade.[39]

It was, in fact, this sense of genuineness that caused rock critics to herald the band as *the* avant-rock "glitter-styled" group of the moment. Indeed the Dolls added a sense of mayhem to glitter and inadvertently transformed it in ways the others (Bowie, Lou Reed, Brian Ferry) couldn't. The Dolls, for one, were not even twenty when their first album was released.[40] Second, the band's streetwise, working-class stage demeanor drastically contrasted with the more elevated class pretenses subscribed to by performers such as Bowie and Brian Ferry. Third, amid the implementation of catchy hooks and standard pop items such as whistles, sighs, and glaring riffs, the Dolls still forwarded the notion that they were producing *difficult* music.

Upon noting the album's glaring chaotic textures, dedicated rock critics wondered if the band's musical and visual style(s) would be "decipherable" to listeners who were not involved in New York's Max's Kansas City scene. In pondering the very notion of contextuality, however, most critics agreed that the Dolls' unpolished image could actually be used as a springboard for creating effective publicity. Because the Dolls' sound and image qualified the essence of teenage rebellion, the hope was that adolescents would be able to identify with the band, no matter the local context.[41] Thus, in defending the Dolls' potential ability to obliterate contextual limitations and to instigate nationwide pop subversion, critics forced the argument that in this case "authenticity" could and *should* coincide with commercial appeal.

The following month *Creem* writer Robert Christgau began his review of the Dolls' album by first discussing the inconsistencies posed by contextuality even in the city that had spawned the band. Christgau briefly explained that if you claimed to be a New York Dolls' fan in New York, heterosexuals automatically assumed you were gay. At the same time, Christgau claimed that gay people assumed Dolls' fans to be straight.[42] After all, the Dolls' music exhibited no correlation to that which was played in gay nightclubs. Finally, Christgau contended that *any* claim of allegiance to the band resulted in the "hip people" baiting you as being *too* trendy; thus, for the Dolls such "abuse" had become "more or less the natural thing."[43] After spending four paragraphs pondering the "dynamite riffs" and the "careening

screech of their music," Christgau concluded that it was his hope that the Dolls would be able to "break out" of New York:

> All good music—all good art, if you'll pardon my French—is rooted in particulars and moves out from there. This is the most exciting hard rock band in the country and maybe the world right now, and it has room to get two or three times as good as it is.[44]

In essence, each of these critics (Christgau, Duncan, Edmunds) *and* Johansen were concerned with a similar type of question: Would the band's "camp approach" somehow conceal its attempt to effectively produce earnest, primal rock and roll? Concurrently, all of these commentators were cognizant of the confusion that might arise in regard to the band's *doubly* ironic stance of "camping on pop" (which, following on the assertions of both Johansen and Duncan, actually suggested "camping on glitter").

To further clarify these kinds of concerns, we might briefly denote the differences between the New York Dolls and a band such as the Velvet Underground.[45] Arguably, the Velvets were *explicitly* serious in their endeavors, never mocking the world they were describing but instead exposing its contradictions through a series of juxtaposed vocal, lyrical, and stage-produced arrangements. The Velvets were certainly, as Ellen Willis has pointed out, "punk aesthetes." Thus, when willing to transcend their world and reach the possibilities of another, they engaged in more direct philosophical pursuits.[46] The classic "Jesus"/"Heroin" dichotomy provides the clearest case.

Conversely, the Dolls were to be taken *seriously*, but they were working on the pop terrain of avant-rock, not the darker and more brooding avant-garde format subscribed to by the Velvets. In reaching this more pop-oriented plateau, the Dolls employed what gay historian Michael Bronski cites as "camouflage" (i.e., camp) by not expressing the world "as it is," but instead by "imagining it as it could be."[47] This, the very nature of camp, seems highly analogous to the uncanny penchant that the Dolls had for maintaining a sense of humor throughout their music and their stage act. As Bronski claims:

> Camp is the re-imagining of the material world into ways and forms which transform and comment upon the original. It changes the "natural" and "normal" into style and artifice.... Ultimately camp changes the real, hostile world into a new one which is controllable and safe.[48]

In attacking Sontag's suggestion that camp is apolitical, Bronski retorts, "because it contains the possibility of structuring and encouraging limitless imagination—to literally create a new reality—it is not only political but progressive."[49] But what are we to make of a camp aesthetic that was designed to be self-referential to its own transformation of "the natural"

(pop as "pop," glitter as "glitter")? In attempting to answer such a question, Robert Duncan once again provides insight by suggesting that the New York Dolls took *nothing* seriously:

> Not rock and roll, not rock stardom, and especially not the back room [at Max's]. Nihilism on nihilism, and before it inevitably imploded, it served to keep them honest—and us too. By which I mean it kept us all laughing.[50]

Based on Duncan's assessment, we can begin to ascertain the impact of presenting glitter as "glitter," for whereas the Dolls might not have (openly) *claimed* to have subscribed to the concept, it is quite certain that they implemented it in principle. And, most assuredly, it was this tenet of camping on an already camp-laden genre that resulted in confusion among those who were not explicitly aware of the "insider" premises that guided the band. After all, double-negative "films within films" are never quite perceived as such unless the audience is made explicitly aware of the director's intentions.

Thus the trouble for the Dolls began when they assumed that the "kid buying the Allman Bros." (i.e., the "mass audience") would be able to delineate between quotes, and quotes layered on top of quotes. In essence, the Dolls overloaded their assumptions concerning the mass audience, which lead the band to exclaim, *Too Much Too Soon*.[51] But in the process of comprehending the impact of double citations, the Dolls encountered what seemed to be a set of endless possibilities—well intentioned or well conceived, it mattered not. By the fall of 1973 the band had begun a thirteen-gig tour, with stops across the East Coast, the Midwest, the South, and the West Coast. Banking on the possibilities of Mercury's promotional banner ("A band you're gonna like, whether you like it or not"), the Dolls found that their image *had* struck a chord among an unexpectedly large group of fans.[52] These fans composed a cult audience, and the Dolls were booked mostly in small concert venues, but nonetheless the capacity crowds suggested that, yes, even the "kids in Kansas" were perhaps capable of comprehending the band's campy approach to rock and roll.

Of all the stops on the tour, Los Angeles and Memphis were the most significant, due to the fanatical responses of fans in these cities. In Los Angeles, the Dolls were booked to play at the infamous Whiskey A Go-Go, where, on the afternoon of their performance, fans were already lining up in anticipation. Lisa Robinson, a native of the New York Max's/Mercer scene, was sent by *Creem* to investigate both the fans and the L.A. rock circuit. One of her first assessments was that "kids in L.A. *live* for rock concerts," because unlike the scene makers in New York who are "up all night anyway," the L.A. kids are starved for *any* form of excitement that might help them transcend their "mundane lives."[53] Robinson's East Coast snobbery was

supported by local resident David Robinson of the Modern Lovers: "This is
the dullest town. This is absolutely the biggest thing to hit this town....
[L]ittle kids have been waiting all their lives to see the New York Dolls."[54]
After setting out on her journey, Robinson's first encounter with fans
occurred outside the Whiskey:

> Kids who can't be more than twelve years old, boys with lipstick smeared
> on their faces, girls with all those kitschy, clutzy shoes, hot pants and
> feathers. Like some kind of fungus, it's slowly creeping across the coun-
> try, but it's at its best in L.A. I'm talking about *sleeeeeeze*.[55]

After the performance that evening, Johansen excitedly described the fans'
sense of style and humor as "low camp" and reported his bewilderment
when gazing at the crowd:

> It was amazing. I didn't think they let children like that out at night. If you
> could have seen it from where I was standing, little kids grabbing at me;
> literally they couldn't have been more than twelve years old. Little boys
> with lipstick—thirteen-year-olds, and they would touch my legs and
> hands. I *loved* it. These kids just want to be part of the pandemonium.[56]

The following morning Robinson concluded her journey to L.A. with a
stroll down Hollywood Boulevard. Dressed in high-heels and tight jeans,
Johansen and Thunders accompanied her. At one point the two performers
stopped to pose beside the show window at Frederick's of Hollywood. At
that moment Robinson arrived at a fitting appraisal of the two-day experi-
ence: "New York Trash had met L.A. Sleaze and the confrontation was for-
midable."[57] Elektra promoter Danny Fields, also along for the trip, summed
up the Dolls' impact in a more direct manner. When questioned about the
reason the Dolls' music had instigated a cult following in Los Angeles, Fields
responded with a concise and satiric answer: "Don't talk to me about
music.... It's too absurd. Anyone connected with this industry who talks
about *music*, well that's just astonishing. Play music indeed—thank god they
don't have to."[58]

On September 21, 1973, roughly one month and five stops later, the Dolls
set their sights on Memphis, Tennessee, a city with officials who did not pre-
fer to let the band perform without facing some local harassment. On the
day of the concert, the Memphis Board of Review announced that opening
performer Iggy Pop would be arrested for any number of offenses if he dared
to engage in his routine antics. As for the Dolls, the Board *assumed* that they
were a troupe of female impersonators, and because this kind of presentation
was outlawed in the city, the band members were informed in no uncertain
terms that they *could not portray women onstage*.

By 8:00 P.M. that evening, the Memphis police force had been doubled for

the concert, with the uniformed officers surrounding the stage and the boundaries of the auditorium. The Dolls played all of the numbers from their impudent repertoire, while facing what Johansen described as "Red Square on May Day."[59] Leading the brigade was a collection of teenage males who were particularly noticeable due to their military haircuts and sequin-covered faces. After the Dolls had completed a grueling ninety-minute set, these young men guided the crowd through chants that emphatically demanded an encore. In giving concession to the outbursts, the Dolls returned to the stage, therefore exciting one young man to the point that he ignored the police, pushed straight over the orchestra pit, embraced Johansen, and kissed him on the mouth. Johansen responded positively by lurching toward the crowd in an attempt to endorse more physical participation. But by this point, the police force was in action. The "intruder" had been captured and was visibly being beaten, thus causing Johansen to stop "Jet-Boy" in midsentence and scream, "Are we going to take this?" Collectively the crowd resounded with negative remarks as Johansen lead a series of obscene taunts. As the chaos mounted, audience members pushed toward the band and cheered wildly as Johansen grabbed Thunders's guitar, broke the neck on center stage, and then threw the pieces into the crowd.

During these proceedings, however, the police had managed to encircle the band. Johansen boasted a satirical reaction as he lifted his fists in anger, while presenting a casual, pouting pose. The officers responded by pulling him from the stage and hustling him out a side door. Not wishing to be upstaged, Johansen momentarily disengaged an arm and blew kisses toward his fans. Taking his apprehension none too lightly, the fans became so unruly that they were forcibly pushed (by the police) from the concert hall into the downtown streets, where many were then arrested on a number of "riot" charges.

On the way to the police station, handcuffs on, Johansen asked, "Would you do this to Elvis?" The arresting officer answered, "I'd *love* to get Elvis."[60] After spending a night in jail for disorderly conduct, Johansen appeared on the courthouse steps, and announced to a shocked and eager local press: "They *loved* me in the cellblock!"[61]

It was a night that seemed to bring together all that the band had come to epitomize during the past year. For the New York Dolls, camping on glitter/pop certainly *did* have serious ramifications, which the Memphis fans understood all too well. Within a week the band members had become local heroes, and the stories of arrests and court proceedings provided fans with evidence that they (like their New York compatriots) were *also* an insider's club. Obviously this was a club that was willing to risk a great deal in order to find refuge in the Dolls' unsettling music and campy visual style.

1974:
THE DANGEROUS GAME OF LISTENING TO ROCK JOURNALISTS

As 1973 drew to a close, the New York Dolls began a tour of Europe, starting in London where they played Biba's Rainbow Room. While in Britain, the band was watched by fashion designer/situationist Malcom McLaren, who had met the band earlier that year in New York and found their music "so awful that it crashed through to the other side, into magnificence."[62] Accompanying the Dolls on every stop, and taking note of their fashions and their caustic attitudes toward the press, McLaren was careful to absorb all he could, especially from David Johansen. But by this point, the band had taken a number of subtle turns, and it simply was not the same as it had been at its inception.

For one, the extremity of the Dolls' "transvestite image" had caused London journalists to draw comparisons to a number of British glam/glitter acts. Sensing what were to them obvious differences, the Dolls toned down their more overt gender-bending exhibitions and inaugurated other images of shock. Johnny Thunders, for example, began wearing a swastika armband while onstage.[63] Despite the changes in visual style, members of the British press did not consider the Dolls to be particularly remarkable; thus, the focus centered on the band's "malicious reasoning" and "awe-inspiring" public behavior.[64]

Ironically, while the Dolls were provoking reporters in Britain, they were continuing to acquire critical acclaim in the States, especially at *Rock Scene* and *Creem*, where Dave Marsh, Lester Bangs, and Lisa Robinson were delivering reverent accolades on the band. The excessive attention given to the Dolls prompted them to begin to cultivate what would eventually become a steadfast desire: increasingly, they wanted to move from the "level" of cult appeal into a more commercial arena where they would still be accepted on their own terms but would receive the benefits of well-deserved fame. Because the critics were so unwavering in their claims, perhaps the Dolls could *become* the very band that was being described.

Upon their return to the United States in the spring of 1974, however, the Dolls did not become "America's answer to David Bowie [or the Stones]," nor did they achieve the kind of compensation that often coincides with impassioned critical labels and enthusiastic press releases. While continuing to tour, they found that, at most, only small factions of rock and roll fans seemed to grasp the band's hard-edged sense of style and its musical nihilism. Hiring Shadow Morton as the producer of their second album (*Too Much Too Soon*) didn't improve matters, though critics such as Dave Marsh claimed that the band's effort represented "the best hard rock in America."[65] Nonetheless, the Dolls' attempt to finally break out of New York on a massive scale failed, and too many among the "broader" audience simply viewed

the band as yet another version of the "it's so bad it's good" approach to rock and roll. But as Robert Christgau recounts:

> Camp or no camp, theirs was not a cause of a "seriousness that fails," of this-is-so-bad-it's-good. On the contrary, the Dolls were the ultimate instance of the miracle of pop, using their honest passion, sharp wits, and attention to form to transform the ordinary into the extraordinary.[66]

In giving consideration to Christgau's assertion, it is reasonable to suggest that the Dolls' inability to actually "achieve the extraordinary" in the manner established by Bowie (or the Stones) was, in part, due to the kinds of assumptions (trisexualism, camping on pop/glitter) that the band had so forcefully advanced during the Mercer days, and, subsequently, during their first tour. For even as the Dolls hoped to achieve the kind of mass approval that sometimes follows enormous amounts of critical praise, they found it problematic to cross the hurdle of being perceived as "a band that was camping on pop/glitter"—the very theme that they had alternately dismissed and magnified during 1973, the very theme that in some senses seemed dated by 1974. After all, it was difficult to tease the image of "glitter rock stars" when the actual stars had, by this point, abandoned the genre and moved on to other musical/stylistic domains. Thus, if glitter could no longer be played out as "glitter," then the Dolls faced the task of breaking somewhat from this self-referential mold, while simultaneously attempting to find favor with a larger audience.

But the band's disposal of its "feminine" clothes and its attempt to enter the terrain of hard/pop rock resulted in confusion among original fans.[67] From the fans' standpoint such tactics suggested that the Dolls were in the process of creating an overtly commercial image. (As we will recall, this was a serious faux pas for an "authentic band" to commit.) While the fans were not grossly misinterpreting the situation, the Dolls' new image *was* ill defined. More was said about what it did *not* represent than about what it was actually capable of conveying.

Here we might consider that the Dolls' loosely defined stratagems would probably be more acceptable in contemporary times.[68] However, in 1974 the band's "methods" served to confuse not only fans, but also those who were unfamiliar with the Dolls' "authentic stance." For one, the much-hoped-for broader audience actually had little frame of reference for ordering or locating the band within the range of a preordained hard rock (or, for that matter, pop) genre. Second, the music of *Too Much Too Soon* was a long distance from any category of rock and roll where it might have found an easy fit. The album certainly wasn't similar to Bowie's *Ziggy Stardust*; it was too sophisticated for the listeners of Grand Funk; it was not "heavy" enough for the fans of Led Zeppelin or Black Sabbath.

Simultaneously, the band faced another bind. Having no new attitudinal/performance techniques that might aid in expanding their core following, the Dolls seemingly assumed that a toned-down wardrobe, some subtle changes in musical style, and a number of verbal disclaimers would result in the acquisition of a mass audience. This assumption, however, did not pan out, and by the end of summer 1974, as Pete Frame states, "the Dolls were back where they started in small New York clubs ... 'a wrecked monument to pill-popping, booze swilling, multisexual, wasted teenage America.'"[69]

But what was the ultimate reason for this kind of conclusion? Whereas I have discussed some of the specific details that lead to the Dolls' dissolution, at this point I want to suggest that during 1974 this "authentic band" committed the ultimate dysfunctional act: the Dolls ignored the negatively inspired premise (i.e., fans paying *their* dues) that had been so instrumental in establishing their nationwide cult audience. In the process, the Dolls half-heartedly attempted to construct a new image; more importantly, they made it clear that they hoped to construct a new audience. In these ways, then, the Dolls were similar to any other commercial act, but this was not a band that could expect to envision the possibilities of commercialism through the process of corporate blueprinting. Thus, as the Dolls proceeded to enter a more expansive commercial sphere, they disregarded one of the central determinants in the establishment of their cult following: from 1972 to 1973 the band had required that fandom arise through the development of "acquired tastes." And whereas none of these procedures activated total rejection among members of the "insider's club(s)," the band's agenda did suggest that it might be wavering somewhere between authenticity and blatant dishonesty.

THE INSIDER'S CLUB AND THE FINAL WORD ON AUTHENTICITY

Additional confusion among original followers during the spring of 1974 resulted mainly from the fact that the Dolls consistently attempted to give credence to the critical labels ("greatest," "best," "the answer to ...") that seemed inherently oppositional to the band's lawless infrastructure. Such credence was observable in interviews with the press in which the Dolls, in a very urbane and defensive manner, attempted to play down the notion that they "were a glitter band." In responding to questions, they also slighted their origination in a "camp on pop/glitter" approach to rock and roll.[70] What seemed shortsighted about these ongoing, and thus wearisome, claims was that during the months in which the band had gained a following, it was admired for having an honest and veritable stance. In fact, it was the Dolls themselves who had often exaggerated the idea of "camping on glitter," and an attempt to dismiss this concept in an extremely *serious* manner seemed contrary to the band's well-established chaotic and humorous patterns.

In the views of fans, an expansion of this concept would have perhaps been admirable. To encourage the application of commercially acceptable labels and to disparage the "camp premise" altogether, however, seemed fake. The Dolls, unlike Bowie, had not adopted personas; the band could not have successfully employed the so-called "chameleon pose." Likewise, Bowie's stage personas were framed within the realm of fantasy, whereas the Dolls had brilliantly confused fantasy through combining cross-dressing (as a camp on pop) with a very real image of the frustrated (and joyous) teenager. By way of further comparison, I refer to Simon Frith's claim that Bowie is the only star who cannot "sell out" because his emphasis has always been on the invention of self. As Frith explains:

> To appreciate Bowie was not just to like his music or shows or his looks, but also to enjoy the way he set himself up as a commercial image. How he was packaged was as much an aspect of his art as what the package contained.[71]

Unlike Bowie, the Dolls had originally presented an image that was not constructed per se, but one that forwarded the premise that they were to be held in high esteem simply because they were "outcasts."[72] At the time of the Dolls' first tour they appealed to a cult following that felt empowered by the band's ability to relate an extraordinary sense of disempowerment: what it meant to be a part of "wasted teenage America." The population that actually identified with the Dolls was small, disenfranchised, and very much of the belief that it understood the band's ironic (campy) posture, as well as the more straightforward notions implied by Johansen's claim regarding trisexualism. To draw on another comparison, Bowie's admission of bisexuality was perceived by Dolls' fans as being to the right of radical when measured against Johansen's claim, "We're trisexual. . . . We'll try anything."

Certainly, Johansen's claim regarding sexual freedom provided some fans with the encouragement to "try on a lifestyle," while other followers found the claim (and image of the band) to be within the realm of pure approachability, and thus complementary to their own sense of sexual libertarianism. Johansen assessed the attitudes of this second group of fans in the following manner:

> Kids are finding out that there isn't that much difference between them sexually. They're finding out that the sexual terms, homosexual, bisexual, heterosexual, all those are just words in front of sexual. . . . You can go to England where they have homosexuals, heterosexuals, and bisexuals [who are up-front about their sexuality], but it doesn't make any difference because nobody gets laid. That's just an analogy. I mean, people are just sexual, man.[73]

In presenting a corresponding claim, Christgau notes:

> What made them [the Dolls] different was that their sweetness and tough-
> ness and alienation knew no inhibitions, so that where love was concerned
> they were ready for anything. By their camping they announced to the
> world that hippie mindblowing was a lot more conventional than it pre-
> tended to be, that human possibility was infinite. Of course between
> Arthur's instinctive awkwardness and Syl's clowning and David's pursuit
> of the funny move, they suggested that human possibility was hilarious.
> And the band's overall air of droogy desperation implied as well that
> human possibility was doomed.[74]

In part, the demise of the Dolls was inevitable, because no matter their
commercial designs, they remained staunch in their attitudes regarding
sexual desire. Still, in spite of their efforts, the possibilities set forth by such
"try anything" premises were in fact so open-ended that they had little
likelihood of appealing to more than a cult audience. Such premises were,
oddly enough, generic, and perhaps, given the context of the early 1970s, a
little too all-assuming. In fact the Dolls' "one size should fit all" principle
was *so* impartial and carried such subcultural weight that it simply did not
have the possibility of translating beyond particular insider locales and
contexts.

The fans who appreciated the Dolls did not comprehensively dismiss the
band during its shift toward a more "toned-down" gender-bending style,
because trisexualism (however subdued) remained central to the band's atti-
tude and image. Nor were fans unanimously perturbed by the Dolls' desire
to enter the hard rock genre; even at their most commercial level, the Dolls
were a far cry from Bachman Turner Overdrive or Grand Funk. However,
by the end of 1974, what became unacceptable was the band's refusal to
acknowledge the message that original fans had related all along: Dolls' fan-
dom didn't require the hard sell; it had to be *earned*. The fans were content
to pay their own dues, and this often carried with it the implicit under-
standing that the Dolls were not meant to be comprehended beyond the
progressive, ironic, and disruptive structures of meaning that they had so
cleverly forwarded as a cult band. But when the Dolls attempted to reverse
the premise of fans developing *with them*, original followers could not blankly
claim allegiance to the same set of possibilities—because the open approba-
tion of the Dolls' generic premises, when matched with their grievously
comforting rock and roll, was indeed the point of it all, the reason for the
exhilaration that was so often misunderstood.[75] All things considered, the
Dolls' music did translate outside of New York. In the process, the band
instigated the formation of another insider's club—one that was unwilling
to give concession to those who wanted pleasure without having to pay the
price.

NOTES

I would like to thank Alexander Doty, Lawrence Grossberg, and Carole Spitzack for their valuable comments on an earlier draft. I would like to thank Mandy Richardson, Kathleen Turner, and Nick Yurczak for their encouragement and support.

1. Simon Frith, *Sound Effects: Youth, Leisure, and the Politics of Rock and Roll* (New York: Pantheon, 1981), 48–52.

2. For an in-depth explanation of the subcultural underpinnings of glitter rock, see Van M. Cagle, *Reconstructing Pop/Subculture: Art, Rock, and Andy Warhol* (Thousand Oaks, Calif.: Sage Publications, 1995).

3. Specifically, Andy Warhol's Factory, the late 1960s rock and roll subcultures of Ann Arbor/Detroit, and the arts lab subcultures of London (1967–69).

4. Here my use of the term recontextualization is not to be compared to Hebdige's use of the term in *Subculture: The Meaning of Style* (London: Methuen, 1979). At this point in the paper I am suggesting that a number of glitter musicians (in the New York/London/Detroit vein) simply translated localized/subcultural notions about style for a wider audience. Since glitter derived from urban locations, I am particularly concerned with those populations of young people who were located in more remote geographic areas.

5. I am not suggesting that without glitter rock potential fans would have had no knowledge of the kinds of styles/themes it promoted. At the same time, glitter provided immediate access to styles and attitudes that were previously *not* available to rock and roll–oriented youth. In particular, as I will point out, at a time in which bisexuality and homosexuality were not openly treated in popular music, glitter made accessible that which had previously been ignored.

6. Gary Herman, *Rock and Roll Babylon* (New York: Perigee Books, 1982), 71.

7. Angela Bowie, *Free Spirit* (London: Mushroom Books, 1981), 74.

8. Hebdige, *Subculture*, 61.

9. See Cagle, *Reconstructing Pop/Subculture*, 1–48, 205–23.

10. "World domination" was the goal of Bowie's manager, Tony DeFries. See Barry Miles, *David Bowie Black Book* (London: Omnibus Press, 1980), 38.

11. Roy Hollingsworth, "You Wanna Play House With the Dolls?" *Melody Maker*, 22 July 1972, 17.

12. Ibid.

13. Ibid.

14. See Jack Hiemenz, "New York Dolls: From Welfare to the Waldorf," *Zoo World*, 20 December 1973, 26–27; and Tricia Henry, *Break All the Rules: Punk Rock and the Making of a Style* (Ann Arbor: University of Michigan Research Press, 1989), 40. Whereas neither author uses the label "Stones Clones," they do acknowledge and briefly describe the origins of this comparison.

15. As quoted in Van Cagle, "David Johansen," *Punk* (May/June 1979): 17.

16. Pete Frame, "Out in the Streets," *The Complete Rock Family Trees* (London: Omnibus Press, 1979), 27.

17. Ibid.

18. As quoted in Jon Savage, *England's Dreaming: The Sex Pistols and Punk Rock* (New York: Faber and Faber, 1991), 61.

19. Hollingsworth, "Wanna Play House With the Dolls?" 17.

20. "First Annual New York Dolls Trivia Quiz," *Zoo World*, 3 January 1973, 10–11.

21. Savage, *England's Dreaming*, 61.

22. For a similar description, see Robert Christgau, "New York Dolls," in *Stranded: Rock and Roll for a Desert Island*, ed. Greil Marcus (New York: Knopf, 1979), 133.

23. Ken Tucker, "All Shook Up: The Punk Explosion," in *Rock of Ages*, ed. Ed Ward et al. (Englewood Cliffs, N.J.: Random House, 1986), 549.

24. Christgau, "New York Dolls," 134–35.

25. Ibid., 134, emphasis mine.

26. Both Robert Christgau and Jon Savage have forwarded similar claims. See Robert Christgau, "New York Dolls: L.U.V. 'Em or Leave 'Em," *Creem* (November 1973): 62–63; and Savage, *England's Dreaming*, 60.

27. Emily Oakes, "The Advent of the Obnoxoids," *Rock*, 10 September 1973, 6. "Billion dollar baby" was a common catchphrase, which referenced the title of an Alice Cooper album.

28. For a similar description, see Christgau, "New York Dolls," 132–47.

29. During the early 1970s "punk" was often used in a colloquial manner among rock critics, but it was not yet commonly used in reference to a particular genre/style of rock and roll.

30. See Hollingsworth, "Wanna Play House With the Dolls?" 17; and Dave Marsh, "Too Much Too Soon," *Rolling Stone*, 20 January 1974, 79.

31. Readers' Poll, *Creem* (May 1974): 46–48.

32. As told to Bob Gruen, and as quoted in Savage, *England's Dreaming*, 61.

33. Ibid., 41.

34. Audiences were no doubt familiar with Bowie and his androgynous Ziggy; yet this particular image centered on a "play at" gender ambiguity. Bowie never appeared as a woman during this period. Thus, fans who were already predisposed to glitter found that the Dolls presented a more directly confrontational construction of gender bending.

35. Danny Sugerman, "They Walk, They Talk, They Eat, They Excrete! They're the New York Dolls," *Rock*, 25 March 1974, 20.

36. As quoted in ibid., 21.

37. Here I am using the term as a reference to the music that would arise two to three years after the Dolls' demise: New York and British punk.

38. Tony Parsons, liner notes, *The New York Dolls* (Double Reissue), Mercury/Polygram (London n.d.), Catalog # 6641631CF.

39. Robert Duncan, *The Noise: Notes from a Rock 'n' Roll Era* (New York: Ticknor and Fields, 1984), 98, emphasis mine.

40. Bowie was not much older, yet his music seemed extremely sophisticated. The Dolls presented unrefined, garage-styled rock that was more in line with the late-1960s Detroit/Ann Arbor sound than it was with Bowie's highly conceptual approach to rock and roll.

41. For example, rock critic Ben Edmunds claimed:

 The question exists as to whether something so totally tied to New York can possibly mean anything to somebody in Kansas; the kind of culture gap that cost the Kinks so much of their American audience with "Waterloo Sunset." The answer is *Yes*. In the first place the Dolls' music talks to rock and roll kids about the things common to all of them; New York just makes those things more obvious and immediate. And the Dolls, in turn, help New York transcend its ugliness and become once again the city of myth and mystery it once was. Many observers contend that the Dolls define New York in the same way as the Velvet Underground, but the way the New York Dolls define New York is actually much closer to *West Side Story*. The difference is between success and failure.

 Edmunds, "The Dolls' Greatest Hits Vol. I.," *Creem* (October 1973): 42.

42. It should be noted that although Christgau's claims were perhaps intended to be humorous, he does use the term *fags* in reference to gay people. Given the negative connotations of this term, I refuse to quote him directly in this particular case. The content of the article is, however, directly described.

43. Robert Christgau, "The New York Dolls," 62.

44. Ibid., 63.

45. As mentioned in Edmunds, "The Dolls' Greatest Hits Vol. I.," 42.

46. See Ellen Willis, "Velvet Underground Golden Archive Series," in *Stranded*, 71–83.

47. Michael Bronski, *Culture Clash: The Making of Gay Sensibility* (Boston: South End Press, 1984), 43.

48. Ibid.

49. Ibid.

50. Duncan, *The Noise*, 103.

51. The album's title reflected the band's disdain for a scene that was often imposed on them during their first tour of the U.S. and during their subsequent trip to Europe. The title referenced personal as well as more audience-based concerns. Concurrently, as Jon Savage points out, the title was also the same as that of Diana Barrymore's biography. See Savage, *England's Dreaming*, 86.

52. In other words, the Dolls' music was translatable outside of New York. Yet, as Johansen will later point out, the "kids" didn't always comprehend the band's campy punch lines.

53. Lisa Robinson, "The New York Dolls in L.A.," *Creem* (November 1973): 44.

54. Ibid.

55. Ibid.

56. Ibid., 76.

57. Ibid., 78.

58. Ibid.

59. "Random Notes," *Rolling Stone*, 25 October 1973, 26.

60. Ibid.

61. Ibid.

62. As quoted in Savage, *England's Dreaming*, 62. In 1975, during a period not covered in this paper, McLaren served a brief stint as the Dolls' "manager."

63. Of course, at this particular point, the popularity of glitter rock was also diminishing. In addition, the Dolls had grown tired of "explaining" their cross-gendered fashions. At the same time, the band felt that a less obvious approach to "camp" might gain them more fans.

64. See Savage, *England's Dreaming*, 62–63. This is not to say that the Dolls did not receive positive reviews in Britain. I am suggesting, however, that their language and streetwise attitudes were not appreciated by British journalists, who were accustomed to a more refined approach (even among working-class British bands).

65. Marsh, "Too Much Too Soon," 79.

66. Christgau, "New York Dolls," 146.

67. Although critics had sometimes labeled the band's music as "hard rock," the category was not one that seemed entirely appropriate for the Dolls. "Hard rock" was a term that was often used to describe metal-oriented bands with a pop edge. Again, during the early 1970s musical categories were not as distinct as they would become by the late 1970s (e.g., hard rock/metal vs. punk).

68. Consider, for example, a band such as Sonic Youth, which has been able to effectively cross between a number of musical genres and visual styles. Nirvana provides a similar example. We sometimes forget that in the early 1970s, rock and roll requested an orderly labeling system.

69. Frame, "Out in the Streets," in *Rock Family Trees*, 27. Frame does not provide a reference for the quote within the quote.

70. See Sugerman, "They Walk, They Talk, They Eat, They Excrete. They're The New York Dolls!" 20–21.

71. Simon Frith, "Only Dancing: David Bowie Flirts With the Issues," in *Zoot Suits and Second Hand Dresses*, ed. Angela McRobbie (Boston: Unwin Hymen, 1988), 132.

72. I have no direct information that suggests the sexual orientation of band members. At the same time, the social construction of sexual otherness positioned the band as outcasts. And indeed, while onstage, Johansen and other band members often *appeared* to be more attracted to males than to females.

73. As quoted in Sugerman, "They Walk, They Talk, They Eat, They Excrete. They're the New York Dolls!" 29.

74. Christgau, "New York Dolls," 133–34.

75. As I have noted, the Dolls never established themselves among a mass audience; thus, this particular audience posed no actual threat to diehard Dolls fans (because the mass audience was, in effect, nonexistent). What was significant, however, was the fact that the Dolls *attempted* to broaden their audience base. In the views of fans, this attempt at mass appeal demonstrated a direct turn toward inauthenticity.

Fashioning
the Body

6

"These Boots Were Made for Walkin'"
Fashion as "Compulsive Artifice"

ANNE-LISE FRANÇOIS

Clothes, from the King's-mantle downwards, are Emblematic, not of want only, but of a manifold cunning Victory over Want.
—Thomas Carlyle, *Sartor Resartus*, 1833

"If you don't like the fit, you can split, you can quit, you can exit."
—Gloria Gaynor from the 1978 album *Love Tracks*

Skintight bell-bottoms, satin hotpants, velour T-shirts, three- to five-inch platforms, four- to five-inch wide ties, twenty-six-inch flares, collars out to the shoulders, polyester everywhere ... so one might begin to catalog the sartorial details for which seventies looks have been stigmatized and more recently revered. To accept these accents, overemphases, protrusions, and mix-ups as available and appropriate means of fitting in; to take such synthetics as natural; and to make a habit of exaggeration, wearing excess to conventionalize rather than stand out by it, is to participate, I want to argue, in a specifically seventies aesthetic of dress. From Carly Simon's casual way of showing us what she isn't wearing on the cover of her 1972 album *No Secrets*, to John Travolta's unabashed showing off of clothes that he hasn't earned in the movie *Saturday Night Fever*, seventies looks play on the simple but deeply interesting fact that clothes always perform a double function of concealing and revealing, of directing and deflecting attention; hiding at one level what they show at another, they doubly inscribe the body as the site of shame and vulnerability and sight of power and armor.[1] Thus Carly Simon backs up her ludicrous promise to keep no secrets with a peculiarly opaque form of transparency: she does not bare her breasts; she simply lets us see that she isn't wearing a bra (fig. 6.1). The banality of her jeans and T-shirt, simple and undatable except for the drawstring ties at the wrists, suggests that in the seventies, the disclaimer "No Secrets" is less a claim to the openness of the spotlight than a plea for trust—a question not of throwing off artifice and proclaiming freedom from convention but of

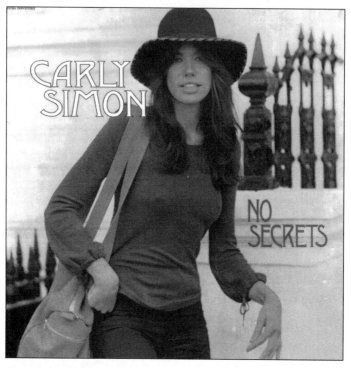

figure 6.1

de-emphasizing through habit otherwise noticeable absences, of demystify-
ing previously mystified erogenous zones, defusing and diffusing (at the risk
of wasting on the wrists) the psychic energies cathected upon the female
body. Simon's example reminds us that if women in the sixties burned their
bras, the challenge for feminists of the early seventies would have been to
take the scandal out of bralessness, making the practice so prominent and
accepted as to be both visible and hardly capable of attracting notice. If we
accept this admittedly crude historical schematic, following upon the cul-
tural revolution of the sixties, seventies looks engage a politics of habit, and,
by working and reworking unobtrusiveness into conspicuousness and vice
versa, they everywhere raise the heavily charged question of what it means
to accept anything as ordinary.

 This essay takes up this question as posed by seventies fashions in their
uneasy combination of over- and understatement. As an opening gambit,
the image of Carly Simon, the daughter of Simon of the publishing house
Simon and Schuster, dressing down as the ordinary American girl, seeking
to establish intimacy with everyone and anyone on the street, not because
she is special or famous but simply because she is like everyone else, already
anticipates the counterimage of Tony, the social climber in *Saturday Night Fever*,

with which this essay ends. For with her feathered hair and drawstrung wrists, Simon makes it clear from the start that there is no return to nature in seventies looks, only a compulsive attempt to naturalize want—like privilege—as simple idiosyncrasy or, better yet, mere conformism. There are too many contradictory reasons for why Simon might not be wearing a bra—she might have wanted to make the feminist point of shedding the marker of oppressive patriarchal constraints, or she might have wanted to flaunt her breasts, but she might also have forgotten to put one on that day, or have remembered and not cared, or more to the point of this essay, she might just have been conforming to the fashion of the time. Only the diffuseness of its possible explanations allows us to trust her look as she wants us to, as something less than staged. In the same way, in using so general and so amorphous a defining category as the seventies, my readings resist assigning clear agency to the potentially subversive, potentially innocent play of style to which they call attention. Metacritically, this indeterminacy corresponds to the tenuousness and tentativeness but also multivalence and open-endedness of any claims to be made about a common culture—the seventies—shared by people who might have shared nothing but the accident of a decade.

The same mixing-up of high and low registers, of plain and ornamental styles, that helps neutralize and reintegrate the mystified feminized body into a continuum of distracting details, works in men's fashions of the seventies to the opposite end of destabilizing the traditional inconspicuousness of male dress. Seventies looks for men embarrass because they undermine the image of manly independence from the vicissitudes of time, body, and context, which understated masculine garb has from the Enlightenment onward sought to project. If we think, for example, of the typical man's business suit in the fifties, the sixties, the eighties, and the nineties, we find a straight, predictable form that undergoes only minimal changes, and confirms Kaja Silverman's recent summary of the history of modern male dress:

> Whereas in earlier centuries dominant male dress gave a certain play to fancy, it has subsequently settled into sobriety and rectitude . . . [and has] given a very small margin to variation, remaining largely unchanged for two centuries. These last two features define male sexuality as stable and constant, and so align it with the symbolic order.[2]

As the (non)markers of a seemingly classless modern male dress code, uniformity and nondistinctiveness express the liberal, universalist ideal of the subject who does not need appearances to speak for him and who expects to be judged not by what he's wearing but by who he is "inside."[3] But if an indifference to bodily fashionings and a reliance on invisible expressive media (whether reason, words, the ballot, or paper money) over visual

ostentation, have indeed been the privilege of the straight white male sub-
ject, seventies fashions present a notable exception to the "Great Masculine
Renunciation" of exhibitionism in dress.[4] Only in the seventies do business
executives wear suits whose pants are flared. From stitching that shows to
lapels overworked with useless buttons, from the classic flared three-piece
suit to polyester leisure suits to velour jogging suits, the complexity and
flamboyance of men's clothes in the seventies match those of women's
(fig. 6.2). Confusing luxury with practicality, putting background ahead of
foreground, and giving the literal marks of stature without corresponding
status, seventies fashions deconstruct the difference between empty orna-
ment and loaded sign. Whether these styles represent accentuations of mas-

figure 6.2

culinity (wide ties and extended sideburns) or feminizations of the vertical phallic male body (flares, wide collars, and platforms), whether at work is an African-Americanization of the mainstream (the popularity of the Afro and Afrocentric looks) or a corporate takeover of working-class and hippie looks (the denim suit, fig. 6.3), seventies fashion wearers seem to be equally at home betraying their insecurities as advancing claims to power. Their clothes seem as much a practical means of achieving comfort (of facilitating entry into the dominant order) as a mode of expressing discomfort, a discomfort that easily shades into a form of dissent and silent protest.[5]

At the risk of showing an incredible literal-mindedness of my own, I want to take the following passage from *Vogue*'s January 1980 issue at its

THE
DENIM
BUSINESS
SUIT
$59.95

figure 6.3

word, and define the aesthetic of the seventies as everything the voice of January 1980 says "we" no longer need:

> The approach is different now and yesterday's attitudes play no part.... Our attitudes come through now, straight across; we no longer approach our goals on the bias.... Presence does not require adornment.... We used to deal with a lack of assurance by compulsive artifice. Presence is understanding that fashion is there to delight, enhance, and amuse, not to disguise.[6]

Uncritically valorizing presence and the present, these bald assertions identify full accession to adulthood and the exercise of power within liberal society with the ability to "come through straight across" without disguise, without delay, and without the help of "yesterday's attitudes." Claiming to emerge from the seventies as from a time of infantlike captivity to indirection and subterfuge, *Vogue*'s 1980s self-definition parrots the long-standing dream of Kantian enlightenment as man's liberation from self-imposed immaturity. Far from liberating, the dream of a presence achieved without disguise demands the wholesale adoption of the look of the moment as adequate to all time and the liquidation of any gap between essence and appearance, self and image, desire and the path of its achievement. Whereas in the seventies adornment was the tool or prop that allowed "us" to "approach things on the bias" and that asserted itself in our place, sometimes for and sometimes over against "us," *Vogue*'s forecast for the eighties once again makes of fashion a luxury, available only to those who can afford its indulgence and who need it only to enhance the power of a presence already fully backed by economic or political status.

But the "we" who "used to deal with a lack of assurance by compulsive artifice" knew the truth of the lie of adornment: namely, that adornment at once substitutes for and mimics the power of "presence," thereby both compensating for and prolonging its absence. The term "compulsive artifice" surprises and sustains our attention by its disarming honesty: not only does it admit that fashion is artifice—an attempt to control appearances, to strike a pose and make up an identity whose falseness remains unabashedly exposed—but it further demystifies the "presence" of fashion by suggesting that its artifice is like most habits—compulsive, second nature, automatic, and unwilled. It names a plea for control that is itself out of control. The term resonates with the compulsiveness of Adorno's figure of the jitterbug who latches on to popular songs and replays them in his head with a creative energy that might have been his own. It identifies the kind of latent creativity available to the consumer of late capitalist cultural practices who must choose, and yet finds no choice, between an internal emptiness and a wealth of commodified images without.[7] In this sense, "compulsive artifice" is synonymous with what Michel de Certeau, in his work on everyday consumer

practices, calls "an art of the weak"——"a calculated action determined by the absence of a proper locus." Like those sartorial habits that only further expose the deficiency they are supposed to remedy, "art of the weak" and "compulsive artifice" are terms that may well disturb or embarrass the reader, for rather than denying want, they openly admit it on at least one scale of value, whether political, economic, or psychological. Far from a means to sufficiency, the unexpected resourcefulness that they bespeak consists of blurring the difference between necessity and style, convention and freedom, techné and trope.[8]

Thus, according to *Vogue's* forecast in January 1970, the seventies will indeed understand fashion as a practical necessity (albeit one whose demands may carry one to impractical lengths) and not as the simple expression of a unique look all one's own and of one's making. It makes no sense to judge a decade's style as high or autonomous (as opposed to practical and tactical) art, when by its own account in January 1970, yesterday's cultures and countercultures have already become tools for getting on in the world. Where 1980 will lay pretense to presence without disguise, the fashion industry's number one source is here refreshingly honest about its basic dishonesty, for what 1980 will call "compulsive artifice"——a creativity imposed from without, having no proper locus at its origin——is the unscrupulous art of both the colonized and colonizer, exploited and exploiter:

> This is the year when everything is available and extremely good—not to a jaded eye. But to the woman with active tastes and her eye on things, fashion for 1970 will look very very good indeed—always with a different little teeny weeny gigantic slant to it. Skirt lengths will vary with your moods. And forget all the rules about one right look—indulge your imagination. . . . We are going back to instinct. We have had the gypsy look and we are sticking with it. We have had the hippie look and we adore it. These are the rich looks now. These are the looks that make you discipline yourself and you have to weigh and play with color, design, proportion, how much, how little to put on, when and if, and how—in fashion today, selectiveness is as important to you as a friend at Chase Manhattan.[9]

Fashion is like a friend at Chase Manhattan—what doors will it, he, or she open for you? One thinks in this context of how often seventies looks have been scoffed at for their "tackiness." Tacky used to mean lower-class and now connotes illegitimate pretense and showiness, as when a person makes a point of showing what she does not actually have, or when we use (as we did in the seventies) inflated currency we can't actually back; what is most resented in tacky things is not their lie but the way in which their lie shows.

Platform shoes, for example, are an extremely literal way of giving oneself a little extra boost. But how can a device allow me to pass for taller if

what it does most in being seen is expose my inability, or perhaps most truly, my unwillingness to meet such a standard? Thus a mail-order ad appearing in *Ebony*'s August 1972 issue shows a black, braceleted hand raising up a two-inch-heeled platform shoe to the words "Rise on" (fig. 6.4). Extraordinarily overdetermined, the ad owes its success, I would argue, to its literalism, to the obviousness with which it suggests using fashion as a friend at Chase Manhattan. Command or wish, the slogan "Rise on" naturalizes progress as something that is already happening and just has to keep *on* happening. "Rise on" instead of "ride on" (or even Right on!); in 1972 it would be hard not to hear this as a transposition of civil rights expressions of faith in black power and black freedom into an asocial and depoliticized consumer context where the address can no longer be collective because it is no longer a question of a struggle to mobilize people around a common experience of racial disempowerment but of any individual's quest for upward mobility. The ad, it seems, has taken political calls for redistribution of power too literally; all the shoe promises is to take its wearer up on the ladder of success.

But in articulating the slogan's silenced political content, we cannot escape the blatant fact that the shoe isn't being worn. Like the passage from *Vogue* in January 1970, the ad is unsettlingly honest about its own decontextualizing violence. The disembodied hand holding up the shoe couldn't be more obvious: the image not only cuts off a supposed means of elevation from any historical, political, or social contexts in which elevation might take place, but openly puts this means before the end: it is, in fact, the only

figure 6.4

thing being elevated. The image is so clearly an inversion of the norm where shoes are normally at the bottom—on one's feet—that it almost willfully forces the viewer to see something wrong with the way in which the shoe has to be held up by the human hand even as it advertises itself as a means of human transcendence. So while the subordination of what is human and what is black to the shoe is a first level of irony, it is also clear that the ad wants us to focus as much on the severed black hand as on the shoe; it is as if the ad were already anticipating the humanist critique of commodity capitalism I've just put forward, making it impossible to return to terms like humanness and blackness as the real, unproblematic sources of liberation. Clearly these are zones as fetishized and commodified as the shoe, a point that the African bone bracelet sported by the hand makes all the more obvious. For the extraneous presence of the unadvertised bracelet suggests that the shoe is only the means to gain entrance into the white-dominated corporate world, while the bracelet—the only thing actually being worn—becomes the true expression of African-American identity. But the fact that both—shoe and bracelet—are fashion accessories makes it hard to stabilize any difference between the two; whether it is a question of recovering or creating new identities, fashion as the domain where ornament meets need, the ad seems to say, is the means to all. Playing on the ambiguities of sartorial expression as free, self-expressive style or practical necessity, the ad makes it impossible to say what *is* rising on here, as a platform shoe is elevated by a black hand wearing an Afrocentric bracelet.[10]

"We have had the hippie look and we adore it." We are keeping what we've had, and we can have it all because no matter how politically incompatible and heterogeneous, it's all wearable. Fig. 6.5, the photograph of a pair of jeans themselves developed from a photograph, presents evidence that, even when new, seventies fashion was serving as the museum of very recent history and was helping to make the counterculture available for aesthetic consumption. Probably dating from around 1970, the jeans may be a reprint of a photo of Woodstock, but it's important that one not be sure about the original source—that the people could be any people; they are, simply, "the people." In a wonderful dovetailing of form and content, the photographed faces get bigger as the pant flares widen to the ground. Content may be conforming to a pant cut that gives more to the legs than to the waist, or form may be privileging content, the pants widening so as to bring the faces into focus as individuals. In this, the jeans both reverse and continue the mail-order ad's inversion of Western humanism's hierarchical positioning of head over feet and human subject over inanimate object. Bringing the locus of subjectivity closer to the ground, they present an especially clear instance of the propensity of seventies fashions to unsettle the conventional seats of consciousness and desire. And in this case, the flares do more than distract attention from the genital zone: they enable vision. The jeans, in this sense,

figure 6.5

point beyond the questionable opposition so often made between sixties radicalism and seventies apoliticism. Regardless of the wearer's conscious complicity, the jeans "know"—are on familiar terms with—every stranger the wearer might meet on the street; as another locus of knowledge, they suggest how seventies fashion might be wearing the political unconscious on its sleeve. They are an extreme and obvious example of the way in which seventies fashion works at the level of the open secret, representing never otherwise acknowledged realities and utopias everywhere denied.

Maybe this is one reason people are always so ready to disavow the seventies and ask, "However did we do it? How could I have let myself?": their clothes said more than they ever did and said things they'd never have thought to utter themselves; in fact we grew to depend, dangerously in the eyes of later decades, on having our clothes do certain things for us. Photographed on the back of her 1974 album *Stories to Tell*, the Brazilian jazz singer Flora Purim typifies a certain seventies look that moves, in this way, between what desires notice and what doesn't, and that allows one thing to take place under the auspices of another, or one part of the body to provide cover for another. (See fig. 6.6.) The photo invites the viewer to ask, Who or what is telling the story in this pose? Is it because she is so well defended that she is so laid back? Prominently poised in front, her open-toed platform sandal asserts its own presence, and from the photo's weird angle, it's not clear

figure 6.6

that this presence is the same as or opposes the presence to be read in Purim's ambiguous smile. Her face—the site of her speaking self—recedes to the background, its expressiveness intercepted by the hand gesture that arrests and puts off the viewer's questions. Deconstructing the idea that the "cause" of desire, gesture, and act can be localized within the "self" of the actor, Purim's accessories betray the presence of other active nonactors; they gesture toward the ideological forces that produce the idea of a single agent in the first place.

Also working to upstage Purim's face is the distractive power of her multicolored patchwork knee and its bell-bottom flare. Rather than following the so-called natural contours of the human body, the bell-bottom cut epitomizes a knack, pervasive in the decade, for putting the accent on the inessential and going overboard where elsewhere efforts have been made to save. Gradually emerging from the exaggerated tightness and straightness at the hips, flares open to a width that belies the earlier economical scrimping of cloth above and foils the claims of that most fetishized of zones. Bell-bottoms trope the standard pant cut in a number of directions, all of them meaningful and none of them more conclusive than another; this multiplicity of possible, nearly legible meanings is typical of the seventies aesthetic. The bell-bottom cut gives to pants (traditionally either masculine or unisex garb) the same refinement and complexity of shaping commonly

reserved for women's skirts and dresses (fig. 6.7). The form may recall the gracefulness of long evening wear of the 1930s, suggesting another transposition of a style originally belonging to a context of leisure and privilege into the quotidian and workaday world. Bell-bottoms in this sense not only threaten the straightforwardness and stability of male images but democratize by functionalizing an aesthetic once reserved for the few who could afford the luxury. At the same time, however, their effect can, like Carly Simon's, be just the opposite—that of informalizing a normally more for-

figure 6.7

mal and serious-looking garment. Deviating as they do from the body's own contours, seventies bell-bottoms cannot be called natural in any simple or literal sense; but making themselves at home in so many contexts, they nevertheless participate in the ambiguities of the "go-natural" looks of the early seventies: even as they dress up the "dressed-down" pant look beyond expectations, they often convey an impression of down-home casualness and readiness to take the streets for home: in them you can sweep the streets as you might your living-room floor.

Naturalizing deviance, wearing disguises as if they were one's everyday clothes, fitting in by standing out, are among the effects that seventies looks are good at producing. A first-album cover pose, Hot Chocolate's 1974 *Cicero Park* photo represents a stage-set replica of the 1940s look, not faithfully but in order to exceed it. (See fig. 6.8.) The trace of the real lies not only in the inversions of the historical white/black positions of racist oppression but also in the style—the high waist and generous pant width of the three-piece suits being the mark of 1974. Hot Chocolate musicians Tony Wilson and Patrick Olive are not only symbolically rewriting history, inverting racial subordination and inserting themselves into the position of power: the joke is that they're not in disguise; this is the 1974 look. The question is not then, What's wrong with this picture? but, rather, What or who is meant by stylistic wrongness? Does it represent the historical wrongness of racial oppression? or the difficulty of righting history by mere appearances? Key to

figure 6.8

making this a good example of seventies style is the undecidability as to whether by their anachronistic appearance, Hot Chocolate wants more to fit in—to write themselves back into history and claim, with this first album, their right to historically white-defined status symbols—or to stand out and be taken for wrong by the still operative standards of white-owned market culture.

This ability to move between different contexts, between metaphoric and literal registers, and on different scales of value, gives to seventies style the strange efficiency that makes it an art of the weak, an art where what's going on in the background is constantly informing and intruding upon the foreground. The idea of style as resistance—as a resistance that is effective precisely because it takes place in the background, in areas and arenas not immediately perceived as political—has traditionally been developed in the context of deviance and subcultures. Thus in his seminal study of punk culture, *Subculture*, Dick Hebdige describes how the British punks of the late seventies consciously took up for their own expressive purposes the trashed objects of postindustrial capitalism, and arrested attention on these seemingly harmless objects in order to make aggressive and in-your-face assertions of otherness. But if work such as Hebdige's has long familiarized us with the self-conscious attempts on the part of openly deviant subcultures to signify their difference through decontextualization and denaturalization, too little critical attention has been given to a process such as the compulsive naturalization—of flamboyance, exaggeration, polyester, bigness, wideness—evidenced in the mainstream fashions of the decade as a whole. Whereas Hebdige's punks willfully call attention to themselves by their intransigent "fuck you"s to culture, adulthood, and conformity, the diffusion of loudness in seventies fashions works both to deflect and focus attention, to turn up the volume and tone it down. Thus the decade's immensely popular matching pantsuits justify their loud and obnoxious color patterns by their internal consistency; the conventionality with which everyone wears platforms, awkward and hazardous to walk in, immediately offsets their potential in-your-face rejection of the norm. Uneasily combining coercion and creativity, compulsive artifice enables stagings of the norm that may be conformist in intent and only deviant in effect, or conversely, subversive in intent while safely conformist in effect.[11]

Already at play in Carly Simon's boast of no secrets, this ambiguity as to whether the dissemination of rebel-looks equals the diffusion or intensification of their message of dissent arises in particular with those seventies looks that can be read as a mainstreaming of late-sixties counterculture: ex-hippies enter the corporate workplace with longer or bigger hair; would-be executives no longer shed business suits for blue jeans but, instead, wear suits made of denim. The entrance of these styles into the mainstream might have worked either as a loss of specific political meaning and counterhegemonic

force or as a potential gain in common understanding and openness to something previously unacceptable—and often probably as both. How can we register, and do theories of subcultures and subversion give us the tools to measure, what we gain when long hair in men is no longer considered deviant but at least as masculine and suitable as short? Seventies styles seem, in this way, willing to accept as part of and indeed as central to their norm a certain "teeny weeny gigantic slant" on it. In the popularity of leisure suits and other cross-gender styles that show a real effort to achieve consistency, we can, for example, read the loss of a stronger basis for conformity— a reaction to the shaking-up of established means of social division and organization. Worn by both men and women, leisure suits ensure not just that men and women look alike but that they match, or, in Gaynor's words, fit one another; as if in response to the sixties' overturning of sexual mores, fashions such as these substitute obedience to the law of form, however nonsensical, for adherence to rules of conduct that can no longer be assumed as given and shared.[12]

Just as the tenor of Carly Simon's pose easily slips from "please accept me for what I'm wearing" to "please accept me regardless of what I'm wearing," seventies looks, I've been arguing, combine heavy investment in appearance with the demand that the viewer ignore the exceptionality of their sartorial accents, and thus send a number of mixed messages as to their expressive and ornamental, political and pragmatic functions. They allow us to see as parallel and related processes the diffusion of politically conscious messages into compulsive habits of ornamentation and the devaluation of luxury goods through their sustained reproduction and use in the most banal of contexts. Discussing the deployment of consumer practices to political ends, de Certeau defines a "tactic" over against a "strategy" as a necessarily short-lived and unexportable maneuver whose effectiveness is of limited duration and context. But seventies fashion is like a sustained deployment of as many tactics as are available at once, in, to borrow from Nietzsche, a constant and never finished "disavowal of indigence." We are faced with an insistent, repeated, and long-term (over)use and recontextualization of tactics whose intent and effect become, in the process, unclear. You don't, for example, in the seventies, own just one suede jacket, a prized and irreplaceable possession. You wear suede everywhere—in shirts, dresses, pants, the most banal of working-day suits. Or, even better, you wear ultrasuede, 60 percent polyester, 40 percent polyurethane—"the only un-suede thing about it: it's water repellent." Its one flaw—the fact that it's not real—is the source of its greatest value: its practicality. The effect of such constant and repeated deployment is to make the garment's suedeness, real or not, invisible—incapable of garnering the wearer special attention. Once the measure and guarantor of the wearer's value, suedeness loses its power to authenticate its wearer's claims to value even as it ensures her mobility among

crowds, whatever the context, whatever the weather: "Put this coat in your life and fire Crack Meterologist."[13]

In the same way, there's no getting away from the secret terrorism of platforms, lapels, wide collars, and sideburns. Of all of these, the wide tie stands out perhaps as the most prominent and indecipherable open secret, both disconcertingly obvious and mutely unaware of its phallic connotations. Returning us to the problematic of over- and underdetermination in male dress with which this essay began, the wide tie's unreadable rhetorical effects reopen the question of whether the projection of phallic power is helped or hindered by its literal representation (fig. 6.9). The wide tie of the seventies does not openly deform conventional male dress code. It only makes itself more prominent, and in typical seventies fashion perversely exaggerates a claim to power that usually works best unnoticed. The extra width is a way of *doing* masculinity twice over; whether one reads this as an overassertion of power or a double betrayal of insecurity, one cannot exactly call it parody. Rather it is a form of slanting the tie and once again troping all that the tie is supposed to convey: the air of confidence and cool, the mixture of ease and rigidity that comes from being at home within the towers of the white- and male-defined corporate establishment. Whereas the standard tie projects dominance metaphorically without exposing the workings of phallic power, the seventies tie, one might say, exposes the workings without conveying the effects, because it brings to the foreground precisely that kind of power that wants to recede to the background as natural, omnipresent, and uniform. At the same time, as a visible signifier that attracts both too much and too little attention, the extrawide seventies tie can appear itself ironically subtle and understated. Obvious, exposed, in full view, it's just big; one can hardly accuse it of much more.

"Compulsive artifice," I've been arguing, is a singularly inspired term by

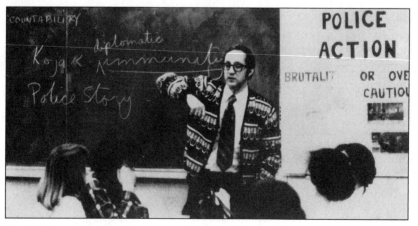

figure 6.9

which to describe the seventies fashion consumer as one whose lack of assurance, knowledge, or power forces him or her to "approach things on the bias" and to turn the volume up on external signs. If tackiness signals poverty—the very opposite of what tackiness intends—the joke here is that the very energy with which the seventies fashion consumer over-compensates for his or her supposed lack of inner resource, belies it. The opening shots of 1977's *Saturday Night Fever* show a white John Travolta walk-ing down a Brooklyn street to the tune of "Stayin' Alive" and, in the words of the Bee Gees (and *Vogue* in January 1970), "usin' his walk" to put "a teeny weeny, gigantic slant" on his relationship to the world. On the job, the can of paint that he will later sell at a double markup in hand, Travolta's char-acter is the epitome of the *arriviste* using style to overcome his working-class origins. His funky streetwalk—a self-serving echo of black street styles—may be what is most "his" about him (fig. 6.10). His first gesture is to compare one of his shoes and, in particular, the height of its heel to that of one in a shop window; later in the sequence he stops before a shop-window shirt he wants but doesn't have the money to buy. Economically short-changed and creatively overloaded, Travolta is an exhibitionist of "com-pulsive artifice," if nothing else, and most appealing for the imaginative intensity with which he "does" a subjective identity first seen and scripted through the eyes of market culture.

figure 6.10

Throughout this opening sequence, the camera meets Travolta's eyes only once, and Travolta immediately looks away. The opening shot cuts from the Brooklyn train overpass to the black leather shoes already pounding the pavement to the beat of the Bee Gees; the sequence is then shot from a number of angles, as if the camera wanted to get Travolta from every perspective but straight on. At one point, the camera angles up Travolta's body at a diagonal, from the level of the black bell-bottom flares, putting his crotch and waist in center view and making unmistakable the value of "approaching things on the bias." All this, of course, effects a decentering of the self and presents the viewer with a multiplicity of sources for power and agency. But what makes this the opening of a *seventies* movie is that the point of the sequence is not—or is not merely—to deconstruct the idea that the self has a proper locus, but to put forward a subjective identity, and it does so most effectively when it captures Travolta's inattention to and avoidance of the camera. His is not an outwardly directed performance; we cannot be sure that he is in control of his effects any more than that his pants are not wearing him. In the same way, the camera's focus on the can of paint he's carrying makes no secret of his working-class status; literally and in the movie's figurative terms, he's not going anywhere but to the hardware store where he sells paint. While one might say that this works as an ironic demystification of the power asserted by the way he walks, it also confirms the song's truth about what he's doing—namely stayin' alive. If not on the street, then where else? If not by his look, then how else?

NOTES

1. For a discussion of the mystifying power of clothes as a triple power to conceal a mystery, indicate its presence, or create one where there is none, see Kenneth Burke's discussion of Carlyle's *Sartor Resartus* in connection with *The German Ideology* in *The Rhetoric of Motives*. Burke argues that both works concern the mystification of social inequality and draws particularly fruitful comparisons between Marx's humanist anxieties over the way in which money allows a person to do and be more than he is naturally endowed to do, and the ways in which clothes allow a person to show more than he might ever have.

2. Kaja Silverman, "Fragments of a Fashionable Discourse," in *On Fashion* (New Brunswick, N.J.: Rutgers University Press, 1994), 191.

3. Such naturalism remains blind first to the irony that while the modern subject makes his sartorial appearance secondary to his voice, he may well owe the primacy of his voice to the visual constructions of race and gender, and second to the more subtle point that the male wearer does in fact depend, however secretly, on the neutrality of his clothes to align himself with the dominant order. As Silverman's astute analysis shows, this alignment works through figurative suggestion rather than bald statement: without risking the literal exposure of the male sexual organ, the modern male suit allows

the phallus to be "metaphorically rather than metonymically evoked (that is, represented more through a general effect of verticality than through anything in the style or cut of a garment that might articulate an organ beneath)" (Silverman, "Fragments," 191). The symbolic order to which Silverman refers privileges the metaphoric over the literal and demands that the literal sign—the physical organ—remain unimportant and even irrelevant to the phallic power signified. One can assume no linear correspondence between metaphoric and literal within the phallocentric logic upheld by Western male dress. Hence the potential subversiveness of being so literal-minded as to assume that a bigger tie equals more phallic power.

4. Silverman cites this term as coined by Flügel in *The Psychology of Clothes* to describe the inhibition of male narcissistic desires for exhibition that occurred when "masculine clothing ceased to proclaim hierarchical distinction and became a harmonizing and homogenizing uniform serving to integrate not only male members of the same class, but male members of different classes" (Silverman, "Fragments," 185). As Silverman points out, with this renunciation, the changing and extravagant world of fashion is henceforth gendered as feminine. Modern identities gendered as masculine or feminine thus sustain very different relations to the clothes by which they both hide and show their bodies and selves, but for neither male nor female subject is simple and nonequivocal identification with their sartorial expression possible. In this essay, I wish to emphasize the event of nonidentification between dress and self—when your clothes speak out ahead of you, for you, against you—that occurs in different ways to both male and female subjects. In so doing, however, I do not mean to question the premise of much recent work on fashion that Western culture's long and oppressive history of identifying women with things of the body has given women-centered perspectives a thicker understanding of the inevitability of fashion and fashioning the body. (See, for example, Shari Benstock's and Suzanne Ferris's "Introduction" to *On Fashion*, 1–20.) Approaching fashion as the site on which identities with bodies are constructed, recent fashion theory builds on earlier work on the crucial place of style in sub-, oppressed, and colonized cultures, women's included.

5. In this context, readers are invited to keep in mind the multiplicity of historical causes, both progressive and reactionary, that were at the time making it difficult to take any position of power for granted—as a natural given. Thus while the entrance of African Americans into previously all-white economic sectors on the last wave of the civil rights movement, the Black is Beautiful movement, the new militancy of Black Power, and an increasingly visible women's movement organized, in particular, around the struggle for the ERA, were presenting positive critiques from without of unquestioned white male claims to and definitions of power, America's failure in Vietnam, Watergate, the OPEC oil crisis, terrorism, inflation, unemployment, and the Iran-hostage crisis, were all so many blows struck from within to faith in the American Establishment. It is interesting to note

that a period whose fashion would afterward have such power to embarrass its former wearers was itself marked by failures of a particularly public and embarrassing nature to American power, from Watergate to the SLA's one-year Patty Hearst media stunt at the expense of the FBI to President Carter's televised confession in April 1980 to having first ordered and then aborted an Iran-hostage rescue mission that ended in death and disaster. By the late seventies, foreign-made efficient compacts had made obsolete the oversized American gas guzzlers. That big things were being shown up, sometimes in painfully public ways, as no longer necessarily so powerful, gives a special resonance to the show just then of bigness in fashion. Women, for example, wore big sunglasses covering half their faces—though the glasses themselves were bulky, obnoxious, and indiscreet, they gave their wearers a terrorist-like anonymity.

6. John Stember, "A Look at New Priorities, New Options," *Vogue* 175, 1 (January 1980): 118.

7. Adorno's scathing critique of the compulsive listener of popular music refuses to forget this listener's redemptive potential as a human agent out of touch with his own agency: "as the actor of his own enthusiasm ... He can switch off his enthusiasm as easily and suddenly as he turns it on. He is only under a spell of his own making" ("On Popular Music," *Studies in Philosophy and Social Science* 9 [1941]: 47).

8. Michel de Certeau, *The Practices of Everyday Life*, trans. Steven Rendall (Berkeley: University of California Press, 1984), 37. In its understanding of style as a secret but everywhere available means of resistance to dominant constructions of identity, de Certeau's recuperative study of the quotidian anticipates more recent insights into the crucial role of repetition in forming and potentially transforming the discursive categories of identity, gender, and race. See, for example, the work of Judith Butler, Henry Louis Gates, Kobena Mercer, and Stuart Hall.

9. "Forecast—1970," *Vogue* 155, 1 (January 1970): 96.

10. In this last sense, the braceleted rather than manacled black hand may well be a self-conscious reference to the history of slavery. Pointedly not for sale, i.e., not available through market-defined means of empowerment, the bracelet signifies freedom in the double sense that it is an ornament freely put on for none but decorative purposes and that it represents the recovery of the free African identity lost upon entrance into America and slavery.

11. Dick Hebdige, *Subculture: The Meaning of Style* (London: Methuen, 1979). Hebdige's insights into the hidden powers of speech (or signifying powers) latent in "humble," seemingly insignificant, ordinary objects, are in a sense better suited to seventies styles that "approach things on the bias," than to explicit expressions of subcultural deviance, for the former better sustain the ambiguity as to whether their power lies in being noticed or unnoticed.

12. We can usefully revisit here George Lipsitz's description of what the seventies did to the sixties, cited by Shelton Waldrep in another essay in this collection: "sequins [became a substitute] for beads, decadence for politics, and

open plagiarism for originality. Whereas the counterculture of the 1960s tried to defuse sexual tension by having men and women take off their clothes, the 'glam' ... rock of the 1970s encouraged men and women to wear each other's clothes" (*The Sixties: From Memory to History*, ed. David Farber [Chapel Hill: The University of North Carolina Press, 1994], 230). We need not and indeed ought not see these changes as regressions or returns to the norm. Taking off one's clothes (and all that this can mean metaphorically) may achieve a momentary, solitary liberation; the more arduous enterprise of exchanging clothes and helping one another put them on means applying continuous pressure to the fabric of social relations and locates the hope of freedom in a never-achieved reinvention of socially prescribed roles.

The problem of the "mainstream" cannot be addressed apart from the related question of the value of "cross-over," and both issues bring to a head the question of what it means for aesthetic and political contestations to take place in the arena of the market. Simplified, the standard critique of mainstreaming might go as follows: a politically encoded message can only enter mainstream markets as a look (for it is only as a look that it can be bought and sold), and having lost its political content, it becomes *mere* style. Crude as it is, this critique is interesting precisely because it invites further reflection on the problem of style: on its limits and potential as a political weapon; and on what we mean by "mere style." Kobena Mercer's subtle analysis of the ambiguities of "inter-culturation" in his essay "Black Hair/Style Politics," takes us quite a bit further; it frames the problem in terms of the way in which a particular style can reserve a cultural legacy and political value for those (and only those) who participate in its making, even as profits to be made on this same style continue to fall to "dominant commodity culture": "Style encoded political 'messages' to those in the know which were otherwise unintelligible to white society by virtue of their ambiguous accentuation and intonation. But, on the other hand, that dominant commodity culture appropriated bits and pieces from the otherness of ethnic differentiation in order to reproduce the 'new' and so, in turn, strengthen its dominance and revalorize its own synthetic capital" ("Black Hair/Style Politics," in *Out There* [New York: MIT Press, 1990], 260).

13. *Vogue* 159, 4 (February 1972): 27. From the disparate examples of Carly Simon, the mail-order shoes, and face jeans, we can begin to get a sense of the kind of familiarity which seventies fashions ensure between people— one that unlike the traditional sense of "family" relies, however paradoxically, on indistinguishability and anonymity. A particularly abstract form of exchanging material goods, mail-order catalogues distribute the same identical goods to people who may never cross the same street. Their advertisements can never assure the post-seventies viewer that the clothes they show were ever worn or indeed that they ever existed except as images. In their eeriness, these images can stand for the abstract, never tested, and never exhausted possibility for community not based on physical contact, shared geographical space, race, class, or gender, which is the strange "home" of seventies fashions.

State of Grace

American *Vogue* in the Seventies

AMBER VOGEL

Slender Charlotte Rampling poses on a spiral-legged desk in the most densely ornamented room on earth. Above her is a chandelier, the many lights of which are reflected in the panes of lace-covered, unshuttered, darkened French windows; behind her is a mirror with a huge, wild swirl of frame, and a narrow table to match; beneath the desk on which she sits is an Oriental carpet of concentrated design. Near her on the desk are car keys and a pack of cigarettes. Resting her weight on her left palm, Rampling leans back slightly. She holds a wineglass in her right hand. She props her feet on an elaborate chair. She wears a pair of dark slingback shoes reminiscent of those worn in the thirties. Her dark hair, her white skin, her famous hooded eyes are her only other ornaments. She is appareled with admirable restraint, in counterbalance to the overdressed room she now inhabits, the room she may soon leave (in her shoes, through the French windows, with her car keys in hand), once she has finished the glass of wine—and after Helmut Newton, at whom she is gazing over her naked right shoulder, has taken her black-and-white photograph for the December 1974 issue of American *Vogue*.[1]

In *Vogue*'s hundredth-anniversary special, published in April 1992, the photograph of Rampling is one of a collection of thirty-three pictures that must stand for the whole astonishing photographic history of that women's fashion magazine.[2] Superimposed on this photograph, which fills page 380, is the motto "A wealth of meaning emerges, a poignant essay on Time" (fig. 7.1). But, really, despite the obvious quality of the picture, "meaning" emerges impoverished here; and any "essay" must be reduced to some ironic description of a moment, some speculation on the moment's circumstance, and not on "Time." Neither this photograph nor any of the other thirty-

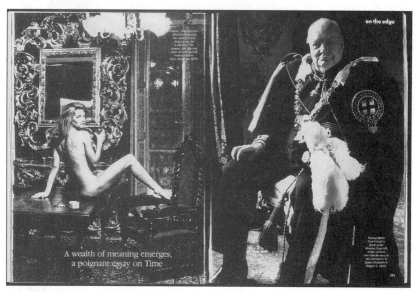

A wealth of meaning emerges, a poignant essay on Time

on the edge

figure 7.1

two can adequately represent the complex of images and texts that comprised not just the issue, but the decades of issues, whole moral universes, that gave each photograph in *Vogue* a peculiar life, an existence resonant with meaning.

Introducing the collection of thirty-three images, Kennedy Fraser notes that "Severed from their original moment (the lights, the pose, the shutter click), these photographs rearrange themselves in a new collage—each suddenly equal to its neighbor and interrogating it."[3] But that, too, is not quite right. After all, these photographs, their assignment, their selection and placement, their copy and cutlines, never arranged "themselves." The "moment" that should be acknowledged in such a statement, in such a retrospective, is of the editor's, not the photographer's, origination; and the publication—much more than the taking or the development—of photographs constitutes the sequence of events significant to *Vogue*'s history. To remove any photograph from its first context in *Vogue*—its original cropped and bled and bound edges, caption and editorial, and juxtaposed advertisement—is to make something quite different of it. Perhaps something more useful, more amusing, even more beautiful—but not a more faithful thing, and not, also, the truth.

Almost any issue of *Vogue* published in the seventies might have diverted and enlightened the reader who saw no other issue of the magazine. But a full understanding and appreciation of any issue—indeed, of any image or object presented within it—was reserved for the constant reader, who subscribed not only to the magazine but to a way of reading it. The way to read

Vogue in the seventies was shaped by Grace Mirabella. Mirabella, who goes unmentioned in Fraser's introduction, was first listed as editor in the April 15, 1971, issue. She continued in that capacity until 1988, when, following tradition at *Vogue*, she was unceremoniously fired. Under her direction, *Vogue* provided what a good magazine with sufficient resources can and should provide: a significant collection of graphic objets, as well as guides, both explicit and implicit, to the relative value of each. Indeed, Mirabella's association with *Vogue*'s value system in the seventies might have led to her downfall, just as Diane Vreeland's association with the sixties led to hers. Mirabella describes her colleague Alexander Liberman saying to her in the eighties, when they found themselves at odds over the magazine's direction, "You have such a *seventies* way of thinking."[4] Like many things Mirabella recalls people saying to her, this is understood to be a slight.

Liberman, for thirty-one years the editorial director for *Vogue*'s publisher, calls fashion editing "an art in its own right," one of the "incredible accumulation of minor talents" that produce a magazine such as *Vogue*.[5] Now it seems that Edna Woolman Chase, who (along with Condé Nast, the magazine's Gatsby-like owner) made *Vogue* in the first half of the century what it still is in most respects, and Vreeland, who (before she was fired) made herself and the magazine famous for aesthetic and rhetorical extravagances in the sixties, are the editors-in-chief most likely to be recognized for their contributions to *Vogue*. But Mirabella, Vreeland's direct successor, also deserves to be recognized, for her work in the seventies. In that decade, under her direction, *Vogue* offered an innovative vision of the modern American woman as vital, confident, independent, involved. It was an idealized vision, to be sure, but more powerful because of that. In her autobiography, *In and Out of Vogue*, Mirabella writes, "I wanted to give *Vogue* back to *real women.* And even though I'd repeatedly been told that my idea of reality, 'as seen in *Vogue*,' bore no resemblance to the real thing, I still wanted to create a new image of reality, a 'heightened reality,' as I always called it, that would show women working, playing, acting, dancing—*doing things* that mattered in the world and wearing clothes that allowed them to enjoy them."[6]

Central to this ideal, this superior reality, was the redemption—paradoxical but significant in such a magazine—of women's physical selves from fashion's constraint and nudity's shame. That this ideal reflected her own beliefs (and was not simply a component of an editorial formula foisted on her by Liberman) was made clear when Rupert Murdoch gave the out-of-work Mirabella an opportunity to found and edit an eponymous magazine. In June 1989, the first number of *Mirabella* issued what amounted to a manifesto reechoing, in image and language, themes familiar to anyone who had read *Vogue* in the seventies. On the page opposite a photograph, by Michael O'Neill, of a woman shown from the waist up, her arms wrapped

around her naked torso, her hair pulled back, her face with no evident makeup, *Mirabella's* statement begins: "NATURAL [...] direct ... honest ... guileless ... unadorned ... understated ... bare ... The most powerful kind of beauty is found in a face where bone structure, skin tone, thought, and emotion come through."[7]

How freely, or unavoidably, such an assertion of woman's essential innocence and guilelessness borrows from a longer-established belief system is at once amusing and provocative to see. Feeling shame, Adam and Eve made aprons of fig leaves, and God—the first couturier—replaced them: *Adam called his wife's name Eve; because she was the mother of all living. Unto Adam also and to his wife did the Lord God make coats of skins, and clothed them.* The connection between Eve's physical, sexual self—connoted by her role as mother of all living—and her need for a wardrobe is unmistakable in Genesis. In *Vogue*, fashion's bible, image and language served throughout the seventies not only to remove the ancient stigma attached to the female body, but to analyze and subvert the requirement to clothe it, to teach women to turn that requirement to their own advantage when they wished and to flout it when they preferred. The photograph of Charlotte Rampling, unadorned and unrepentant, suggests the power women could have, not only over couture, but over culture.

Because it is denuded of a particular complex of aesthetic, ethical, and historical connections, the anniversary special introduces a view of *Vogue* in the seventies that is accurate and still not the truth. "Yes," the knowing reader says, "this picture of Charlotte Rampling appeared in the December 1974 issue of *Vogue*—but it did not appear exactly like *this*."

On the page opposite the photograph of Rampling as it was republished in 1992, there is a black-and-white photograph of "Winston Churchill in the uniform and robe he wore to the coronation of Queen Elizabeth II. August 1, 1953."[8] Unlike Rampling, Churchill was photographed by a woman (Toni Frissell Bacon, whose home life and beauty rituals are described in the June 1973 issue, in which her photograph of Churchill is also reprinted).[9] Unlike Rampling, the physically substantial Churchill fills the page, he sits in a proper chair, he faces almost fully forward, he holds a plumed hat instead of a wineglass. Like Rampling, Churchill wears a pair of shoes. Upholstered in a dark cape, adorned with an insignia seeming as large as a gilt-framed mirror, festooned with gold, trimmed with ribbons and tassels, he also appears to have been outfitted by the decorator of the very room in which Rampling poses. Certainly this juxtaposition of images provides subliminal commentary on dress and undress, on gender and perspective, on affluence and decadence, on ceremony and mores. But this is neither the juxtaposition nor exactly the commentary provided by the original publication of the photograph of Rampling.

In the December 1974 issue, the photograph faces another, also full-page, of Rampling with her son Barnaby. Their heads and shoulders are visible, their eyes are cast down. "Mum Charlotte, Son Barnaby," they are labeled. Mum is dressed in a cardigan, Son in a sensible garment of the sort two-year-olds typically wear, with an open snap-fastener at the neck. Accompanying the two photographs, under the headline "The Sexiest Woman in the World," is text half concerned with Rampling's "sex-slave, sex-symbol global notoriety" (resulting from her role in the "plangent, sadomasochistic movie, *The Night Porter*") and half concerned with "motherhood [which] is most important to her." Rampling "feels that today people aren't physically free." She wants Barnaby "not only to be a free spirit but to be free in his body"—and still to dress sensibly, it seems.[10]

This assemblage of words and pictures only seems reasonable rather than incongruous (or, in the nineties, suspicious) in the context of the decade of issues in which it was published. In that context, when *Vogue* was subtly and unsubtly preaching the moral goodness of the naked body, Rampling's "indefinable quality of being romantically of this current, tough, baffling, '70s moment" could incorporate, and not be baffled by, her representation as mother, as Mum, as Madonna, also.[11] On this point Anthony West gushes forth an argument. In "Nakedness vs. Nudity," published in the May 1971 issue, he says of woman:

> In her nakedness she becomes one with the oldest of man's loves and the first of his goddesses, the Queen of Heaven, the Mother of all living, the mistress of the barren heights and the rich valleys, of the grasslands and the dark forests, of the lush pastures and the fields of ripening grain, of the abundant orchards and the fertile gardens, of the teeming rivers and the inexhaustible seas, of the wild things and the tame. She is the replenisher and the renewer, the giver of all gifts and the destroyer of all things; she is life in all the splendour of its infinite menace, generosity, and promise and, beyond all measure, *glorious*.[12]

At least chronologically, West's essay shows the way for *Vogue*'s redemption, through the images of women it would present in the seventies, of whatever is "indefinable" and "baffling" and of "infinite menace" in such images.

In the November 1976 issue, which reprints his photograph of a woman called "Winnie," who is naked at the Negresco, Newton is described as having "a passion for women; an esthetic sense of depravity, raised to visual elegance; wit; irony ... a profound, noble understanding of the 'beauty of sinister things.'"[13] These conflictive attractions—to depravity and elegance, to wit and profundity, to the noble and the sinister—derive from the first, his "passion for women," which motivates and signifies them all. This largely has to do with the uncomfortable admixture of pleasure and shame—the intimate skirmish between nature and civilization, between

sex and etiquette—that often constitutes the viewer's response to the model's glance, to the naked shoulder over which she gazes. West acknowledges the shame, "those complex and upsetting feelings," aroused in men by the sight of woman's nakedness, shame that has been wrongly attached to her, that she has often come to share. Men's shame is more properly attached to themselves, to their own primitive nudity, which discomfits them and which they weakly attempt to disguise. West says that "the naked body of a woman . . . is a talisman that reveals to them the fragility of the pretenses they live by and makes them realize how much there is in them that is primitive, instinctive, and unregenerate."[14] West's argument, also *Vogue*'s in the seventies, is *for* nature and *against* shame. Thus, naked Charlotte Rampling exists unabashed among the surfeit of a civilization's accoutrements, which apparently she can take or leave.

The wit and irony of Newton's photographs derive principally from their appearance in *Vogue*, a fashion magazine, the business of which in the seventies was supposed to be to report how Yves Saint Laurent and Oscar de la Renta and Halston would be clothing Rampling, Winnie, and every other woman who could afford high fashion that season. *Vogue*'s publication of an essay on nakedness—in which the author declares of woman that "She is, indeed, often most herself in her nakedness because she is then liberated from the banal categories in which she unwittingly places herself by the way she does her hair, dresses, or comports herself. She sets her social being aside with her clothes and is visibly undisguised"—is also an act of some editorial wit.[15] It is an act in keeping with the editorial practice of *Vogue* in the seventies, which was to document the latest and oldest trends in disguise, as usual, and at the same time to acknowledge and affirm woman's nature, her undisguised self.

In Fraser's grouping, four photographs represent Mirabella's *Vogue* in the seventies: the one of Rampling; one of Woody Allen impersonating Groucho Marx; and two of the model Lisa Taylor, static and in motion. In the anniversary special, these last three, which form a sort of border at the edge of page 377, also disclose few suggestions of their original complexity, little notion of the moral universe in which they first came to light. How would one know that, directly following the essay on Allen in the December 1972 issue, there was an article about Zizi Jeanmaire, bare-breasted star of the Casino de Paris, and a multitude of other almost-naked exotics with whom she performed? *Vogue* reported that Saint Laurent—famous in the seventies for designing clothes patterned on Russian and Gypsy folk-costumes and assembled with extraordinary accumulations of materials—had been at work here, too, and "made sets and costumes and nakedness shine like something-else-again."[16] *Vogue* revisited the Casino de Paris in the October 1973 issue. Now Lauren Hutton, overdressed in "Halston's great oversized

shirt in acid-green Ultrasuède," posed awkwardly next to Lisette Malidor, at ease and charming in a bejeweled g-string and her own dark skin.[17] Seeing only the anniversary issue, could one know how keenly and frequently, in the seventies, the universe comprised of all the elements of *Vogue* was attuned to something both simpler and more complicated than fashion? How it was attuned to skin, to the anointment and adornment of skin, and to exegeses and praises of these acts, these arts?

Both photographs of Taylor featured in the anniversary special were also selected to be among thirteen accompanying Liberman's essay in the November 1979 issue, an introduction to the *Vogue Book of Fashion Photography, 1919–1979*.[18] The "fashions" these images originally illustrated were among a woman's most intimate accessories—her scent, her skin. "It amuses me," Vreeland says in her autobiography, "when I look at magazines today, to see the credit line 'Perfume by. . . .' We never did this at *Vogue* or *Harper's Bazaar*. We were very square in those days—believe it or not—and very literal."[19] In Mirabella's day—in the April 1975 issue—Newton's photograph of Taylor wearing a smock blouse and matching wrap skirt designed by Calvin Klein could be accompanied by the caption "The bareness, *left* . . . the dégagé charm of a neckline left untied—and filled with scent (the shadow knows!)." Believe it or not. "No question," *Vogue* declared. "The look of the moment is the look of skin—bare summer skin, tinted lightly by sun, showing silkily through cut-away backs and fronts and sides and middles. And smelling delicious."[20] In the October 1976 issue, the other photograph of Taylor, by Arthur Elgot, shows this "Symbol of an American Beauty in the 70's" driving a car and wearing her makeup the "way makeup should be worn today . . . to *improve* appearance and *promote* healthy skin."[21] The aesthetic connection between "super-looking skin" and super-looking fashion—involving the idea that skin is not only dressed by fashion, but that skin *is* fashion, is part of the design, can itself be designed—is made often in *Vogue* in the seventies.[22]

Way Bandy, introduced in the September 1, 1972, issue as "a spiffy young 'face designer,'" proffers this inescapable advice: "Start with your naked face."[23] In the same issue, a photograph by Richard Avedon shows the work of makeup artist Pablo on the left half of a woman's face, while the right half of her face remains bare.[24] The photographer Francesco Scavullo, Bandy's collaborator on many photographs for *Vogue* in the seventies, rehearses this visual conceit in *Scavullo Women*, in which the model Janice Dickinson appears with the left half of her face un-made-up.[25] The argument bolstered by such illustrations is not that the naked face and the naked body are the better face and the better body. Rather, that—like Patti Hansen's freckles, about which Bandy says, "These are, after all, the things that really make you *you*"—they are natural, integral, inescapable; that they are not shameful; and, still, they are not always the most distinct representations of the

persons to whom they belong.[26] The way to a clearer, truer self-definition, as *Vogue* guided the reader to it, was through art—and through the efforts art requires—which women should not be ashamed to understand, would not be wrong to employ. The *Vogue Beauty/Health Guide* for 1978–79 includes a holiday snapshot of Dickinson taken by her husband, a fashion photographer, in which her scrubbed face smiles between pigtails that hang like very small branches at both sides of her head, and her body scarcely emerges from the camouflage of several heavy, knitted garments in browns and greens. This is set on the page opposite Avedon's "remarkable photograph" of Dickinson with iridescent makeup on her solemn face, a tendril of dark-brown hair winding down to her neck, clusters of jewels falling over her collarbone, and the sequins and thin straps of a red evening dress by Saint Laurent shining against her skin. "Just look," *Vogue* directs the reader, and just looking reveals how much more vividly Dickinson is herself—is *someone*—in Avedon's portrait than she is in her husband's snapshot, which shows her beaming like no one in particular in front of a row of boats.[27]

Such evident visual success notwithstanding, part of *Vogue*'s program in the seventies was also to expose to its reader the legerdemain inherent in its own stock in trade, the fashion photograph, which might document a fact and thereby obscure a truth at the same time. In an essay on Avedon's work, Harold Rosenberg remarks on the camera, that unreliable but convincing god: "The likeness recorded by the camera is a species of naturalistic evidence.... You do not have to be a primitive to look at a photo and respond, 'It doesn't look like him at all,' but in time the visual record tends to become conclusive. The camera has made it possible to fool people through facts."[28] In the same vein, actor and director Woody Allen (certainly not presented in *Vogue* as a New York primitive) says of a photograph of himself published in the December 1972 issue, "I don't think it looks exactly like me."[29] That photograph, like the one of Allen featured in the anniversary special, was originally part of a set taken by Irving Penn and published together. They record Allen's "rough impersonations" of Groucho and Harpo Marx, Buster Keaton, Charlie Chaplin, and himself. To achieve the last effect—Woody Allen wearing a soft hat the brim of which reaches the top of his spectacles, and a cardigan over the neck of which juts a tieless, white shirt collar—Allen took fewest pains. As a result, he says, it doesn't really look like him. He says, "I could look more like myself than this photo of me by taking the time to look more like me."[30]

Here and elsewhere, *Vogue* was acknowledging that there are as many arts to looking well in one's own skin as there are to seeming authentic in someone else's. Rampling, for instance, also had her role to play—her self to look like—before Newton's camera. She had her costume: dark hair, white skin, shoes to walk off that elaborate stage in. She had her props: cigarettes, car keys, wineglass. She had her effort to make: her gaze to gaze with famous

hooded eyes. In the seventies, *Vogue* managed to educate its readers in these arts. It both presented the most appealing disguises for women to use and peeled them away for women to understand.

The photographs of Allen and Rampling reiterate *Vogue*'s connections to the theatrical arts, which go back to the magazine's beginnings, when reviews of performances by actresses such as Mrs. Patrick Campbell and opera singers such as Geraldine Farrar appeared regularly, accompanied by photographs of the performers. In the seventies, these connections—related to *Vogue*'s interests in disguise, tableau, spectacle—were strengthened and elaborated on. *Vogue* announces "The new real-life drama you'll want for your face"—and that Bandy, who "designed the makeup for those famous faces in 'No, No, Nanette,' has his own consulting service for all of us with faces seeking star quality."[31] More theatrical conceits are bandied about. "One stick of gum can spoil the whole chemical drama taking place on your inner stage."[32] But there's "a happy ending for a girl who's played—with spirit and persistence—one or more of the health-and-beauty-discipline dramas on the next eight pages, starring Candice Bergen, Julie Christie, and Lauren Hutton."[33] Actresses, including Farrah Fawcett-Majors and Jaclyn Smith, two of the cast of television's *Charlie's Angels*, regularly star in *Vogue*'s editorial pages and on its covers. On the cover of the special holiday issue in which Allen's photographs appear is the performer Cher, attached to false eyelashes dense enough to bear the weight of a boxful of ornaments.

Relatively obscure, but significant in the context of *Vogue* in the seventies, are a group of young women with family connections to the Hollywood elite, presented in *Vogue* as fashion models—and also, complicatedly, as avatars of a life-way encompassing human relationships, social arts, and aesthetic values. For instance, early in the decade Kitty Hawks, a literary and talent agent, the daughter of socialite Slim Keith and director Howard Hawks, later the wife of the head of Universal Pictures, is featured frequently in beauty and lifestyle squibs and fashion layouts. In 1972, gathering data with almost every issue, the reader knows that Hawks is "young, brunette, arresting, with glorious cats-colored eyes"; that she does needlework and "can't stand to knit"; that she "scrub[s] with a bathbrush" because, she says, "it's really clean-making and makes your skin pink"; that "[h]er lashes are so long she has to trim them to see out, the way other girls do with fakes"; that she has a "charming, quirky sense of humor," cats named "Tiffany and Harry Winston," and a "flair for giving small parties in her cheery, blue-and-white flower-filled apartment"; that she "loves to try on the liquid jerseys"; and that she "currently is pulling back her luscious wavy hair with plastic barrettes she gets in the five-and-ten-cent store."[34] At the same time, Berry Berenson, a photographer, also appears among *Vogue*'s flora and fauna (fig. 7.2). She is the granddaughter of Schiaparelli, the

figure 7.2

designer credited with inventing shocking pink; sister of Marisa Berenson, a frequent model in *Vogue* and an actress in *Cabaret* (1972) and *Barry Lyndon* (1975); later, wife of Tony Perkins, the star of *Psycho* (1960). In 1972, the reader learns what Berenson (whose opinions on the same matter are recorded alongside those of Cher, Kurt Vonnegut, and Andy Warhol) prefers to talk about: "I talk about what I'm doing, what the other person is doing, her job, his job, my job, about travels. I like amusing gossip, but I don't want to hear about something that hits hard. I never talk about the coquette things and I don't confide in anyone."[35] The reader learns that Berenson is "tall, slim, with sea-green eyes and a splash of honey-blond hair"; that she has a "close pal Halston" and a "dog, Squadgy"; that she "is one of the first to have her hair cut really short" and that "her friend, artist Joe Eula," did the cutting.[36]

These biographical trifles gain weight in their steady accumulation and reinforce a set of values promoted by *Vogue* in the seventies. Hawks and Berenson—like Candice Bergen (daughter of Edgar) and Taryn Power (daughter of Tyrone) and others similarly featured, with varying degrees of frequency and detail, throughout the decade—are exhibited for admiration and emulation because they are modern, natural, good. They are, in *Vogue*'s editorial opinion, "great girls." Hawks's "glamour is in no way nostalgic. Kitty is a straight-from-the-hip girl, a great girl in the cool, modern idiom. Frank, intelligent, . . . efficient and ambitious, followed by that luck which seems to trail the well-organized."[37] "Berry is today. Out in the world and on her own, involved with her life, her work, her friends. . . . She has that quality of putting others at ease, and a rather touching trust and openness. A

responsible young woman, . . . one of the great girls who spark up the New York scene."[38] According to a caption in the anniversary special, "Classic, androgynous—Charlotte Rampling was considered by *Vogue* to be the archetypal '70s woman."[39] Certainly Rampling appeared in several numbers of *Vogue*, in various guises: as "a sleek little kitten playing cat in the corner in one zebra-striped corner of the El Morocco" in the February 15, 1972, issue; as "the boneless wonder, in another of her yoga positions—supple as a seal" in the July 1976 issue (in which she again mentions "my son Barnaby").[40] But women like Hawks and Berenson and Lauren Hutton (model, actress in *American Gigolo* [1980], "Tom Sawyer, 1973 . . . anything but a classical beauty") were called upon much more often to fill the complicated role of modern woman in *Vogue*, to adapt men's and women's traditional effects to new uses.[41]

In her autobiography, Edna Woolman Chase recalls earlier editorial struggles: "I have remonstrated when [Liberman] and the editors have passed photographs of models who do not look like ladies and therefore are not *Vogue* material, but they contend that that's what ladies of today look like and as journalists we should show them as they are, not as we think they should be."[42] In tame shapes, Hawks and Berenson embody Liberman's idea of "what ladies of today look like," which he indicates in "All about Men . . . and Women." This essay, first printed in *Vogue* in May 1961, is reprinted in the October 1, 1971, issue because, according to the introductory note, "a decade later, it is even more of our time." Liberman's idea is at once daring and redemptive, designed to promote images of the modern woman "as a working, interested being," whose purposeful movement through life "seems to purify the naturally seductive feminine motion."[43] This signifies, Liberman suggests, her movement away from "the image of beauty, the image of woman, . . . made by man into a purely erotic idol"—and toward liberation "from banal categories" of dress and deportment, as described by West in "Nakedness vs. Nudity," imposed in response to man's sense of ancient shame in worshiping that idol.[44] "The woman of our time has destroyed the erotic strait jacket," Liberman declares, and now can enjoy the "open, naked courage to be oneself."[45] And to be enjoyed, and praised, in that new role: "For these people who are without fear," West says, "being naked together and enjoying each other's nakedness is sacramental, a true act of worship in which the woman is at once the priestess and the embodiment of the divine."[46]

Mirabella does not approve of what she considers prurient in West's essay, and she came to disapprove of what she saw as Liberman's decadent views in the eighties. But in less ecstatic, more plausible terms, she appears to subscribe to their essays' underlying theme. She says that her own project at *Vogue* in the seventies was "creating the image I was always after of the feminine woman *as agent*"—rather than as object. "I did think," she says

even more directly, "that in working with the best photographers of the era, we had a unique opportunity to use sexually charged imagery to turn the tables on who seemed to have the power in an encounter between a man and a woman."[47] Certainly she offered up images to illustrate her own conception of the archetypal seventies woman, which fitted Liberman's and West's conceptions, too. Berenson's bicycle, her "Cycling wear," Taylor's car, Rampling's car keys, her shoes, effectively signify the liberated woman's pure motion, her movement forward.[48] And Hawks's "blouson buttoned only twice to display pale, flawless skin" while she stands with arms akimbo is—like Taylor's perfumed skin and untied neckline and careless posture and unrepentant gaze at the half-dressed man who crosses her path (Mirabella calls this "one of my absolute favorite pictures from this period")—suitable to replace any straitjacket, erotic or otherwise.[49]

A fashion editorial directly following Liberman's essay on men and women includes Avedon's photograph of Hutton with "a show-biz regal python."[50] This is the real star of the ancient drama that had been updated for the seventies and was being played out again in Mirabella's *Vogue*. The serpent, adopting many poses, shedding costumes with regularity, is one of the oldest and most interesting players in the moral universes created by *Vogue* through the decades. Across two pages at the center of the September 5, 1907, issue, an illustration labeled "Camaraderie" shows a woman supine outdoors: drapery twists round her lower limbs, her torso is bare, her hair spreads out in tendrils across the grass, her mouth is half-open in a smile, her gaze is directed to a snake on the grass (fig. 7.3). The snake, almost touching her naked left shoulder, rises up, flicking its forked tongue.[51] More than seventy years later, in the October 1981 issue, there is Avedon's photograph of the actress Nastassia Kinski posing with a boa constrictor. Kinski lies along the magazine, her stomach oddly protuberant, as though she had swallowed a large object and not digested it yet.[52] The anniversary special reprints Irving Penn's photograph from the August 1990 issue: the left side of a woman's face is shown in Kabuki-like makeup, against which a small, real snake shows vividly on her cheek.[53]

Quite different from these is a photograph of Hutton in 1971, which shows her in a black leotard, her hair pulled back, her makeup ordinary. She sits on the floor with her back straight, her right hand on her hip, her left hand lightly holding the snake against the length of her body. She looks straight toward the reader, and casually handles the python as though she were Emilien Bouglione—a male trainer of animals at the Cirque d'Hiver (in another photograph by Avedon, taken in Paris in 1955)—and not some supine, mesmerized woman. Hutton seems, indeed, "the mistress of . . . the wild things and the tame."[54] This photograph, far more than the portrait of Churchill in his upholstery, seems the perfect complement to the one of

figure 7.3

Rampling featured in the anniversary special. In its original context, the photograph of Rampling complicates, and emends for the seventies, the image of woman as Madonna, mother of all. The photograph of Hutton redeems the image of woman as Eve, archetype and sinner. Here, Eve masters the serpent and wittily apparels herself in it. The serpent—former token of woman's shame, memento of the time before her female body was a burden to her—has become a guise to be worn to its best effect, for woman's own benefit. It is like the fashionable dress Hutton wears on another page, "all crushy and curvy," that "ripples as it wraps," and "the simplest, slinkiest bias of black matte jersey" Hawks puts on in another issue.[55] In the seventies, in American *Vogue*, it is finally shown to be only another garment that woman is free to slip into or cast off as she pleases.

NOTES

1. "People Are Talking About . . . The Sexiest Woman in the World," 167.
2. "On the Edge," 359ff.
3. Ibid., 363.
4. Grace Mirabella with Judith Warner, *In and Out of Vogue* (New York: Doubleday, 1995), 198.
5. "'This Fleeting Seduction': Fashion Photography and Women, 1919–1979" (November 1979): 359.
6. Ibid., 145.
7. "From the Natural to the Ornamental," *Mirabella* (June 1989): 156–57.
8. Ibid., 381.

9. "Now I'm Sixty-six and I Love It," 140ff.

10. Ibid., 166–67.

11. Ibid., 167.

12. 119.

13. "Night-Eyes," 231.

14. Ibid., 119.

15. Ibid., 118.

16. "Casino, Zizi, Ooh la la!," 152–55, 153.

17. "A Whole New Way of Dressing in Black," 155.

18. 358–59.

19. Diana Vreeland, *DV* (New York: Knopf, 1984), 160.

20. "The Story of Ohhhh . . . ," (April 1975): 106, 103.

21. "The Beauty Collections," (October 1976): 216–17.

22. Ibid., 229. *Vogue* is thorough in its treatment of the topic, offering a rather scientific dissertation on the effects of soap and water on skin, accompanied by Penn's photographs of a woman soaping her body ("Simple Beauty: The Soap and Water Ritual" [February 1979]: 262ff).

23. "This Year's Makeup," 1 September 1972, 243.

24. Ibid., 242.

25. Francesco Scavullo with Sean Byrnes, *Scavullo Women* (New York: Harper and Row, 1982), 80–81.

26. "What's the Most Important Thing about Makeup?" *Vogue Beauty/Health Guide* (Fall/Winter 1978–79): 100. Applied correctly, makeup can also make you you: the base should become "part of your skin, part of you," Bandy instructs ("This Year's Makeup," 243).

27. Ibid., 82–83.

28. "Avedon and People" (October 1976): 280.

29. Leo Lerman, "Woody the Great," 144.

30. Ibid., 144–51.

31. "This Year's Makeup," 243.

32. "Vogue's Take it off / Keep it off Super Diet," 15 October 1971, 148.

33. "The Beauty Way," 1 October 1971, 116.

34. "Great Girls in Great Jackets," 1 January 1972, 79; "They Do It," 15 January 1972, 59; "Vogue's Beauty Checkout," 1 February 1972, 76; "In the Dark of the Night—The Dress with a Jacket," 1 February 1972, 149; "Vogue Beauty Checkout" (July 1972): 10; "Vogue Boutique," 1 August 1972, 41; "Vogue Observations," 15 August 1972, 23. Writing on "The Avedon Eye" in the September 1978 issue, Susan Sontag suggests that time and dislocation alter the fashion photograph from an immediate, anonymous record of contemporary style to a "manneristic branch of portrait photography" (508). In fact, *Vogue* frequently merged these photographic genres in the seventies, using

as models women who were not professional mannequins (even as unlikely a woman as Nancy Kissinger, wife of the secretary of state), but who were known, or were made known, to readers.

35 "What Women Really Talk about with Men/with Women," 15 March 1972, 63.

36. "Berry Berenson—A Natural Girl," 1 August 1972, 79; "Vogue Observatons," 15 August 1972, 23. Berenson's family is exhibited with particular frequency by *Vogue* in the seventies. The January 1977 issue reports: "At Marisa Schiaparelli Berenson's marriage to James H. Randall, in his Beverly Hills palazzo . . . the most glamorous girls in the world wept, waltzed, laughed" ("Super Girls," 106–7). The June 1978 issue features "Berry and Tony Perkins, sons Osgood and Elvis, . . . with Marisa Berenson Randall, and her baby daughter, Starlite" ("You Now: New Ways Americans live, love, play," 135–39). The *Vogue Health/Beauty Guide* discusses Berry's home life and her new career as an actress ("Berry Berenson Perkins: Living Healthy, Looking Better than Ever," 94–97).

37. "Kitty Hawks: Fast Runner On A Modern Track," 15 August 1972, 61.

38. "Berry Berenson—A Natural Girl," 79.

39. "On the Edge," 380.

40. "What's on for Tonight . . . Black Point d'Esprit," 80; "Charlotte Rampling's Stolen Moments," 104, 106.

41. Kate Lloyd, "Lauren Hutton: The Spirit and Mind Behind the Beauty" (June 1973): 93. In the January 1973 issue, Hutton is "our definition of a modern, pretty woman" ("Beauty Now," 97); in June she is "model, actress, and Vogue's prototype of the American look as we see it in 1973—vital, self-assured, of-the-moment . . . in a totally modern way" ("The Look of the American Woman Today," 76); in August she is "today's kind of girl" ("The look of today, worn by today's kind of girl—Lauren Hutton," 72). Throughout the decade she appears in Ultima II advertisements in the magazine.

42. Edna Woolman Chase and Ilka Chase, *Always in Vogue* (New York: Modern Literary Editions, 1954), 282–83.

43. "All about Men . . . and Women," 115–16.

44. Ibid., 116; West, 118.

45. "All about Men . . . and Women," 116.

46. West, 119.

47. Mirabella and Warner, *In and Out of Vogue*, 156, 160.

48. "Berry Berenson—A Natural Girl," 83.

49. "Kitty Hawks: Fast Runner on a Modern Track," 63; Mirabella and Warner, *In and Out of Vogue*, 160.

50. "Lauren Hutton and the Serpent," 1 October 1971, 125.

51. 260–61.

52. "New-Age Beauty/High Spirited Fashion" (October 1981): 488–97.

53. "On the Edge," 365.

54. West, 119.

55. "Lauren Hutton Laughter," 1 October 1971, 126; "In the Dark of the Night," 1 February 1972, 149.

Queering
the Seventies

8

Domesticating the Enemy

Bewitched and the Seventies Sitcom

(For Elizabeth Montgomery)

DAVID ALLEN CASE

Fifties situation comedies still seem crude in their pseudorealism, whether crudely bland and conformist (*Leave It to Beaver, Father Knows Best, Ozzie and Harriet*), crudely antifeminist (*I Love Lucy, I Married Joan*), or simply crude (*The Honeymooners*). This is not to say that these shows were incapable of stunning farce and amazing characterization from time to time, or incapable of including what is heteronomous: *Beaver*'s Eddie Haskell *is* Original Sin. He is as insidious as Talleyrand. Still, his worst efforts can cause no more than twenty or thirty seconds of vexation for Ward or June Cleaver. An exception might be made for *The George Burns and Gracie Allen Show*, which toyed with self-referentiality and Ionesco-like dialogue. On the whole, however, the impression that remains of fifties situation comedies is of something laughably bland and frighteningly conformist.

One remembers seventies television wholly differently, as representing the liberation of the situation comedy from the constraints of religious and middle-class tyranny, with Norman Lear productions like *All in the Family* and *Maude* sustaining enviable ratings by addressing "societal problems" and "controversial issues" with the grim determination of Zola or Dreiser. To the horror of much of the public, lesbian and gay characters could make guest appearances in which the scripts presented them "sympathetically": this is true not only of the Lear sitcoms but also of the MTM triumvirate constituted by *The Mary Tyler Moore Show, Rhoda*, and *Phyllis*, and of the prime-time soap opera *Family*. Seventies television also made the somewhat bold move of presenting a (half-)Asian renegade Buddhist monk (though played by the clearly Caucasian David Carradine) as superhero in *Kung Fu*—leading to denunciations of television violence that conventional (Anglo) Westerns like *Gunsmoke* and *The Rifleman* had somehow escaped. These shows

coexisted with *The Brady Bunch, Welcome Back Kotter, The Waltons, Love Boat,* and many other productions that hardly seem bold. Nevertheless, the fact remains that seventies TV was willing at times to promote (or, indeed, be boastful about promoting) an understanding of what might have been sexually, racially, or religiously alien to most of its audience.

American culture in the seventies, then, can be defined as the extension of avant-garde sixties values to a suburban audience, the domestication of rebellion (so well exemplified on *The Partridge Family* by Susan Dey's and David Cassidy's very long but *clean* hair, and by Mom's singing along).[1] The famous video of Bing Crosby and David Bowie singing "The Little Drummer Boy/Peace on Earth" as a duet marks a late high-water mark of this domestication. Television led the way in mass marketing, thereby partly neutralizing the trappings of what might once have actually been a counterculture.[2] Tokens of the sixties were never absent in the seventies; very young people these days continually confuse the two decades. Indeed, some historians regard the sixties as having lasted until the resignation of Nixon in August 1974, in much the way that other historians would have the nineteenth century persist until August 1914. Throughout the seventies, children (along with the elderly and unemployed) continued to see sixties television in daytime syndication; these reruns were as much a part of my childhood as the newer programs—and, in some ways, a greater part, which is my excuse for writing about *Bewitched*, a series ending an eight-year run in 1972, though its first episodes were taped before the assassination of President Kennedy.

By what path did television pass from the ethos of *Leave It to Beaver* to that of *Maude*? Sixties television does not at first appear to have effected the transition, for, in some ways, the series of that decade were *more* isolated from social upheaval than were their predecessors. To be more precise, a strange variation of the romance developed. (After the evening news, sixties TV viewers obviously required an anodyne.) I would suggest that television "progressed" through the sixties along a continuum of these romances, a sequence of fantastical comedies including the dadaist *Green Acres,* connected by the antique phone in Sam Drucker's General Store to the incomprehensible *Petticoat Junction,* but certainly not connected to "controversial issues"; *Gilligan's Island,* which remains famous for its efforts to make the banal exotic (or vice versa); *My Mother the Car,* which took the absurdist credo too far and lasted only a season; the titillation of "comically" aristocratic European values on *The Addams Family;* and the titillation of comically backward premodern American values as seen on *The Andy Griffith Show* and *Gomer Pyle.*

Bewitched begins vaguely in this company, but then, in part through sheer longevity, exceeds its sensibility, growing in some ways to be more threatening to puritanical values than were the representative Norman Lear

comedies. Perhaps only a show that could claim a purely unreal and romantic intent would be allowed to depict the outbreak of powers beyond the control of The American Father Who Had Once Known Best (here, the feckless Darrin Stephens). The very real threats to patriarchy emerging between 1964 and 1972 are presented in the guise of forces invading the suburban family from a supernatural (and, unavoidably, theological) world of apparitions and disappearances—forces brought to the marriage by the wife. One could maintain that the family of Samantha Stephens, with various relations introduced gradually over the course of more than two hundred and fifty episodes, is composed largely of heretics, beings who despise the suburban world in which Samantha has been marooned, who adhere to a different faith: the faith that magic happens, as it were.

The premise of *Bewitched* anticipates that of many seventies comedies: dangerously foreign but attractive powers penetrate the suburban milieu, where they cause some commotion but ultimately prove domesticable. An unstable accommodation is reached, with Samantha balancing the demands of Darrin and Endora, and with Edith Bunker's attempts to maintain peace and good cheer despite the hostility between Archie and Mike. Are Samantha's powers, and the supernatural pranks of her relations, basically un-American or basically harmless and endearing? Are the fatherless Partridge children in fact "hippies," or are they simply an amazingly untalented twist on the Von Trapps?

Whether or not witchcraft is successfully domesticated by the *Bewitched* plot machine, then, is a key question. Endora believes that her daughter has agreed to slavery by her marriage to a "mortal." Samantha's acceptance of servitude to her husband, however, is qualified by many things, not least among them the character of the male to whom she submits: Darrin Stephens is a buffoon. Is Darrin's buffoonery relieved by the sturdiness of other male characters? Hardly. Darrin's boss, Larry Tate, is the very figure of chuckle-headed unscrupulousness and waffling.[3] The name of Darrin's firm ironically emphasizes virility: Mc*Mann* and Tate. The clients (usually male) whom Larry, Darrin, and often Samantha struggle to please are inevitably authoritarian, spoiled, and alcoholic—showcases of arrested development. These figures to whom "Sam" slyly defers have no authority, or are incapable of exercising it effectively. The implications of this situation are ambiguous, admittedly; a portrayal of male authority figures as bumbling but harmless could be read as masking the real horrors experienced by women and children living in terror of capricious, alcoholic males, victims having no recourse to magic. One of the standard gags of *Bewitched* involves a quarrel between Samantha and Darrin; at the point where Darrin finally becomes too hysterical for her to tolerate, he will find himself zapped downstairs, banished to the sofa—often without a blanket. Was viewing this act of liberation escapist or empowering?

Real power clearly resides in the mother, the least domesticized character of the show. Endora—named for the witch who foretold the doom of King Saul—is perhaps the great camp creation of sixties and seventies television. As played by Agnes Moorehead, she is the queen's queen, with exaggerated hauteur, exaggerated makeup, several layers of chiffon robes, dramatic entrances and indignant exits, and some of the biggest hair of her time. In the opening (animated) shots of each episode, her name appears in the middle of a puff of smoke that quickly grows into a large cloud hiding the two figures of Samantha and Darrin. This sequence establishes her relative importance in the scheme of things: no wrath is like hers, no imprecations are as perfectly delivered. As Samantha confesses, "Zap for zap, Mother is pretty much unbeatable." In most episodes, Samantha literally ends up *praying*—angrily—to her mother, begging her to undo whatever new humiliation she has inflicted on Darrin, Larry, or Darrin's own surly, ill-matched parents. Endora assaults the name of the father, never referring to Darrin as such, but instead carrying the name through a (to him) infuriating and (to the adult viewer) puerile litany of mutations, including Durwood, Donald, Darwin, David, Dustin, Durweed, Dum-dum, Dobbin, and others I have forgotten. That fundamentalist Christians were disturbed by the implications of all this is documented in Herbie Pilato's *The Bewitched Book*.[4]

Endora is "married," which is to say that Samantha has a father, Maurice, but Endora and Maurice seldom encounter each other, and Maurice, a blustering Edwin Booth type, has a healthy respect for the technical powers of his former mate. In the episode introducing Maurice, the two actually face off: Endora has hidden Darrin so that he can escape her husband's murderous anger over his marriage to Samantha, and Maurice demands that she reveal his hiding place. Endora stares him down. Maurice then mutters, "You've grown stronger." She replies: "And you've grown older."[5]

Both Maurice and Endora seem foreign, not just because of their powers but because of their manners: Maurice speaks with a theatrical intonation (while wearing a cape and sporting a cane), and Endora enunciates with snippy affectation. Whenever she makes an unhurried exit, we hear that she is about to "fly" off to Paris, or that she "must" be in Paris in twenty minutes. Exactly what she will do there is unclear, but it will certainly be either illicit or unmentionably self-indulgent. She will not, for example, be vacuuming for anyone. (Samantha is constantly shown vacuuming her own house, for some reason—with an implied pun on "vacuum"?) Though Endora's pleas for Samantha to join her on these trips are usually rejected (in one early episode, Sam gets into trouble by agreeing),[6] Samantha obviously possesses the superiority that the option bestows. In effect, Endora is also pleading with the viewers: for once, leave your vacuum behind and see the World—the rest of the world that America had distrusted through so much

of its history, and distrusted with a special intensity in the fifties and early sixties. Endora may be, like Wilde's Lady Bracknell (on whom she seems to be modelled, at least in part), "a monster without being a myth," but, also like Lady Bracknell, she is in many ways the main attraction. Who could fail to share her disdain for Darrin Stephens, Gladys Kravitz, Larry Tate, and the rest of Samantha's suburban company?

Things beguilingly dangerous, as many critics these days have noted, are also manifest in Samantha's uncle Arthur (Paul Lynde), who actually wears a foulard and possesses an unmistakably queer manner. His own pranks at Darrin's expense consequently look like an unthinkable flirtation. At the same time, he maintains a healthy instinctual scorn for everything that Darrin's life represents. *The Bewitched Book* employs the standard euphemisms in describing Lynde both on and off the show: "flamboyant," "outrageous," but also, where his personal life is concerned, "private."[7] Pilato's book includes an interesting comment by a writer for the ill-starred *Paul Lynde Show* (1979): "Paul's outrageousness was not acceptable then in a main character. He was just too much to take on a weekly basis" (!). Exactly what was "too much to take" seems clear.

A good illustration comes in Lynde's appearance on an episode of *I Dream of Jeannie*, where he guest-stars as an obnoxious IRS agent about to assess and punish Major Healey for the "great art" that Jeannie has conjured up for him. One of the art objects is a crude miniature replica of Michelangelo's *David* (we never get the full frontal view, of course). Lynde announces his intention to stay with the suspicious evidence until his art assessor arrives: "Tonight, I'm sleeping with Michelangelo!" More daring, indeed, than any exchange between Samantha and Uncle Arthur—but the Healey household is one to which Lynde cannot return. He is the unambiguous villain here, as are all men who would like to sleep with Michelangelo.

On one episode of *Bewitched*, however, the writers actually exposed prime-time audiences to an incident in the life of Oscar Wilde, with Wilde's words appropriately put into Uncle Arthur's mouth. When Samantha responds cleverly to one of Arthur's prank arrivals (I believe his face has just appeared in a serving tray), Arthur says, "Oh Samantha, I wish I had said that." Samantha, taking the part of James Whistler, replies: "Oh you will, Uncle Arthur, you will!" (The laugh track then explodes at exactly its standard volume—as if all the audience were in on the joke.) Surely, one of the episode's writers felt a special satisfaction in hearing this exchange broadcast on ABC, as it confirms for the alert viewer what most people felt at the time, that there was "something funny" about Paul Lynde that went beyond the "funny" things that were acceptable on situation comedies. This episode also illustrates Samantha's interesting attitude toward her "bachelor" uncle, one of amused tolerance, mingled with deference—an attitude that many viewers might not have been inclined to share, but one proper for the hero-

ine of a romance, like Beatrice in *Much Ado*, or Rosalind in *As You Like It*. Montgomery makes Arthur as much at home on *Bewitched* as he is an outsider on *Jeannie*.

Elizabeth Montgomery's confusingly effective impersonation of the fifties housewife (a housewife, however, with unusual reserve and a smile that hints at superiority) sanctioned the representation of much that would otherwise have been unacceptable. Prominent among these were the episodes featuring Samantha's "cousin" Serena, mentioned in the closing credits as being played by Pandora Spocks, with the character actually played by Montgomery in a black wig and a miniskirt. The name Pandora suggests the regressive mythology behind this depiction of a woman who is all "mischief" and innuendo. Still, the very presence of female sexuality on the loose, so to speak, with unlimited mobility, perfect disguises, and a deep fund of mockery at its disposal, points in its own way to the autumn of the patriarch. Samantha, by doubling as Serena, makes even less real her token commitment to vacuuming the house, caring for Tabitha and Adam, and mixing cocktails for Darrin and his colleagues. Serena's "swinging" dress and petulant demeanor make her the perfect match for Uncle Arthur, some of whose mannerisms Montgomery adopts for this role. (Both Arthur and Serena, for example, greet Samantha with a caustic "Hiya, Sammie.") Through Serena, Montgomery, with the connivance of the writers, presents audiences with another heretical type—one very properly suspect in the eyes of Darrin's parents and of the Stephenses' neighbors.

In response to these suspicions, the producers of *Bewitched* filmed a series of episodes in Salem, Massachusetts, where Samantha and Endora make passing but strong condemnations of witch-hunting and witch stereotyping. These protests obviously translate into protests against a number of other middle-American phobias. To some extent, Darrin and his parents embody these phobias, but they are most tellingly represented by the voyeuristic paranoia of Gladys Kravitz, the John Bircher–style neighbor across the street who is always convinced that "something funny is going on over there." In one episode, she actually walks into the Stephenses' residence saying, "To the naked eye, this looks like the average American home" (although in many episodes a very strange painting, of an ancient man or satyr playing guitar, can be seen displayed above the hearth). There is nothing like the smugness of Mrs. Kravitz when confronting Samantha, Endora, or Arthur about her discoveries—as if *laws* had been violated. The viewer must translate: there were/are laws against "sodomy," "subversion," and "disturbing the peace." Witches and warlocks can only be violating these laws, a violation disguised on the show as a defiance of the laws of physics, or laws of *nature*. The viewer may ask herself: Why is Gladys so upset about magic? Why should she not instead be thrilled, fascinated, grateful? Even Samantha, gracious to almost every mortal she encounters, despises Gladys Kravitz: her scorn, shared

emphatically by Endora and the rest of the "family," could be translated into the scorn of the show's creators for Birchers and proto–moral majoritarians—people on whom camp is simply lost.

Elizabeth Montgomery could be said to have fulfilled the promise of this mildly queer-friendly guise by serving (along with Dick Sargent, the second Darrin) as Grand Marshall of the 1993 Gay Pride Parade in West Hollywood. Somehow, it all made perfect sense. More startling, perhaps, was Montgomery's narration of the Barbara Trent documentary *The Panama Deception* (1992): in retrospect, it may be almost too easy to read subversion into Montgomery's earlier performances. We must remember that the "true" Samantha and the "true" Darrin kiss and make up at the end of each episode, regardless of the number of metamorphoses the characters undergo in the dizzying twenty-three minutes of exposition and resolution of every situation, in which the absurdity sometimes rises to the level of opera buffa.

Allegories like *Bewitched* depend on the skills of translation that develop from the necessity for disguise. When ABC, in January 1972, programmed *Bewitched* directly opposite *All in the Family*, the audience for the cute sitcom about a housewife who is also a sorceress vanished as quickly as had the audience for silent film. (The transition from *As You Like It* to *Every Man in His Humour* also comes to mind.) How could *Bewitched* escape seeming quaint and irrelevant in the face of this fully realized seventies creation? If Darrin Stephens was a buffoon, Archie Bunker was a full-fledged cretin; while Paul Lynde's Arthur was an interesting, half-closeted experiment, the Bunkers had friends and cousins who talked with therapy-group "openness" about being gay or lesbian. Elizabeth Montgomery's own genial superiority was bland when juxtaposed with Jean Stapleton's masterful embodiment of the proletarian ingenue. The canned laughter of *Bewitched* must also have seemed outmoded beside the guffaws of the rowdy studio audiences assembled for Norman Lear's programs.

All in the Family and *Maude* dared challenge bigotry directly because the producers were assured that, at the same time, they were directly satisfying audience *prurience*—much like the dynamics of Molière's *Tartuffe*, which ends with a tirade against puritanism and hypocrisy, but only after satisfying a prurience born of puritanical repression. Eventually, the seventies would evolve its own type of romance (*Love Boat, Fantasy Island*—do these scenarios sound familiar?) that, while artistically deplorable, would be able to compete with the Lear sitcoms in satisfying a different sort of prurience, but the allegory, disguises, and geniality of *Bewitched* were no longer possible.[8]

Thanks to the longevity of *Bewitched*, however, and its extended success in morning and afternoon syndication, it and some of the earlier comedies continued to nourish the imaginations of my generation of TV viewers through the early and middle seventies: in the time of *Chico and the Man, Monday Night Football, The Waltons, Emergency,* and *Rhoda*, one could see, in reruns,

Arnold the Pig (of *Green Acres*) having a successful exhibition of his paintings in Chicago;[9] Morticia and Gomez Addams indulging openly sadomasochistic sexuality; a genie living in a luxuriously furnished bottle (though regressively calling her mortal lover "Master"); and, most important of all, Endora's grandeur, anti-American values, and Bunburying in Paris, Uncle Arthur's foulard, and Serena's efforts to persuade a mortal rock band to perform at the Cosmos Cotillion. Elizabeth Montgomery made these last characters feel at home in a house very much like our houses, and television in general began reconciling the American majority to elements it had so long regarded as the enemy.

NOTES

1. In one *Partridge* episode, after a middle-aged man has referred to her children as "a bunch of hippies," Shirley Jones scowls, repeating the word "Hippies!" with considerable indignation. The middle-aged man had put his finger on all the ambiguity of the Partridge project of domesticated rebellion: they wanted at once to be and not to be hippies.

2. Susan Dey's commercials for Pssssst! Shampoo, which, as many will recall, was to be sprayed on in front of the mirror (Spray! Comb! Flip! Go!) rather than used in the shower, are among the characteristic images of domestication in this period (fig. 8.1). The fanzine *Susan MiniMag* has recently fully exploited these images.

3. An L.A. underground band active from 1987 to 1989, led by Rick Fink of the UCLA Music Department, called itself The Larry Tate Experience, undoubtedly because Tate embodied these qualities so well. A contemporaneous southern band adopted the name Reuben Kincaid, after the fumbling manager on *The Partridge Family*. These efforts to reclaim the domesticated counterculture of the early seventies for eighties irony was one of the first signs of the mock seventies nostalgia that culminated in the masterful *Dazed and Confused*.

4. Herbie J. Pilato, *The Bewitched Book* (New York: Dell, 1992), 21–23, 29.

5. Episode 10, "Just One Happy Family" (19 November 1964).

6. Episode 9, "Witch or Wife?" (12 November 1964).

7. Pilato, *The Bewitched Book*, 73–75, 276–77.

8. Now, however, at the end of the nineties, one can detect echoes of the *Bewitched* style in *Friends* and, a fortiori, *Will and Grace*.

9. His greatest success was titled *Nude at a Watering Trough*.

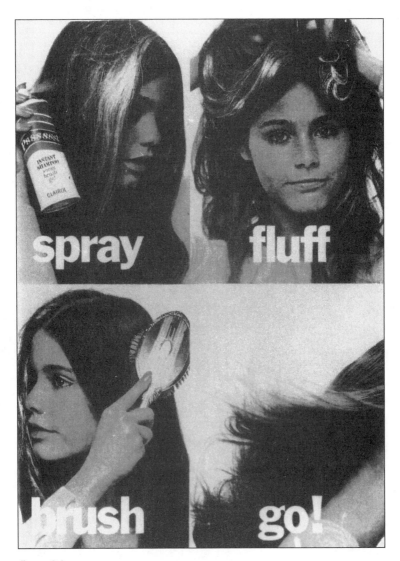

figure 8.1

The Way We Were

Remembering the Gay Seventies

CHRISTOPHER CASTIGLIA

By the time I started having sex with men, the 1970s were almost over. At first my experiences were infrequent and ill choreographed, but by the time I was a college sophomore, I was more fluent in the codes and conventions of gay sex. Some of that fluency came with experience, but my most crucial education came from books, beginning with Andrew Holleran's 1978 novel, *Dancer From the Dance*. As I devoured that tale of urban sexual revolution, even in rural Massachusetts I began to appreciate the "gayness" of the music, sexual customs, and above all storytelling styles that were, by the late 1970s, becoming regular props in our dances, parties, and meetings.

Above all, the novel showed a network of men in the city among whom—contrary to the television I grew up with in which ex-lovers were always the bitterest enemies—sex led to intimate and often lasting social networks. I learned from the novel, full of dishy gossip, that those networks are created not by sex itself but through the storytelling afterward, which established trust, familiarity, and shared knowledge between intimates. That knowledge was reinforced in the novel by a cultural vocabulary—deejays and dance divas, drugs, locations where men could find quick sex or night-long orgies, how to know who wanted "it" and which "it" he wanted—that showed me that the things the rest of the culture deemed trivial were in fact creating a safe place in a hostile environment, a culture within a culture. The details of this culture's productive vocabulary changed quickly: indeed, it was the nature of the things the culture valued—drugs, dance, music, cruising—to be constantly in flux. It was not just promiscuous sex this culture was inventing; it was promiscuous representation. The impermanence of the vocabulary mattered little, however, for, if anything, its flux stressed the apparent permanence of the network

through which the details moved. This week's hottest boy would not be next week's, but the friend who called to dish him would stay the same. Producing a rich culture in a world that considered them sick and immoral, the men in the novel could not count on archives and history books, but they could count on the communication networks generated through patterns of sex and sexual narration. It was this world that I expected to inhabit once I moved to New York.

The presumed permanence of the networks represented in Holleran's novel was challenged, however, before I could get to the city. During my senior year, I developed a crush on a blond who finally kissed me one night in my dorm room. I didn't want to stop with the kiss, but, alas, he did, so instead of making love we went for a walk in the snow. The air felt strangely warm, and the snow-covered campus was gorgeous; he was talking to me about something with dead earnestness, but I was too happy to really listen. Only later did I realize that I was, for the first time, hearing about AIDS, but it wasn't until a day or two later that I thought seriously about what he had told me that night. We were two years into the Reagan decade, but, in my personal mythology, the 1970s ended on that night.

When I graduated in May, I moved to New York to pursue, not sex and disco, but graduate study. I had always imagined that I was separated from the world I read about in Holleran by geography. When I finally reached Manhattan, however, I found that Holleran's world was now beyond a historical divide. "'I don't know anyone who is gay anymore,' says a woman I know," Holleran reports in *Ground Zero*, his 1988 postmortem on the 1970s. "'Gay is not an option.' The bars, the discotheques that are still open seem pointless in a way; the social contract, the assumptions, that gave them their meaning, is gone."[1] I knew what Holleran meant. Organizations were somber (the leader of the gay reading group in which I participated committed suicide after his lover died from AIDS). Friends stopped going to bars and dances and started coupling up, feathering nests. If anyone still had tales of sexual adventure, he kept them to himself. The culture of *Dancer* was disappearing because, as Holleran put it, Sex had become the Siamese twin of Death.[2]

Holleran's metaphor of the Siamese twins makes the linkage of sex and death a natural phenomenon, and the most powerful agent in the natural arsenal was, of course, the virus itself, which quickly took on anthropomorphic powers. "The death of Dionysus—the closing down of promiscuity—took a long time to complete itself," Holleran writes, "a lot of fear. But fear was what the plague has produced copiously, till it now constitutes the substance of homosexual life. AIDS has been a massive form of aversion therapy. For if you finally equate sex with death, you don't have to worry about observing safe sex techniques; sex itself will eventually become unappetizing."[3] But in his account of how sex got linked to death, Holleran

moves from the virus to a human agent ("you"). Such a move is no surprise from an author whose novel demonstrates how the stories we tell produce the social world we inhabit; if that is the case, wouldn't the "death" of sex be the result, not of nature or a virus or the will of God, but of a change in stories? I want to pursue the idea that the "killing" of the 1970s, the move from a cultural self-representation that valorized sexual adventure, expansion, and optimism to one that stressed harrowing guilt, isolation, and despair, was not a "natural" or a historical inevitability, but the result of changes in representation that in turn have had crippling social and political consequences for gay men today. At the crux of that change, I want to suggest, is how we talk about what happened in the 1970s and what impact that culture—and the ways we talk about it now—has on our lives today. Our historiography, I will argue, is changing our history.

In too many AIDS narratives, death necessarily marks a gay man's future because sin has characterized his past, a blame game that makes the gay past readable as the "cause" of death and loss and implies—and too often asserts—that gay men brought AIDS on themselves. Illness thus becomes proof positive that one has lurked in the dark dens of perversion, relinquishing all claims to compassion, comprehension, or credibility. Too often, critical and activist interventions in narratives that mark gay futurity as fatality have focused on the blame placed on individual gay men for their illnesses; yet a potentially more dangerous narrative places blame for AIDS on gay male culture more generally, a supposedly less cruel because more abstract gesture. Even if individual gay men are not genetically or psychologically programmed for self-destruction and suicide, this story goes, the culture these men produced, centered on reckless perversion and unthinking abandon, contained the seeds of death and dissolution. Here, a morbid and pathologizing essentialism is displaced from individuals to the collective, but the causal logic of blame still prevails. Such narratives rely on a strategy I will call *counternostalgia*: a look back in fury, representing the sexual "excesses" of the immediately pre-AIDS generation as immature, pathological, and diseased. The danger of counternostalgia is not that it represents the past inaccurately, but that it proscribes the present normatively by limiting the options for identification and pleasure, for public intimacy. The renewed politics of conformity (seen, for example, in the "we're just like you" arguments made to support claims for gay marriage and domestic-partnership benefits) is made palatable through narratives that, in the guise of evaluating a sexual past whose flawed features are self-evident, directly or implicitly urge gay men to distance themselves from the tainted past and to structure their lives along cleaner, healthier lines that end up looking very much like the borders of normative heterosexuality (monogamous, domestic, organized by property rights, including child raising). Working in a culture of sexual paranoia so profound that such ideological work may be

carried out easily in the guise of "common sense," counternostalgia represents gay male sex as a fixed object of moral evaluation, obscures the dominant culture's role in establishing sexual "norms" as a technology of power, and denies the agency of "deviants" who use unsanctioned sex to generate unconventional public intimacies and therefore to challenge the normalizing structures of mainstream America.[4]

One might expect the production of counternostalgia by right-wing avatars of "traditional family values" who have done their best to bring the parties of the 1970s to an end. Less predictable, however, is its persistent production by gay men themselves. Why gay men would want to serve the interests of a "general public" that has made little effort to serve gay interests is a complex question, and not one I can fully answer. On the most banal level, gay men, as AIDS activists have long pointed out, are part of that "general public," which not only entitles us (theoretically) to civil rights and police protection, but frequently makes us agents as well as objects of mainstream thought. Counternostalgia is also partially understandable in light of the fear that led many gay men in the early years of the epidemic, when safer sex education was scarce and changed rapidly, to conceive of celibacy or monogamy as the only viable responses to a sexually transmitted virus. One could argue as well that gay men, shocked at the decimation of a subculture they had worked so hard to create and by the deaths of those with whom they inhabited it, have sought to defend themselves by minimalizing the value of what was lost.[5] Finally, there is an implied prophylactic syllogism of blame: if the sexual revolution caused illness, and one distances oneself from the sexual revolution, one is therefore distanced from illness.

I want to focus here not on the motivations for counternostalgia, however, but on its consequences, for I believe that the stories we tell of our past assert who we are in the present and create the spaces for and modes of sociality open to us today. This became startlingly clear to me in 1987 when ACT UP formed in New York and, tired of feeling scared and isolated, I began attending meetings. Over the next years, those meetings reenlivened my sexual and political imagination, not only because of the cruisy meetings and demos, but because of the merging of pride, anger, community concern, compassion, tenderness, and exuberant fun, all in the context of sex-positiveness. ACT UP was keeping something of the 1970s alive for me, even while altering the cultural forms of that decade to meet very different political, medical, emotional, and cultural necessities.

The most important lesson I learned about the 1970s from ACT UP is not that gay men produced any revolutionary sexual practice or discovered how sex can liberate in previously unimaginable ways. Rather, urban gay male culture of the 1970s, like that of ACT UP, turned sex acts into a public vocabulary that has the potential to change the values propagated in mainstream culture, as gay men such as Charley Shively argued throughout the 1970s.

In "Indiscriminate Promiscuity as an Act of Revolution" (1974), for example, Shively argued that by participating in anonymous promiscuity, gay men reject a "massive tool of social control" by rejecting the commodification of Anglo-Saxon masculine beauty as the standard of worth and value.[6] ACT UP revitalized the insight that sex is a prime location of social regulation and that resistance to sexual normativity has broad social implications. In "How to Have Promiscuity in an Epidemic," for instance, Douglas Crimp, a cultural critic closely allied with ACT UP, writes,

> All those who contend that gay male promiscuity is merely sexual *compulsion* resulting from fear of intimacy are now faced with very strong evidence against their prejudices. . . . Gay male promiscuity should be seen instead as a positive model of how sexual pleasures might be pursued by and granted to everyone if those pleasures were not confined within the narrow limits of institutionalized sexuality.[7]

The values set forth in these two pieces—pleasure, anonymity, promiscuity, diversity—challenge the cornerstones of 1980s conservative politics centered on the work ethic, individualism, and self-contained, privatized reproductive families. Thinking through the transformative potential not of gay sex as much as of gay sexual culture, of gay promiscuous representation, ACT UP demanded not only a place at the table, to borrow the title of Bruce Bawer's counternostalgic treatise, but a change of menu.

The confidence necessary to rally for transformation rather than acceptance or "rights" that inscribe us within dominant constructions of citizenship is largely missing in gay culture today. But that loss need not be permanent. I am not advocating that we "return" to the 1970s, an impossible enterprise even if it were desirable. What I am urging, rather, is that we think critically about what stories are credited with access to truth, to the social "real," beginning with our stories of the gay sexual culture in the 1970s. Only in so doing will gay men's sexual representations transform the restrictive and normalizing counternostalgia at work in current memory narratives. It's time to tell new stories about urban gay male culture in the 1970s and, by so doing, to make a new gay "real."

The difficulty of representing alternatives to current sexual conservatism once gay men disavow the sexual culture of the 1970s becomes evident in Gregg Araki's 1992 film *The Living End*, in which two gay men, Luke and Jon, respond defiantly to their seropositivity by taking to the road, driving aimlessly, shooting up ATMs, and fucking with and without condoms, in public and in private. The appropriated "road trip" narrative is made to refuse the structure of cause and overdetermined outcome that has driven AIDS stories repeatedly toward death while placing blame on the "behaviors" of those infected by the virus. *The Living End* calls attention to and frustrates the

abjection audiences have come to expect as an appropriate closure to the story of AIDS, while at the same time mocking the possibility that a narrative produced in a homophobic culture with intense fears of death and no national health care could or should end "happily ever after."

While *The Living End* refuses to make individual gay men's sexual acts the cause of their inevitable despair and demise, it does engage a causal narrative of blame that introduces into the film a tension between two historical narratives: one that might be called redemptive and the other counternostalgic. Counternostalgia enters the film in the scene following Luke and Jon's first night together, as Luke explains his AIDS-inspired philosophy over breakfast:

> So figure this: There's thousands, maybe millions of us walking around with this thing inside of us, this time bomb making our futures finite. Suddenly I realize: we got nothing to lose. We can say, "Fuck work. Fuck the system. Fuck everything." Don't you get it? We're totally free. We can do whatever the fuck we want to do.

Luke's conception of freedom teeters, in this scene, between an oppositional stand toward obligatory capitalism ("Fuck work. Fuck the system") and the hopeless lack of commitment ("Fuck everything") that is, according to conventional AIDS narratives, the teleological necessity of an HIV+ diagnosis. Luke's inability to sustain opposition without lapsing into despair—his "Fuck everything" ends in his later exasperated claim, "I don't care about anything anymore"—appears to arise from his attempt to purchase his "freedom" through a counternostalgic discourse of generational blame. Immediately preceding the lines quoted above, Luke tells Jon:

> I mean, we're both gonna die. Maybe in ten years, maybe next week. But it's not like I want to live forever and get old and fat and die in this ugly, stupid world anyway. I mean, we're victims of the sexual revolution. The generation before us had all the fun, and we get to pick up the tab. Anyone who got fucked before safe sex *is* fucked. I think it's all part of the neo-Nazi, Republican final solution. Germ warfare, you know? Genocide.

If Luke refuses the closure of despair, if he knows he is not to blame for his own seropositivity, he can claim his innocence only by displacing guilt from the individual to the cultural past. It remains unclear, in Luke's account, how the "fun" had by a previous generation of gay men *and* Republican genocide can both be responsible for AIDS, but both somehow are; the "sexual revolution," rather than constituting a challenge to conservatism, acts in tandem with the political climate that allowed the epidemic to flourish.

Yet Luke's counternostalgic narrative generates contradictions that come dramatically to the surface at the film's conclusion. For while Luke may want to distance himself from a previous generation of gay men whose

"fun" has gotten him in his present fix, only by engaging in the rescripting of sex as defiance and as the basis of illicit intimacy can Luke express his anger and achieve the agency that helps him escape isolation and despair. In the film's concluding scene, when Jon, sick and disgusted with Luke's antics, decides to go home, Luke rapes him, holding the barrel of a revolver in his own mouth and vowing to pull the trigger as he climaxes. The film has reached the despair that the AIDS narrative seemingly requires as closure. Yet the film diverts the conventional AIDS narrative at the last moment, when Luke throws aside his gun and Jon, who slaps Luke and walks away, returns again. The film's last shot shows Luke and Jon sitting side by side in the middle of an arid landscape, leaning on one another's shoulder. Each turns out to be the other's support, literally and figuratively, in a narrative that, while it will not suggest where these men might go next, also refuses to sentence them to isolation and death-figured-as-suicide.

The film's conclusion suggests, in other words, that Luke owes more than one debt to the previous generation's enabling fantasy of sex-as-community and of sexuality-as-resistance. While counternostalgic discourses that vilify politics or companionship based on sexual pleasure place Jon and Luke in the overdetermined narratives of inevitable illness ("Anyone who got fucked before safe sex *is* fucked") and despair ("I mean, we're gonna die"), the connections they forge from their sexual pleasures, neither entirely arbitrary nor ineffective in opposing hatred, prove the most effective tools for resisting the victimizing narratives of straight America.

Granted, those older sexual narratives cannot be resurrected uncritically to meet the political demands of the film's historical moment. Not only has AIDS made it difficult to see some forms of sexual pleasure as liberating (indeed, the film associates Luke's desire to be fucked without a condom with his other despair-induced suicidal behaviors), but because gay men's devastating losses despite heroic efforts have made liberty itself seem like a utopian project. Nor does the film suggest that "community" is synonymous with "sameness." The yoking of the two men works best as a coalition against external violence (Jon meets Luke, for instance, when he inadvertently helps Luke escape after he has shot three queer-bashers); without the immediacy of an external defining threat, Jon's and Luke's efforts to find common frames of reference often produce their own violences, such as Luke's rape of Jon when the latter threatens to put an end to the couple's "hackneyed romantic fantasy" (the American road trip? the buddy film? community itself?). Yet, if the sexual narratives of the 1970s cannot be adapted uncritically, neither, the film seems to suggest, should they be left behind. Given the tension between counternostalgia and sexual redemption, the film shows the latter to be, while not perfect, the best bet for ensuring a living end.

The tensions in *The Living End* between two versions of contemporary gay men's relationship to the 1970s—a distancing desire for amnesia on the one hand and, on the other, a trace memory that enables a resistant intimacy—reflect more immediate debates over gay memory and its relation to cultural authority and public policy. One sees similar contrasting approaches to memory, for example, in New York City, where skirmishes over the closing of bathhouses and sex clubs demonstrate how counternostalgia helps define the heteronormativity of public space. On a National Public Radio *All Things Considered* segment, "Sex Clubs and Bathhouses Again Popular With Some Gay Men" (June 1, 1995), Mike, a "thirtysomething professional," HIV+ gay man who is "fit, trim and exudes health and energy," but frequents bathhouses, tells reporter Joe Neel,

> I became, first, kind of surprised at the amount of chances I had to infect other men. I had a 21-year-old a couple of weeks ago, who was ready to be unsafe. And at that point, I said, "Well, you know, I'm positive. Is that OK?" And—because I thought he might be positive too. And he said, "No." And suddenly he tensed up and got his pants on, and left. And I spoke to him later and he said, "I'm really angry that I was ready to take that chance."

From Mike's anecdote Neel concludes, "In this atmosphere of uninhibited male sexuality, men forget about safe sex."

There is, however, another lesson one could derive from Mike's story: that one of the two men *didn't* forget about safe sex. Not only did a gay man take responsibility for a stranger's health, the later conversation between the two men demonstrates the networks of compassionate communication that arise from "anonymous" public sex. Despite the evidence provided by Mike's anecdote, however, Neel, like the proponents of closing the bathhouses, draws a different conclusion that makes it unclear whether the "threat" posed in Mike's anecdote comes from a gay man forgetting safe sex guidelines or from the "uninhibited" nature of (gay) male sexuality itself. When historian Allen Berubé tells a dissenting story about "uninhibited" gay sex, Neel again glosses his testimony so as to produce a conventional moral:

> For me, it's the adventure of meeting someone you don't know and feeling this erotic charge and you know, exploring them and their bodies and having conversations and having this kind of bond with someone that you never met before and may never meet again. There's this specialness about this kind of intimacy with a stranger, that there's nothing else like it and it's its own thing.... There can be magic in those moments that really have a lot to do with trusting strangers. And there's very few places in this society where that can happen.

Despite Berubé's description of the trust that can arise in "anonymous" sex, Neel declares, "In New York, closing some places did send a message to the

gay community that danger lurked in bathhouses and clubs." Again, trust established among gay men through subcultural codes and physical intimacy gets turned into a lurking danger.

To be sure, gay voices have been raised in opposition to government regulation of public sex. Gay men are credited in this debate, however, only when they support heteronormativity, and such credibility is frequently established by denouncing the uninhibited hedonism of the gay past.[8] Those who bash the sexual past are legitimated, as Michael Warner notes, through access to columns and editorial space in New York's largest newspapers.[9] On the NPR segment, one such columnist, Gabriel Rotello, begins his case for closing the baths and sex clubs by drawing a sharp distinction between the unhealthy behaviors of those traumatically rooted in the past and the healthy vision of those who can leave that past behind:

> On the one hand is the specter of governmental involvement in gay sexuality, which is something that I don't think that any gay liberationist or self-respecting gay person welcomes. On the other hand, is the specter of a continuing epidemic that will continue to take the lives of 40 or 50 or 60 percent of all gay men. A rational person would have to say that the danger of a permanent epidemic is worse. But, unfortunately, in the gay world, many people, on this particular subject, are not rational. Many people are so traumatized by their past as gay men and by the stigma, and they see the resistance of that as their primary motivation in gay liberation, rather than actually the saving of their own community from this cataclysmic holocaust.

"In the best of all possible worlds," Neel further reports,

> Gabriel Rotello wants a 20- to 30-year period of what he calls sexual conservatism, where gay men have far fewer partners than they do today. That, he says, would break the chain of infection. But that also means a complete break with the past. Gay men must totally rethink the way they conceive their sexual behavior. But he says they can't do it alone. Society also has a responsibility.

Rotello's counternostalgic desire that we "break with the past" grows from his problematic assumption that we can overcome homophobia, not to mention HIV infection, by conforming to standards of social normalcy, having fewer partners and replicating marriage as sanctioned by the laws of a society again configured as exclusively straight. Given that "normalcy" requires a stigmatized deviant to maintain its ontological stability, how exactly that same normalcy can be expected to rescue gay men from stigma remains disturbingly unclear. Rather than investigating the past for the historical connections between "normalcy" and gay male trauma, Rotello chooses to blame the sexual culture of gay men for the "holocaust" of

stigma and shame. In so doing, Rotello establishes "sexual conservatism" as the sine qua non of "public" life, promising gay men access to public space if we surrender any claims to enjoy it in ways that challenge the primary status of the exclusive couple.

Arguably, the most effective response to counternostalgia has come in the form of what Michel Foucault calls *counter-memory*, a competing narrative of the past composed from memories that exceed official history.[10] Gay counter-memory finds in the recreation of the past opportunities for oppositional pleasures that nevertheless acknowledge the difference necessarily at the heart of memory.[11] Some gay men have rejected counternostalgia by generating alternative narratives of gay history that augment the conventional focus on the monogamous private couple with options such as communal life, multiple and anonymous sexual partners, shifting ownership and occupation of space, and non(re)productive sex.

A number of recent films have used gay counter-memory to resist the effects of counternostalgia. The second short film in the 1995 trilogy *Boys Life*, Raoul O'Connell's "A Friend of Dorothy," capitalizes on gay male cultural history as the source of public intimacy and survival. The film's protagonist, Winston, sets off to Greenwich Village to begin his freshman year at New York University armed with his Barbra Streisand, Bette Midler, and Cher albums. These singers, whom a homophobic character in the video identifies as "fag divas," provide Winston with comfort and, ultimately, a boyfriend. While shopping for a Streisand CD, Winston makes eye contact with a man perusing the Judy Garland selections. After camping for a few moments, the boy asks Winston if he is "a friend of Dorothy's," in other words, "Are you gay?" When Winston answers, "Yes, I guess I am," the man responds, "Someone should teach you to smile when you say that," and asks him out to, of all nostalgic locales, a piano bar. The film ends by suggesting that icons of the gay cultural past continue to provide places to meet, signs of identification, and modes of communication.

The final film in the trio, Robert Lee King's "The Disco Years," takes the viewer back to 1978—the height of the disco rage—when Tom Peters, a straight-acting, straight-appearing high school athlete begins to realize his homosexuality following a one-night stand with a fellow athlete, Matt. Trying to reassert his heterosexuality, Matt joins a group of students in terrorizing a gay teacher, writing homophobic epithets and taping male centerfolds on his classroom walls. When Tom identifies the vandals to school authorities, an anonymous caller notifies his mother that her son is gay, and Tom, fleeing his mother's tears and "it's just a phase" philosophizing, ends up at the local gay disco where, as Tom's voice-over makes clear, he could "be around people who would accept me the way I was." The final scene of the film underlines the message that seems to structure "A Friend of Dorothy" as well: the gay cultural past offers young gay men the vocab-

ulary through which to imagine, if not absolute freedom, then liberty from the individuating, lethalizing subjectivities provided by counternostalgia. As the soundtrack plays Cheryl Lynn's "Got to Be Real" and the viewer watches Tom disco with the high school's much vilified queer, Tom's voice-over, itself a marker both of memory and historical distance, explains, "In time the world of gay dance clubs would prove to be a trap of its own. But for now none of that mattered. At last I had found a place where the dance floor was filled with people like me. And the air was charged with a sense of freedom and excitement. And disco."

While the segments in *Boys Life* either isolate the gay male subject in the present moment or transport him back to the 1970s, Mark Christopher's "The Dead Boys' Club," part of a 1994 video collection entitled *Boys Shorts*, makes the relationship between the two cultural moments its central diegetic focus and stylistic device. In the opening sequence, the mise-en-scène suggests that Toby, our young gay protagonist, is torn between two generations: in one hand he holds that depressing AIDS emblem, a bottle of bleach, which he brings to his cousin who is cleaning up following the death of a friend; in the other he holds that account of the gay male sexual revolution, *Dancer From the Dance*. The impact of that novel becomes clear when Toby cruises a man on the street and takes his phone number, but the antiseptic and antisex ethos of his own day reasserts itself when Toby throws the number away. In the following scene, the viewer is introduced to Toby's gay older cousin, Packard, and Packard's friend Charles, a swishing, wig-wearing queen who immediately begins to hit on Toby. The video's contrast between the anxious and undersexed young man and the humorous, sociable older men highlights the generational change that is its central concern, and shows that cultural values of the past become more, not less, valuable in the context of AIDS. When the video introduces the older gay men, they are packing up the belongings of a friend who has just died from AIDS. Their wit and shared cultural references—encapsulated in narratives of memory—comfort them in grief. For them, AIDS is not the denouement in narrative of selfish recklessness, but the decimation of a gay culture essential to survival, especially for those caught in counternostalgia's imperatives. When Toby doesn't know who disco diva Donna Summer is, Charles laments, "Your generation will never know what it missed," to which Packard responds, "I think they do." The video's principal "hook" highlights the contrast between the sexual austerity of the present and the sex-positiveness of the past. Packard gives Toby his friend's favorite "slut shoes," and when Toby tries them on he is given a miraculous view into the "sexual underworld" of the 1970s, placing him among scantily clad men in leather cruising dark, disco-filled corridors. Toby at first tries to get rid of the shoes, but they continually return to him. When he wears them out to a bar one night he gets picked up by the boy whose phone

number he threw away the previous day, and, when he wakes up in the morning in the boy's bed and finds the condom Packard gave him still unopened in his pocket, Toby assumes, in the logic of counternostalgia, that his glimpse into the older sexual culture has led him to reckless, unsafe sex. The past has risked his health, Toby believes, and he refuses to see his one-night stand when he returns the shoes Toby has left behind. The film draws the reader away from Toby's counternostalgic conclusions, however, showing us the open condom packages that Toby cannot see. One-night stands, bar culture, disco—none of these is antithetical to responsibility and health, the video implies; on the contrary, they are potentially the source of companionship and pleasure.

"The Dead Boys' Club" acknowledges that we cannot wholly reclaim the past, for AIDS has changed the past as much for Packard and Charles as for Toby. But to disavow the past, to deny its representational importance for the present and the future, is equally futile, as the trope of the continually returning shoes demonstrates. The past will not be left behind; like the protagonist of Gloria Gaynor's disco hit, it will survive. And if Toby wants to survive, he must accept the past, embracing the mutual responsibility organized around the shared signifier "gay" developed by an older sexual culture. Ultimately Toby reconciles the present with the past: the last time Toby throws the shoes away, a street merchant finds them and places them among his wares. When Toby, apparently rethinking his rejection, reaches for the shoes, his hand touches that of another young gay man, who is also reaching for them, and they smile at one another as the video ends. Through his experiences with the past—represented by the community practices of his cousin no less than by the literal view the shoes afford—Toby completes the pass fumbled at the video's start. If completely reentering the past is an impossibility (signified by the contemporary production of seventies footage), the "past" can be rendered as cultural discourse, as counter-memories, that will enable new and more pleasurable narratives for gay men today: endings-in-sex rather than the sex-as-ending that counternostalgia requires. The representations of then and now coexist in the same video as they coexist in the same culture. By accepting that sex equals neither death nor irresponsibility, but companionship, pleasure, and knowledge, Toby ends up recognizing that he shares desires with other men, both living and dead.

It is significant that gay counter-memories are emerging through film (even the ambivalent treatment of memory in *The Living End*), for, as Foucault has observed, the mass media have become an essential site of resistant "popular memory." With the regulation of oral folk narratives in the nineteenth century, Foucault argues, resistant memory began to emerge in mass media, which show people "not who they were, but what they must remember having been." These mass-mediated memories become centrally important

for cultural resistance, Foucault contends, because "if one controls people's memory, one controls their dynamism. And one also controls their experience, their knowledge of previous struggles."[12] It is just such a knowledge of previous struggles, those now grouped under the rubric "the sexual revolution," that is at stake in current battles over queer memory. Engaging in filmic counter-memory becomes a way to "remember having been" gay in the oppositional and creative manner Foucault describes in "Friendship as a Way of Life": "Homosexuality is an historic occasion to re-open effective and relational virtualities, not so much through intrinsic qualities of the homosexual, but due to the biases against the position he occupies."[13] Among the "virtualities" Foucault imagines becoming visible through gay counter-memory are social relationships that sound very much like those developed in urban gay male culture in the 1970s: "A way of life can be shared among individuals of different age, status, and social activity. It can yield intense relations not resembling those that are institutionalized. It seems to me that a way of life can yield a culture and an ethics."[14]

Given the importance of film to the shaping and transmission of gay counter-memories, it is noteworthy that the heroes of two recent historical novels—Brad Gooch's *The Golden Age of Promiscuity* (1996) and Ethan Mordden's *How Long Has This Been Going On?* (1995)—are filmmakers concerned with the shaping of resistant gay memory. The exclusion of gay men and lesbians from conventional history is suggested by the ironic titles of these novels: a mysterious "this" that the mainstream doesn't know is "going on," gay culture, denied a "golden age" of public grandeur, has existed as an "intense subtext."[15] At the same time as they expose the exclusion of gays from conventional history, these novels employ counter-memories as the basis of communal subjectivity, making the 1970s a site of creative reimaginings rather than a paradise lost. Mordden renders the relationship of memory, self-invention, and community formation explicit in the story of Jim and Henry, former college classmates who are surprised to run into one another at a gay bar in New York. Rather than sharing conventional reminiscences of college days, Mordden writes, "this time they are going to work out a very different kind of nostalgia—whom they had crushes on in college, who else *was*, what exactly they themselves knew they were—the conversation, in short, that marks the two men's passing from acquaintances to comrades."[16] Nostalgia becomes a way to circulate codes of identity ("what exactly they themselves knew they were"), while the narrative collaboration creates a lasting bond: "One hour of such talk and you can be intimates for life."[17] Gossip takes on a more explicitly historiographic function in the novel when Larken Young tells Frank Hubbard, a Los Angeles vice squad decoy attempting to come out, stories of his gay past that over time lead Frank to resign from the police force in order to enter the "gay scene." Dissatisfied with remaining in the margins of national history, Larken and

Frank take a more active role in recording their own experiences; over the course of the novel, history becomes the means to codify everyday practices, which become almost mythic in the process, and to circulate those codes, providing gay men with ways to recognize and communicate with each other, and to perpetuate the illusion of communal cohesion even in the face of violence, death, or dislocation.

Effective as gossip and interpersonal storytelling are in generating memory narratives that enable alternative public intimacies, the novel suggests the need for more far-reaching vehicles for resistant acts of memory and desire. To satisfy that need, Mordden has Frank transform from a vice cop to a gay pornographer. Pornography not only shares with gossip an explicitly sexual content, it also transforms popular memory into an expandable public site of collective sexual pleasure and interpretive recollection. Like the filmmakers discussed above, Frank's movies are deliberate counter-memories. Unhappy with porn's implausible plots, which bear no relation to gay life as he leads it, Frank decides to write and star in his own films, which quickly become gay classics. In the first film he makes, a "pleasant-looking but unerotic young man" arrives on Fire Island, knowing no one. Eventually he has sex with a series of men and, after each encounter, takes on some aspect of his partner's apparel, until he is ultimately transformed into a sexy leatherman. At the end of the film, through trick photography, the newly created leather-hero fails to recognize his former self when they pass one another on the beach. Frank's film tells a somewhat unconventional coming-out story, but one that proves immediately recognizable to those in the audience who, like Frank, have learned how to survive as gay men not through official channels of instruction—religion, family, education—but through encounters, often sexual, with other men: his history is—or becomes—their history. As one audience member in Minneapolis who has come to the porn theater to figure out how to "be gay" says, "I am in this film."[18]

Frank's film—familiar to his 1970s audience because of its depiction of instruction through a living, sexual community—possibly resonates for a 1990s audience because of its suggestion of a different yet related endorsement of history, not as a scene of instruction, but of preservation. According to Freud, survivors mourn their lost loved ones by incorporating character traits of the dead into their own personalities.[19] If a living community instructs Frank's protagonist on how to "be gay," he, in turn, becomes a living commemoration of that community in the face of its dissolution. Frank's porn is not only his history, then; it is the record of his transformation into gay historiographer.

In order to reach the audience that needs his story most—in order to inscribe gay counter-memory—Frank breaks with a number of historical conventions. Most obviously, in restaging history as porn Frank marks sex

as a narrative act crucial to the forming of gay identities and of the bonds that provide a release from isolation and "unerotic" prescription. But if sex is discursive, and hence rule-bound, it marks a gay man's progress, not from oppression to liberation, but from one set of conventions to another. The pornographer who teaches gay men how to be gay is, after all, a former cop who is described in the novel as a "titanic authority figure," "an absolute."[20] Frank may live outside of the System, but he does so only by participating in what Mordden acknowledges as "the codes, the terminology, the system, . . . a chart of behavioral styles"[21] of which Frank becomes the authoritative enforcer and exemplar.

The interpellation of gay men into predictable "types" can be just as constraining as enforced heterosexuality, as Brad Gooch shows in *The Golden Age of Promiscuity*. Watching gay culture evolve throughout the 1970s from a frenzy of self-invention in the emerging culture of New York sex clubs and leather bars to a predictable performance of standardized deviance, one character worries that "gay life might wind up being a snore."[22] Gooch's narrator, Sean Devlin, "felt aroused by freedom. But freedom and identity were canceling each other out."[23] To avoid being "canceled out," Sean, who always felt gay life to be "a surface of images,"[24] becomes, like Frank, a maker of films that revise his personal experiences into representations of communal reinvention. Rendering the gay bar scene as representation, Sean reintroduces the interpretive flux for which gay men's sexual culture, according to Gooch, is especially suited. Far from bringing the end of shared endeavor, rendering gay life as an interpretable text makes it once again a site of communal self-invention as well as of prescription. Describing the cast of Sean's film, Gooch writes, "By now a lot of the men from the Shaft had shown up in the movie. . . . If they were a tribe, they were an improvisatory tribe with no set tests."[25] For Gooch as for Mordden, the formation of improvisatory tribes becomes possible through the circulation of sexual narratives that constitute a "snippet of history,"[26] while such provisional formations in turn constitute a "golden age" of gay public life.

The various and often divergent depictions in these texts of what constitutes gay life in the 1970s—s/m clubs and piano bars, disco divas and Barbra Streisand, porn and police raids—make abundantly clear that no one narrative of gay urban culture in the 1970s will represent the "real" story. Memory is not transparent—a simple reflection of what actually "was"— and therefore gay counter-memories will often differ and sometimes even collide. Nevertheless, the acts of renovation explored in these texts lead to, in Foucault's words, "the appropriation of a vocabulary turned against those who had once used it."[27] Gay counter-memory becomes self-defense as it intervenes in contemporary political discourse, engaging the gay cultural past—particularly the sexual cultures of the 1970s—to challenge contemporary imperatives toward irrevocable loss, isolating individualism, and

social conservatism. To look back is, after all, to refuse the imperatives laid down at the destruction of Sodom. In these counter-memories, the "sexual revolution," rather than causing AIDS, offers the codes of intimacy and the models of communal preservation that contrast the abstemious and individuating ways of life developed in the eighties. When, at the conclusion of Mordden's novel, Henry, discouraged, considers "that probably no political movement in history counted as little solidarity as this one," his faith is restored by an act of remembering. As the gay pride march stops to honor the memories of those who have died from AIDS, Henry remembers Jim, his college classmate and best friend, who died from AIDS the previous year. It's a moment of anguish for Henry, but also of renewed optimism, for, despite the lack of solidarity in gay life, "on this afternoon, the feeling was unity. This was the one day when everyone In the Life seemed part of a great striding giant of a history that would never cease its advance."[28]

At a dinner party in early 1991, I was asked if I had ever seen a movie that I felt fairly represented the world I lived in. Almost without hesitation I offered *Longtime Companion*, the 1990 movie that was hailed as the first mainstream cinematic treatment of AIDS. When pressed as to why I felt *Longtime Companion* represented my world, I responded that it was the first film to depict the icons of an urban gay culture that I inhabited, such as Silence=Death posters, Read My Lips T-shirts, baseball caps, and ACT UP demonstrations. From a distance, however, I don't think that was my strongest source of identification with the film. Rather, I think I identified with its concluding fantasy, in which the three surviving characters, standing on the beach at Fire Island, imagine the moment when a cure for AIDS is found. Suddenly crowds of cheering people, including the characters who have died, come running onto the beach from the boardwalk, embracing their living friends. This final scene was virulently criticized for its manipulative and sentimental suggestion that our losses to AIDS will ever be recovered, even in fantasy.[29] But I read the scene as a fantasy not of recovery but rather of continuity, that the values and experiences of an older generation of gay men have been passed on to the younger ones, who will use their identification with the past to strengthen their determination to fight in the future. When the fantasy suddenly ends and one of the characters says, "I just want to be there," the "there" signifies both the past and the future, the lost community envisioned in the fantasy and the future moment when the epidemic ends. Both in fact combine in the speaker, who is moved by his memories of the past to demonstrate against government inaction on AIDS, thereby helping to inscribe gay men's cultural future.

Like other gay counter-memories, *Longtime Companion* suggests to me that posing alternatives to counternostalgic versions of the past can open possibilities for public intimacy and hence strengthen gay men's resistance to isolation, guilt, and despair. Ultimately, however, gay male counter-memories

must do more than reverse counternostalgia's oppositional logic; they must analyze the stakes in generating and perpetuating such oppositions in the first place. We must address counternostalgic narratives as a technology of identity not only for gay men but, more dangerously, for the normative social subject. Only by challenging conservative subject positions and the counternostalgic narratives that establish and justify them will we be able to stop the Blame Game that tries to contain an already bereaved and besieged community. Only then can we begin to tell other stories, to have competing memories, which is perhaps one of our most significant acts of resistance. If limiting our sexual scripts—and hence sexuality itself—in the name of state-derived standards of "normalcy" is necessarily conservative, then the proliferation of sexual scripts that value unsanctioned modes of interaction and pleasure can serve as the basis of a crucial intervention in the state's disciplining of queer subjects. In telling different stories of the past, we are avoiding unnecessary loss and becoming present to ourselves. We must continue to tell such stories because of, not despite, the way we were.

NOTES

I want to thank David Bergman, Shad Christopoulos, Allen Frantzen, Christopher Lane, Susan Manning, Alan Sinfield, Marc Stein, and Shelton Waldrep for their valuable comments on this essay; they didn't all agree, but they all helped. As always, Chris Reed discussed every idea with me with care and generosity.

1. Andrew Holleran, *Ground Zero* (New York: Morrow, 1988), 21–22.

2. Ibid., 24.

3. Ibid., 24–25.

4. See Lauren Berlant and Michael Warner, "Sex in Public," *Critical Inquiry* 24, 2 (Winter 1998): 547–66.

5. Douglas Crimp attributes to melancholia "the sorry need of some gay men to look upon our imperfectly liberated past as immature and immoral": "In Freud's analysis, melancholia differs from mourning in a single feature: 'a fall in self-esteem.'. . . And this lowering of self-esteem, Freud insists, is predominantly moral"; it is a "dissatisfaction with the self on moral grounds. 'The patient represents his ego to us as worthless, incapable of any effort, and morally despicable; he reproaches himself, vilifies himself, and expects to be cast out and chastised'; 'in his exacerbation of self-criticism he describes himself as petty, egotistic, dishonest, lacking in independence, one whose sole aim has been to hide the uncleanness of his own nature. . . .' Moreover, the melancholic 'does not realize that any change has taken place in him, but extends his self-criticism back over the past and declares that he never was any better.'" Crimp, "Mourning and Militancy" in *Out There: Marginalization and Contemporary Cultures*, ed. Russell Ferguson et al. (Cambridge, Mass.: MIT Press, 1990), 239.

6. Charley Shively, "Indiscriminate Promiscuity as an Act of Revolution," in

Gay Roots: An Anthology of Gay History, Sex, Politics and Culture, ed. Winston Leyland (San Francisco: Gay Sunshine Press, 1989), 261.

7. Douglas Crimp, "How to Have Promiscuity in an Epidemic," *October* 43 (1987): 253.

8. Michael Warner has similarly argued that gay neoconservatives "repudiate the legacies of the gay movement—its democratic conception of activism, its goal of political mobilization, its resistance to the regulation of sex and its aspiration to a queer world." This repudiation of the 1970s legacy allows gay neocons—among whom Warner names Bawer, Larry Kramer, Michelangelo Signorile, and Andrew Sullivan—to "promote a vision of the gay future as assimilation, and they willingly endorse state regulation of sex to that end. They are interested in sex only insofar as it lends itself to respectability and self-esteem; and forget unconscious desire, or the tension between pleasure and normalization, or the diversity of contacts through which queers have made a world for one another" ("Media Gays: A New Stone Wall," *The Nation*, 14 July 1997, 15).

9. Gabriel Rotello was a columnist for *New York Newsday*, for instance, while another advocate for regulation of the bathhouses, Michelangelo Signorile, wrote a column for the *New York Times*.

10. Foucault, "Nietzsche, Genealogy, History," in *Language, Counter-Memory, Practice: Selected Essays and Interviews*, trans. Donald F. Bouchard and Sherry Simon (Ithaca, N.Y.: Cornell University Press, 1977), 160–64. On Foucault and "popular memory," see *Foucault Live: Interviews, 1966–84*, trans. John Jonston, ed. Sylvere Lotringer (New York: Semiotext(e), 1989), 207. For Foucault, gay male desire is itself a form of memory, as he makes clear in "Sexual Choice, Sexual Act": "for a homosexual, the best moment of love is likely to be when the lover leaves in the taxi. It is when the act is over and the boy is gone that one begins to dream about the warmth of his body, the quality of his smile, the tone of his voice. This is why the great homosexual writers of our culture (Cocteau, Genet, Burroughs) can write so elegantly about the sexual act itself, because the homosexual imagination is for the most part concerned with reminiscing" (Foucault, *Foucault Live*, 224). I am indebted to David Halperin for his fascinating analysis of the possibilities for queer politics opened up by Foucault's writings on history; see, for instance, *Saint Foucault: Towards a Gay Hagiography* (New York: Oxford University Press, 1995), 104–06.

11. Foucault discusses the distance or "loss" at the heart of acts of memory, particularly those that attempt to regain lost origins: "From the vantage point of an absolute distance, free from the restraints of positive knowledge, the origin makes possible a field of knowledge whose function is to recover it, but always in a false recognition due to the excesses of its own speech." "Nietzsche," 143.

12. Foucault, "Film and Popular Memory," *Foucault Live*, 92.

13. Foucault, "Friendship as a Way of Life," *Foucault Live*, 207.

14. Ibid.

15. Brad Gooch, *The Golden Age of Promiscuity* (New York: Knopf, 1996), 16.

16. Ethan Mordden, *How Long Has This Been Going On?* (New York: Villard Books, 1995), 233.

17. Ibid.

18. Ibid., 400.

19. See Crimp, "Mourning and Militancy."

20. Ibid., 330.

21. Ibid., 301.

22. Gooch, *The Golden Age*, 94.

23. Ibid., 42.

24. Ibid., 35.

25. Ibid., 203–04.

26. Ibid., 300.

27. Foucault, "Nietzsche," 154.

28. Mordden, *How Long*, 584.

29. Although the crowd booed the director and author of *Longtime Companion* when they spoke at a New York gay pride rally in 1990, Simon Watney has produced an appreciative reading of the film's fantasy ending that parallels my own. The dream-sequence, Watney writes,

 speaks of the most simple and passionate wish that none of this had ever happened, that our dearest friends might indeed come back to life again, that we miss them horribly. This is surely not to be dismissed as "denial" or "delusion," but should be understood as a necessary catharsis, and moreover a catharsis that binds our communities even closer in their fight to save lives." (Simon Watney, "Short-Term Companions: AIDS as Popular Entertainment," in *A Leap in the Dark: AIDS, Art & Contemporary Cultures*, ed. Allan Klusacek and Ken Morrison [Montreal: Vehicule Press, 1992], 163.)

The Returns of Cleopatra Jones

JENNIFER DEVERE BRODY

Nostalgia can hide the discontinuities between the present and the past; it falsifies, turning the past into a safe, familiar place.[1]

—Anne Friedberg

What's Past is Prologue; but in black history it's also Precedent.[2]

—Ossie Davis

The 1990s—a revival of retro products and popcultural icons from the 1970s is in full swing: platform shoes adorn fly feet; rapper Ice Cube sports an Afro; former President Jimmy Carter again makes headline news; blaxploitation queen Pam Grier graces the big screen. How have such artifacts from the polyester decade (allowing for the error of the idea of an historical era) reemerged and been recirculated in different communities? What could the renewed visibility and consumption of such phenomena mean to and for the continuing struggles of black feminists in the (post–)Black Power era? Returning to an artifact from the 1970s, specifically the blaxploitation "heroine" Cleopatra Jones seen in the film *Cleopatra Jones* (1973) and its sequel, *Cleopatra Jones and the Casino of Gold* (1975),[3] I pose possible answers to these questions and attempt to expose problems relating to the practice of retroactive reading.

Among the first to exhume Cleopatra Jones for the 1990s was the feminist (in word and deed) rap group Digable Planets, who reference Cleo in their hit 1992 track, "Rebirth of Slick (I'm cool like that)."[4] At a 1993 conference on "queer" video, critic Alycee Lane presented a paper about *Cleopatra Jones*. In *Watermelon Woman*, a feature-length film by black lesbian filmmaker Cheryl Dunye released in 1996, a character recommends renting the video *Cleopatra Jones*. So, too, it may be no accident that Queen Latifah's role as a black lesbian bank robber in the film *Set It Off* (1996) is named "Cleo." What can it mean that these feminists (and black lesbian feminists in particular) have revived Cleopatra Jones?[5] What might be taken to be "familiar" about

Cleo's character for such readers? Are the previous citations nostalgic representations that express an impossible desire for what never was? In order to (mis)recognize Cleo as a "queer" black heroine, these readers have creatively deformed and erased aspects of the film character's initial reception. In other words, the image of Cleopatra Jones can be "queered" only through a canny counterreading that privileges different desires that result from spatiotemporal distance.

Where most critics in the 1970s believed that *Cleopatra Jones and the Casino of Gold* failed, a retrospective, retroactive reading reproduces and reinterprets such "failure." Through acts of "rememory," to use Toni Morrison's term, one can imagine and perform a kind of "queer" appropriation of the film.[6] The first epigraph of this essay claims nostalgia as a problem: thus, it acknowledges that re-membering Cleopatra Jones as a black queer figure requires forgetting the ultimate failure of the radical goals of black nationalism as practiced in the late 1960s and early 1970s; forgetting black women's multiple struggles for sexual equality; and forgetting the class conflicts and homophobia of both the black and women's organizations that flourished during the period.[7] In the 1990s, where there has been a resurgence in the production of black feminisms—from ad hoc coalitions such as African-American Women in Defense of Ourselves, to scholarly books, to the first national conference on black women in the academy—black feminists and feminisms can still face resistance. Angela Davis testifies to this problem of style over politics as well as to the marginalization of black feminism in the contemporary hypermasculine moment in her essay, "Afro Images: Politics, Fashion, and Nostalgia."[8]

Davis critiques the commodification of her own image, which appeared as a "docufashion" spread in an issue of *Vibe* magazine. In this fashion layout, the magazine's editors chose to replicate poses from Davis's mug shots. Davis explains how such recontextualizations were not only absurd but also dangerous. She writes:

> The way in which this document provided a historical pretext for something akin to a reign of terror for black women is effectively erased by its use as a prop for selling clothes and promoting seventies fashion nostalgia. What is also lost in this nostalgic surrogate for historical memory—in these "arrested moments" to use John Berger's word—is the activist involvement of vast numbers of black women in movements that are now represented with even greater masculinist contours than they actually exhibited at the time.[9]

In short, Davis points out the pitfalls of such recontextualized *images.* No doubt she would agree with Danae Clark's reading of "commodity lesbianism."[10] Clark explains that "Style as resistance becomes commodifiable as chic when it leaves the political realm and enters the fashion world. This

simultaneously diffuses the political edge of style. Resistant trends [such as wearing an Afro] become restyled as high-priced fashion."[11] These remarks are crucial to note because they contrast so clearly with the already commodified, "originally" depoliticized film character Cleopatra Jones.

Borrowing and recontextualizing images from the past is part of the pleasure of queer reading. Although I actively engage in the pleasures of pastiche and camp reading that allow one to imagine Cleopatra Jones as "queer," such musings must be tempered with the awareness of the violence inflicted by the irreverent re-membering of Angela Davis's Afro in *Vibe*. While one might "buy" Cleo as a black queer, one need not own her as such. Thus, I read *Cleopatra Jones and the Casino of Gold* as

> a piece of cultural ephemera from the Black Power era—[like] hot combs, NuNile pomade, dashikis, Ron O'Neal as Superfly. . . . Like fellow African-American conceptualists who have used the conventions of museum display to work against official forms of popular memory—and forgetting . . . [this reading belongs] to a generation who perceive earlier models of black political identity as "past."[12]

Deliberately "emptied of its already ambivalent aura,"[13] *Cleopatra Jones and the Casino of Gold* can signify black queer desire. In the manner prescribed by the second epigraph, the film read as black history can be both prologue and precedent. Examining the returns of different returns and arguing that the yield (stopping point and cumulative product) depends upon the field of desire—both the vintage and vantage from which one looks—this essay participates in the recent shift in cinema studies from an emphasis on the formal, passive positioning of the spectator by the gaze of the film itself to the active role of the viewer in determining meaning.[14] If, as Donna Haraway posits, "vision requires instruments of vision: an optics is a politics of positioning," then the possibility exists that the return of the character Cleopatra Jones in *Cleopatra Jones and the Casino of Gold* can be read through a "queer" lens that celebrates and critiques both the film and its black heroine.[15]

Considering Cleopatra Jones as a black queer character requires that one "see" this figure in a different light, as it were. This performative strategy has been deployed by black queer filmmakers Isaac Julien and Cheryl Dunye, whose nostalgic musings on "queer" figures acknowledge (the latter's more overtly) that communities need to "invent" a past in order to reach the present. Both Julien's *Looking for Langston* (1989) and Dunye's *Watermelon Woman* (1996) claim desire that is productive. Limited in scope, such projects acknowledge their own implicit projections while suggesting that the act of reading itself produces a queer product.[16] As Carole-Anne Tyler suggests, "the queer desire latent in [such] fantasies of the 'eyes of the homo' makes manifest one's own desire [to see] a masquerade of heterosexuality . . .

behind which is the enigma of desire that queers all identities, even queer ones."[17] In other words, what one sees is and is not what one gets.

In the annals of Hollywood, Cleopatra Jones is anything but a conventional heroine. She occupies the paradoxical position of being both handmaiden to the black revolution and hired handgun for the U.S. government. Created by black actor Max Julien, Jones is a karate-trained CIA special agent whose area of expertise is international drug trafficking. Most of all, however, she is a magnified and magnificent mahogany diva—especially as she was played by the six-foot-two-inch former model Tamara Dobson. Cleo's "feminist" image contrasts sharply with past and current filmic images of black women—particularly those produced by the exclusively male Hollywood-sanctioned "Black pack." The "New Boyz" films valorize the father, and, as Kobena Mercer argues, "depend on gender polarization and the denigration of black women [at times calling to] excommunicate the black feminist … as either inauthentically black or as a manipulated fool whose unflattering portrayals of [black masculinity] are said to collude with the white male power structure."[18] These so-called neo-blaxploitation films romantically reconstruct "domestic" spaces and scenarios absent from many of the "original" blaxploitation films.[19] Unlike the current spate of black-directed films, several of the "original" 1970s blaxploitation films starred black women.[20]

The "sub-genre" of the female-driven blaxploitation film includes titles such as *Cleopatra Jones* (1973), *Coffy* (1973), *Friday Foster* (1975), and *Sheba Baby* (1975).[21] The genealogy of black heroines consisting of Cleo, Coffy, and Foxy Brown is just beginning to be revived for cultural consumption. Actress Pam Grier is most often associated with the female-driven blaxploitation film since she was the most frequent star of movies in this genre. Until very recently, black exploitation films produced by whites and often rejected by the black intelligentsia of the period were unlikely candidates for critical reconsideration. Even comedian Keenen Ivory Wayans's film *I'm Gonna Git You Sucka* (1988)—a sendup of *Shaft* (1971), *Superfly* (1972), and other successful blaxploitation films (all titled after the main male characters)—ignored Cleopatra Jones along with the other popular blaxploitation "sheroes."[22]

The marginalization of these films is not a recent phenomenon—indeed, criticism, especially from the black intelligentsia, was concomitant with the release of these films. The fact that the films have been actively forgotten is in part a result of black intellectuals' increasing dissatisfaction with blaxploitation films and black actresses' unwillingness to participate in such exploitative ventures.[23] In a 1975 cover article in *Ms.* magazine, Jamaica Kincaid interviewed Pam Grier as a wildly popular actress generally acknowledged as the queen of blaxploitation. In the course of the article, Kincaid claims that Grier's films, *Coffy, Foxy Brown* (1974), *Friday Foster*, and the like

have never received critical notice because they were not meant to. They are mostly simplistic, sensational, violent, and technically faulty. But . . . the Pam Grier . . . vehicles have one . . . redeeming value—they are the only films to come out of Hollywood . . . to show us a woman who is independent, resourceful, self-confident, strong and courageous . . . [T]hey are also the only films to show us a woman who triumphs."[24]

While this might have been true, Grier's characters triumphed only in the most limited way.

Generally speaking, Pam Grier's films were "guilty" (a word used advisedly) of a kind of documentary realism or "formulaic verisimilitude." Grier's characters almost always appear in closed interiors that suggest nineteenth-century bourgeois domestic realism. The audience enters the "private" (and deprived) spaces of various houses in an inner-city neighborhood.[25] To emphasize Pam Grier's characters' confinement and their limitedness, they usually battle only one "bad guy" at a time. As exemplified by the films *Coffy* and *Foxy Brown,* Pam Grier's vehicles work as women's revenge films in which an individual motivated by emotional tragedy (loss of a family member) kills her opponents. The individual nature of Grier's films marks her crimes as specific and makes them into mere personal vendetta—private matters, and not necessarily attacks on systemic oppression.[26] By contrast, Cleo, especially in the second film, performs different roles and typically fends off throngs of fiends. The films in which she appeared work more along the lines of (male) action films. The differences between the films need to be addressed, because the visual images of Grier and Dobson mentioned above work against the reductive narratives that read these characters as essentially the same.

Several leading scholars and archivists of the blaxploitation genre mention the films in which the character Cleopatra Jones appeared under the rubric of the "blaxploitation shero" or, to use Donald Bogle's inaccurate term, "Macho Matriarch."[27] In so doing, these critics inevitably discuss Cleopatra Jones as part of a group of films that also includes at least four films in which Pam Grier starred. The oblique references to Cleo in this context tend to gloss over her specificity, even though stills from the films seem to complicate her representation.

In Mark Reid's study *Redefining Black Film,* Cleo appears framed in a doorway with a machine gun cocked in front of her body and a serious "don't mess with me" look on her face (fig 10.1). The still from *Cleopatra Jones* clearly highlights "phallic" lines by displaying vertical stripes on Cleo's bell-bottoms and the curves of her Afro that follow the rounded archway of the door. Similarly, in Ed Guerrero's book *Framing Blackness,* the author selects an image from the same 1973 film in which Cleo, with 'fro picked to perfection, confronts the viewer with a steady gaze with her "weapons" (this time her

figure 10.1

karate-trained fists) raised in front of her metallic jacket (fig. 10.2). She is pictured ready to spar with her comrades, the brothers Johnson.

Reid's and Guerrero's books contain equally emblematic images of Pain Grier's characters, Friday Foster and Coffy, respectively. The still that Mark Reid selects is from *Friday Foster* and shows Grier caught in the chokehold "embrace" of a black male attacker. Grier is seen struggling in his arms with her mouth open as if frozen in a silent scream. Guererro uses a still from *Coffy* that epitomizes this heroine's paradoxical vulnerability. Coffy/Grier stands politely poised by a door, almost clasping hands with her boyfriend (fig. 10.3). This superfly seventies couple is clad in complementary polyester jumpsuits with thigh-length capes. Coffy/Grier's bouffant wig is the same height as her boyfriend's classic "pimp" hat with de rigueur feather. These images serve to demarcate the differences between the two most popular female "B" movie stars.

Mark Reid's conclusion that "Psychologically all five [female blaxploitation] films appeal to *a* [*sic*] male ego threatened by the rise of women's lib—[the films] were equally appealing to women who *waffle* between liberation and subservient roles" is rendered problematic given the preceding

figure 10.2

figure 10.3

illustrations.[28] His comments echo Donald Bogle's statement, with which Ed Guerrero concurs, that "black women do not identify with [such heroines] because the exploits of the latter are too far removed from the everyday realities of black women's lives."[29] Of course, all action movies are part fantasy projection. Indeed, these films might recall the fantasies of power many black women desired. Such low-budget, mass-marketed films directed to a black urban audience need not "reflect" *a* reality. Realism or realistic representation may not even be required. Why, then, is this ambivalence a problem, and for whom?[30]

Rather than rehearse the call for such "reality," one might make a plea for "reel-ism"—for reveling in the fantasy of filmic images that does not simply replicate an always already known "reality" but instead takes pains to read (as well as to get pleasure from reading) "realness" in phastasmic terms. This desire resembles Kobena Mercer's call for a "radical paradigm shift in black cultural politics that would see identification as a dynamic verb."[31] Mercer's understanding of the complexity of identification underscores the fact that readers identify differently—that identity-based readings always involve disidentifications.[32]

As filmed in *Casino*, Cleopatra Jones seems to challenge certain cinematic practices that have circumscribed the representation of black women on film by placing them primarily in purely domestic and domesticated spaces. Moreover, by crossing barriers between blackness (assumed to be heterosexual) and lesbian/queerness (assumed to be white), Cleo complicates categories and allows for different identifications. Alycee Lane claims that the success of *Cleopatra Jones* depended in part upon Cleo being "heterosexualized" and desirable (because not threatening to) a monolithic, adamantly *male* urban black community.[33] She observes that "part of [Cleo's] trueness or authenticity is the extent to which she can be inscribed within the community's ideological parameters."[34] Lane bases her reading on several scenes in the film in which black men observe Cleo without her knowledge, thereby making her the object of their desire. In her debut film *Cleopatra Jones*, then, Cleo fit within the restricted ideological contours of a "straight" black male community; however, where Cleo might have been "heterosexualized" in the first film, she is "queered" in the second.

In *Cleopatra Jones and the Casino of Gold*, Cleo sets out to find her black American colleagues, Melvin and Marvin Johnson, "brothers" who have been kidnapped in a Hong Kong drug deal gone wrong. The film is an anticolonialist travel narrative in that Cleo is not there to "conquer" others but to reclaim lost cargo. Initially, the supposed bad guy is someone named Chen; however, it turns out that Chen's cocaine empire has been taken over by the villainous Bianca Jovan, an evil white lesbian who, "like [her] casino, is known as 'The Dragon Lady.'" Cleo's quest to find the Johnsons leads her first to Mi Ling Fong, another female undercover agent who is working with Cleo

without the latter's knowledge, and finally to the island of Macau where the Dragon Lady reigns.

Cleo's rescue mission takes her beyond her home community to the "heart" of global capitalism. In leaving "home" to recover her stolen captives, the Johnson brothers, Cleo participates in a homosocial exchange in which the black men, whom she calls "hers" (they are her black brothers in the black nationalist discourse promoted at the time), are utterly ineffectual in the lair of the Dragon Lady. They are passive once they surrender to the Dragon Lady's possession, and rather than being raped, as female counterparts might have been, the black men are seduced. Pacified by being plied with pleasure in the form of Asian women "servants"—and thus effectively disarmed—they become pawns between women. A scenario in which the heroes are distracted and detained by the trap of the sirens makes way for the introduction of a sister-heroine, who will not be distracted by love in the conventional sense, to come to the rescue. Thus, in the second film, it is black men who are endangered and Cleo who becomes their savior.

Although technically *Cleopatra Jones and the Casino of Gold* must certainly be classed as belonging to the tradition of "classical Hollywood cinema" that privileges realism, Cleo functions fantastically in this largely realist narrative. In short, Cleo appears to be "unreal" in *Casino* as she courageously careens through the congested streets of Hong Kong, creating chaos in open markets and on broad boardwalks. There is an ambivalent quality that emerges from reading Cleo's character in *Casino*—her cartoonish qualities and surrealness—which might actually make her a more appealing figure for queer theory to take up. The film begins with hyperelongated shots that distort the figures rather than "realize" them. This distortion reinforces the stylized violence that propels the film's major action scenes and highlights the manipulation of film technique in the construction of the character's identity.[35] Also, in the second film, Dobson did her own makeup—which is heavy (in both senses of the word). Cleo's outrageous outfits and her surreal, silvery eye shadow serve to illuminate her awareness of self-construction as a source of power. Drawing attention to her constructedness—to the many costumes she puts on and roles she plays— may even be a way of signifying on the minstrel origins of American film from which no "black" representation can escape.[36] So too, *Casino*'s soundtrack *questions* rather than confirms Cleo's identity—in spite of the fact that her character's identity had supposedly been established in the first film. *Casino*'s title song is called "Playing with Fire"; and unlike the largely celebratory lyrics of *Shaft* (1971), for example, it is fraught with the dangers of Cleo's far-out, Far East mission.[37]

Despite the movie's garnering respectable returns at the box office, most critics dismissed *Cleopatra Jones and the Casino of Gold* on the grounds that the film did not live up to the original. Vincent Canby is one of the critics who

read Cleo's venture to and adventure in Hong Kong as a diminished return. He argues that the shift in the mise-en-scène from "local" (i.e., Watts in the first film) to "global" (i.e., Hong Kong in the second) is detrimental to Cleo's character. Most critics of the second film believe that Cleo lacks authority in Hong Kong, where she does not speak the native language and requires a native informant/local guide to aid her in her quest. And yet, by operating (granted, with assistance) outside a circumscribed community, she also broadens her jurisdiction. Hong Kong as a juncture for transnational capital in the age of multinationals (not to mention the fact that the Fourth World Conference on Women was held in China in 1995) and Cleo's narrative, however contrived, at least suggest a reconsideration of the boundaries of blackness (and here I am thinking of the absolute circumscription and homogenization posited in the litany of contemporary black urban films produced by Hollywood). It is difficult to imagine a 1990s film in which white men are marginalized, white women are demonized, and figures like Cleopatra Jones and her Asian partner, Mi Ling Fong (played by the actress Tanny), dominate the screen.

In linking the character Blanche Dubois's plea "I don't want realism. I want magic . . . I [want to] misrepresent things . . . I don't tell the truth, I tell what *ought* to be true," with W. E. B. Du Bois's idea of "double consciousness" (articulated in *The Souls of Black Folk*), the pair might be seen to enact an expanding vocabulary of political and erotic role-playing where each plays the "Other." Although ultimately the film upholds white heteropatriarchal values that call for the white femme fatale's destruction, its use of Cleo and Mi Ling to bring the Dragon Lady down is different from classic femme fatale plots.[39] Moreover, Mi Ling's position as Cleo's "Third World" counterpart cancels stereotypes of the Third World woman as "more" gender-oppressed than her occidental sisters. Of course, one might also read this as a fantasy that women of color could count in oppressive systems—but given the rhetoric of "positive" role models, these government agents deserve at least more than the scant and inaccurate attention they have received in recent reconsiderations of the blaxploitation genre.

Mi Ling is also important because although the other Asian women in the film are eroticized and exoticized, Mi Ling disrupts the fantasy that *all* Asian women are sexually available. Like Cleo, then, she stands out as an unusual figure in American iconography. This Third World woman who has authority in her own, supposedly less civilized, country had not been seen before in Hollywood. Mi Ling, as a secret agent operating in Hong Kong (a colonized city that she works both for and against), and Cleo occupy a rather similar position vis-à-vis their respective governing bodies.

Throughout *Cleopatra Jones and the Casino of Gold,* Cleo periodically gestures, à la John Wayne, by thumping the broad brim of her fedora and speaking in a deep voice. This gestural masculinity underscores her ability to act, in both

senses of the word. She is always seen strutting through the streets of Hong Kong in her curious collage of multicolored Georgio St. Angelo pantsuits and pigtails (figs. 10.4 and 10.5). During several shot–reverse-shot sequences, Cleo exchanges glances with Mi Ling—thus, the audience often sees things from their doubled perspective.

figure 10.4

figure 10.5

Early in the film, in a congested market, Mi Ling rushes to Cleo's rescue by jumping into the scene with a double kick. The next frame shows the two women back to back—hats juxtaposed, turning slowly, intimidating their opponents—as a gang of the Dragon Lady's goons close in. This is just one of many shots in the film in which Cleo and Mi Ling are framed together. This sequence sutures them so that they appear as one Janus-faced obverse/reverse figure. Their formal introduction follows this encounter. Cleo asks Mi Ling for her particulars after exclaiming, "Girl, when I looked up and saw you, it was like money from home. Say, why did you follow me?" Mi Ling responds, "I wanted to see if you were as bad as you acted . . . and . . . I've seen worse!" They laugh in a flirtatious way. Cleo again expresses her gratitude to Mi Ling by stating: "I sure am glad that you were there to take care of business." There is a brief interlude where they meet a motorcycle technician, Davy Jones, whom Mi Ling introduces nonchalantly. He seems to function as a distraction in the scene—for what is *not* occurring—i.e., commerce between the opposite sexes. The women dismiss him quickly and proceed upstairs to an empty gym.

In the following scene, their flirtation takes the form of a mock duel where they show off for one another. Mi Ling repeats an often-used phrase in the film, "One must always be ready for business." Throughout this film, this sentence serves as an introduction to scenes in which the line between (women's) business and pleasure is crossed. Along one wall of the gym, a row of mirrors revolves, revealing in the interstices a two-dimensional white cut-out androgen target with an enlarged red paper heart. Mi Ling, whose aim is perfect, throws first one dart, then another—hitting the target squarely in the heart. Cleo is clearly impressed with this demonstration of skill. In response, she reaches into an open closet, pulls out a pistol, and shoots the same figure straight through the already darted heart. The camera cuts to Mi Ling's face with her mouth and eyes open in astonishment. Like several other scenes in *Casino,* this one underscores that Mi Ling and Cleo are a formidable team that gets the job done . . . together. So too, the emphasis in this scene on "business" rather than romance might suggest that they are removed from matters of the heart.

Mi Ling and Cleo alternate playing the Lone Ranger and Tonto—the film's running joke in terms of dialogue. Each is capable of taking care of herself; but together they cannot be beaten.[40] Unlike the "blackface" narratives of *Shaft* or *Superfly* that, like much black nationalist discourse, inverted value systems, making black beautiful, the repartee and reversals within positions that Mi Ling and Cleo evince are more fluid. They seem to undercut the rigid and stable subjectivities of the Lone Ranger/Tonto–master/slave binary. Also, unlike Pain Grier's role as Friday Foster, in which she plays a girl "Friday" consistently in a film of the same name, Cleo and Mi Ling alternate

who is in the position of "Tonto/Friday." Thus, Mi Ling is not merely a "side-kick" to Cleo or vice versa.

In a reading of "same"-sex interracial relationships, B. Ruby Rich argues that, in some same-sex relationships,

> Race occupies the place vacated by gender. The non-sameness of color, language, or culture is a marker of difference in relationships otherwise defined by the sameness of gender. Race is a constructed presence of same-gender couples, one which allows a sorting out of identities that can avoid both the essentialism of prescribed racial expectations and the artificiality of entirely self-constructed paradigms.[41]

The difficulty with such a formulation is that race cannot be divorced from gender/sexuality as an analytic category. In thinking the category "race," one must implicitly think "sexuality." Thus, rather than grant this intriguing reading, it is more important to try to write a counternarrative that emphasizes the interrelatedness of race and sexuality disallowed by dominant discourses adhering to formulas of supremacist segregation.

Because *Casino* is a black action film from the era of blaxploitation, whiteness is not normative.[42] Indeed, one of the functions of the blaxploitation film is to render "whitey" bad (but never *baaaaad!*). To a certain extent, this representation subverts hegemonic representations of whiteness. Here it may be instructive to remember that blaxploitation films were marketed for and seen by predominantly black urban audiences.[43] These films were meant to rupture the idea that "white is right" at the same time that they simply ignored the good white suburban family, perhaps keeping that ideal whiteness unsullied by marginalizing it and keeping it off stage.

The representation of whiteness as "wrong" is rendered quite problematical through the inversion of "traditional" gender roles which convert *Casino*'s major white characters into a phallic white woman and a castrated white man. Original audiences perhaps were meant to read the main white characters, Norman Fell's ineffectual Stanley, and Stella Stevens's rakish Dragon Lady, as examples of the pathologized effeminate man and masculine woman. There could then be a clear contrast by which the colored characters in the film could be read as "nonpathological." The fact that in 1974 the American Psychological Association deleted homosexuality from its official roster of mental diseases provides a coincidental parallel for the shift in reading the second Cleopatra Jones film as "queer." Such changes might affect retroactive readings of *Casino*, lending them more readily to "queer" appropriations and interpretations.

So, too, at the end of the civil rights era, feminism was coded as white, and the slide between feminists and lesbians was evoked continually in a range of discourses—hegemonic and counterhegemonic alike. As in the

first Cleopatra Jones film, the presence of an evil white lesbian—Bianca Jovan, in the second film—cuts two ways. On the one hand, her proximity provides the viewer with a clear manifestation of lesbianism that separates Cleo from this "taint." On the other hand, Cleo's partnership with Mi Ling makes the "threat" of lesbianism seem less contained. Bianca's evilness is marked further by the fact that she is an adoptive, incestuous, and unnatural mother who murders her daughter and does not reflect what Lynda Hart terms "white heteropatriarchy."[44] *Casino* dramatizes an analogy Hart claims links the (straight) single black woman with the (white) lesbian; however, since Hart's analysis is based on "mainstream" film, as a blaxploitation film *Casino* complicates this analogy.

Wearing ornate swashbuckler "drag" and wielding an enormous sword, Bianca takes over a ship in the first scene. She next appears in her private rooms, a sequestered, surreal setting from which she rules her heroin empire and runs her casino. Stevens's character, who can perform the essential gestures of white femininity (evidenced in her polite hostess routine), is reminiscent of the many hyperfeminine femmes fatales of classic Hollywood film noir. Yet as a drug trafficker and casino operator, Bianca circulates as opposed to being circulated—a taboo for women.[45] Bianca's ruthlessness is epitomized by the scene near the end of the film in which she drives a stake through her daughter's tongue because the girl had spoken on behalf of the Johnsons, whom Bianca believes are her rivals.

In the film's only explicit sex scene, Bianca is seen amid a group of naked Asian women rubbing oil on each other and moaning. Just before this "orgy" is interrupted, Bianca kisses her adopted "daughter" on the mouth. This gesture underscores the fact that her whiteness is colonizing, imperial, and individual. In contrast, *Casino* denies any overt sexual behavior for colored heroines. Their sexuality seems to be marked only by innuendo and gesture.

Although Cleo delivered innuendo-patched lines in the first film, she was always tied to a straight black male milieu that seemed to deter more overt queer associations. In the penultimate scene of *Casino*, Cleo brings Mi Ling as her date to the Dragon Lady's casino. Dashingly dressed in sequined finery, the two enter the casino together. They ogle each other as much as they are ogled by the crowd of middle-American and Chinese businessmen. Cleo asks Mi Ling, "What's your pleasure?" Mi Ling answers: "I'd like to be someplace else!" Cleo's bravado in this scene is sublime. She bets on roulette—"always on the black, baby"—as Mi Ling exclaims, "I hope you have someone to leave all that money to." Cleo replies, "Honey, the way I feel tonight Muhammad Ali could have his hands full." The camera cuts to a man fiddling with a cigar as thick and brown as his fingers, who blows a kiss to Cleo. She answers his gesture by stating: "Don't race your motor, baby, it's not leaving the garage."

When Cleo and Mi Ling spy their blonde nemesis, the Dragon Lady Bianca Jovan, standing in a gaudy green gown on the stairwell, Mi Ling comments to Cleo that Bianca "hardly looks the type to kick small dogs and children." By suggesting that things are not what they seem, this comment might also apply to the lovely ladies themselves. In the finale of *Casino*, Cleo appears in her most feminine garb to perform her most violent acts. Her sequined lingerie-inspired gown and matching sheer boudoir cape are shed just before her climactic encounter with the Dragon Lady to reveal Cleo's statuesque figure in a bodysuit. Certainly it must be said that Cleo and Mi Ling hardly "look the type" to murder people and be karate-kicking, "queer" special agents. Indeed, they "look like" Bianca. Bianca, Cleo, and Mi Ling could each vie for the role of most glamorous femme fatale.[46] In this same scene, Bianca looks knowingly at Mi Ling and Cleo and says: "What is this, *two* beautiful ladies ... unescorted? (fig. 10.6). The pause and emphasis here are crucial to the line's meaning. The last word, as delivered by Stella Stevens, drips with irony; it is clear that she assumes, perhaps correctly, that Cleo and Mi Ling are "together." This statement is highlighted by the explicitly marked lesbian gaze of Bianca herself. Cleo's response to this suggestive quip is "Well, my mother trusts me." Again, Cleo's retort is equivocal and supports the argument that although her "queerness" is not (because it cannot be) marked, certainly her heterosexuality is not recorded and therefore not "secured" (as it appeared to be in the first film). This encounter with the Dragon Lady concludes with Cleo winking at Mi Ling as the two touch elbows, adding more "evidence" that the ambivalence around Cleo's sexuality opens a space that can be filled with other narratives of desire.

figure 10.6

Cleo's moves in *Casino* that remove her from the authorized "true" straight, male, black nationalist community to the space of the untrue are not only temporal and ideological, but are also racial, sexual, and geopolitical. The first version succeeded in part because the discourses of black power and (white) feminism were distinct; however, by 1975 they were beginning to be reformed by the increased visibility and articulation of black feminism. Whereas in 1973 Tamara Dobson could argue in a *New York Times* interview that "Cleopatra Jones is not a women's libber"—that black liberation was different from (white) women's liberation—by 1975 this was no longer applicable. If Cleo's character made sense earlier because she was avowedly a "race woman" (to use the black vernacular term) who worked against (white) feminism and for the singular benefit of black men, by the end of the blaxploitation era, cultural productions had to be more disavowing of feminism. Part of the failure of *Casino* might have been its inability to disavow sufficiently the potential homoerotic tensions inherent in the scenes described above.

Indeed, in the two years between 1973, when *Cleopatra Jones* was released, and 1975, the release date of *Casino*, racial as well as sexual politics changed.[47] Black feminist criticism had become a critical practice sanctioned by and produced in the academy, and so-called black feminist practice flourished. The explicit, self-named political movement known as "black feminism," whose existence was essentially inchoate in the early 1970s, began to be articulated clearly after 1972, as did an explicitly black lesbian feminism.[48] One of the earliest collections of Black feminist writing was Toni Cade's *The Black Woman* (1970). In New York in 1973, the year of the first Cleo film, the National Black Feminist Organization (NBFO) was formed. The year 1974 witnessed the momentous publication of black activist Angela Davis's autobiography. The "black lesbian feminist" Combahee River Collective began meeting in the Boston area in 1974 and published its famous statement in 1977. So, too, interethnic organizing among feminists of color during the 1970s resulted in the publication of several important collections, such as *This Bridge Called My Back* (1981), edited by Cherrie Moraga and Gloria Anzaldua.[50] In short, "Third World feminism" began to be enacted on multiple stages and in various sites.

This team composed of an Asian woman and a black woman is difficult to imagine in the current cultural climate.[51] Feminists of color—a resolutely political term—may need to envision, if not enact, other alliances such as the one tentatively shown in *Casino*. Although the partnership between Cleo and Mi Ling is utopic, it still gestures toward a possible political alliance. Though temporary, their relationship is effective. It may even be read as an allegorical model for "black" feminism. The ending of the film has Cleo depart on a plane bound for Los Angeles. She waves from the door of the plane—a gesture echoed in the ending of the interracial romance film *The Bodyguard* (1992), which itself quotes from the final shot of *Casablanca* (1942). Implicit in the final shot is Cleo's safe return.

JUMP CUT
Treatment for *The Return of Cleopatra Jones*
Los Angeles, 1999

Cleopatra Jones returns to the screen to wrangle with long-term mayor Richard Rearguard over the misdirection of funds for the still-unfinished Rebuild South Central Los Angeles Project. Cleo teams up with her newly immigrated (post-1997 Hong Kong) former partner (did they stop in Hawaii and become life partners?) Mi Ling Fong. Mi Ling and Cleo, with the help of "Salsa and Chips," a women-of-color computer collective run by an agent with the code name "Supermaria," come up with a plan to simulate/stage an earthquake that wipes out all of the corrupt power-mongers in Los Angeles's 90210 zip code.[52] Having dismantled Proposition 187, they blast open the border, where among the ruins they build a new queer Afro-Asiatic Atzlan.

And who should star in this remake? Given the logic of Hollywood, the only choice to recreate the role of Cleopatra Jones would be transvestite "supermodel" RuPaul. The six-foot-seven-inch singer has already appeared in sensational (and sensationalized) cameos in Spike Lee's *Crooklyn* (1994) and in *To Wong Foo* (1995). Given the present fondness for such films—where it is quite clear that the best "woman" for the job is a "man"—RuPaul is the only conceivable choice to revive the larger-than-life role of Cleopatra Jones. So, too, given the desire for depoliticized retrowear—RuPaul is a M.A.C. supermodel, and his/her autobiography, *Lettin' It All Hang Out* (1995), is a tract of conspicuous consumption, showcasing cars, designer clothes, and numerous other purchasable items[53]—RuPaul seems to be the perfect person to star in a film produced through Hollywood's profit-motive machine that is committed to the Disneyfication of historical memory. But would casting RuPaul elide the "problem" and perhaps the power of women/feminism altogether? The answer would depend on the value one stakes in reading relationships between representation and the real. Who can and should represent us?

Ironically, the increase in black feminist visibility and power (which are not the same, as Peggy Phelan reminds us) might have disadvantaged the return (especially in Hollywood) of Cleopatra Jones.[54] Such a film could only succeed if the new version could, like the first film, continue to disavow an actual, activist black feminist agenda. Powerful black women such as Anita Hill, Angela Davis, Jocelyn Elders, and Lani Guinier thus far have not been allowed to stand their own ground without reprimands. Perhaps this is why, even as the 1970s black actress Ellen Holly proclaimed, "Fantasy Shafts go down easily: *real* black performances do not." What is important to reference here is the problematic of queer representation. By resignifying the products of Western capitalism, queer readings can shift meaning—and

make interventions into the representation of ethnicity, sexuality, and other differences although such reappropriations are themselves subject to sale.[55]

The times are ripe for the return of Cleopatra Jones. Although this return is not likely to result in the discovery of another Tamara Dobson or a comparable black *female* superstar, perhaps, given the precedent set by the previous readings, it need not. In retrospect, what remains to be answered is how black feminisms and queer theory might transform black women both on and off the screen. Getting behind the camera, as well as in front of it, may be a start. Still, there is good reason to believe that the rise of RuPaul will collide with the return(s) of Cleopatra Jones. In closing, there is only one thing to say: RuPaul, you better WORK!

NOTES

1. Anne Friedberg, *Window Shopping: Cinema and the Postmodern* (Berkeley: University of California Press, 1993), 188.

2. Ossie Davis, "Forward," in *Black Magic: A Pictorial History of African-American Performing Arts*, ed. Langston Hughes and Milton Meltzer (New York: De Capo, 1990).

3. *Cleopatra Jones* grossed $3.25 million in commercial release, and the soundtrack sold more than 500,000 copies. Besides spawning a successful sequel, the figure might also have been the catalyst for the television series *Get Christie Love!*, which starred Teresa Graves as a black female officer for the Los Angeles Police Department. The series ran from 1974 to 1975. For more information, see Donald Bogle, *Blacks in American Film and Television: An Encyclopedia* (New York: Simon and Schuster, 1989).

4. Digable Planets, *Reachin': A New Refutation of Time and Space*, Warner Brothers Records, 1992,

5. An exception to the focus on Cleopatra Jones is provided by Etang Inyang's video *Baddass Supermama* (1996), which pays tribute to Pam Grier in an homage similar to the citations of Jones.

6. Toni Morrison, "Unspeakable Things Unspoken: The Afro-American Presence in American Literature," *Michigan Quarterly Review* 5, 1 (Winter 1989): 32.

7. See Angela Davis, "Black Nationalism: The Sixties and the Nineties," in *Black Popular Culture*, ed. Gina Dent (Seattle: Bay Press, 1992), 317–24.

8. Angela Davis, "Afro Images: Politics, Fashion, Nostalgia," in *Picturing Us: African American Identity in Photography*, ed. Deborah Willis (New York: Norton, 1994), 170–79.

9. Ibid., 175.

10. Danae Clark, "Commodity Lesbianism," in *Out in Culture: Gay, Lesbian, and Queer Essays on Popular Culture*, ed. Corey K. Creekmur and Alexander Doty (Durham, N.C.: Duke University Press, 1995), 485.

11. Ibid., 494.

12. Kobena Mercer, *Welcome to the Jungle* (New York: Routledge, 1994), 161.

13. Ibid.

14. For a useful overview of questions related to feminist film theory, see Suzanna Danuta Walters, *Material Girls: Making Sense of Feminist Cultural Theory* (Berkeley: University of California Press, 1995), 50–115.

15. See Donna Haraway, "Situated Knowledges: The Science Question in Feminism and the Privilege of Partial Perspective," in her *Simians, Cyborgs, and Women: The Reinvention of Nature* (New York: Routledge, 1991), 188–201. For a genealogy of the concept of "queerness," see Annamarie Jagose, *Queer Theory: An Introduction* (New York: Melbourne University Press, 1996).

16. Such retroactive reading depends on a particular mode of reception. Although in the 1990s blaxploitation festivals have become popular in major U.S. cities, the most common access to such films today is through video rental. The relatively private mode of reception that home video screenings afford (e.g., they allow one to rewind the tape; details are often distorted in translation from film to video) changes how these films are seen.

17. Carole-Anne Tyler, "Far-Sighted? Queer Spectacles," unpublished paper, 1995.

18. Kobena Mercer, "Endangered Species," *Artforum* 30 (Summer 1992): 76.

19. Spike Lee's release, *Girl 6* (1996), scripted by Suzi Lori-Parks, conflates Cleo with Coffy in its citation of the blaxploitation heroine. For a black feminist critique of Lee's work with which I concur, see Wahneema Lubiano, "But Compared to What?" *Black American Literature Forum* 25, 2 (Summer 1991).

20. The genre might have been inaugurated with the success of Mario Van Peebles's *New Jack City* (1991). See Ed Guerrero, *Framing Blackness: The African American Image on Film* (Philadelphia: Temple University Press, 1994) for more information. An interesting definition of blaxploitation comes from one of the genre's stars, namely, Pam Grier. In a recent interview, Grier explains that blaxploitation films

> really document[ed] what was going on in our society and community as far as the sexual revolution, the drug revolution. We got to document music, culture, religion, politics, and the male and female agenda. Everyone always asks me regarding exploitation: "What does it really mean?" And there's three sides to the coin. Some think it's a marketing term coined by the rental agencies who rent the films to the theaters with theater owners [sic] understanding it was a film geared to a Black audience. The other side is a Black film owned by Whites and the money basically going to them, and not much going to the actors. A third side is a film that was done by Blacks and shared with Whites, exploiting the Black community.

See "Interview with Pam Grier," *Black Elegance* (Spring 1996): 41.

21. *Cleopatra Jones and the Casino of Gold* breaks many generic stereotypes such as the female buddy film, the interracial buddy film, the action genre, and others. An analysis that focuses on "genre" shall not be broached here. For

an analysis of the generic aspects of these films, see Charles Kronengold, "Identity, Value, and the Work of Genre: Black Action Films," in this volume.

22. The smash hit by the infamous Zucker Brothers, *Kentucky Fried Movie* (1977), spoofed Cleopatra Jones in an advertisement for a film called, appropriately, *Cleopatra Swartz*, in which Cleo, married to a rabbi, changes costumes nearly ten times in the three-minute segment. It is beyond the scope of this paper to comment upon the multiple significations parodied in this film.

23. Indeed, in 1973 a distinguished group of black actresses, including Cicely Tyson and Beah Richards, convened to discredit the current roles for black women in film. The conference, sponsored by the Afro-American Studies Program at Boston University, yielded heated discussion and criticized the blaxploitation genre of which these films were not always a part, since some feminists celebrated them for their "break" with earlier blaxploitation films. For more information, see *Proceedings of a Symposium on Black Images and Self-Perception as Viewed by Black Actresses* (Boston: Afro-American Studies Program, Boston University, 1973). It is also important to note that recent feminist film theory has ignored the blaxploitation shero in part because the propensity to analogize categories of race and sexuality persists. For example, a quick glance at Annette Kuhn's important reference, *Dictionary of Women and Film* (1991), contains entries for "black women," "feminist film," "heroines," and "lesbians"—none of which mentions female blaxploitation stars. A notable exception is Jane Gaines's essay "White Women and Looking Relations: Race and Gender in Feminist Film Theory," in *Issues in Feminist Film Criticism*, ed. Patricia Erens (Bloomington: Indiana University Press, 1990).

24. Jamaica Kincaid, "The Mocha Mogul of Hollywood," *Ms.* (1975): 52.

25. In the final scene of the film, Coffy, a nurse who inexplicably turns violent after her sister becomes a dope addict, confronts her ex-lover, a corrupt black official on his way to the governorship. We see Coffy seated with her shotgun cocked in her lap—"talking" with her former beau, who tries to spin-doctor himself out of his predicament (in the previous scene he had sanctioned Coffy's murder). As he spews spurious rhetoric about helping the black community, she debates her options. Pam Grier, although wielding the (phallic) power, is an ambiguous figure. The fact that she has chosen to go undercover as a prostitute (and to go down on many a mafia mogul) does seem to undercut her authority. The final fadeaway shot is of Grier walking alone on the beach (worthy of an Isley Brothers album cover) as the title track, which is nondiegetic, tries to give closure and meaning to the film. The theme song, "Coffy Is the Color," written by Roy Ayers, heralds her as the heroine of an authentic black community. The refrain is:

> You're a shining symbol
> You're a new breed, a future seed
> Revenge is a virtue
> You stood like we all wish we could.

This final track portrays Coffy as an avenging angel who acts out revenge fantasies of the black community. She has stood up for the solidified "true" and "real" interests of the community by eliminating the black betrayers (and, invariably, their white collaborators) who have employed black revolutionary rhetoric for deviant and ultimately destructive ends.

26. Similarly, in a film called *Original Gangstas* (1995), Grier plays an angry mother whose son is killed as a result of gang violence. The community of Gary, Indiana, decides to fight back. As in previous films, this film situates Grier firmly within the community's hypermasculine contours (literally all the other stars are blaxploitation heroes such as Fred Williamson, who produced the film for Orion Pictures, Jim Brown, Ron O'Neal, and Richard Roundtree).

27. Donald Bogle, *Brown Sugar: Eighty Years of America's Black Female Superstars* (New York: Harmony Books, 1980). After a discussion of Grier and Dobson, where he says that *all* the characters "took men when they wanted," Bogle qualifies his statement to say that Dobson's Cleopatra Jones "was a living wonder to behold, but impossible to possess" (190).

28. Reid, *Redefining Black Film*, 88.

29. Donald Bogle, *Blacks in American Film and Television*, 58.

30. One obvious answer is that a focus on "realism" and "positive" (and implicitly *black*-made) images counters the "negative" images of black-faced performances and bald stereotypes that marked "black" performances in Hollywood.

31. Kobena Mercer, "Skin Head Sex Thing," in *How Do I Look?: Queer Film and Video*, ed. Bad Object Choices (Seattle: Bay Press, 1991).

32. Barbara Johnson has made a similar argument in her provocative piece "Lesbian Spectacles," in which she reads the manifestly straight film *The Accused* as "queerer" than the seemingly more homoerotic film *Thelma and Louise*. See Barbara Johnson, "Lesbian, Spectacles: Reading *Sula*, *Passing*, *Thelma and Louis*, and *The Accused*," *Media Spectacles*, ed. Marjorie Garber et al. (New York: Routledge, 1993), 160–66.

33. Alycee J. Lane, "Sexuality and Urban Spaces in *Cleopatra Jones*," unpublished paper delivered at "Looking Out/Looking Over: A Conference on Lesbian and Gay Film," held at the University of California, Davis, 1993.

34. Lane, "Sexuality and Space in *Cleopatra Jones*," 8.

35. Even if this distortion is a result of Cinemascope translation to video—of the use of anamorphic lenses—it still works with the idea of retroactive reading since the film has not been rereleased and is not readily available except on video. Interestingly, my introduction to Cleopatra Jones came through the stories of two people, both of whom grew up in East Africa, where blaxploitation films were screened as recently as the 1980s. Thus, this geopolitical "return" to the United States is another aspect of the film's disjunctive temporality and its (re)distribution between First and Third Worlds.

36. See James Snead, *White Screens/Black Images: Hollywood from the Dark Side*, ed. Colin MacCabe and Cornel West (New York: Routledge, 1994).

37. Listen to the two-volume set *The Very Best of Black Movie Hits*, released on the Virgin label in 1997. Interestingly, this collection contains the theme song to *Cleopatra Jones* but not to *Cleopatra Jones and the Casino of Gold*.

38. Tennessee Williams, *A Streetcar Named Desire* (1947), scene nine.

39. See Mary Ann Doane, *Femmes Fatales: Feminism Film Theory, Psychoanalysis* (New York: Routledge, 1991).

40. This leads me to ask, "Does it take two women of color to defeat one white woman?" Here, I allude to the infamous seen in *King Kong* (1931) in which an entire village of African maidens is offered in exchange for a single blonde heroine.

41. B. Ruby Rich, "When Difference Is (More Than) Skin Deep," in *Queer Look: Perspectives on Lesbian and Gay Film and Video*, ed. Gever et al. (New York: Routledge, 1993), 321. The difficulty here is that gender is always already imbricated with "race" and/or culture. Gender here cannot then be "the same."

42. See Richard Dyer, "White," *Screen* 29 (1988): 44–64.

43. For more on the marketing of blaxploitation films, see Ed Guerrero's *Framing Blackness*.

44. Lynda Hart, *Fatal Women: Lesbian Sexuality and the Mark of Aggression* (Princeton, N.J.: Princeton University Press, 1994). Hart has an interesting discussion of the way in which lesbians, who are always already white, come to be conflated with single black women—all of whom mock the importance of white fathers in their refusal to reproduce "white heteropatriarchy."

45. See Gayle Rubin, "The Traffic in Women: Notes on the Political Economy of Sex," in *Towards an Anthropology of Women*, ed. Rayna R. Reiter (New York: Monthly Review Press, 1975), 157–210.

46. In the first film, Cleopatra Jones also battled a white lesbian; that figure, named "Mommy" and played by Shelly Winters, was a "big momma" butch who wore a leather jacket and carried a switchblade. Thus the differences between Cleo and her antagonist are drawn more starkly in the first film than in the second.

47. It should be remembered that during the 1970s, "Black women were excluded from beauty, from advertising, from magazines" ("Interview with Pam Grier," 42). Coincidentally, "supermodel" Veronica Webb wrote a cover feature for *Essence* (Fall 1996) that commented on the current "taste" for blonde models in the fashion industry. Her article describes the cyclical nature of such "black outs." While I am sympathetic to such statements, I also always think of my students who tell me, "So . . . advertisers show us a dark-skinned model; she's still selling cigarettes and liquor."

48. See Paula Giddings, *When and Where I Enter: The Impact of Black Women on Race and Sex in America* (New York: Morrow, 1984), 344.

49. For a history of these organizations, see Miriam Lynell Harris, "From

Kennedy to Combahee: Black Feminist Activism from 1960 to 1980," Ph.D. dissertation, University of Minnesota, 1997.

50. As my colleague Traise Yamamoto reminded me, the term "women of color" is resolutely political. There is no "women of color" food, for example, that would allow us to see this as a cultural marker.

51. I emphasize popular culture here because in other venues such as independent film, alternative theater, and academic journals there has been collaboration between these ethnic groups; however, there has been tension as well. Gayatri Spivak's reading of the black and Asian lesbians portrayed in Hanif Kureishi's film *Sammy and Rosie Get Laid* (1987) addresses this problem. An excerpt from Spivak's essay reads: "interraciality is predominantly lesbian and the other side of white is a variety of blackness. . . . In the wake of the Los Angeles clash between African-Americans and Asian migrants in the Rodney King protest of 1992, it would be idle to deny that one of the facts of the migrant's or marginal's everyday that all must combat in crisis and after is the hostility between inner-city Blacks of Afro-Caribbean, African and Asian origin" (*Outside in the Teaching Machine* [New York: Routledge, 1993], 253).

52. The play on "salsa and chips" and "supermaria" is taken from a performance by Betty Gonzalez-Nash at Highways Theater in Los Angeles.

53. I was not at all surprised to read that at age twelve, RuPaul wanted to "be Cleopatra Jones." He lists the first film as one of his fifteen favorite drag films. See *Lettin' it All Hang Out* (New York: Hyperion, 1995), 65.

54. See Peggy Phelan, *Unmarked: The Politics of Performance* (New York: New York University Press, 1994), 6–11.

55. Although Marxist-influenced critics claim that "of all the spheres of ideological regulation, the disruption of the aesthetic sphere offers the least material or social disorganisation in the lives of those who would alter the system," this paper acknowledges that there may also be power in representations. Certainly members of the religious right who seek to dismantle the National Endowment for the Arts feel that images are ideological. See Clyde Taylor, "Black Cinema in the Post-Aesthetic Era," in *Questions of Third Cinema*, ed. Jim Pines and Paul Willemen (London: British Film Institute, 1989), 99.

How to Do Things with Sound

CINDY PATTON

SEYMOUR LOVE: Misty, it is your job to learn to develop in yourself the instinct to convert a trivial act, a mundane routine, a daily chore, into something stimulating, creative, and above all, *communicative*.

MISTY: I think men stink.

SEYMOUR LOVE: Well, they think you stink. In fact, it's one of the most perfectly balanced equations in nature.

—*The Opening of Misty Beethoven* (1975)

Of course, this is bound to be a little boring and dry to listen to and digest; not nearly so much so as to think and write. Moreover, I leave to my readers the real fun of applying it in philosophy.

—J. L. Austin, *How to Do Things with Words* (1975) [1962]

In the more than three decades that have passed since its publication, Austin's principal work—*How to Do Things with Words*—has been discussed, has faded from view, and has reemerged several times, most provocatively in recent queer theory, with expropriations of Austin's elusive "performativity" that might seem unrecognizable to many ordinary language philosophers. At first, it was not clear whether these recent riffs on Austin's interrogation of the "doing" over and against the "being" dimension of words would bear the orthogonality required to earn a place in queer theory. However, there is a veritable cottage industry of criticism extending Judith Butler's and Eve Kosofsky Sedgwick's exploratory uses of the term. But has Austin been well explored in this *fort da* relationship, which plays out the concern inaugurated by Jacques Derrida in his signal "Signature, Event, Context," (1982/1972), on the "etiolations" (Austin's term) or "parasitical" (Derrida's term) forms of language use? Granted, Sedgwick and Butler contest this distinction in Austin in different ways: Sedgwick remains within the deconstructionist tradition and allows for the labile and complex relation between something like "performativity" and something called "performance." She asks how Austin's attempts to exclude poetry and theater work together with his apparent obsession with marriage and its attendant cere-

monies to implicitly construct heterosexuality as "ordinary." Butler prefers
to extend Austin into the domain of social reproduction of gender, grafting
Louis Althusser's concept of interpellation to a post-Foucauldian revision of
Lacan to explain how these "compulsive" reiterations of gender are taken up
as a sense of self-identity by enactants, more or less collapsing any distinc-
tion between "performative" as a philosophical concept and "performance"
as an entire domain of art production and academic inquiry.

But Austin's culminating analysis is little damaged by a retreat from the
brief and early suggestion to bracket poetry and theater from the ordinary.
Indeed, this distinction is of so little significance (comprising only a para-
graph or two in Derrida) that other key players in communication theory
have developed Austin in rather different directions. Figures as critical of one
another as Jean-François Lyotard (1984/1979) and Jurgen Habermas
(1979/1976) were mounting much more exhaustive readings of Austin not
long after Derrida penned his short, and perhaps overread, "SEC" essay. In
fact, a cursory glance through the contemporaneous work of Gilles Deleuze
and Felix Guatarri (1987/1980), Pierre Bourdieu (1991/1982), and Michel de
Certeau (1984/1974) suggests that there was something of an Austin craze in
France, with productive reworkings and critiques that consider his work's
value as social theory and radical analysis of power and language. Indeed, on
the American side, Stanley Fish developed an Austinian form of drama crit-
icism, most notably expanded in Shakespeare criticism; Austin (and speech
act theory generally) also is reworked in Mary Louis Pratt's highly influen-
tial analysis of cross-cultural contact—a rather different Austin than the
one so cursorily alluded to in current gender/queer theory uses of the word
"performativity."

I don't want to start a "performativity anti-defamation league," because
I too have criticisms of Austin. I do want to reopen the question of perfor-
mativity and its utility and problems for gender/queer theory, but by recen-
tering the work within philosophy of communication—a project also
undertaken, and with regard to Austin and others in the Anglo-American
analytic and ordinary language traditions, by Briankle Chang (1993) and
Benjamin Lee (1997). It is within this social theoretical consideration of
Austin that I place my consideration of the issue of sound. Indeed, explor-
ing the lectures—and the obsessive care taken in posthumously recon-
structing them as the book we now know—and then considering the
theory and use of sound in a rather different genre should shed light on
some important assumptions about the basis of even the most banal social
conventions.

Accounts of Austin's interactive group pedagogy suggest that he was at
his best when listening to and posing questions of his students in a method
that might have been used by Socrates, had he not believed in truth. In fact,
as Fish notes, this was a method not unlike that associated with the decon-

struction that would appear a decade and a half after Austin's death. In the classroom, Austin could prod his students to propose rules of language, offer counterexamples, and become depressed or elated at the spiral of clarity and muddle which constitutes Austin's way of philosophizing and—if one reads Austin rhetorically, as Fish does—is the leitmotif of the lectures most of us know. Although it perhaps comes across this way in the reading, Austin's experimental praxis in its classroom form was neither a "performance," in the sense of a necessary pedagogic conceit, nor "performative," in the watered-down sense of being what it is doing or of being a "compulsive repetition" that seems the most common meaning of the term in current uses within gender/queer theory. Indeed, Austin seems acutely aware of the problem of lecturing and tries to make his stint into an "event"— something that tracks conventions but can have its contours noted through violation. Austin seems fully aware of the problem of presenting his work on the performative in the form of *lecturing*, a problematic social convention at the heart of, and explicitly referenced in, the lectures. When he opens and closes the series, Austin exhibits the bind in which showing up to lecture has placed him. He has pretty well banned the language-inside/outside-the-head distinction that underwrites the transference model of language, which would seem fundamental to many theories of education. Lecturing seems to envision that speech content unites two subjectivities in locution. But what is Austin's wordplay doing? Austin knows, but dances around, the truth that the bodies before him may be learning, but at the moment of doing-lecturing, neither he nor they can know for sure. At best, he can hope that he is *being-heard*; since, by convention, lecturing to students carries with it some obligation to verify the intersubjective exchange, he can imagine that the students expect a test of some kind—if only to recognize the convention by offering questions. We might say that a lecture involves not only the force that characterizes illocution ("illocutionary force" invites a response, but does not effect it) but, by virtue of the dull thudding by which our hearers take up our words, is necessarily also perlocutionary—the non-convention-bound act, possibly violent, but certainly easily nonverbal, which achieves its effective object. We all recognize how different it feels to offer up the public lecture than to lapse into the long classroom monologue that amounts to an attempt to *beat knowledge into their heads*. Settling the issue of whether hearers really hear what we say (a practice that can only be relevant in the reporting or locutionary/constative dimension of language that Austin considers uninteresting) returns us to the test, to a desperate verificatory gambit that privileges content once again.

In general, Austin's mild disdain for privileging the constative is a point well taken. But in an effort to be done with the tawdry issues of referentiality, Austin too quickly glosses over the force relations in perlocutionary speech acts which result in allowing, making, causing to be made, or forc-

ing into silence sounds of consent, assent, or dissent, much less of under-
standing, confusion, or complete nonhearing. He sloughs off the vexing
issue of whether extralocutionary force relations produce the illusion that
there is a real congruence between the "phonic act" upon which locution is
always anyway based and the "aural-receptive act," which Austin fails to dis-
cuss, but which must also be fundamental to a felicitous performative. The
concept of sincerity implies a speech situation in which the gay deceiver is
trying to make a gain rather than trying to avoid a dire consequence as a
result of failing to participate in a felicitous performative. Austin seems to
consider the performative primarily from the vantage point of an equal or
superior interlocutor, not from the standpoint of the disempowered partic-
ipant who is likely to be at most risk. Austin tries to underplay his hearers'
reasons for going along with his own insincerity—they may be trying to
accumulate educational capital by learning Austin's strange vocabulary, or
trying to avoid getting in trouble for failing to turn up for the term's most
famous speaker. Thus, he equivocates on the status of his own act of lectur-
ing: on one hand, he claims what he does as reporting on "the way things
have already begun to go," but on the other, he perpetrates a double viola-
tion of the performative by being insincere and by creating an obligation on
which he won't collect:

> In these lectures, then, I have been doing two things which I do not alto-
> gether like doing. These are:
> (1) producing a programme, that is, saying what ought to be done
> rather than doing something;
> (2) lecturing.
> However, against (1), I should very much like to think that I have been
> sorting out a bit the way things have already begun to go and are going
> with increasing momentum in some parts of philosophy, rather than pro-
> claiming an individual manifesto. And as against (2), I should certainly
> like to say that nowhere could, to me, be a nicer place to lecture in than
> Harvard.[1]

Shockingly, after twelve days of unstinting labor, Austin says he does not
like to lecture! He sets up two crucial distinctions in this coy ending to his
coy lecture series. Producing a program—presumably troubling because its
air of "individual manifesto" tends to slow philosophy and close lines of
inquiry—is equated with lecturing, an activity the hearer may substitute for
the more difficult, less amusing activities that Austin himself prefers: think-
ing and writing.

Apparently, teaching—at least as lecturing—is *not* doing of a serious
kind, but instead a necessary ruse, an infelicity of the kind Austin outlines
in Lectures II through IV. Austin may be parodying the Socrates of *Phaedrus*;
he engages in verbal practices that he views as intrinsically inferior in order

to move the student to a more receptive state, a kind of prodromal peda-
gogy that sets up the truth-seeking relation. Like the Socrates of *Phaedrus*
("I'll speak with my face covered. In that way I shall get through the speech
most quickly, and I shan't be put out by catching your eye and feeling
ashamed"),[2] Austin covers his ass with regard to the demand that a lectur-
er say something new, controversial, or entertaining: "what I shall say here
is neither difficult nor contentious; the only merit I should like to claim for
it is that of being true, at least in parts."[3]

Having set severe limits on the content of their lectures, both educators
further diminish their status as speakers. Socrates produces a speech on love
which seems to be an unattributed imitation of Isocrates, while Austin
reduces himself to the anonymous vessel of "the way things have already
begun to go and are going with increasing momentum in some parts of phi-
losophy."[4]

At first glance, Austin's ending seems merely to be his acknowledgment
that, if we haven't figured it out by now, he has been doing what he was try-
ing to convey as content. But Austin *can't* perform the performative, at least
according to the rules he gives and then later problematizes. In the con-
ventional procedure of lecturing, the speaker must believe in the process of
conveying knowledge. But by his own account, Austin does not. Lecturing
and programmacizing are not doing; or at least, they are not doings of the
kind Austin seems to be discussing as performatives. To the last breath of
praising his sponsors, every aspect of the speech act is properly executed, but
Austin does not possess the "thoughts or feelings" that a person invoking a
particular conventional procedure is presumed to have. Abusing the lec-
ture—for the money, for the prestige, for the ease of luring students into
his way of thinking—Austin has taken on an activity which he doesn't
believe is on par with doings of the sort to which he intends to open our
eyes. Austin might well have intended to put his hearers (and us, as reader-
ly surrogate hearers) in an infelicitous state of the kind he designates an
"abuse," specifically, an insincerity.[5] But unless Austin means to reveal lec-
turing as a systematic and formal conceit, he has demonstrated the exis-
tence of a pervasive convention of doing-in/as-words that, because it hinges
on multiple insincerities, falls outside the performative. The listener, then,
comes to the shocking discovery that Austin can't be giving a *real* lecture
series, but instead a *performance*[6] of the very ease with which we accept the
case of the performative. Austin's own lecture is a fake!

FROM HEARER TO READER AND BACK

It must have been daunting to take up the project of committing to book
form the lectures of a man noted for a theory of perlocution and perfor-
matives, those nuances involved in achieving intersubjective coordination

or in using words to achieve an action or obligation from someone else. Even a student with the most minimal grasp on Austin's theory will have noted the irony of making booklike meaning out of lectures on the performative dimension of words. The project was almost guaranteed to produce misunderstanding—to produce a recipe from Austin's fastidious and refractory way of thinking out problems. (Most of us originally learned Austin this way . . . but we now realize what a peculiar form such recipes take: first, we add ingredients, then we pick at the mixture to take some back out!) Now, it may seem ordinary to try out ideas on the road and then turn them into a book; this is what most of us do. Yet, as I've noted, Austin apparently went to some lengths to signal the problems of lecturing, but this kind of anxiety is not evident, or at least not marked in the same way, in his other works. The fact that Austin was dead when the book was published required the editors to make decisions about what the book was to be. It might also have been the case that use of recorded versions of one's lectures was ordinary— certainly, the capture of one's asides and chance additions via a cassette recorder is common in our academic world. But once again, the posthumous nature of the book project seems to have caused some worries for the editors, which is quite manifest in the way they talk about the use of tape recordings of Austin. My question here, which I'll extend in the analysis of another case of transportation of one "present" to another through the medium of recording, is how sound and assumptions about its immediacy or documentarity inform ideas about language use.

The editors cope with the embarrassing project of turning Austin into a book by encouraging us to imagine ourselves as hearers at the lecture. They obsessively reassure us that this text gets as close as possible to what Austin actually *said*, not what he might have wanted to write had he accomplished his task in writing—doing—instead of lecturing—faking. The editor insists that *this* text is as unmediatedly "Austin" as is possible—even though *in print* (rather than as writing) what Austin *did* is barely a book at all. They admit to having sparingly "interpreted" some of Austin's notes by checking them against the notes of several hearers. But the most important guarantee of the book (as a reproduction of *lectures* rather than merely the lecturer's notes— that is, what we would have heard had we been there) is two tape recordings, one produced by the BBC (no better radio than that!) and an unattributed (the technician of a recording has done nothing, has no authorship) "tape-recording of a lecture entitled 'Performatives' delivered at Gothenberg in October 1959."[7] In 1962, when the preface and book first appeared, this reference to tapes pretty well sewed up the issue of the book's relationship to the dead Austin: relying on the presumption of the fidelity of the written text to the tapes effectively secured *How to Do Things with Words* as "Austin."

But Austin's own lectures obliquely recognize that there is a logical problem involved in conflating muscle movements with their effects. He

admits that we don't bother to distinguish between "I moved my finger" and "pulling on the muscles" in my finger and tries to resolve the problem by arguing for differing notions of causality:

> the sense in which saying something produces effects on other persons, or *causes* things, is a fundamentally different sense of cause from that used in physical causation by pressure, &c. It has to operate through the conventions of language and is a matter of influence exerted by one person on another: this is probably the original sense of 'cause.'[8]

Significantly, Austin's principal concern is with the valence of causality (of power, some might say), not with the force of sound itself. Throat noises are the medium in which perlocutionary force is achieved: the fact of having had one's eardrums pounded on with another's vocalizations is merely an intermediate step to a hearer's being bound to the demand of the performative. Sound-signs with which we can do things are more interesting than mere grunts (pulling on my vocal cords), which only incidentally result in action but are not proper signs: apparently, phonic productions must be words before they can be used performatively. Vague grunts, if they must be attended to as performatives, are treated as virtual words rather than as sounds.

The editors take Austin *as* his word: the tape is treated as confirmation of the accuracy of the written words, not as sounds, but as more perfectly transparent words than those written down by even the most reliable note-taker at Austin's lectures. But the editors cannot get rid of the sound issue so quickly: they try frantically to conceal the crucial discussion about pulling on muscles by representing it in the text as two footnotes—a perplexing sotto voce that only exacerbates the quandary about the text's status for readers who have been asked to imagine themselves as listeners. Of what sort of speech do the footnotes stand as a mark? a verbal aside, captured on tape, which the editors demoted to a footnote? a marginal entry on Austin's own lecture notes? a onetime response or perpetual addition, a sort of canned reply ready for offer if he were pressed on the issue? If so, why are there so few notations like this? Was the clarification originally conjured up in the middle of the lecture? during a question and answer period? as a note made in private, later, after persistent misunderstanding? If so, why was this crucial point never incorporated into the body, the regular text for his performance of the lecture on the performative?

Raising and then dismissing as excessively picky the issue of muscle pulling (vocalization) implicit in a discussion of word-sounds in their interlocutionary context, Austin privileges—even by silencing discussion of it—the linear production of codes-in-speech to the exclusion of other dimensions, occurrences, or concepts of sound. Sound and sign are conflated: phonic production is reduced to a temporal phenomenon. A body may

grunt *here*, but the grunt is taken to be part of a sequence of grunts or grunts and silences, not part of the body's placement.[9]

The emphasis on codes-in-speech mistakes as normative a situation that must be the exceptional case of sound: the case in which a sound is produced in a witnessed real time, and in which the witness acts as if the moment of production is equivalent to the sounds being produced. The line of reasoning that takes this case as its exemplar invokes an originary moment when a first ostensive gesture established the procedure of attributing meaning to a word-sound that could, by analogy, establish new words when they were needed: a First-Word-In-Use which guaranteed the perpetual assimilation of sound to word. Phonics-as-signs implies an endless play of verifications (I can always point and grunt until you give me the object I want), but these verifications are rarely executed. This desperate attempt to evade skepticism toward word use (meaning has long fallen by the wayside) results in Austin's emphasis on the misuse of interlocutory conventions over and against the effect of discrepancies in assigning meaning to the wide variety of sounds (call them accents, mispronunciations, even wholly wrong words) that pass as a single sign—a word—that could appear in a performative act.

In so casually dismissing the issue of phonating, Austin—or his editors—wills us to the other side of the probable normative case of infelicity, where we force a congruence between what we witness and what we "hear." Even if we stick to the banal and narrow situation of practical communication, we have ample experience of not being sure what we have heard, or of conflating what we think we have heard with what we think we saw someone say—or what we later believe makes sense of what happened in a particular context ("he must have said ..."). If mishearing words is a common source of humor, mishearing *non*content aspects of sound production, like quality and markers in voice, is equally common, though a more dangerous kind of cultural transgression. Even in their absence, we make judgments about the *producers* of sound. We think we can hear race, and certainly gender. This is why the woman's "No!" is so universally disregarded, or the African American's statement of assent must be accompanied by rituals of deference. The woman's voice is believed to convey a true desire that her words belie. Black intonations are so frightening and controvertible to whites that even agreement requires the African-American person to perform soothing sounds devoid of content. On the side of cultural production, drag and camp rely heavily on bending vocal cues: we have a peculiar fascination with cross-dressed males who lip-synch the songs of female singers, performances that are even more transgressive if there is a perceived racial mismatch.

Thinking about codes-in-speech—"content"—as but *one* aspect of sound begins to loosen the temporal grip on speech and suggests the need for thinking about a geography of sound. Thinking speech as a particular case

of sound, instead of reducing sound to an embarrassing bodily prerequisite of speech, requires us to consider intrusions that otherwise seem incidental to the communicative scene—background noises and sounds that are generated elsewhere, recorded, or dislocated. We are back to tape recording as a promise of an absolute presence in sound. I take up this issue from a different perspective, the infamous but once-popular film that was produced and nearly became a pornographic crossover, a text produced two decades after Austin's "actual" lecturing and a dozen years after their posthumous publication.

"THE GIFT OF THE TAPE RECORDING"

From the beginning of sound recording, artists experimented with synchronous and asynchronous usage, engendering debates and tracking those of film itself about the relative "artistic" and "documentary" nature of the technology. Taping had obvious military applications, and, as Paul Virilio suggests in relationship to cinema, the possibilities for covert surveillance and general snooping made tape recording attractive as an area of research and development. The miniature tape recorder was the stuff of spy thrillers in the sixties, and the popular TV show *Mission: Impossible* signified the "secrecy" of the project director by featuring his instructions on a self-destructing tape. From Warhol and Cage to Altman and Coppola, artists of the 1950s through 1970s played with self-consciously rough overdubbing, having actors off camera when their voices appeared and amplifying ambient sounds to obscure visually observable scenes of dialogue. The fascination with and growing reality of the popular use of tape recorders ignited interest in what society would be like if everyone could create sound documents. Two of the best-known meditations on the possibility of capturing and possessing another's sound are *The Conversation* (1973) and *Klute* (1971), which revolve around the danger that a tape will reveal the ultimate secret: a sexual transgression.

 The Conversation hinges on the interpretation of the eponymous conversation that had been surreptitiously taped in a public place. The dramatic tension in the film builds as scenes of Gene Hackman straining to make out the words on the tape are juxtaposed with scenes in which incidental sounds force him to confirm or revise his construction of the words on the tape. In a prescient challenge to the reliability of tape recording, the film warns of the danger in aural interpretation: Hackman fabricates an entire narrative of sexual betrayal based on fragments of sound. However smart Coppola's critique of aural interpretation, it would take until the Rodney King trial (with its troubling relationship to "reality TV") before Americans ceded their belief that innovation would eventually yield the technological capacity to produce indisputable documents of real events.

In *Klute*, the dangerous tape is a recording of an s/m scene which culminates in murder. As in *The Conversation*, narrative tension builds as the contents of a tape are progressively revealed—we slowly realize the murderer's identity and understand the link between his sexual and homicidal impulses. Here, the tape has captured the "truth" of the psyche in the voice it records, but only later will we understand the significance of the psyche's relation to the conditions of the sound production. If *The Conversation* hinges on a tape produced without the knowledge of those whose voices were recorded, *Klute* considers the psychology of producing and saving a damning tape of/for oneself.[10] The miniature tape recorder, which appears several times close-up as it plays its "secret," is a sign for both the power and the corruption of the executive who is rich enough to own it. The tape recording is the "closet" of a perverse sexuality at risk of being aurally revealed.

The interest in secrets and sound technology in the 1970s found its way into pornography, already undergoing a dramatic change in conditions of production and consumption. Perceived liberalization in the law and in social attitudes ignited a new wave of film pornography.[11] The advent of cheap eight-millimeter film projectors for home use and the rapid rise in home video use in the early 1980s created not only an expanded market but also brought pornography to new kinds of viewers. In the 1970s, independent "art" filmmakers and pornographers converged: the artistic avant-garde saw an opening for more explicit critiques of sexual mores, while pornographers saw the possibility of attracting a newly less "uptight" mainstream audience, perhaps even in mainstream theaters. I want to describe a film from this period, highlighting its critique through its use of sound, of ordinary language theories' belief in action as an intersubjective guarantee of word-use. But first I want to describe the use of sound in pornography before and after this sliver of innovations in the 1970s.

Pornography producers had fun with sound, with important implications for porn acting. Early porn houses and peep shows frequently played sound loops autonomously over films. A single sound loop would repeat multiple times in the course of a film and, thus, was not synchronized with the events in the film. The sound loops were not necessarily generated by the people in the films, and, reportedly, the same sound loops were used with multiple films. It is important to note that while the sound loops were performances, they did not require the actor to simultaneously perform sex and the sounds supposed to be associated *with* sex. Like method acting, making porn loops only required the actor to think of sex and then produce appropriate sounds. The sexual recollections of the actor who produced the sex sounds might have nothing to do with the activities of the actors in the film. For example, male sex sounds produced while remembering a favorite blow job rendered by the actor's boyfriend might be played over visuals of male-female intercourse, and then again later, over a woman performing fellatio.

The lack of congruence between sound and image was apparently not a problem, in part because these films had very little plot, and, thus, sound did not operate as a narrative device within the film. These early films rarely had more than a pretext, a scene. Freed from the requirement to make appropriate sounds, much less actually master lines—that is, freed from the requirement to *act*—porn-bodies, while they still performed, were not producing sexual fictions. Even though—or perhaps because—the sound intrudes from another condition of production (masturbatory moments imbued with the most concentratedly memory-driven eroticism), the visuals of these films may be as close to "real" sex—unfaked or felicitous sex—as it gets.

Even if their crudeness was due to budgetary rather than artistic concerns, these early films seemed to argue that sexual subjectivity is something like "tapes" that we run. Whether for production economy or because they had read the burgeoning works on sexuality and sexual liberation (which seems fairly clear in the rhetoric of films like *Deep Throat* [1972], directors suggested that in the "actual" moment of sex, actants might not be participating in the same drama. The unstable relationship between sex-actors and sex-act viewers opened up the possibility of imagining oneself or one's partners to be persons of another size, gender, race, sex, or social role, or to be someone famous, or to be saying or doing something different from what they might appear to be saying or doing. The early films' disregard for reconciling sight and sound acknowledged that any particular episode of sex is a murky combination of memory, fulfillment of practiced fantasy, and surprise. These films did not try to render sex as a narrative; instead, they suggested that a particular starting place for sexual arousal might not be the actual starting place at all—that sex might have begun anywhere, at any time, that an "actual" episode of sex is as much a memory of something that happened elsewhere or with/as some other person. The refusal of narrative, accomplished through unlinking the visual and the aural, opened up space for the viewer's diverse and changing desires and erotic triggers, unbounding the apparently limited geography of heterosexuality.

The effect of early porn is quite different from the porn most of us know today: the 1980s videos, which, though more elegant, dramatically coherent, and explicit, restrict the terrain the viewer's imagining may traverse. Instead of articulating the range of perversions, they recuperate a small number of them—principally oral and anal sex—to "ordinary" heterosexuality. Rendered as the dutiful accomplishment of these two aims, even homosexuality is "ordinary," if not fully normal. These films rely heavily on cinematic and televisual conventions, and their use of sound differs in two ways from their earlier cousins.

First, sound is used fetishistically. Like the come shot, specific words or

phrases bear an indexical relation to sex acts. Where older porn ran its endless grunting and groaning loops, 1980s porn intersperses sex noises with phrases like "suck my big dick." Clearly, we don't need to hear the words in order to understand the narrative progression, indeed; the mismatch between the visuals and the word "big" reminds us that even without exotic scenes or spectacular sex acts, today's porn is truly fantasy. Such phrases operate not as referential signs, but as verbal fetishes that compress and miniaturize a narrative of desire. When the actor asks to have his dick sucked and it happens, we are as (or more) excited to hear him ask as we are scopophilicly satisfied to see him get it. But we like hearing him say it, producing a kind of aural erotic that tracks the "message" that otherwise simply sustains the narrative structure. Like the performative, such phrases fetishize *communication* as much as they discipline the desire undergirding interlocution.

Second, and perhaps more interesting, is the introduction of dialogue only loosely tied to sex acts. The 1980s porn concocts stories, sometimes quite complex ones, that require that actors perform nonsexual dialogue to answer questions like: Who are these people? How did they meet? Why and how will they have sex? Where pre-crossover films established character through crude devises like costumes and props or iconic references like hair color, much 1980s pornography uses psychological states and problems to explain why particular people might be having sex. While both pre-crossover and 1980s porn rely on cultural stereotypes, the introduction of narrative and psychology represent an important change in the films' apparent theory of how and why people have sex: the motive is no longer brute attraction to an image, nor the physical desire to perform specific pleasurable acts, but a psychological crisis that requires a sexual resolution. Though it soon segues into verbal foreplay, the dialogue is not explicitly erotic:[12] like the dialogue of mainstream cinema, it functions to constitute characters' subjectivity, as transportation between diegetic locations and between scenes, and to provide narrative continuity. But this *use* also narrativized sex: by the 1980s, sexual desire had a specific trigger, might be thwarted by circumstances, but would eventually find enactment with another person until orgasm marked "the end," after which characters return to "daily" life.

LEARNING TO TRANSGRESS

> DR. LOVE: Now the instructions on the tape can be transmitted easily and therefore can be meticulously followed ... everything here is custom made, nothing is off the shelf. (Handing microphone to Misty) You hold this—take down every word. It's audiovisual time!

The Opening of Misty Beethoven was produced in 1975, about midway through the historical shift I have been cursorily describing.[13] Following hot on the heels of the highly successful and controversial *Deep Throat*, *Misty Beethoven* also

takes up the then current theme of the transgression of fellatio. Interestingly and typically enough, both take up for heterosexuals a practice already spectacularized as a practice of homosexuals, a phenomenon of heterosexual discovery that would be repeated when heterosexual porn took up the taboo of anal sex in the early 1980s. But the problem of fellatio is articulated quite differently in the two films. In *Deep Throat*, a woman who discovers that her clitoris—and, therefore, according to the film, her site of sexual pleasure—is in her throat must learn to perform fellatio. The focus of the film is completely on her acquiring a knack for the act, with a sex therapist's diagnosis and treatment as a conceit to explain why she wants to perform fellatio.[14]

Misty Beethoven is a sophisticated version of *Pygmalion* (or, more likely, an intermediary, contemporaneous film, *My Fair Lady* [1964]). Here, a jet-setting star maker cultivates Misty as the world's top model in the annual "Miss Golden Rod" contest. To win, Misty must seduce the publisher of an important fashion magazine, who is more or less coded as gay.[15] But Misty appears to have neither sexual desire nor any repertoire of sexual techniques beyond the hand job: as Dr. Love tells her, "You are the absolute nadir of passion, the most unexciting thing God has ever created, a sexual civil service worker." If Austin's boredom-prone students must be seduced into training, Misty must be trained to seduce.[16]

Dr. Love recruits Misty to perform actions with which he is well acquainted, but in a contest he, because of his gender, cannot actually enter. In one scene, he semidemonstrates fellatio by wiggling his tongue next to a dildo. In others, he models positions and strategies that Misty takes up. It would be easy to read the permeability between Misty and Love as a contemporary case of the narrative format Eve Kosofsky Sedgwick describes in *Between Men*. But something more sinister is happening here: while the conquest is organized around a series of seductions between Love and various target men, accomplished through fellatio performed by Misty, the usual figure of sexual performance—intercourse—is displaced. The "good part" features Misty anally penetrating a man while he vaginally penetrates another woman, a strange scene in which the man/phallus/penis circulates between women. The gender calculus of heterosexuality is finally collapsed, and this, rather than the invitation to fellatio that characterizes *Deep Throat*, may be why *Misty Beethoven* is orally fixated almost to the point of tedium. The film seems to be aware that it is wearing out its central figure: in the pivotal scene to which I'll turn in a moment, Dr. Love, who is fellated almost as a reflex, is more excited and engaged by the idea of transforming his charge into a sexual predator than he is in the dramatic resolution of his hard-on: while watching Misty watch his assistants rehearse her seduction strategy, Love stands up, apparently having forgotten someone was sucking his dick.

Misty eventually masters the blow job. But unlike *Deep Throat*, the story doesn't stop here. If the clitoral throat situated female desire, then the blow job became a kind of Pavlovian response to the appearance of a hard dick. Misty's evident asexuality and lack of even a technical interest in fellatio requires another form of propulsion for the sexual narrative. The film rejects the idea that transcendent desire joins bodies in practice through the temporal medium of a sexual scenario. Although she has tackled the critical act, she has no means to insert it into a sequence: Misty must also learn the progression known as seduction. Like the editors who try to make Austin real, tape recording and broadcast come to the rescue.

In a stunning segment, Misty watches her female assistants record the seduction scene that she is to perform. First Misty and then an assistant hold a rather large and phallic microphone, while Dr. Love's publisher (the woman with whom he has made the bet about Misty's potential) plays the man (described by Dr. Love as "Very handsome for an impotent man. Very straight, square, he hasn't even *visited* the closet yet"), while an actress plays the part of the seductress that Misty is to take up.

On one hand, the use of the Actress to play Misty's part suggests that it is only possible to *act* the part of a woman with no desire. But a more cynical reading would suggest that however variably credible, any display of desire is only ever acting. Indeed, when Love recruits her services, he tells the Actress that everything he knows about scamming he learned from her. As if acknowledging their mutual complicity in sexual fraud, she replies: "We learned from each other." Unlike Austin's demand for sincerity, *Misty Beethoven* suggests that "perfect" sex may be when both parties "fake it" perfectly.

Shifts in address in the dialogue expose the dynamics of sexuality as a scene compounding within a scene. The taping segment begins with the Actress's announcement to the crew: "The Bringing Out of a Difficult Man—Sound Only—Take One." Most of her subsequent dialogue is in the first person, often a repetition of Dr. Love's commands. For example, when he says "suck his nipple," she announces, to be recorded, "I'm sucking his nipple." But the shifts out of first person are significant; commands are sometimes given to a third person, eventually Misty: "Lick the side of his cock," but are sometimes in second person between the Actress and her partner (the Publisher): "I'm going to suck your cock." At one point Dr. Love commands the Actress to "Suck it like a ripe mango." She directs her reply to her partner: "I'm going to suck your cock like the inside of a ripe mango." This gender disjunction lesbianizes the scene, especially when the Publisher cries out: "Take Two!" and the Actress replies: "Ripe Mango—Take Two!" As the Publisher has an orgasm, the Maid (who has taken over the recording from Misty) moves the microphone toward her face to record

these sex sounds. Her orgasming sounds continue as the camera shifts between the cunnilingus shot, a close-up of the Maid recording the scene, and a close-up of the Publisher's orgasming face.

Invoking the temporality of both seduction and pedagogy ("practice makes perfect"), and continuing the diegetic pretext of producing educational aids, the Actress closes the "lesbian" scene with: "Why not do the sequel right now?" She and Dr. Love repeat the same activities—with the same music—but this time culminating in fucking. As usual, Misty watches with a studious gaze. This doubling of Misty's instruction might be in the service of recuperating the Actress as heterosexual. But why not simply have her make the tape with Dr. Love in the first place? The simple answer is the convenience of this plot twist for providing the obligatory lesbian sex scene. But there is one major difference in the sequel (well, two, if you count its introduction of a male participant): the intermediary taping does not occur, and we observe their sexual performance directly. Thus, through the gender play and the visualization of the microphone and its movement across the initial tableaux, we are afforded access to the conditions of production of the tape—the sound—which lays bare pornography's timeworn disregard for synchronicity. But it wreaks havoc in the viewer's gender and sexuality calculus.

This soundtrack of the instructional scene appears again when Misty goes off to seduce the fashion designer, this time via broadcast to a tiny receiver she wears in her ear. We see her seducing the disinterested designer, while we hear two women performing a seduction scene. The soundtrack carries the lesbian performance we witnessed to the site of a cross-gender, cross-sexuality seduction. Try as we might, what we think we saw when we heard what we thought we heard just doesn't synch up to what we see and hear now.

Misty does become Miss Golden Rod, but she has to perform a final seduction in front of a warehouse filled with the international elite from the art and fashion world. This time she must seduce the fashion magazine magnate's wife, who is coded lesbian. Misty seems to have some talent here. The wife straps the "golden rod" onto Misty, who sodomizes the fashion magazine magnate while he fucks his wife, a kind of "between women" scene of butch desire. Like the tape being replayed in another venue with different actors, the queer sandwich operates by splicing the penis and phallus, disappearing the male body, and hinting at potentially infinite series of insertions around which all bodies might merge.

Unlike the nonpornographic contemporaries—*Klute* or *The Conversation*—the sound experiment in *Misty Beethoven* does not propose a hidden sexual psyche. The tape in *Misty Beethoven* is not an extension of an interior sexual perversion, but a means of dispersing sex through space. Insofar as

tape stands in as memory, it is not a secret memory to be revealed, but a chain of surface connections: syndetonic links in a sexual geography rather than the transcription of a returning repressed. This concept of what phonicity represents exactly mirrors Austin's own refusal to see words as the thing that can mark the inside or outside of thought or its transference between subjectivities.

Misty Beethoven evacuates sexual desire and even sexual spectacle in favor of perfected sexual performance. Correct conduct of the convention of seduction is paramount, but neither sincerity nor sexual fulfillment enter this equation. The hundreds of acts of fellatio practiced on multicolored dildoes never result in orgasm. There are occasional come shots when Misty practices on real penises, but fellatio rather than orgasm, the prosthetic phallus not hot fluids, organizes the film. The various episodes of sex are not connected through any common well of desire, but through the circulation of the phallic prosthetic: not art imitating life, but art bigger than life. The culminating scene of sodomy/intercourse does not displace fellatio with a more advanced relative, but reinforces the lesson that the golden rod, the unyielding, unpleasured prize, drives the sad little flesh-and-blood penis. The queer sandwich does not pronounce the necessity of fucking as narrative climax, but reifies the golden rod's place as the central but desireless character—the object that is passed between women.

We might come to the depressing conclusion that the entire film is in service of the phallus. But throughout *Misty Beethoven*, the phallus is detached from the male body. A subtle range of gender codings sustains the film's high modernist ideal of the perfect penis—not as the possession of a man, but as the thing that can top even the sexual union which is supposed to guarantee ordinary heterosexuality: sexually sublimate Misty "tops" the copulating heterosexual couple, tops even heterosexuality. The film thus undercuts any reading of intercourse as the ultimate completion of sexual desire. Even Dr. Love, who has the most orgasms in the film, is finally most interested in perfecting Misty's technique: his primary goal is not his own immediate pleasure, but possession of the golden rod by proxy.

Sex is all on the surface—not the surface of the body, but dispersed across the sexual scene. The banality of ordinary sex is precisely its unerotic, degendered fetishization of the act, freed from pleasure, unmotivated by desire, driven only by the quest to repeat: sex is a tape that gets played over and over in different places. Genital organization is inconsequential: the phallus can be miked, reproduced, and transferred. *Misty Beethoven* confronts us with the one thing we know about sex, if we can bear to remember it: we never had much confidence in the truth of its presence, we could only listen to its soundscape with hopes that if they were faking, at least they were faking for *us*.

A VERY ORDINARY LESSON

The point of my outrageous comparison between a famous book and an infamous porn film is twofold. First, I want to suggest that we take a closer look at some of the cultural products of the 1970s. After all, who takes much of anything from the 1970s seriously? Wedged between fertile political decades dedicated first to the left and then to the right, the 1970s evoke for many little more than discos or hideous polyester clothes and shoes that should never have made a comeback, even in Madonna's perverse accessorizing of her futuristic, s/m leather Gaultier outfits. But the 1970s were also a crucial rupture between high modernist political ideas (the warring twin metanarratives of Marxist liberation and liberal plurality) and the lowest form of supply-side economics and laissez-faire morality. We went from the 1960s dream of a great commonweal of sentiment to the 1980s cynicism that refuses even to care how anyone else feels. Unless *The Opening of Misty Beethoven* is completely idiosyncratic, the film suggests which fundamental tenets about intersubjectivity ruptured in between. The ease of picking cloned porn videotapes off the shelves today should not blind us to the peculiar form of political commentary that crossover hopefuls of the mid-seventies could produce.

But second, however productive the "linguistic turn," it too readily restores otherwise failed foundations in precisely the situations that *Misty Beethoven* so opulently and humorously lays bare. In the absence of God and country as guarantors of ethics in the post–World War II era, a range of philosophers developed several theories that took everyday uses of language as the building block or analogy or "universal" structure of human interaction that might provide the foundation for some modified form of social contract. Analogies between an "everyday communication"—which we are all supposed to recognize—and larger claims about language or legitimation embed local, temporal narratives—in which I utter and you respond—in larger, panhistorical sequences in which the long accumulation of past acts of agreement over phonic production are reiterated through subsequent use until they are built into a shared language.

But as *Misty Beethoven* shows, communication theories that argue from face-to-face situations to the universal structure of language or social order misunderstand the complexity of the sounds they take for signs. Arguments from "the ordinary" would seem to exclude several significant cases—the sex about which we are supposed to know far too much, and the lectures whose very scene indicates that we know far too little. Granting their mutual differences, I want to take exception with two particular forms of arguing from the "ordinary," however intuitively plausible. First, those intent on proving the existence of the referent of indexicals—"reality"—have been known to

kick a rock or pound a wall. It seems unfair to ask someone to dispute such a claim, to insist, like the sexual fetishist, that if only he or she repeated one's gesture they, too, would discover the solidity—the erotic desirability—of the object. But what has this inability to dispute the reality of the rock (or stubbed toe) proved? The obvious ludicrousness of disputing the rock kicker's claim masks the power imbalance involved in any case of coercive confirmation or disconfirmation (though power operates differently in each case).

Richard Rorty is beached on this shore when he implicitly tries to build a limited ethical foundation from the presumption of a power-free confirmation of pain. He suggests that we shift the question we ask in political debate from one intended to achieve philosophical agreement—Do you want and believe what I want and believe?—to one designed to address only "real violence"—Are you in pain? The problem, of course, lies in the possibility of recognizing another's pain.[17] Rorty concedes that indexicals create problems in political debates about the social contract, and suggests that most final vocabularies—and the ironic attitude toward one's own final vocabulary that he advocates—are not deaf to the sound of a pain cry, at least as long as they separate the issue of group desires from the issue of an Other's suffering.[18] Insisting that the world could be divvied into "private" realms of debate (ultimately ungroundable struggles over "final vocabularies") and a public where we treat only the most serious questions of moral responsibility ignores the asymmetry of power built into the apparently confirmable ordinary case of the pain cry. Either: (1) *someone* will have to determine who is *really* in pain (by consensus? That hangs on the coercive agreement of the banged-toe type. By empathy? That hangs on a structure much closer to the original framing of the political question: Are you hurt by the same things I'm hurt by?), or, (2) we will have to accept *all* claims to being-in-pain, even those utterly offensive ones offered by torturers who claim to also be in pain. Ironist Rorty finally has an instrumental view of language: words compound, contest, communicate. A pain cry is a phenomenon that becomes a sign when another applies the words, "Are you in pain?"

The second form of this argument from the ordinary involves cases of apparent concordance between action and words, in which I say, for example, "Hand me that book," and you give me the one I wanted. The young[19] Habermas of the universal speech situation grafts Lawrence Kohlberg's developmental account of moral reasoning onto the analogy between the banal speech act (what he calls instrumental) and more complex practices of state legitimation. This increases the demands on the simplest case of communication until "ordinary" speech acts cry out under the strain. While useful, the decades of revision that have produced Habermas's currently popular theorization of the public sphere have not come to grips with the basic problem of arguing from the "real" banal case to the "abstract" historical-political one.

Of course, we do stub our toes before empathetic witnesses and often get what we ask for—and we would drive ourselves crazy, or never get past our first daily interaction, if we worried about these simple cases very much. I may seem to be engaging in intellectual pickiness here, but I am not disputing the existence of the everyday cases. Indeed, I am not even disputing the utility of not thinking about them very much. What I object to is the analogical leap to the larger case, the tendency to take from the quotidian case only its achievements while ignoring the problems that its failures present to the analogy. I can accept that interlocution can culminate in temporary harmony without having to accept, by analogy, claims about communicative intersubjectivity as a mode of global governance. What if we *don't* care whether the person really understood, as long as we *got* what we wanted?

Arguing by analogy from everyday occurrences makes unwarrantedly optimistic assumptions about the possibly unknowable motives and desires bound up in an interaction, and imports them into more complex claims about ethics or government. If we only look at the "ordinary" situations that conform to our desire to define rules that could allow communication to supercede violence, we will import into our philosophical and social scientific rationales highly problematic assumptions about the degree of concurrence that has happened and deeply arrogant disavowals of our self-interests. The fact that grunting and pointing gets us what we want is no cause for celebration of our superior communication skills, much less a solid grounding for looking at increasingly complex levels of interlocution between humans, and even less a basis for constructing analogies to complex processes of state formation and governmentality. Quine made this complaint in a more philosophically respectable way when he argued that communication is really better thought of as a system of partial translation in which we go along until we discover a mistake—that is, until we don't get the desired result. What Quine does not say as clearly is that power relations, not "communication," are attenuated at that point. The "good communication" that overtherapized individuals and modernist political theorists desire is too often just power exercised in silences, in the absence of obvious contestation.

Sound doesn't *do* or *mean* in a constant way; indeed, the *meaning of sound* has not only changed during "postmodernity" but has been debated and contested and subverted quite publicly. The idea that the sounds produced during face-to-face contacts provide the basic element of a theory of communicative contract is not just implausible, it is, finally, dangerous to those who cannot make their pain recognized. Reexamination of popular culture of the 1970s may show that for a brief moment, we understood that communication is more strategy than transcendence.

NOTES

1. In fact, this is one of the most reconstructed sections of the lectures. The bulk of the notes transformed into the book were from a specific occasion—at least, they were the last time the many different versions of the lectures were pasted together as one. The editors acknowledge the place of this "final" lecture, even as they produce the book version of something more than an occasional lecture. The editors have to leave in "Harvard" or else their project would simply be to have finished a *writing*, not committing a lecture to print. Thus, for the sake of authenticity, the editors fake their attention to the absolute Austin by letting him have the last situated word. J. L. Austin, *How to Do Things with Words* (Cambridge, Mass.: Harvard University Press, 1975), 164.

2. This section is especially interesting, confounding Socrates' anguish at having to produce rhetoric with his embarrassment at falling for pretty-boy Phaedrus's trick of getting him into the countryside to give speeches on love. The dialectic, once justified and restored to its position above rhetoric, re-equilibrates the great teacher and his student, the reluctant pedophile and his promiscuous teaser.

3. Austin, *How to Do Things with Words*, 1.

4. Ibid., 164.

5. Ibid., 18.

6. Recent debates in queer theory have tended to conflate performance and performativity. It would be a good idea to separate them for two reasons. First, Austin himself seems to distinguish the eventlike time of going through the motions of a speech act from the specific requirements that make a performative successful. While the text is coy about how strictly to maintain distinctions proposed during any phase of the investigation, the issue of sincerity seems to remain constant. Thus, going through the motions—whether this is publicly framed as acting or privately motivated and undisclosed—is not sufficient for a phonic act to be raised (through the linkage of illocutionary force to effect) to the status of a performative. At least from Austin's standpoint, while it pervades every speech act, a performative is a technically narrower entity. Performance, as in the discipline devoted to its study per se, seems to be a category orthogonal to Austin's concerns, perhaps because it is extra-ordinary. Of course, the discourses of acting that performance studies seeks to undercover have their own technicalities. But here, the "ordinary" would be a special case in a larger discussion about bodily presence. Detailing the convergences of these to areas of inquiry is promising. But simply using the terms "performance" and "performativity" interchangeably loses the particular investigative actuities that obtain under each.

7. The editors thank these anonymous hearers for the "loan of notes, and for the gift of the tape recording." Austin, *How to Do Things with Words*, vii.

8. Ibid., 112–13, 113.

9. But think of the sounds of a footstep; the brush of fabric against fabric as a body walks, then accelerates to run; a fist against a hand.

10. Robert Packwood seems to have taken a page out of this story, even if his crimes

were less fatal. The confessional psychosis that afflicts powerful people who record their crimes holds a peculiar fascination. Why do we lend more credence to the records of an arrogant man than we do to the tape serendipitously made by the bystander? Are we more impressed by confession than representation?

11. I do not mean to suggest that this period was marked by an overturning of a great suppression, but only to remind post-Foucualdian readers that, at the time, filmmakers believed this was the case and framed their productions and artistic ambitions with a palpable sense of "liberation."

12. Paradoxically, these videos are simultaneously more visually explicit but somehow less "erotic" than their earlier cousins. They do not so much invite the viewer to discover erotic mystery and mastery, but to catalogue and diagnose the neurotic manifestations of thwarted aims. This shift toward a more Freudian conceptualization of sexuality, which occurs in the 1980s, is all the more curious given that mainstream cinema had become obsessed with sexual neurosis as the motivation of character and action as early as the 1930s. Indeed, two genres seem to revolve around hack versions of Freudian concepts: melodrama and hysteria, film noir and the failure to achieve coitus (either due to homosexual desire or impotence, if these are, in fact, distinguishable in noir). Instead of viewing porn after the 1970s as a "break" from taboo, as the repressive hypothesis so eloquently criticized by Foucault would have it, the scientization of this more explicit pornography suggests itself as an incitement to reproduce the repression/expression complex. It is, at least, the final frontier where *ars erotica* have given way to *scientia sexualis*. (See Michel Foucault, *The History of Sexuality; An Introduction* [New York: Pantheon Books, 1978].)

13. The most thoughtful history of pornography continues to be Linda Williams, *Hard Core: Power, Pleasure, and the "Frenzy of the Visible"* (Berkeley: University of California Press, 1989).

14. It is difficult to know what to make of *Deep Throat*'s obsession with fellatio. On one hand, as antiporn feminists have argued, the film suggests that women can and must be forced to learn how to orally service men. But on the other hand, feminists themselves have had extensive debates about the locus of female sexual pleasure. The clitoris was reclaimed in the 1960s and 1970s, so the film's acceptance of female sexual pleasure and its residence in the clitoris aligns with feminist discourse of the time. On the level of representational conventions—though I have my doubts about whether the filmmakers were explicitly concerned with them—pleasure of a diffusely erotic sort was represented through women's ecstatic faces, a convention that was common to advertising, fashion, and pornography. Placing the newly indisputable site of female pleasure (i.e., the clitoris) in the same intimate, close-up logic as the conventional sign of female pleasure was certainly one solution to the problem of making representations of female pleasure more "realistic," or at least, within the same somatic frame as the come shot.

15. This discourse of sexual lability must be carefully historicized by post–AIDS discourse viewers. As I have argued elsewhere, by the late 1980s, male and

female bisexuality are considered virtually completely different phenomena. The "shadowy" bisexual male is unwilling to commit to one "lifestyle," or the other, and is the putative carrier of HIV from the gay to the straight worlds. Female bisexuality is more diffuse, perhaps a "good solution" to finding sexual intimacy in a world where men cannot be trusted. In *Misty Beethoven* the designer is described as uptight and not having even been to the closet, suggesting that seducing a frigid man is even harder than seducing a homosexual (because fellatio is fellatio?). I also read the fashion magazine magnate as quasi-gay because he looks like the designer, is portrayed as totally narcissistic (a perpetual trope of homosexualness), and has a wife who seems also to be vaguely coded as lesbian. At any rate, the couple is not decisively hetero.

16. She is trained to perform fellatio on a series of striped dildos that merge flag motifs with the then-popular multilayered scented candles, which found their way into the bedrooms of the sexually adventurous. The color coding suggests that the contest is also one of national dominance: the nationalist dick is mass produced, and, as a simulacrum, is superior to the "real thing" since it will not go soft after obtaining its own pleasure.

17. Richard Rorty, *Contingence, Irony, and Solidarity* (New York: Cambridge University Press, 1989), 198.

18. Interestingly, the signification of pain is always rendered as a question to the person in pain: their cry is not treated as having risen to the level of a vocabulary, final or not. What if the person who is in pain is unsure, as might a self-demeaning rape victim be? What if their pain seems incredible, as in the pain ventriloquized by white men through the charge of reverse discrimination?

19. It may seem unfair to go after Habermas's early work, given his revisions after his encounters with Gadamar and Foucault. However, several areas of communications studies rely on this early version of Habermas.

Talking Music

The Dancing Machine

An Oral History

VINCE ALETTI

THE PLAYERS

RAY CAVIANO: Parlayed his success as disco's most persuasive promo man into a high-powered but short-lived deal for his own RFC label at Warner Bros. Although cocaine abuse left him broke and in jail (and landed him on the cover of the *Voice* in 1986), he bounced back to become a perennial promotion man of the year, most recently with MicMac, the New York freestyle indie, which let him go in March. Since then, Caviano's dropped from sight.

AUGUST DARNELL: Cofounder of Dr. Buzzard's Original Savannah Band, leader of Kid Creole & the Coconuts, whose 1992 album, *You Shoulda Told Me You Were . . .* , was their last for Columbia; since being dropped by the label, the group's been without a deal. Darnell spends much of his time these days in Manchester, England, "playing daddy" to two children, Ashley and Dario.

GLORIA GAYNOR: Crowned the first Queen of Disco after "Honey Bee" and "Never Can Say Goodbye," Gaynor originated one of the most imitated disco formulas but faded from the American scene after "I Will Survive." Her recent work has been in Italy (where her *Gloria Gaynor '90* album went gold), the Middle East, and Asia, but she says, "I think I'm ready to come home."

LOLEATTA HOLLOWAY: One of the clubs' fiercest ruling divas with "Hit and Run" and her Dan Hartman duet "Relight My Fire." She still rules, both as sampled wail and featured vocalist, most famously on Marky Mark's "Good

Vibrations." She's currently preparing a second single for the Select label, due early fall.

DAVID MANCUSO: Mancuso turned his lower Broadway loft into a balloon-filled private party once a week in 1973, playing both DJ and host. One of the earliest New York membership clubs, the Loft has moved twice and shut down periodically since then but remains a fixture, with Mancuso in full effect.

RICHIE RIVERA: One of New York's most popular and powerful DJs during the disco boom, Rivera last played at a club in 1983. He's currently working in the chart department at HMV's Upper West Side branch.

FELIPE ROSE: Discovered dancing on platforms in New York clubs by French producer Jacques Morali, Rose, a Puerto Rican Native American, was recruited to play the Indian in the Village People. Still wearing a feathered headdress, still singing "Macho Man," he's among the original People celebrating the group's sixteenth anniversary this year.

KATHY SLEDGE: Thirteen when Sister Sledge was formed, Sledge "grew up in the business." "We Are Family" remains the group's anthem, but Kathy, now married with children, went solo last year with the album *Heart*.

JUDY WEINSTEIN: The cofounder of New York's influential For the Record DJ pool in 1978. Weinstein is partners with DJ/remixer/producer David Morales in Def Mix Productions, which represents Frankie Knuckles and Danny Madden.

BARRY WHITE: His "Love's Theme" in 1974 was the first disco single to top the pop charts. White continues his reign as king-size pillow talker with a retrospective boxed set on the market to be joined by a new album, *Love Is the Icon*, in September.

GLORIA GAYNOR: I started out singing jazz, singing top 40 in clubs, and between sets, disc jockeys would come in to play and I knew that was the next storm coming; I saw that we were going to be phased out. We saw disco coming and decided we were going to furnish music for that.

LOLEATTA HOLLOWAY: Disco was the greatest time ever, and I am happy that I experienced it. When they went out, they went out with one thing in mind, and that was to party. Today it seems like there's always a lot of fights. People had no hardness or no bad thinking on their mind, and everything was free. And it seemed like the peak to me.

BARRY WHITE: The seventies was very glamorous—the very first time I ever saw regular jeans go from $5 to $250. The consumers dressed up like they were the stars.

FELIPE ROSE: Disco was like a sense of youthfulness and decadent innocence that the era had. It was just a hot, hot, hot time.

KATHY SLEDGE: I honestly saw it happening but I wasn't allowed to go out dancing. We were minors at that time period.

BARRY WHITE: It was a freedom time—more people experienced things and tried new things, whether it was drugs or whatever. It wasn't about sex but love and sensuality, communicating, relating. There's a world of difference between making love and having sex, and the seventies was approached as if it was a woman being romanced and made love to.

FELIPE ROSE: You wanted to look your hottest, and damn if you forgot your tambourine when you got that hit of acid. (I stole that from David Hodo who says it in the show.) You were going to meet fabulous people and you were going to party not just for that night, you were going to party for days.

KATHY SLEDGE: Disco snowballed the way it did because it got to be not just music, it got to be peoples' social lives. People got to be stars and shine on their own.

FELIPE ROSE: Every night was a different club, one after another, and there were really no barriers in the clubs. There were blacks and whites, gays and straights—it was really more a harmonic thing. You never felt threatened when you went to a club. It's not like today when you have to wonder who's carrying a gun or something.

AUGUST DARNELL: We were very fond of disco because every artist needs some sort of movement to make them larger than they really are, and disco did that for us. It sort of gave us a niche, if you will, and a place in history. Some radio stations were calling us Dr. Buzzard's Original *Disco* Band, and we never had a problem with that because we were all disco children. We used to hang out at Studio 54 so much that we should have been paying rent.

KATHY SLEDGE: When our song "He's the Greatest Dancer" came out, it was after the *Saturday Night Fever* trend and everybody thought they were the greatest dancer. We literally had people come backstage and say, "I am the person you're singing about." They were definitely not introverts.

RAY CAVIANO: With disco, you were not an observer, you were a participant. You weren't going to the party, you *were* the party.

JUDY WEINSTEIN: In a word? Drama.

RICHIE RIVERA: Party.

AUGUST DARNELL: I'd describe it as passion or, better, neopassion—a passion for the modern times.

BARRY WHITE: Explosive, mystical, magical. Disco brought a lot of smiles to people's faces and I saw it everywhere in the world.

RAY CAVIANO: A disco record doesn't let you dance, it *makes* you dance.

LOLEATTA HOLLOWAY: The producers, like Norman Harris, took the music and stressed it in the studio; when they started playing they never stopped. When I put down the vocals on "Hit and Run," they told me to come back the next day and just work out on the break and I thought, This is the longest song I ever sang in my life. The music just went on and on.

KATHY SLEDGE: Disco music to me was musical elation. I think people forgot who they were for a minute; it had a way of lifting you, making you forget about your worries or your problems—almost like mesmerizing you. It was another way of reaching out and feeling like you're a part of or belonging to the crowd.

AUGUST DARNELL: Hurrah's was one of the first clubs I went to, but I frequented Danceteria, the Mudd Club, Studio 54, the Continental Baths, Electric Circus—and there were at least a dozen after-hours places that we used to hang out at. I'd have to look into my diaries to find out their names.

JUDY WEINSTEIN: The first club I ever went to was in downtown Brooklyn, called COCP; it was all black and I snuck out there on the weekends. I was like sixteen. Then there was Frammis, Salvation, Sanctuary, Tarot across from Max's, and Max's for a minute. The Loft, 12 West, Flamingo once or twice. The Gallery, the Garage, Better Days. Infinity, Le Jardin, Studio 54, but those were work-related—the other places I lived at. I was a Loft baby.

RAY CAVIANO: The first club I can remember going to was the Firehouse, early in the seventies. It was the first place where gay people could get together in an uninhibited way away from the bar scene.

RICHIE RIVERA: The first club I played at was the GAA Firehouse, on Wooster Street. Then Footsteps, Buttermilk Bottom, the Anvil, the Sandpiper on

Fire Island, Flamingo, the Cock Ring, the Underground, 12 West (which became the River Club after the Saint opened), Studio 54, and back to the Cock Ring.

FELIPE ROSE: We were like G.I. Joe action dolls under the strobe lights. The intensity back then was stronger, the volume was bigger. We were one of the only groups to go live with a band into the clubs, and when we appeared in stadiums, we brought motorcycles, a tepee, a Jeep, and Portosans—for the construction worker—onstage.

AUGUST DARNELL: We were a band with a mission—to bring dance music back to the world—and we felt like the crowds almost lived by a credo that dance is everything. In England now they have all these rave parties, but when people say there's nothing like a rave, I say I saw all this in 1976 at Studio 54. Studio 54 was like ritual escapism to the max.

RAY CAVIANO: There was no question about it: the DJ was in full control—almost mind control—of the dance floor, and he had the capacity to take you on a trip. In some cases people felt it was a religious experience of sorts. It was almost a physical thing too—quasi-sexual. The DJ was manipulating the dance floor through a whole steeplechase of sounds. I wanna take you higher.

RICHIE RIVERA: People got to trust me and we bounced off one another. I had a feel for what they might like so I'd go two or three degrees further, and they usually went along.

DAVID MANCUSO: Rule number one: Don't let the music stop.

RICHIE RIVERA: It was difficult for me to accept [Donna Summer's] "Last Dance" when it came out. It was such a drastic change. For years, everybody had been refining their style so the music flowed nonstop. And all of a sudden here came a song where it stopped—and people needed that. They'd been dancing nonstop for years at that point.

RAY CAVIANO: Never speak to a DJ when he's got the earphones on and mixing. Know when to talk to the DJ, not to interrupt his artistic flow. You're talking to him during his performance.

JUDY WEINSTEIN: A DJ should always pay attention to his dance floor and entertain—that's his job, to read the audience and react to what they want. Make them scream when they're good and punish them when they're bad.

DAVID MANCUSO: A night at the Loft was like three bardos. There was the coming together, calmness. In the first two hours, it starts out very smooth-

ly, gathering. Second bardo would be like the circus: music, lights going, the balloons. Third bardo would be the reentry—going back to where you came from, maybe not the same person, but you land back on your feet gently, a little wiser and a little more sociable.

RAY CAVIANO: Every club was different. At Flamingo the DJ was like the Svengali of the dance floor, the maestro. Funhouse was a little more casual; Jellybean was looser.

RICHIE RIVERA: At Flamingo, it was like Moses in a scene from *The Ten Commandments*. At the Anvil, the booth was right in the middle of everything and people's faces were like three or four feet away from me, so it was really like being in the heart of the whole proceedings.

RAY CAVIANO: The most famous booth in the industry was at the Paradise Garage. It was literally a who's who of the music business in New York— from Frankie Crocker to any number of record company promo people. If a hot new record got played, word would spread like a bullet from that booth and within forty-eight hours you'd have a hit.

JUDY WEINSTEIN: At the Garage, I was the godmother of the booth. As the evening progressed from midnight on, there was a pattern as to who showed up. Early on, it was members of the music industry who came to promote their records but not necessarily to dance. They'd try to set up the DJ, Larry Levan, with a test pressing. After two, those people would disappear and the serious record people would show up. That's when the party would start. After four or five, the booth would be void of anybody who wasn't there to seriously dance or listen to music, and those people stayed until closing, sometimes until noon the next day.

RAY CAVIANO: The Infinity booth was famous for DJ groupies. The booth was high above the floor at one end of the room and Jim Burgess ruled. But the groupies had a certain amount of influence; they could get the records they liked played when some promo person didn't have a chance.

AUGUST DARNELL: I'd have to say my favorite club was Studio 54, it was so decadent and so exciting in that period to be part of something you knew was a world movement. It was a bit magical and the music was devastatingly loud. I was never into the alcohol or the drugs, so the appeal of the club was different for me from its appeal to other members of Savannah Band who will go nameless here. I went primarily for the glamour of it—so many beautiful women hanging out in one place. Steve Rubell *did* make it ridiculous after a while. He could stagger around higher than anyone I ever saw and still be coherent.

RICHIE RIVERA: In the course of a night, the tempo would generally curve downward, but sometimes the manager thought it was too gradual. People needed a reminder when it was time to take the downs. They told me, You've got to do something to make them realize it's time to start coming down—something dramatic. Some people showed up at four because they wanted to hear all that down stuff, what came to be known as sleaze music. They didn't blend in with the earlier crowd, who were like *Saturday Night Fever* and just wanted to take speed and fly.

JUDY WEINSTEIN: Leaving the club, we'd hit the streets looking terribly ugly because we were all very worn out and soiled and everybody out there was fresh. We'd go out to breakfast and talk over the records, the show, the dish of the night, then go home and try to sleep. Come Sunday night, you were fried but not ready to call it a weekend, so Better Days was the dessert when Larry Levan had been the appetizer and dinner.

LOLEATTA HOLLOWAY: I was working this gay club, right? And I talk a lot before I start to sing. And I said I want a lady to come up onstage that don't mind being a bitch. I told her to look around for whatever man she wanted and I'd bring him up. And then I brought a guy—he was gay—up and instructed him to call up whoever he wanted and put his tongue way down their throat. He looked around for a minute and then grabbed me and turned me way over—you know how you do—and kissed *me!* The audience went crazy, but I never did that again.

FELIPE ROSE: In different clubs they would throw different things on the stage. Girls would throw bras, and guys would jump onstage and take off their shirts and flex for "Macho Man."

KATHY SLEDGE: We did the club circuit in New York, and during the Son of Sam period, I learned how much people looked forward to going out at night and when they couldn't how much they missed it. I remember so clearly Disco Sally was at one of our shows. I saw her in the bathroom with this long brown fall on. They said Son of Sam was preying on women with long brown hair, and when I told her that, she just whipped it off and put it in her bag.

BARRY WHITE: I loved the people, the attitude of the people. The consumer participated not only listening to the music but dressing to the music.

GLORIA GAYNOR: I kind of liked trendy and funky clothes. I don't like women showing more of their body than is really necessary, but I like fun clothes—sparkle blouses and all.

AUGUST DARNELL: The thing about the style of disco, in retrospect it was quite ridiculous and laughable. To be quite honest, I didn't think much of the clothing, but the Beautiful People who came to 54, they did have style. The good thing was it gave people a reason to say "Let's get dressed up and go out."

JUDY WEINSTEIN: The downside was monotony—how a certain style of music would be totally driven into the ground before a change would come. Like the whole Eurodisco thing: no change, no growth.

RICHIE RIVERA: It did get a little repetitious. It became so "in" that everybody did it, or thought they could. I mean, Ethel Merman doing a disco album?

KATHY SLEDGE: There was less pressure then. People came out to dance and have a good time, but it was kind of a double-edged sword. Especially when the hustle came out, you could feel the cohesiveness on the dance floor, but it was also a lonely time. Like the place would be crowded with people, but a lot of them would be dancing alone.

JUDY WEINSTEIN: My best memory is standing in the middle of Paradise Garage in the early evening before the club filled up. Larry Levan was playing the O'Jays' "I Love Music" and I was totally straight and just about totally alone and dancing by myself and actually got lost in the music, traveled with the music and within the sound system—just me and the club.

DAVID MANCUSO: The night of the blackout, people stayed over all night. We had candles and played radios and people were sleeping over, camping out. It was very peaceful, a little Woodstockish. The party still went on.

GLORIA GAYNOR: Disco started out as a sound and unfortunately evolved into a lifestyle that Middle America found distasteful—and that was the demise of disco. It got into sex and drugs that really had nothing to do with the music but that was the lifestyle that identified with disco.

AUGUST DARNELL: The most decadent I got was dancing with two girls simultaneously, but the decadence of it was great to observe. In the bowels of Studio 54, there was a higher high. But I was like an observer more than a participant. I was like a journalist witnessing a national event.

DAVID MANCUSO: If people were using drugs, they were mild and recreational, where today it's all about economics. But three-quarters was purely spontaneous energy.

RAY CAVIANO: In hindsight, the experience was exhausting and the lifestyle was obviously way beyond the call of duty. We were going to have a good

time even if it was going to kill us. We wanted to take the trip as far as we could take it.

LOLEATTA HOLLOWAY: What killed disco? The people behind the desks. They do what they wanna do. They changed disco into dance and they changed dance into house. But when you listen to it, it's still all the same.

AUGUST DARNELL: I would imagine what happened is the same thing that will kill every innovative form: greed—people who don't have the heart and soul of the music but just want to cash in on it. They think they have the formula without realizing that disco was much more than that at the beginning.

JUDY WEINSTEIN: Disco killed disco. The word *disco* killed disco. Like pop will eat itself, disco ate itself. Anything that becomes too popular is apt to be destroyed by the same people who gave it the name.

AUGUST DARNELL: The music today—I call it disco part five.

BARRY WHITE: Disco was a sexy smooth era, very chic era. Now things are mechanical, more raw, closer to the streets. The attitude in America is distrust and disillusion. Now it's time to rip, take the money and run, sell the country, sell your mother.

AUGUST DARNELL: It was a good period to go through because it was exaggerated and there's nothing wrong with that as long as you find your balance eventually.

—*The Village Voice*, Summer 1993.

Twenty Years after Tonight
An Interview with KC

RANDOLPH HEARD

"Wasn't he the Vanilla Ice of the seventies?" asks a member of the alt.cul-ture.us.1970s Usenet newsgroup, in which discussions of *Schoolhouse Rock*, knee socks, and Irwin Allen disaster movies proliferate like so many seasons in the sun. A response quickly follows: "No, because people actually liked him."

People did like Harry Wayne Casey and his happy band out of Florida. The appeal of his jubilant, carefree music and his own slightly goofy, pix-ieish persona cut across racial and social boundaries. Despite the fact that he and his cosongwriter/coproducer/bassist Richard Finch were two white men working with a group of black musicians, he was not perceived as a poseur or a co-opter of black music. He took the rhythm-and-blues music he grew up with and added the spice of the Miami Sound, with its emphasis on percussion and horns, all of it drenched in the funk pio-neered by James Brown. And from August 1975 to September of 1977, KC & the Sunshine Band ruled the charts and the dance floors of America.

Flip open any reference guide to popular music and you'll find KC's accomplishments have their own indelible imprint. "Rock Your Baby," the song KC and Finch wrote for George McCrae, became an international number one hit and sold over 10 million copies. KC & the Sunshine Band were the second group in the seventies (after the Jackson Five) to have four number one singles, and the first since The Beatles to have three of them within a twelve-month period. Though someone associated with the sev-enties, KC also had the first number one single of the eighties, a ballad released in an attempt to move on from his disco image. And, according to the *Billboard Book of #1 Hits,* KC's "(Shake, Shake, Shake) Shake Your Booty" is the only song to hit number one that has the same word repeated four times in the title alone.

Fig. 13.1

In addition to constructing this spiderweb of pop statistics, in his cluster
of classic songs—"Get Down Tonight," "I'm Your Boogie Man," "That's the
Way (I Like It)," and "Shake Your Booty"—he laid out the thematic concerns
his disco children rarely strayed from: to party, dance, and have fun. ("Fun"
here could be interpreted as sex, drugs, sex & drugs, or, if like me you were
thirteen years old in 1975, could be just an exhilarating sense of ... fun.)
Disco producer Giorgio Morodor created the dominant cliche of disco as
soulless machine-made music, but KC's records always utilized the expres-
sive power of a full band and looked back to the rhythm-and-blues records

his mother used to collect. With little production experience, KC and Finch created tracks filled with a sparkling, expansive sound that can still shock a dancefloor today. Powered by a muscular horn section, the records were embellished with shimmering details like the Orientalized guitar in "Get Down Tonight" or the intro to "Boogie Man," which could be the groove to a contemporary African high-life pop song.

What most people retain of KC's career, outside of his most famous singles, is the image of a grinning, effervescent, youthful KC, a shaggy-haired white boy dressed in outrageous garb, rocking to his own funky beat. The unadulterated sense of joy he exuded seems alien today in an era of dance music that often favors a more confrontational edge. There's little sense of this joy when I arrive at his apartment in Durham, North Carolina, at about ten o'clock one Sunday morning in July 1995, almost twenty years after the U.S. release of "Get Down Tonight." For one thing, neither of us is very happy about being awake. KC has just rolled out of bed. We shake hands, both of us wearing grim morning faces. KC has been splitting his time between working on a new album at a studio in Florida and living in Durham, where, as his press release proudly notes, he is "following a rigorous health and fitness plan at the Duke University Diet and Fitness Center." The night before he had sung the national anthem at a Durham Bulls baseball game.

There is also no visual resemblance to the KC of the 1970s. The only tip-off is his gold ring formed in the shape of his initials. He's heavy set, his hair is closely cropped, and he is visibly balding (see fig. 13.1). In concert these days he often favors a baseball cap and a colorful variant on the safari suit. He's friendly but obviously tired and responds to my questions in a gruff voice, between sips of coffee, at times struggling to recall names or what it felt like at various points in his career. During our conversation, he oftens responds to questions of a more personal nature with "I'm saving that for my book."

Recently, I watched the video Rhino put out of your 1974 concert in Miami from your first U.S. tour. What you were doing then live was really raw, earthy music. Whereas now the first impression people have of disco is that it was very studio-produced.

That came later. The whole thing was R&B and they started calling it disco. That's why I got really pissed. I felt like it was a slap in the face for black music.

So you wouldn't want to use that term for your music? Does it mean anything?

Well, we created a whole new sound and it got called "disco." It was dance music but it was really rhythm-and-blues. A discotheque was the place you went to dance. So I guess because the music was played in a discotheque

they called it disco music. And did that mean that all the music on the radio should have been called radio music? I've never liked categories.

And a lot of people who came out in disco had a sound that was different from yours.

Yeah, well, theirs was more programmed. That came out like four or five years later.

It started for you there first in Europe before you made it in the States. "Queen of Clubs" was a big hit for you there. Why was that?

Everything was huger in Europe. They already had a lot of what I guess you would call discotheques. They'd play anything that was uptempo from dance to rhythm-and-blues. They loved the Miami Sound because they liked to change their music so often.

How would you describe the Miami Sound?

I don't know [shrugs and laughs]. Our sound was just bright and happy. Like sunshine is bright and happy.

There're a lot of different musical influences in your sound. I know that growing up you listened to all kinds of music.

Everything. My family was musically inclined. A lot of my relatives had gospel records out and my mother did commercials and things with her sisters. I was around a musical family. It was just natural.

You started off playing piano?

When I was about seven. I had my first band when I was fourteen. It was called Five Doors Down. There were five of us. And like one was taller and then it went down like this [gestures to indicate decreasing height].

And you played keyboards?

I just sang. We did all covers, like of The Rascals. We played live, made sixteen bucks a day. We ended up with like three bucks each. We played local parks and stuff. The parks used to have bands play there on Fridays or Saturdays. We did that for about two years. Then I just went into a whole different direction. I didn't want to have a group.

What was the different direction?

Just not in a group, not like most people are in group after group. I guess probably cause I went to one group and they said I didn't have enough soul.

That's funny.

Yeah, they kinda regretted that one too.

You ended up working for a retail record store at one point.

I loved music so I wanted to be around it so I went into retail. I wanted to learn everything. Then I went to wholesale. And after work I'd just go hang out around the TK studios until everybody left.

Did you used to go out to a lot of clubs to hear music or did you just get it from records?

I just bought every record that came out.

Was there live music you could go see?

I wasn't interested in that.

Why?

Cause it stunk. That's why discos happened. Because the local band was so bad—people would hire them, I guess—but very rarely do you get a great group. I think people just got tired of going out and spending their money on a band in a bar and seeing this awful, bad group with all cover versions. Or trying to play some new things you never heard of. That doesn't even go when you're huge; you don't play something people never heard of before. You do sometimes, but you can't overload it because they just don't like that.

What about funk music in the seventies, were you pretty much into that?

We were that funk music! [laughs] We were that funk music.

Did you ever listen to Funkadelic?

Oh yeah. All the time. Before anybody even knew about them. That first one, *Free Your Mind and Your Ass Will Follow*, is pretty cool. That's when I was working in the record store.

So you were pretty hip to what was going on.

Oh yeah. Cutting edge. I remember when that album came out I used to play it in the record store all the time and I used to sell fifty or sixty a week. It was underground. That was a big figure.

Who were you selling it to?

Well, Miami's always been a city known to go for some of the off-the-wall stuff. Before any city Miami would be having all of the newest stuff in music. I think that's in part because their playlists were a little bit more open than most national playlists. Probably more than L.A. even. L.A. got everything twelve weeks after it came out.

When you started hanging around the TK studios, were you thinking of being more of a performer at this point or getting into production?

It didn't matter where I was gonna be. When I got to TK, I managed Timmy Thomas who had "Why Can't We Live Together" out during that time, and I comanaged Betty Wright. I did a little bit of everything. I always thought to be an entertainer would be cool, a writer, whatever. I didn't know where I was gonna land. I just got into whatever I did in the entertainment business and I did my best at it and I guess I did better at making records than anything else.

How did you get into making records there?

The place would close and I would hang out in the studio.

What kind of setup did they have there?

The whole studio was upstairs in one room about as big as this living room. It was eight track. They were putting out rhythm-and-blues stuff—a bunch of people the masses probably wouldn't have heard of.

You hooked up with Richard Finch at the studio?

Yeah, that's where I met him. He was doing engineering, I think, for them.

So how did you start recording groups? They needed somebody at a certain point and you stepped in?

No, everybody had a chance there. You couldn't just walk right in, but once you were there a while. It was a little company and they wanted records out and it was like this small family that always cut records there. I just became part of the family. I was always writing when I was a little kid, so I just started helping, cowriting songs. I'd do background sessions, played on some songs. And then I wanted to do it myself. The only way you could get it done yourself was to do it yourself.

So you'd stay late at night in the studio . . .

. . . to prepare a demo.

On those demo sessions, you had Rick with you and who else?

In fact on those first records, Rick didn't even play on them. We used whoever was in the studio. They'd come in and out of there like flies. I just did a song and it happened.

Was this "Blow Your Whistle"?

"Blow Your Whistle" and "Sound Your Funky Horn."

"Blow Your Whistle" was influenced by junkanoo music, wasn't it?

Yeah. We were originally called KC & the Sunshine Junkanoo Band. In the Caribbean, junkanoo is just music with steel drums and a lot of percussion. I don't think it has guitars or anything in it.

So you incorporated that because it had a cool sound and it became a hit?

And I said to the guys, "Hey, we just had two of the Top 50 R&B records—why don't we become a group?"

Did the intense success surprise you at all? What did you feel when that was first happening?

Well, you know when they say there's an American Dream that's come true or whatever, well, that's what it was. When they speak about reaching your dreams of the American dream, it's true.

Did it all go really fast when the records started hitting?

I don't even remember it. While one thing was happening, we were doing something else. I think I was always on to the next thing because by the time the record came out, you know, it was already off my playlist. I was always on to doing the next record or caught up in the touring part of it.

And you toured all over, stadium size, everything.

Everything that was built, we played it.

At this time you guys were sort of pioneering the whole disco movement . . .

I can remember when they first wanted me to do a dance record in a long version, seven minutes. I said, "Please, this is ridiculous." I remember thinking, a song is three minutes . . . what more can you do? When we grew up, a record was a minute and fifty seconds. I just couldn't imagine having a record longer. I mean "MacArthur Park" was 7 minutes, 29 seconds. That was like forever.

You think the Bee Gees were influenced by some of the stuff you did?

I'm sure that we were the influence for the Bee Gees. All that . . . *Saturday Night Fever* . . . everything that came out after '74, definitely we had influenced.

Your sound never ended up going in the direction of Giorgio Morodor or anything like that.

No, because I wasn't going to follow. That's why when he went that way, I went into doing a ballad to show there was more depth to KC & the Sunshine Band than "That's the Way (I Like It)."

What did you think of some of the other groups that came out?

I liked everybody.

Some of them, like the Village People, depended more on novelty and seemed like they were part of a machine, where a producer would be brought in to form a sound for them and maybe even a concept. Whereas you were doing your own music.

There was a difference with my group. We were our whole machine. We weren't a part of the Casablanca empire. The group you saw on stage was the group that produced and wrote the songs.

On stage you used to wear some pretty outrageous costumes. In the Rhino video you have this V-neck thing on that goes down below your belly button.

I think those V-neck things were just some creation of the costume to show more skin or something. I don't know. It wasn't something I requested.

It wasn't?

No [laughs].

I'd have to have a few beers to walk out on stage in one of those things.

Well, I didn't like it, that one outfit I wore in the Rhino thing with the cape on it. Jesus! But I didn't see it until the night I performed.

So who was making this stuff?

Somebody in L.A. A very famous designer, Harvey Krantz. Once we placed the order, it would come in and it'd be, well, that's what he sent, so that's what you wore.

Looking at those outfits, it seems so extreme. At the time I'm sure it didn't seem that way.

It was extreme at the time, I remember.

In that one particular video the women all have these . . .

Oh, well that was their own creation too. They were called Fire and they thought they were going to put these things that looked like flames on them or whatever and they only wore them for a few minutes and then they came right off.

So that wasn't something you were doing in the beginning—as you became bigger you needed costumes.

Oh no, no. From the beginning we had costumes. I remember the first time everybody went down to Walgreens or something and I said, "Everybody get bright sparkles to put on your clothes."

The whole concert was like one big party. What about the whole feeling of partying during that time? Things were a lot more open regarding sexuality, drugs. . . .

Well, that was a time when you had nothing to worry about. Of course you should've but they didn't know it. It was the way the life was meant to be. You could enjoy the way you felt.

Maybe that's part of why there's such a revival of interest in the pop culture of the time.

I think a lot of people are realizing the seventies was a cool time and that's why so many people are so heavily into it. And it's all over the world. It's just amazing. It's like it's never gone away. It's bigger than it was in the seventies. There's a whole new generation out there that knows every lyric. It's weird.

Your own part in it was unique. A white guy with a largely black band who had an appeal that went across the board. That's something that hasn't really happened in, say, rap music.

I just did what came natural to me. I guess when you get into rap music, you start . . . I don't know, I don't like to get into color, so I won't get on that. I just did what was natural to me and I didn't listen to anybody who told me that just cause I was white I didn't make it.

Like that one band who told you you didn't have enough soul in your voice. Did you have problems like that in general?

Well, Steve Alaimo used to tell me that all the time.

He was from TK?

Yeah, and he was also on a TV show called *Where The Action Is*. He used to say, "You're white and you'll never make it." I didn't try to appeal to any color, maybe that's the difference. I just tried to appeal to the masses and to bring them happy music. I was just not trying to appeal to any particular race, creed, or whatever.

I don't think it could be done today in the same way.

Today it's easier because we opened the doors for it. I think it opened the door for black artists to be accepted more with the white audiences.

Do you ever listen to any hip hop?

It's nothing. Senseless. I like music, I don't like [makes whoawhoawhoa noise].

. . . the rapping?

When it's not saying anything, it's senseless. Some of it's okay.

Have you been sampled?

If I do, I get paid for it. I've been sampled to death. After James Brown, I'm the most sampled man in music.

Can you name some records?

Stereo MCs. Vanilla Ice. I can't even think of all the groups. I've got a stack of CDs about that high.

Are they going for the horns, the vocal?

The horns, the tracks are in a lot of stuff. "Boogie Shoes" is in a lot of things. I don't mind as long as I get paid.

You ever hear other groups you think have been influenced by your sound?

Yeah, a lot of 'em. Steve Miller told me I was the influence for his dance records. What was that group ... "She Drives Me Crazy"? The Fine Young Cannibals. At first I thought it was the Bee Gees. Then everybody was saying, "KC, you have a new record out." You hear our sound all over everybody's records. That's what made me actually get back into it. I had retired and wasn't going to do it anymore. In the last four or five years everybody was saying, "Everybody sounds like KC & the Sunshine Band on the radio. *You* should be the one out there."

What's your latest album Yummy *like?*

I don't know. It's KC & the Sunshine Band '90s, I guess. Who the hell knows? [laughs]

Is there anybody in the current Sunshine Band from the original lineup?

Just the percussionist and one of the singers.

What's happened to the rest of the guys?

Robert Johnson's dead. Jerome either he's ... somewhere. I don't really know where everybody is.

And Rick Finch, is he ...

Somewhere.

So you haven't really kept in contact with them.

No. You see people every now and then. That's about it. It's better that way.

Do you still enjoy making music or does it feel like a job?

Same way. I love it and hate it. It's what I love to do so that's what I want to do.

Do you still look forward to getting up on stage?

That's my favorite part. That's where I'm the happiest. Getting there is a pain in the ass, but once you're there, it's cool.

Self Portrait No. 25

GREIL MARCUS

CHORUS: Charles Perry, Jenny Marcus, Jann Wenner, Erik Bernstein, Ed Ward, John Burks, Ralph Gleason, Langdon Winner, Bruce Miroff, Richard Vaughn, and Mike Goodwin

What is this shit?

(1) "All The Tired Horses" is a gorgeous piece of music, perhaps the most memorable song on this album. In an older form it was "All The Pretty Ponies In The Yard"; now it could serve as the theme song to any classic Western. Shane *comes into view, and* The Magnificent Seven: *gunmen over the hill and out of time still got to ride. It sounds like Barbara Stanwyck in* Forty Guns *singing, as a matter of fact. Dylan is not singing.*

The beauty of this painted signpost promises what its words belie, and the song's question— "How'm I gonna get any ridin' done?"—becomes the listener's: you can't ride when the horse is asleep in the meadow.

(2)

"I don't know if I should keep playing this," said the disc jockey, as the album made its debut on the radio. "Nobody's calling in and saying they want to hear it or anything ... usually when something like this happens people say 'Hey, the new Dylan album,' but not tonight."

Later someone called and asked for a reprise of "Blue Moon." In the end it all came down to a telephone poll to determine whether radioland really cared. The DJ kept apologizing: "If there is anyone who needs ... or deserves to have his whole album played through it's Bob Dylan."

(2) After a false beginning comes "Alberta #1," an old song now claimed by Dylan. One line stands out: "I'll give you more gold than your apron can hold." We're still at the frontier. The harmonica lets you into the album by way of its nostalgia, and it's the song's promise that matters, not the song itself, which fades.

(3)

"What was it?" said a friend, after we'd heard thirty minutes of *Self Portrait* for the first time. "Were we really that impressionable back in '65, '66? Was it that the stuff really wasn't that good, that this is just as good? Was it some sort of accident in time that made those other records so powerful, or what?

"My life was really turned around, it affected me—I don't know if it was the records or the words or the sound or the noise—maybe the interview: 'What is there to believe in?' I doubt if he'd say that now, though."

We put on "Like A Rolling Stone" from *Highway 61 Revisited* and sat through it. "I was listening to that song five, ten times a day for the last few months, hustling my ass, getting my act together to get into school ... but it's such a drag to hear what he's done with it ..."

(3) Something like a mood collapses with the first Nashville offering, "I Forgot More Than You'll Ever Know," a slick exercise in vocal control that fills a bit of time. After getting closer and closer to the Country Music Capital of the World—and still keeping his distance with Nashville Skyline, *one of the loveliest rock and roll albums ever made—the visitor returns to pay his compliments by recording some of its songs. How does it sound? It sounds alright. He's sung himself into a corner. It sounds alright. Sign up the band*

(4)

GM: "It's such an unambitious album."
JW: "Maybe what we need most of all right now is an unambitious album from Dylan."
GM: "What we need most of all is for Dylan to get ambitious."
JW: "It's such a ..."
GM: "... though it is a really ..."
GM & JW: "... *friendly* album ..."

(4) "Days Of '49" is a fine old ballad. Dylan's beginning is utterly convincing, as he slips past the years of the song (listen to the vaguely bitter way he sings "But what cares I for praise?"). He fumbles as the song moves on, and the cut collapses, despite the deep burr of the horns and the drama generated by the piano. It's a tentative performance, a warm-up, hardly more than a work tape. The depths of the history the song creates—out of the pathos Johnny Cash gave "Hardin Wouldn't Run" (sounding like it was recorded in the shadows of an Arizona canyon) or "Sweet Betsy from Pike"—has been missed. The song is worth more effort than it got.

(5)

"It's hard," he said. "It's hard for Dylan to do anything real, shut off the way he is, not interested in the world, maybe no reason why he should be. Maybe the weight of the days is too strong, maybe withdrawal is a choice we'd make if we could...." One's reminded that art doesn't come—perhaps that it can't be heard—in times of crisis and destruction; art comes in the period of decadence that precedes a revolution, or after the deluge. It's prelude to revolution; it's not contemporary with it save in terms of memory.

But in the midst of it all artists sometimes move in to re-create history. That takes ambition.

(5) When you consider how imaginative the backing on other Dylan records has been, the extremely routine quality of most of the music on Self Portrait *can become irritating. It is so uninteresting. "Early Mornin' Rain" is one of the most lifeless performances of the entire album: a rather mawkish song, a stiff well-formed-vowel vocal, and a vapid instrumental track that has all the flair of canned laughter.*

(6)

The four questions: The four sons gazed at the painting on the museum wall. "It's a painting," said the first son. "It's art," said the second son. "It's a frame," said the third son, and he said it rather coyly. The fourth son was usually considered somewhat stupid, but he at least figured out why they'd come all the way from home to look at the thing in the first place. "It's a signature," he said.

(6) "In Search Of Little Sadie" is an old number called "Badman's Blunder" (or sometimes "Badman's Ballad" and sometimes "Little Sadie") that Dylan now claims as his own composition. As with "Days Of '49," the song is superb—it's these kinds of songs that seem like the vague source of the music the Band makes—and what Dylan is doing with the tune, leading it on a switchback trail, has all sorts of possibilities. But again, the vocal hasn't been given time to develop and the song loses whatever power it might have had to offer, until the final chorus, when Bob takes off and does some real singing.

This bit about getting it all down in one or two takes only works if you get it all down. Otherwise it's at best "charming" and at worst boring, alluding to a song without really making music.

(7)

Imagine a kid in his teens responding to *Self Portrait.* His older brothers and sisters have been living by Dylan for years. They come home with the album and he simply cannot figure out what it's all about. To him, *Self Portrait* sounds more like the stuff his parents listen to than what he wants to hear; in fact, his parents have just gone out and bought *Self Portrait* and given it to him for his birthday. He considers giving it back for Father's Day.

To this kid Dylan is a figure of myth; nothing less, but nothing more. Dylan is not real and the album carries no reality. He's never seen Bob Dylan; he doesn't expect to; he can't figure out why he wants to.

(7) The Everly Brothers' version of "Let it Be Me" is enough to make you cry, and Bob Dylan's version is just about enough to make you listen. For all of the emotion usually found in his singing, there is virtually none here. It is a very formal performance.

(8)

"Bob should go whole-hog and revive the Bing Crosby Look, with its emphasis on five-button, soft-shoulder, wide-collar, plaid country-club lounge jackets (Pendleton probably still makes them). And, like Der Bingle, it might do well for Dylan to work a long-stemmed briar pipe into his act, stopping every so often to light up, puff at it, raise some smoke and gaze, momentarily, toward the horizon, before launching into [this is John Burks in *Rags*, June 1970] the next phrase of 'Peggy Day'. Then, for his finale—the big 'Blue Moon' production number with the girls and the spotlights on the mountains—he does a quick costume change into one of those high-collar 1920s formal shirts with the diamond-shaped bow tie, plus, of course, full length tails and the trousers with the satin stripe down the side, carnation in the buttonhole, like Dick Powell in *Golddiggers of 1933*. Here comes Dylan in his tails, his briar in one hand, his megaphone in the other, strolling down the runway, smiling that toothpaste smile. "Like a *roll*-ing stone. . . .""

(8) "Little Sadie" is an alternate take of "In Search Of ..." I bet we're going to hear a lot of alternate takes in the coming year, especially from bands short on material who want to maintain their commercial presence without working too hard. Ordinarily, when there are no striking musical questions at stake in the clash of various attempts at a song, alternate takes have been used as a graveyard rip-off to squeeze more bread out of the art of dead men or simply to fill up a side. "Little Sadie" fills up the side nicely.

(9)

"It's a high school yearbook. Color pictures this year, because there was a surplus left over from last year, more pages than usual too, a sentimental journey, 'what we did,' it's not all that interesting, it's a memento of something, there's a place for autographs, lots of white space, nobody's name was left out . . . It is June, after all."

(9) On "Woogie Boogie" the band sounds like it's falling all over itself (or maybe slipping on its overdubs) but they hold on to the beat. With no vocal, there's as much of Dylan's feel for music here as on anything else on Self Portrait. *If you were a producer combing through a bunch of* Self Portrait *tapes for something to release, you might choose "Woogie Boogie" as a single— backing "All The Tired Horses," of course.*

(10)

Self Portrait most closely resembles the Dylan album that preceded it: the *Great White Wonder* bootleg. The album is a two-record set masterfully assembled from an odd collection of mostly indifferent recordings made over the course of the last year, complete with alternate takes, chopped endings, loose beginnings, side comments, and all sorts of mistakes. Straight from the can to you, as it were. A bit from Nashville, a taste of the Isle of Wight since you missed it, some sessions from New York that mostly don't make it, but it's *Dylan,* and if you wanted *Great White Wonder* and *Stealin'* and *John Birch* and *Isle of Wight* and *A Thousand Miles Behind, Self Portrait* will surely fill the need.

I don't think it will. It's true that all of the bootlegs (and the *Masked Marauders*, which was a fantasy bootleg) came out in the absence of new music from Dylan, but I think their release was related not to the absence of recordings but to the absence of the man himself. We are dealing with myth, after all, and the more Dylan stays away the greater the weight attached to anything he's done. When King Midas reached out his hand everything he touched not only turned to gold, it became valuable to everyone else, and Dylan still has the Midas touch even though he'd rather not reach out. It is only in the last two years that the collecting of old tapes by Dylan has really become a general phenomenon, and there are many times more tapes in circulation than are represented on the bootlegs. There is a session with the Band from December of 1965, live albums, ancient recordings, tapes of Dylan at the Guthrie Memorial, with the Band last summer in Missouri, radio shows from the early sixties. It sometimes seems as if every public act Dylan ever committed was recorded, and it is all coming together. Eventually, the bootleggers will get their hands on it. Legally, there is virtually nothing he can do to stop it.

He can head off the theft and sale of his first drafts, his secrets, and his memories only with his music. And it is the vitality of the music that is being bootlegged that is the basis of its appeal. The noise of it. *Self Portrait*, though it's a good imitation bootleg, isn't nearly the music that *Great White Wonder* is. "Copper Kettle" is a masterpiece but "Killing Me Alive" will blow it down. *Nashville Skyline* and *John Wesley Harding* are classic albums, but no matter how good they are they lack the power of the music Dylan made in the middle sixties. Unless he returns to the marketplace, with a sense of vocation and the ambition to keep up with his own gifts, the music of those years will continue to dominate his records, whether he releases them or not. If the music Dylan makes doesn't have the power to enter into the lives of his audience— and *Self Portrait* does not have that power—his audience will take over his past.

(10) *Did Dylan write "Belle Isle"? Maybe he did. This is the first time I've ever felt cynical listening to a new Dylan record.*

(11)

In the record industry, music is referred to as "product." "We got Beatle product." When the whirlwind courtship of Johnny Winter and Columbia was finally consummated everyone wanted to know when they would get product. They got product fast but it took them a while longer to get music. Such is showbiz, viz. *Self Portrait*, which is already a triple gold record, the way "O Captain! My Captain!" is more famous than "When Lilacs Last In The Dooryard Bloom'd," is the closest thing to pure product in Dylan's career, even more so than *Greatest Hits*, because that had no pretensions. The purpose of *Self Portrait* is mainly product and the need it fills is for product—for "a Dylan album"—and make no mistake about it, the need for product is felt as deeply by those who buy it, myself included, of course, as by those who sell it, and perhaps more so.

As a throw-together album it resembles the Rolling Stones' *Flowers*; but it's totally unlike *Flowers* in that the album promises to be more than it is, rather than less. By its title alone *Self Portrait* makes claims for itself as the definitive Dylan album—which it may be, in a sad way—but it is still something like an attempt to delude the public into thinking they are getting more than they are, or that *Self Portrait* is more than it is.

(11) "Living The Blues" is a marvelous recording. All sorts of flashes of all sorts of enthusiasms spin around it: The Dovells cheering for the Bristol Stomp, Dylan shadow-boxing with Cassius Clay, Elvis smiling and sneering in Jailhouse Rock *("Baby you're so square, I don't care!"). The singing is great—listen to the way Bob fades off "deep down insyyy-hide," stepping back and slipping in that last syllable. For the first time on this album Dylan sounds excited about the music he's making. The rhythm section, led by the guitar and the piano that's rolling over the most delightful rock and roll changes, is wonderful. The girls go through their routine and they sound—cute. Dylan shines. Give it 100.*

(12)

"... various times he thought of completing his baccalaureate so that he could teach in the college and oddly enough [this is from *A Rimbaud Chronology*, New Directions Press] of learning to play the piano. At last he went to Holland, where, in order to reach the Orient, he enlisted in the Dutch Army and sailed for Java in June of 1876. Three weeks after his arrival in Batavia [Charles Perry: 'We know Dylan was the Rimbaud of his generation; it seems he's found his Abyssinia'] he deserted, wandered among the natives of the jungle and soon signed on a British ship for Liverpool. After a winter at home he went to Hamburg, joined in a circus as interpreter-manager to tour the northern countries, but the cold was too much for him and he was repatriated from Sweden, only to leave home again, this time for Alexandria. Again, illness interrupted his travels and he was put off the ship in Italy and spent

a year recovering on the farm at Roche. In 1878 he was in Hamburg again, trying to reach Genoa to take a ship for the East. Once more he tried to cross the Alps on foot [Charles Perry: 'We know Dylan was the Rimbaud of his generation; it seems he's found his Abyssinia'l but in a snowstorm he almost perished. Saved by monks in a Hospice, he managed to reach Genoa and sail to Alexandria where he worked as a farm labourer for a while. In Suez, where he was stopped on his way to Cyprus, he was employed as a ship-breaker to plunder a ship wrecked on the dangerous coast at Guarda-fui. Most of the first half of 1879 he worked as foreman in a desert quarry on Cyprus, and went home in June to recuperate from typhoid fever."

(12) "Like A Rolling Stone"—Dylan's greatest song. He knows it, and so do we. Not only that, but the greatest song of our era, on that single, on Highway 61 Revisited, *on the tape of a British performance with the Hawks in 1966. If one version is better than the other it's like Robin Hood splitting his father's arrow.*

1965: "Alright. We've done it. Dig it. If you can. If you can take it. Like a complete unknown, *can you feel that?"*

We could, and Bob Dylan took over. All that's come since goes back to the bid for power that was "Like A Rolling Stone."

"Can you keep up with this train?" The train no longer runs; I suppose it depends on where your feet are planted.

Dylan from the Isle of Wight is in your living room and Dylan is blowing his lines, singing country flat, up and down, getting through the song somehow, almost losing the whole mess at the end of the second verse. You don't know whether he dropped the third verse because he didn't want to sing it or because he forgot it. It's enough to make your speakers wilt.

Self Portrait *enforces or suggests a quiet sound. "Like A Rolling Stone" isn't "Blue Moon" but since most of* Self Portrait *is more like "Blue Moon" than "Like A Rolling Stone," and since it is a playable album that blends together, you set the volume low. But if you play this song loud—really loud, until it distorts and rumbles—you'll find the Band is still playing as hard as they can, for real. Their strength is cut in half by the man who recorded it, but volume will bring it back up.*

Some of "Like A Rolling Stone" is still there. A splendid beginning, announcing a conquest; Levon Helm beating his drums over the Band's Motown March (ba-bump barrummmp, ba-bump barrummmp), smashing his cymbals like the glass-breaking finale of a car crash; and best of all, Garth Hudson finding the spirit of the song and holding it firm on every chorus. Near the end when the pallid vocalizing is done with, Dylan moves back to the song and he and the Band begin to stir up a frenzy that ends with a crash of metal and Bob's shout: "JUST LIKE A ROLLING STONE!" There is something left.

1965: "BAM! Once upon a time ..." The song assaults you with a deluge of experience and the song opens up the abyss. "And just how far would you like to go in?" "Not too far but just far enough so we can say we've been there." That wasn't good enough. "When you gaze into the abyss, the abyss also looks back at you." It peered out through "Wheel's On Fire" and "All Along The Watchtower," but it seems Dylan has stepped back from its edge.

The abyss is hidden away now, like the lost mine of a dead prospector. "Like A Rolling Stone," as we hear it now, is like a fragment of a faded map leading back to that lost mine.

(13)

I once said I'd buy an album of Dylan breathing heavily. I still would. But not an album of Dylan breathing softly.

(13) Why does "Copper Kettle" shine (it even sounds like a hit record) when so many other cuts hide in their own dullness? Why does this performance evoke all kinds of experience when most of Self Portrait is so one-dimensional and restrictive? Why does "Copper Kettle" grow on you while the other songs disappear?

Like "All The Tired Horses," it's gorgeous. There are those tiny high notes punctuating the song in the mood of an old Buddy Holly ballad or "The Three Bells" by the Browns, and that slipstream organ, so faint you can barely hear it—you don't hear it, really, but you are aware of it in the subtlest way. There is the power and the real depth of the song itself, which erases our Tennessee truck-stop postcard image of moonshining and moves in with a vision of nature, an ideal of repose, and a sense of rebellion that goes back to the founding of the country. "We ain't paid no whiskey tax since 1792," Bob sings, and that goes all the way back—they passed the whiskey tax in 1791. It's a song about revolt as a vocation, not revolution, merely refusal. Old men hiding out in mountain valleys, keeping their own peace.

[The old moonshiners are sitting around a stove in Thunder Road *trying to come up with an answer to the mobsters that are muscling in on the valley they've held since the Revolution. "Blat sprat muglmmph ruurrrp fffft," says one. The audience stirs, realizing they can't understand his Appalachian dialect. "If you'd take that tobacco plug out of your mouth, Jed," says another whiskey man, "maybe we could understand what you said."]*

What matters most is Bob's singing. He's been the most amazing singer of the last ten years, creating his language of stress, fitting five words into a line of ten and ten into a line of five, shoving the words around and opening up spaces for noise and silence that through assault or seduction or the gift of good timing made room for expression and emotion. Every vocal was a surprise. You couldn't predict what it would sound like. The song itself, the structure of the song, was barely a clue. The limits were there to be evaded. On "Copper Kettle" that all happens, and it is noticeable because this is the only time on Self Portrait *that it happens.*

"Not all great poets—like Wallace Stevens—are great singers," Dylan said a year ago. "But a great singer—like Billie Holiday—is always a great poet." That sort of poetry—and it's that sort of poetry that made Dylan seem like a "poet"—is all there on "Copper Kettle," in the way Bob charges into the lines "... or ROTTEN wood ..." fading into "(they'll get you) by the smo-oke ..." The fact that the rest of the album lacks the grace of "Copper Kettle" isn't a matter of the album being "different" or "new." It is a matter of the music having power, or not having it.

(14, 15, 16)

"... very highly successful in terms of money. Dylan's concerts in the past have been booked by his own firm, Ashes and Sand, rather than by [this is

from *Rolling Stone*, December 1968] private promoters. Promoters are now talking about a ten-city tour with the possibility of adding more dates, according to *Variety*.

"Greta Garbo may also come out of retirement to do a series of personal appearances. The Swedish film star who wanted only 'to be alone' after continued press invasions of her life is rumoured to be considering a series of lavish stage shows, possibly with Dylan . . ."

And we'd just sit there and *stare*.

(*14*) *"Gotta Travel On." Dylan sings "Gotta Travel On."*

(*15*) *We take "Blue Moon" as a joke, a stylized apotheosis of corn, or as further musical evidence of Dylan's retreat from the pop scene. But back on Elvis's first album, there is another version of "Blue Moon," a deep and moving performance that opens up the possibilities of the song and reveals the failure of Dylan's recording.*

Hoofbeats, vaguely aided by a string bass and guitar, form the background to a vocal that blows a cemetery wind across the lines of the song. Elvis moves back and forth with a high phantom wail, singing that part that fiddler Doug Kershaw plays on Dylan's version, finally answering himself with a dark murmur that fades into silence. "It's a revelation," said a friend. "I can't believe it."

There is nothing banal about "Blue Moon." In formal musical terms, Dylan's performance is virtually a cover of Elvis's recording, but while one man sings toward the song, the other sings from behind it, from the other side.

(*16*) *"The Boxer": remember Paul Simon's "How I Was Robert MacNamared Into Submission," or whatever it was called, with that friendly line, "I forgot my harmonica, Albert"? Or Eric Anderson's "The Hustler"? Maybe this number means "no hard feelings." Jesus, is it awful.*

(17)

Before going into the studio to set up the Weathermen, he wrote the Yippies' first position paper, although it took Abbie Hoffman a few years to find it and Jerry Rubin had trouble reading it. A quote:

> *I'm gonna grow my hair down to my feet so strange till I look like a walking mountain range then I'm gonna ride into Omaha on a horse out to the country club and the golf course carrying a* New York Times *shoot a few holes blow their minds.*

"Dylan's coming," said Lang.

"Ah you're full of shit [said Abbie Hoffman in *Woodstock Nation*] he's gonna be in England tonight, don't pull that shit on me."

"Nah I ain't kiddin, Abby-baby, he called up and said he might come . . ."

"You think he'd dig running for president?"

"Nah, that ain't his trip he's into something else."

"You met him, Mike? What's he into?"

"I don't know for sure but it ain't exactly politics. You ever met him?"

"Yeah, once about seven years ago in Gertie's Folk City down in the West Village. I was trying to get him to do a benefit for civil rights or something . . . hey Mike will you introduce us? I sure would like to meet Dylan . . . I only know about meetin' him through Happy Traum . . ."

"There's an easier way . . . Abbs . . . I'll introduce you. In fact he wants to meet you . . ."

Would *Self Portrait* make you want to meet Dylan? No? Perhaps it's there to keep you away?

(17) "The Mighty Quinn" sounds as if it was fun to watch. It's pretty much of a mess on record, and the sound isn't all that much better than the bootleg. The Isle of Wight concert was origi-nally planned as an album, and it's obvious why it wasn't released as such—on tape, it sound-ed bad. The performances were mostly clumsy or languid and all together would have made a lousy record. Two of the songs had something special about them, on the evidence of the bootleg, though neither of them made it to Self Portrait. *One was "Highway 61 Revisited," where Bob and the Band screamed like Mexican tour guides hustling customers for a run down the road: "OUT ON HIGHWAY SIXTY-ONE!" The other was "It Ain't Me, Babe." Dylan sang solo, playing guitar like a lyric poet, transforming the song with a new identity, sweeping in and out of the phrases and the traces of memory. He sounded something like Billie Holiday.*

<div align="center">(18)</div>

It's certainly a rather odd "self portrait": other people's songs and the songs of a few years ago. If the title is serious, Dylan no longer cares much about making music and would just as soon define himself on someone else's terms. There is a curious move toward self-effacement: Dylan removing himself from a position from which he is asked to exercise power in the arena. It's rather like the Duke of Windsor abdicating the throne. After it's over he merely goes away, and occasionally there'll be a picture of him get-ting on a plane somewhere.

(18) "Take Me As I Am Or Let Me Go." The Nashville recordings of Self Portrait, *taken together, may not be all that staggering but they are pleasant—a sentimental little country melo-drama. If the album had been cut to "Tired Horses" at the start and "Wigwam" at the end, with the Nashville tracks sleeping in between, we'd have a good record about which no one would have gotten very excited one way or the other, a kind of musical disappearing act. But the Artist must make a Statement, be he Bob Dylan, the Beach Boys, or Tommy James and the Shondells. He must enter the studio and come out with that masterpiece. If he doesn't, or hasn't bothered, there'll be at least an attempt to make it look as if he had. If Dylan was releasing more music than he's been—a single three times a year, an album every six months or so—then the weight that fixes itself on whatever he does release would be lessened. But the pattern is set now, for the biggest stars—one a year, if that. It's rather degrading for an artist to put out more than one album a year, as if he has to keep trying, you know? Well, three cheers for John Fogerty.*

(19)

Because of what happened in the middle sixties, our fate is bound up with Dylan's whether he or we like it or not. Because *Highway 61 Revisited* changed the world, the albums that follow it must—but not in the same way, of course.

(19) "Take A Message To Mary": the backing band didn't seem to care much about the song, but Dylan did. My ten-year-old nephew thought "It Hurts Me Too" sounded fake but he was sure this was for real.

(20)

RALPH GLEASON: "There was this cat Max Kaminsky talks about in his auto-biography who stole records. He stole one from Max. He *had* to have them, you know? Just had to have them. Once he got busted because he heard this record on a juke box and shoved his fist through the glass of the box trying to get the record out.

'We all have records we'd steal for, that we need that bad. But would you steal this record? You wouldn't steal this record."

You wouldn't steal *Self Portrait?* It wouldn't steal you either. Perhaps that's the real tragedy, because Dylan's last two albums were art breaking and entering into the house of the mind.

(20) Songwriting can hardly be much older than song-stealing. It's part of the tradition. It may even be more honorable than outright imitation; at least it's not as dull.

Early in his career, Bob Dylan, like every other musician on the street with a chance to get off it, copped one or two old blues or folk songs, changed a word or two, and copyrighted them (weirdest of all was claiming "That's Alright Mama," which was Elvis's first record, and writ-ten—or at least written down—by Arthur Crudup). As he developed his own genius, Dylan also used older ballads for the skeletons of his own songs: "Bob Dylan's Dream" is a recasting of "Lord Franklin's Dream"; "I Dreamed I Saw St. Augustine" finds its way back to "I Dreamed I Saw Joe Hill"; "Pledging My Time" has the structure, the spirit, and a line from Robert Johnson's "Come On In My Kitchen"; "Don't the moon look lonesome, shining through the trees," is a quote from an old Jimmy Rushing blues; "Subterranean Homesick Blues" comes off of Chuck Berry's "Too Much Monkey Business." This is a lovely way to write, and to invite, history, and it is part of the beauty and the inevitability of American music. But while Dylan may have added a few words to "It Hurts Me Too," from where he sits, it's simply wrong to claim this old blues, recorded by Elmore James among others, as his own. That Self Portrait *is char-acterized by borrowing, lifting, and plagiarism simply means Bob will get a little more bread and thousands of people will get a phony view of their own history.*

(21, 22)

That splendid frenzy, the strength of new values in the midst of some sort of musical behemoth of destruction, the noise, the power—the *totality* of it! So you said well, alright, there it is . . .

The mythical immediacy of everything Dylan does and the relevance of that force to the way we live our lives is rooted in the three albums and the two breakthrough singles he released in 1965 and 1966: *Bringing It All Back Home, Highway 61 Revisited, Blonde On Blonde,* "Like a Rolling Stone," and "Subterranean Homesick Blues." Those records defined and structured a crucial year—no one has ever caught up with them and most likely no one ever will. What happened then is what we always look for. The power of those recordings and of the music Dylan was making on stage, together with his retreat at the height of his career, made Dylan into a legend and virtually changed his name into a noun. Out of that Dylan gained the freedom to step back and get away with anything he chose to do, commercially and artistically. In a real way, Dylan is trading on the treasure of myth, fame and awe he gathered in '65 and '66. In mythical terms, he doesn't have to do good, because he has done good. One wonders, in mythical terms of course, how long he can get away with it.

(21) *"Minstrel Boy" is the best of the Isle of Wight cuts; it rides easy.*

(22) *The Band plays pretty on "She Belongs To Me" and Dylan runs through the vocal the way he used to hurry through the first half of a concert, getting the crowd-pleasers out of the way so he could play the music that mattered. Garth Hudson has the best moment of the song.*

(23)

Vocation as a Vocation: Dylan is, if he wants to be, an American with a vocation. It might almost be a calling—the old Puritan idea of a gift one should live up to—but it's not, and vocation is strong enough.

There is no theme richer for the American artist than the spirit and the themes of the country and the country's history. We have never figured out what this place is about or what it is for, and the only way to even begin to answer those questions is to watch our movies, read our poets, our novelists, and listen to our music. Robert Johnson and Melville, Hank Williams and Hawthorne, Bob Dylan and Mark Twain, Jimmie Rodgers and John Wayne: America is the life's work of American artists because they are doomed to be American. Dylan has a feel for it; his impulses seem to take him back into the forgotten parts of our history, and even on *Self Portrait,* there is a sense of this vocation; Bob is almost on the verge of writing a Western. But it's an ambitious vocation and there is not enough ambition, only an impulse without the determination to follow it up.

Dylan has a vocation if he wants it; his audience may refuse to accept his refusal unless he simply goes away. In the midst of that vocation there might be something like a Hamlet asking questions, old questions, with a bit of magic to them, but hardly a prophet, merely a man with good vision.

(23) "Wigwam" slowly leads the album to its end. Campfire music, or "3 AM, After The Bullfight." It's a great job of arranging, and the B-side of the album's second natural single, backing "Living The Blues." "Wigwam" puts you to bed, and by that I don't mean it puts you to sleep.

<p style="text-align:center">(24)</p>

Self Portrait, the auteur, and home movies: "Auteur" means, literally, "author," and in America the word has come to signify a formula about films: movies (like books) are made by "authors," i.e., directors. This has led to a dictum that tends to affirm the following: movies are about the personality of the director. We should judge a movie in terms of how well the "auteur" has "developed his personality" in relation to previous films. His best film is that which most fully presents the flowering of his personality. Needless to say such an approach requires a devotion to mannerism, quirk, and self-indulgence. It also turns out that the greatest auteurs are those with the most consistent, obvious and recognizable mannerisms, quirks, and self-indulgences. By this approach *Stolen Kisses* is a better film than *Jules and Jim* because in *Stolen Kisses* we had nothing to look for but Truffaut while in *Jules and Jim* there was this story and those actors who kept getting in the way. The spirit of the auteur approach can be transferred to other arts, and by its dictum, *Self Portrait* is a better album than *Highway 61 Revisited,* because *Self Portrait* is about the auteur, that is, Dylan, and *Highway 61 Revisited* takes on the world, which tends to get in the way. (*Highway 61 Revisited* might well be about Dylan too, but it's more *obvious* on *Self Portrait,* and therefore more relevant to Art, and . . . please don't ask about the music, really . . .)

Now Dylan has been approached this way for years, whether or not the word *auteur* was used, and while in the end it may be the least interesting way to listen to his music it's occasionally a lot of fun and a game that many of us have played (for example, on "Days Of '49" Dylan sings the line "just like a roving sign" and I just can't help almost hearing him say "just like a rolling stone" and wondering if he avoided that on purpose). One writer, named A. J. Weberman, has devoted his life to unraveling Dylan's songs in order to examine the man himself; just as every artist once had his patron now every auteur has his critic.

(24) Self Portrait *is a concept album from the cutting-room floor. It has been constructed so artfully, but as a cover-up, not a revelation. Thus "Alberta #2" is the end, after a false ending, just as "Alberta #1" was the beginning, after a false beginning. The song moves quickly, and ends abruptly. These alternate takes don't just fill up a side, they set up the whole album, and it works, in a way, because I think it's mainly the four songs fitted in at the edges that make the album a playable record. With a circle you tend to see the line that defines it, rather than the hole in the middle.*

Self Portrait, the auteur, and home movies, cont.: We all play the auteur game: We went out and bought *Self Portrait* not because we knew it was great music—it might have been but that's not the first question we'd ask—but because it was a Dylan album. What we *want*, though, is a different matter—and that's what separates most people from auteurists—we *want* great music, and because of those three albums back in '65 and '66, we expect it, or hope for it.

I wouldn't be dwelling on this but for my suspicion that it is exactly a perception of this approach that is the justification for the release of *Self Portrait*, to the degree that it is justified artistically (the commercial justification is something else—self-justification). The auteur approach allows the great artist to limit his ambition, perhaps even to abandon it, and turn inward. To be crude, it begins to seem as if it is his habits that matter, rather than his vision. If *we* approach art in this fashion, we degrade it. Take that second song on *John Wesley Harding*, "As I Went Out One Morning," and two ways of hearing it.

A. J. Weberman has determined a fixed meaning for the song: it relates to a dinner given years ago by the Emergency Civil Liberties Committee at which they awarded Bob Dylan their Thomas Paine prize. Dylan showed up, said a few words about how it was possible to understand how Lee Harvey Oswald felt, and got booed. "As I Went Out One Morning," according to Weberman, is Dylan's way of saying he didn't dig getting booed.

I sometimes hear the song as a brief journey into American history. The singer goes out for a walk in the park, finds himself next to a statue of Tom Paine, and stumbles across an allegory: Tom Paine, symbol of freedom and revolt, co-opted into the role of Patriot by textbooks and statue committees, and now playing, as befits his role as Patriot, enforcer to a girl who runs for freedom—in chains, to the *South*, the source of vitality in America, in America's music—*away* from Tom Paine. We have turned our history on its head; we have perverted our own myths.

Now it would be astonishing if what I've just described was on Dylan's mind when he wrote the song. That's not the point. The point is that Dylan's songs can serve as metaphors, enriching our lives, giving us random insight into the myths we carry and the present we live, intensifying what we've known and leading us toward what we never looked for, while at the same time enforcing an emotional strength upon those perceptions by the power of the music that moves with his words. Weberman's way of hearing, or rather seeing, is more logical, more linear, and perhaps even correct, but it's sterile. Mine is not an answer but a possibility, and I think Dylan's music is about possibilities, rather than facts, like a statue that is not an expenditure of city funds but a gateway to a vision.

If we are to be satisfied with *Self Portrait* we may have to see it in the sterile terms of the auteur, which in our language would be translated as "Hey, far out, Dylan singing Simon and Garfunkel, Rodgers and Hart, and Gordon

Lightfoot . . ." Well, it is far out, in a sad sort of way, but it is also vapid, and if our own untaught perception of the auteur allows us to be satisfied with it, we degrade our own sensibilities and Dylan's capabilities as an American artist as well. Dylan did not become a figure whose every movement carries the force of myth by presenting desultory images of his own career as if that was the only movie that mattered—he did it by taking on the world, by assault, and by seduction.

In an attack on the auteur approach, as it relates to film, Louise Brooks quotes Goethe, and the words she cites reveal the problem: "The novel (the film) (the song) is a subjective epic composition in which the author begs leave to treat the world according to his own point of view. It is only a question, therefore, whether he has a point of view. The rest will take care of itself."

—*Rolling Stone*, July 23, 1970

AFTERWORD

As the formal end of the 1960s approached, in some circles dread over the supposed event was as great as the nagging feeling that upon the dawning of the first day of the year 2000 the world will be rendered unrecognizable, assuming it still exists. The notion was that as the clock struck midnight on January 31, 1969, some spirit of invention and resistance peculiar to the time would magically disappear, and all those who had felt privileged to, as the Chinese proverb has it, "live in interesting times," would immediately turn into pumpkins. Given that in previous years Bob Dylan had been seen as a pathfinder, a trailblazer, his *Self Portrait* was felt by many, I think, as the first true sign that this bad dream was coming true: that in the coming decade adventure would be replaced by entropy, creation by repetition, the sense that every day could be different with the certainty that every day would be the same. And you know, for a while, that's exactly how it was.

—Greil Marcus, 1999

Contributors

VINCE ALETTI contributed music criticism to *Rolling Stone, Creem, Crawdaddy*, and *Fusion* during the 1960s and 1970s, and was *Record World*'s disco columnist every week between 1975 and 1978. He is currently a senior editor and the photography critic at the *Village Voice*.

JENNIFER DEVERE BRODY is associate professor of English at George Washington University. She is the author of *Impossible Purities: Blackness, Femininity, and Victorian Culture* (Duke University Press).

VAN M. CAGLE has served as a visiting instructor in the Department of Popular Culture at Bowling Green and as assistant professor in the Department of Communication at Tulane. He is the author of *Reconstructing Pop/Subculture: Art, Rock, and Andy Warhol* (Sage Press).

DAVID ALLEN CASE teaches English at Los Angeles City College. His essay "The Vocation of Nietzsche and Proust" has just been published in *International Studies in Philosophy*.

HARRY WAYNE CASEY [KC] divides his time between his homes in Chapel Hill, North Carolina, and Miami. In 1995, KC & the Sunshine Band put out a 2-CD concert album on Intersound Records called *Get Down Live*. Their most recent studio recording is *Yummy*.

CHRISTOPHER CASTIGLIA is associate professor of English at Loyola University, Chicago. He is the author of *Bound and Determined: Captivity, Culture-Crossing, and White Womanhood from Mary Rowlandson to Patty Hearst* (University of Chicago Press).

ANNE-LISE FRANÇOIS is assistant professor of comparative literature and English at the University of California, Berkeley. She has written on the

seventies before in *The Journal of Seventies Studies/A Special Issue of Zirkus, the Yale Literary Magazine* (Summer 1988, guest-edited by Charles Kronengold and Suzanne Yang).

RANDOLPH HEARD is a New York–based television writer who believes in chimps. He has enjoyed writing for *The Tick, Space Ghost,* and *Strangers With Candy.*

CHARLES KRONENGOLD has a Ph.D. in music from the University of California, San Diego. He was recently a fellow of the University of California Humanities Research Institute and is currently teaching at the University of Northern Iowa.

GREIL MARCUS is the author of several books, including *Lipstick Traces: A Secret History of the Twentieth Century* (Harvard University Press), *The Dustbin of History* (Harvard University Press), and *Invisible Republic: Bob Dylan's Basement Tapes* (Henry Holt).

CINDY PATTON is associate professor in the Graduate Institute of the Liberal Arts at Emory University. Her most recent book is *Fatal Advice: How Safe-Sex Education Went Wrong* (Duke University Press).

STEPHEN RACHMAN is associate professor of English at Michigan State University. He is the coeditor of *The American Face of Edgar Allan Poe* (Johns Hopkins University Press). He is the author of a forthcoming study, *Cultural Pathology: Disease and Literature in Nineteenth Century America* (Johns Hopkins University Press). The present essay is from a project on humor and culture.

SOHNYA SAYRES is coeditor of *The 60s Without Apology* (University of Minnesota Press) and author of *Susan Sontag: The Elegiac Modernist* (Routledge). She is associate professor of humanities at The Cooper Union.

MICHAEL E. STAUB teaches English and American studies at Bowling Green State University. He is the author of *Voices of Persuasion: Politics of Representation in 1930s America* (Cambridge University Press). Currently, he is completing a book on racial politics, Holocaust consciousness, and the rise of Jewish neo-conservatism.

AMBER VOGEL edits *The Journal of African Travel-Writing* at the University of North Carolina at Chapel Hill. She is now at work on *The Breath of Letters: Selected Correspondence of Laura (Riding) Jackson.*

SHELTON WALDREP is assistant professor of English at the University of Southern Maine. He is a coauthor of *Inside the Mouse: Work and Play at Disney World* (Duke University Press). He is finishing a book entitled *Earnest Play: Oscar Wilde and the Soul of Man under Capitalism.*

Index